WHO OLOGY

REGENERATED EDITION

BBC

DOCTOR WHO
WHOOLOGY
THE OFFICIAL MISCELLANY

CAVAN SCOTT & MARK WRIGHT

Charles County Public Library
www.ccplonline.org

HARPER
DESIGN
An Imprint of HarperCollinsPublishers

This revised edition also published by BBC Books in 2018 in the United Kingdom.

DOCTOR WHO: WHO-OLOGY REGENERATED EDITION

Doctor Who is a BBC Wales production for BBC One.
Executive producers: Steven Moffat and Brian Minchin

Published in 2018 by
Harper Design
An Imprint of HarperCollins*Publishers*
195 Broadway
New York, NY 10007
Tel: (212) 207-7000
Fax: (855) 746-6023
harperdesign@harpercollins.com
www.hc.com

Distributed throughout the world by
HarperCollins Publishers
195 Broadway
New York, NY 10007

Library of Congress Control Number: 2017945066

ISBN 978-0-06-279559-5

Printed in USA, 2018

Daleks created by Terry Nation.
Cybermen created by Kit Pedler and Gerry Davis.
Silurians created by Malcolm Hulke.
Autons and Sontarans created by Robert Holmes.

Commissioning editor: Albert DePetrillo
Illustrations: Ben Morris Illustration
Design: Seagull Design
Production: Alex Merrett

CONTENTS

THREE

THE DOCTOR'S BEST FRIENDS: COMPANIONS AND OTHER ALLIES 97

FOUR

A CARNIVAL OF MONSTERS 166

FIVE

LOTS OF PLANETS HAVE A NORTH: A ROUGH GUIDE TO EARTH AND OTHER WORLDS 209

SIX

A KETTLE AND A PIECE OF STRING: TECHNOLOGY IN DOCTOR WHO 247

SEVEN

RELATIVE DIMENSIONS: DOCTOR WHO AND POPULAR CULTURE 276

EIGHT

THE MATRIX: BEHIND THE SCENES 317

APPENDIX STORY LIST 340

THANKS 355

INTRODUCTION

'Hello. I'm the Doctor. Basically, run...'

The Doctor, *The Eleventh Hour*

We started running with the Doctor on 23 November 1963, and haven't stopped since. Over fifty years of adventure have given us hundreds of stories, at least 14 Doctors and more monsters than you can shake a sink plunger at.

In 2013, we presented the first edition of this book: a miscellany, a rattle-bag of facts, figures and trivia from five decades of wandering in the fourth dimension. Now we're back, with a Regenerated Edition updated to include everything up to the Twelfth Doctor's final moments. From a junkyard on Totter's Lane to a time-twisting encounter in the snow, we revisit the companions that have taught a Time Lord how to be human, the planets the TARDIS has visited and the terrors our errant Gallifreyan has faced.

Here you will discover the many names that the Doctor has used over the years, the many abilities Time Lords possess, and just how mad Missy and the Master actually are. Find out what vehicles the Doctor has piloted, the myriad capabilities of the trusty sonic screwdriver, and the songs that have become the soundtrack to the series.

There are questions to answer—who has written the most *Doctor Who* television stories and how long would it take to watch every episode back to back? There are survival guides that detail the many ways to kill the un-killable Daleks, a timeline of significant events throughout the show's history, and a list of every TARDIS control and mechanism ever mentioned.

Above all, *Who-ology* is a love letter to one of the craziest shows on television. What is it about this mad science-fantasy series that fans get excited about UNIT call-signs or how many episodes Sarah Jane Smith appeared in? After scouring over 250 stories, we still don't have the answer, but we do know how many times the Daleks say 'Exterminate'.

Happy Times and Places,

Cavan Scott and Mark Wright

A note about stories and statistics

The statistics in this book include all regular televised episodes and stories of *Doctor Who* between *An Unearthly Child* (1963) and *Twice Upon A Time* (2017), not including the untelevised story *Shada* (1979).

ONE

THE 55-YEAR DIARY
A DOCTOR WHO TIMELINE

'I tried keeping a diary once. Not chronological, of course. But the trouble with time travel is, one never seems to find the time.'

The Doctor, *The Caves of Androzani*

The Doctor's adventures began in a junkyard at 76 Totter's Lane on 23 November 1963, where an impossible police box awaited two inquisitive school teachers. It was the beginning of the trip of a lifetime.

Since then, there have been many firsts and lasts, comings and goings, tearful farewells and exciting new beginnings. Tales of what went on behind the scenes on *Doctor Who* are as compelling as the Doctor's on-screen adventures.

A man is the sum of his memories, a Time Lord even more so… *Who-ology* presents the 55-year diary of *Doctor Who*.

⬛ The 1960s

March 1962–June 1963 The BBC initiates a survey of published science fiction to establish its relevance to television drama. A series of reports and meetings involving Head of Serials Donald Wilson and staff writers Alice Frick, John Braybon and CE 'Bunny' Webber culminates in the detailed development of a new science fiction drama serial. Sydney Newman, the BBC's new Head of Drama, and CE Webber subsequently produce a proposal document under the title 'Dr Who: General Notes on Background and Approach'. Newman goes on to appoint Verity Lambert as *Doctor Who*'s series producer.

12 July 1963 Actor William Hartnell attends a lunch with Verity Lambert and director Waris Hussein to discuss playing the Doctor. Initially reluctant, Hartnell eventually agrees to the offer.

27 September 1963 Studio recording takes place at the BBC's Lime Grove Studios, London, for the very first

episode, *An Unearthly Child*. Head of Drama Sydney Newman is unhappy with the result and orders that the episode be recorded again.

18 October 1963 A second version of *An Unearthly Child* is recorded at Lime Grove Studios using a revised script.

21 November 1963 The *Radio Times*, the BBC's listing magazine, previews *Doctor Who* for the very first time.

23 November 1963 The first episode of *Doctor Who* is broadcast at 5.16pm and watched by 4.4 million people.

21 December 1963 An early Christmas present as the Daleks make their first appearance. In fact audiences only see a plunger held by Assistant Floor Manager Michael Ferguson, who would later direct several *Doctor Who* stories.

1 February 1964 The final episode of *The Daleks* is watched by an audi-

ence of 10.4 million, more than double that of *An Unearthly Child* ten weeks before.

13 February 1964 *Doctor Who* features for the first time on the cover of the listings magazine *Radio Times*. The series will make the cover more times than any other television programme over the next 55 years.

22 February 1964 Marco Polo becomes the first historical figure to be depicted in *Doctor Who*.

15 August 1964 The second episode of *The Reign of Terror* features the first ever use of location footage in the series as elements of the story are shot outside the confines of the TV studio.

12 September 1964 The first season of *Doctor Who* comes to an end.

31 October 1964 After a seven-week break, *Doctor Who* returns for its second season with *Planet of Giants*.

November 1964 *Doctor Who in an Exciting Adventure with the Daleks*, the first *Doctor Who* novelisation, is published.

21 November 1964 The Daleks make their second appearance in the series—this time invading future Earth.

26 December 1964 Carole Ann Ford makes her final appearance as the Doctor's granddaughter Susan, marking the first departure of a companion.

2 January 1965 The first time the Doctor uses the term 'materialise' to describe the TARDIS landing.

26 June 1965 The final appearances of William Russell and Jacqueline Hill as Ian Chesterton and Barbara Wright, leaving room for the *Doctor Who* debut of companion Steven Taylor, played by Peter Purves.

17 July 1965 The first appearance in the series of a TARDIS other than the Doctor's. The TARDIS belongs to a mysterious monk, played by Peter Butterworth. The Monk is the first member of the Doctor's own people to appear apart from Susan.

23 August 1965 The cinema release of *Dr. Who and the Daleks*, the first of two big-screen adventures starring Peter Cushing as 'Dr Who'. In colour!

September 1965 The first publication of *The Dr Who Annual* by World Distributors, priced 9s 6d. It contains text stories featuring TV monsters the Voord and the Zarbi, as well as puzzles and features.

9 October 1965 Broadcast of *Mission to the Unknown*, the first and only episode not to feature either the Doctor or any of his companions.

13 November 1965 The first appearance of actor Nicholas Courtney, here playing Bret Vyon. Courtney will go on to play a significant character in the Doctor's lives.

4 December 1965 The first on-screen death of a companion, as Adrienne Hill's Katarina is killed.

21 December 1965 *The Curse of the Daleks*, a stage play by David Whitaker and Terry Nation, opens at London's Wyndham's Theatre.

25 December 1965 *Doctor Who*'s first broadcast on Christmas Day, an event that will not be repeated until 2005.

28 May 1966 Broadcast of *The Savages* Episode 1. Up to now each episode has been given individual titles; from now on, they are grouped together under story titles with numbered episodes.

6 August 1966 The official announcement to the press that William Hartnell is to leave the role of the Doctor. On this day, Patrick Troughton signs a contract to appear as the Doctor for 22 episodes.

8 October 1966 The Cybermen make their first appearance, giving *Doctor Who* its second enduring monster.

29 October 1966 In the closing minutes of *The Tenth Planet*, the Doctor regenerates for the first time (though that term won't be used until the Third Doctor changes into the Fourth), and William Hartnell makes

his final regular appearance in the series. Patrick Troughton briefly makes his *Doctor Who* debut.

5 November 1966 Patrick Troughton's first full episode as the Doctor also sees the return of the Daleks.

17 December 1966 The first appearance of Frazer Hines as Jamie Macrimmon. He will clock up 113 regular episodes of *Doctor Who*, the most of any companion.

4 March 1967 The series sees its first use of an optical special effect, as the Cybermen blast a hole in the wall of a moonbase with a space cannon.

11 March 1967 The debut of a revamped title sequence featuring the face of Patrick Troughton. This creates a tradition of using the Doctor's face in the titles that lasts until 1989—a custom absent from the Eighth, Ninth, Tenth and early Eleventh Doctors' eras but reintroduced on 25 December 2012.

1 July 1967 The Daleks make what is intended to be their final appearance in *Doctor Who*. This 'final end' is brought about by writer Terry Nation's desire to launch his creations in their own series. The BBC has turned down the chance to make such a spin-off, and Nation has opened talks with American broadcasters. The monsters that helped cement *Doctor Who*'s popularity will not return to the series in a new story for nearly five years.

30 September 1967 The first appearances of the Yeti and the Great Intelligence.

11 November 1967 The first appearance of the Ice Warriors.

17 February 1968 The first appearance of Nicholas Courtney as Colonel Lethbridge-Stewart. The character's feet have appeared in close-up a week earlier, provided by extra Maurice Brooks.

16 March 1968 The first appearance of the sonic screwdriver.

9 November 1968 The first full appearance of UNIT, the United Nations Intelligence Taskforce, under the command of Alistair Lethbridge-Stewart, now a Brigadier, played once again—and many times in the future—by Nicholas Courtney.

7 January 1969 The announcement to the press that Patrick Troughton is to leave *Doctor Who*.

7 June 1969 The first use of 'Time Lord' to describe the Doctor's people, uttered by an unnamed scientist played by Vernon Dobtcheff in *The War Games*.

17 June 1969 Jon Pertwee is announced as the third actor to take on the TV role of the Doctor in a press call held at BBC Broadcasting House. The actor is accompanied by a Yeti.

21 June 1969 Patrick Troughton's final regular appearance as the Doctor. This episode features the first trip to the Doctor's as yet unnamed home planet.

⏺ The 1970s

3 January 1970 A date marking many firsts in the history of *Doctor Who*. Jon Pertwee makes his debut, and a format change sees the Doctor exiled to Earth by the Time Lords. The Third Doctor becomes scientific adviser to UNIT with Nicholas Courtney's Brigadier Alistair Lethbridge-Stewart joining the series as a regular. The Nestene Consciousness and its plastic servants, the Autons, make their first attempt to invade Earth. Technology is changing in the wider world of television, and *Doctor Who* is broadcast in colour for the first time with a story recorded entirely on film, something that won't happen again until 1996. The series sports a new colour title sequence featuring Pertwee's face, and the number of episodes for the series has been reduced. Instead of running for about ten months of the year, as it has since 1963, *Doctor Who* is now on air for six months.

31 January 1970 *Doctor Who and the Silurians* marks the only time the series name is used within an individual on-screen story title. The Doctor's yellow vintage car Bessie makes her debut. The appearance of a dinosaur marks the first use in the series of a technique known as colour separation overlay, or chromakey. A primary-coloured backdrop is used to 'key in' an image from another camera in a similar way to today's green-screen technique.

21 March 1970 The theme tune 'sting' to emphasise the cliffhanger ending to each episode is used for the first time at the suggestion of director Michael Ferguson.

2 January 1971 Roger Delgado arrives as the Doctor's Time Lord arch nemesis the Master.

1 January 1972 *Day of the Daleks* Episode 1 sees Skaro's finest make their first appearance since May 1967.

29 January 1972 The Ice Warriors return as the Doctor faces *The Curse of Peladon*, although this time they're goodies!

26 February 1972 The first appearance of the Sea Devils.

30 December 1972 A milestone to mark the tenth anniversary of the series, as William Hartnell and Patrick Troughton return to *Doctor Who*, battling the Time Lord Omega with current Doctor Jon Pertwee in *The Three Doctors*.

31 March 1973 The final appearance by Roger Delgado as the Master in the story *Frontier in Space*.

7 April 1973 Dalek creator Terry Nation makes his first script contribution to *Doctor Who* for seven years with *Planet of the Daleks* Episode 1.

2 May 1973 Target Books publish reprints of the novelisations *Doctor Who and the Daleks*, *Doctor Who and the Crusaders* – both by David Whitaker—and *Doctor Who and the Zarbi* by Bill Strutton.

18 June 1973 Roger Delgado is tragically killed in a car accident while filming *Bell of Tibet* in Turkey.

26 June 1973 Elisabeth Sladen is announced to the press as new companion Sarah Jane Smith, with Jon Pertwee joining her at a photo call at BBC Television Centre.

15 December 1973 The first episode of *Doctor Who*'s 11th season not only sees Sarah Jane Smith join the TARDIS, but also features the debut of the potato-headed Sontarans. The series now sports a brand new title sequence, once again designed by Bernard Lodge, who has created each title sequence since *Doctor Who*'s first episode. Lodge also designs a diamond-shaped logo to accompany the new series.

22 December 1973 The first on-screen reference to Gallifrey as the home planet of the Doctor and the Time Lords. This is not the first time the name has cropped up: it has been let slip in issue 124 of *TV Action* comic in July 1973, as the editors responded to a reader's letter asking which planet the Master came from.

5 February 1974 BBC Head of Serials Bill Slater receives a letter from an out-of-work actor called Tom Baker, asking for work.

8 February 1974 The press announcement that Jon Pertwee will leave *Doctor Who* at the end of the current series.

15 February 1974 Tom Baker is unveiled to the press as Jon Pertwee's successor in the role of the Doctor. He is joined by Elisabeth Sladen and a Cyberman at a photo call at BBC Television Centre.

8 June 1974 The final regular appearance by Jon Pertwee as the Doctor after five years. The term 'regeneration' is used for the first time.

28 December 1974 Tom Baker makes his full debut as the Doctor at 5.35pm, watched by 10.8 million viewers. Bernard Lodge's fifth title sequence is unveiled, which now features Tom Baker's face and the TARDIS for the first time.

1 February 1975 13.6 million viewers tune in to the second episode of *The Ark in Space*, propelling *Doctor Who* to its highest rating and chart placing at that point, coming in as the fifth most-watched television programme of the week.

8 March 1975 The first appearance of Davros, the creator of the Daleks.

19 April 1975 The first appearance of the Cybermen since 1968's *The Invasion*. The story is former script editor and Cybermen co-creator Gerry Davis's final contribution to *Doctor Who*. *Revenge of the Cybermen* makes the first reference to the Cybermen's vulnerability to gold.

23 April 1975 William Hartnell passes away, aged 67.

20 September 1975 After 98 episodes, Nicholas Courtney makes his final regular appearance as Brigadier Lethbridge-Stewart in *Terror of the Zygons*.

6 March 1976 The original TARDIS prop makes its final appearance after 13 years' service to adventures in time and space. Years of being battered around studios and locations have taken their toll, resulting in the roof collapsing on Elisabeth Sladen during studio recording for *The Seeds of Doom*.

23 October 1976 Elisabeth Sladen makes her final regular appearance as Sarah Jane Smith—but Sarah's story is in many ways only just beginning.

30 October 1976 Companionless for the very first time, the Doctor returns home to Gallifrey for *The Deadly Assassin*. The

Master makes his first appearance since *Frontier in Space*, now played by Peter Pratt.

1 October 1977 A different kind of companion makes its debut, as robot dog K-9 whirrs into view for the first time.

18 July 1978 The cast and crew of *The Stones of Blood* enjoy a specially made birthday cake to celebrate making *Doctor Who*'s 100th adventure. The cake had originally been ordered as a prop for a scene in which the Doctor celebrates his 751st birthday, but the gag was never taped.

2 September 1978 The first appearance of Mary Tamm as Time Lady companion Romanadvoratrelundar—Romana for short. A season-long story arc begins as the Doctor, Romana and K-9 embark on the quest for the Key to Time.

30 September 1978 Douglas Adams contributes his first script to *Doctor Who*. His famous radio comedy, *The Hitchhiker's Guide to the Galaxy*, first aired in March 1978.

30 April 1979 The *Doctor Who* cast and crew travel to Paris to record sequences for the upcoming *City of Death*, marking the series' first location shoot abroad.

22 September 1979 Broadcast of Dalek creator Terry Nation's final script contribution to *Doctor Who—Destiny of the Daleks*, Episode 4.

20 October 1979 With the BBC's rival broadcaster ITV in the grip of industrial action that has taken it off the air, the final part of *City of Death* attracts *Doctor Who*'s highest-ever audience figure of 16.1 million viewers. It is a record that stands to this day.

10 December 1979 Continued industrial action by various technicians' unions plagues filming on *Shada*, the final story of Season 17, forcing producer Graham Williams to officially abandon production. While it is doomed never to be transmitted, the story will eventually be released commercially as a VHS tape in 1992, with new linking material performed by Tom Baker, and reissued on DVD in 2013.

🕯 The 1980s

30 August 1980 *Doctor Who*'s eighteenth season debuts, and with it a new version of the theme tune. Alterations have been made to the theme over the years, but the original mix created by Delia Derbyshire in 1963 has always been retained until now, as Peter Howell, of the BBC Radiophonic Workshop, completely reimagines the famous theme. To accompany the new arrangement, the title sequence abandons the 'time tunnel' effect for a background of stars, and features a brand new neon-style logo.

24 October 1980 A hastily arranged press conference is held to announce Tom Baker's departure from *Doctor Who* at the end of Season 18. Although producer John Nathan-Turner is already in discussions with the actor who will be his new Doctor, Tom Baker's teasing leads the press to speculate that 'the new Doctor Who may even be a woman'.

5 November 1980 *All Creatures Great and Small* star Peter Davison appears on BBC magazine programme *Nationwide*, confirming that he will be taking over the part of the Doctor from Tom Baker.

24 January 1981 K-9 leaves the series, along with Romana, but the tin dog will return to our screens later in the year.

21 February 1981 Two masterful first appearances in *The Keeper of Traken*. Geoffrey Beevers makes his debut as the emaciated form of the Master, but is replaced at the end of the story by Anthony Ainley, the fourth actor to play the renegade Time Lord.

21 March 1981 An end that spells a new beginning, as Tom Baker makes his final appearance as the Doctor, making way for Peter Davison's brief debut as the Fifth Doctor. Davison's credit in the closing titles is the last time an actor in the role is credited as 'Doctor Who' (rather than 'The Doctor') until 2005.

28 December 1981 The first *Doctor Who* spin-off is broadcast. *K-9 and Company* sees the return of Elisabeth Sladen to the *Doctor Who* universe as Sarah Jane Smith, joining K-9 Mark III for a spooky festive adventure. The hoped-for spin-off series fails to materialise—for now.

4 January 1982 After the longest-ever gap between seasons of *Doctor Who*, a new era begins with *Castrovalva* Part 1, marking Peter Davison's first full episode as the Doctor. After eighteen years occupying a traditional Saturday teatime slot in the schedules, *Doctor Who* moves through time and space to a twice-weekly broadcast on Monday and Tuesday evenings at 6.40pm. This episode also marks the first use of a pre-titles scene, reprising the regeneration scene from the end of *Logopolis* Part 4.

22 February 1982 Millions of *Doctor Who* viewers watch in horror as the sonic screwdriver makes its final appearance, an old friend blasted to pieces by a Terileptil's gun.

8 March 1982 In a shock cliffhanger ending, *Earthshock* sees the Cybermen make their first full appearance in eight years.

16 March 1982 Companion Adric, played by Matthew Waterhouse, is killed off. In a break with tradition, the closing credits run with no music for the one and only time in the series' history.

1 February 1983 *Mawdryn Undead* sees Nicholas Courtney make his first appearance as the Brigadier in eight years.

28 July 1983 Following a press conference, the BBC lunchtime news reveals that Peter Davison will depart the role of the Doctor at the close of the 21st season. His successor has been cast, but is yet to be revealed to the world at large.

19 August 1983 Popular television actor Colin Baker is announced as the sixth actor to play the Doctor. The announcement is made at a press conference in which the actor is joined by Nicola Bryant, who will play the Doctor's latest companion, Peri Brown.

October 1983 *Revenge of the Cybermen* becomes the first *Doctor Who* story to be released on home video on VHS, Betamax and Video 2000 formats.

23 November 1983 *Doctor Who*'s twentieth anniversary, and the first broadcast of the anniversary special *The Five Doctors* takes place—in the USA.

25 November 1983 As part of the BBC's annual Children in Need charity telethon, *The Five Doctors* is broadcast in the UK. Patrick Troughton and Jon Pertwee return to the series, with Tom Baker represented through clips from the unfinished story *Shada*, and

Richard Hurndall taking the place of the late William Hartnell as the First Doctor.

8 February 1984 Part 1 of *Resurrection of the Daleks* is broadcast. Coverage of the Winter Olympics means that the four-part story is stitched together as two double-length episodes.

16 March 1984 After three years, Peter Davison makes his final regular appearance as the Doctor, handing over to Colin Baker who debuts as the Sixth Doctor in the closing moments of the episode. The regeneration takes place in *The Caves of Androzani*, the penultimate story of the season.

22 March 1984 Colin Baker makes his full debut as the Sixth Doctor in *The Twin Dilemma*. The Doctor uses the term

'incarnation' for the first time to describe his new body.

5 January 1985 Colin Baker's first full season as the Doctor opens with a return for the Cybermen. Following the success of longer episodes for last year's *Resurrection of the Daleks*, the series is now broadcast in longer 45-minute episodes and returns to its traditional Saturday night slot.

2 February 1985 The first appearance of Kate O'Mara as the Rani.

16 February 1985 Having enjoyed appearing in *The Five Doctors*, Patrick Troughton returns to the series once more in *The Two Doctors*, joined by Frazer Hines as Jamie.

27 February 1985 Michael Grade, the Controller of BBC One, becomes the most vilified person in the history of *Doctor Who* when his decision to delay the next series by eighteen months is announced.

30 March 1985 The Daleks are seen to hover above the ground for the first time in *Revelation of the Daleks* Part 2. The confusing camera angle used means that many viewers miss this historic event.

25 July 1985 The first episode of radio drama *Doctor Who: Slipback* is broadcast on BBC Radio 4. It stars Colin Baker and Nicola Bryant as the Doctor and Peri, and forms part of the station's *Pirate Radio 4* strand for younger listeners.

6 September 1986 After an enforced hiatus, *Doctor Who* returns to screens with the first episode of the longest-ever *Doctor Who* story, the 14-part *Trial of a Time Lord*.

6 December 1986 Colin Baker makes what will become his final regular televised appearance as the Doctor in the final part of the *Trial* season.

18 December The official press announcement that Colin Baker will not be returning as the Doctor.

28 February 1987 British newspaper *The Sun* breaks the story about Sylvester McCoy's casting as the new Doctor. McCoy, along with Bonnie Langford, attends a photo call for the press on 2 March to confirm the news, and later appears on *Blue Peter*.

28 March 1987 Patrick Troughton passes away at the age of 67 while attending a *Doctor Who* convention in the USA.

7 September 1987 Sylvester McCoy debuts as the Seventh Doctor.

23 November 1987 On *Doctor Who*'s 24th birthday, Sophie Aldred makes her first appearance as Ace in *Dragonfire*.

5 October 1988 A Dalek is seen to hover up a flight of stairs for the first time in *Remembrance of the Daleks*.

23 November 1988 *Doctor Who* celebrates its Silver Jubilee with *Silver Nemesis,* an adventure that appropriately pits the Doctor and Acc against the Cybermen.

23 March 1989 Jon Pertwee stars as the Doctor in the first performance of stage show *Doctor Who: The Ultimate Adventure* at the Wimbledon Theatre, London. Colin Baker takes over the role from Pertwee on 5 June.

12 July 1989 Roger Laughton, Director of Co-Production at BBC Enterprises, receives a telephone call from American-based television producer Philip Segal. Segal expresses an interest in forging a transatlantic co-production deal with the BBC to continue *Doctor Who* into the 1990s.

23 November 1989 On *Doctor Who*'s 26th anniversary, Sylvester McCoy attends a studio session to record the voiceover that will be played in the closing seconds of *Survival*, the final story of Season 26. These are the final lines recorded for the original 26-year run of *Doctor Who*.

6 December 1989 After 26 years and 695 broadcast episodes, *Doctor Who*'s original television run comes to an end as the Doctor and Ace walk off into the distance. But as history will prove, the Doctor still has work to do.

The 1990s

June 1991 Virgin Books publishes the first novel in the *Doctor Who New Adventures* series, *Timewyrm: Genesis* by John Peel. The book is the first full-length novel featuring the Doctor not to be based on a TV story or unused script.

27 August 1993 BBC Radio Five broadcasts the first episode of *Doctor Who: The Paradise of Death*, a brand new radio adventure for Jon Pertwee as the Doctor, with Elisabeth Sladen as Sarah and Nicholas Courtney as the Brigadier, written by Third Doctor producer Barry Letts.

26 November 1993 To celebrate *Doctor Who*'s 30th anniversary, Jon Pertwee, Tom Baker, Peter Davison, Colin Baker and Sylvester McCoy appear as the Doctor in *Dimensions in Time*, a two-part adventure that forms part of that year's BBC Children in Need telethon. Broadcast in experimental 3D, the story features members of the cast of BBC soap opera *EastEnders* and the return of many companions from *Doctor Who*'s 30-year history, several for the last time. Kate O'Mara makes her third and final appearance as the Rani.

12 September 1994 With continuing rumblings of a US co-production deal for *Doctor Who* going back to Philip Segal's phone call to the BBC in July 1989, film and TV actor Paul McGann tapes a screen test for the role of the Doctor in London.

5 January 1996 Over a year after he first auditioned, Paul McGann is confirmed as the new Doctor at a photo call held at

the *Doctor Who* Exhibition at Longleat. Two days later he flies to Vancouver to begin filming the first new *Doctor Who* in production since 1989. He is joined by Sylvester McCoy to allow a regeneration scene from the Seventh to the Eighth Doctor to be filmed.

14 May 1996 Paul McGann makes his one and only screen appearance as the Doctor with the worldwide debut of the feature-length TV movie *Doctor Who* on the Fox network in America.

20 May 1996 Jon Pertwee passes away at the age of 76.

27 May 1996 The first UK broadcast of the *Doctor Who* TV movie attracts 9.1 million viewers—making it the highest-rated tele-vision drama that week. The episode is dedicated to the memory of Jon Pertwee. Sadly, the success of the TV movie in the UK does not lead to a new series. Yet…

2 June 1997 Publication of the novel *The Eight Doctors* by Terrance Dicks commences BBC Books' own line of original *Doctor Who* fiction. Paul McGann's reading of the novelisation of the TV movie is released as part of the BBC Radio Collection.

7 September 1998 Paul McGann returns to the role of the Doctor with the release of *Earth and Beyond*, an audiobook short-story collection for the BBC Radio Collection.

19 July 1999 Big Finish Productions releases *Doctor Who: The Sirens of Time*, a full-cast audio drama starring Peter Davison, Colin Baker and Sylvester McCoy as the Doctor. It begins a range that will include hundreds of individual releases, featuring Doctors, companions and foes from both 20th- and 21st-century incarnations of the show, as well as numerous spin-off adventures.

The 2000s

January 2001 Paul McGann reprises the role of the Doctor once again, with the release of audio drama *Storm Warning* from Big Finish, which also introduces his first regular travelling companion, Charlie Pollard, played by India Fisher.

26 September 2003 As *Doctor Who* approaches its 30th anniversary, the *Daily Telegraph* breaks the news that a new series of *Doctor Who* is being developed by acclaimed writer Russell T Davies. The paper's report quotes BBC One Controller Lorraine Heggessey confirming the news.

13 November 2003 The first episode of *Scream of the Shalka*, an animated BBC webcast starring Richard E. Grant as the Doctor, goes live.

23 November 2003 *Doctor Who*'s 40th anniversary.

20 March 2004 After much tabloid speculation, Christopher Eccleston is announced as the new Doctor.

24 May 2004 Actress and former pop singer Billie Piper is announced as companion Rose Tyler.

18 July 2004 Television-based *Doctor Who* goes into production for the first time in the 21st century.

20 July 2004 As the *Doctor Who* cast and crew prepare to film night scenes in Cardiff, regional news programme *BBC Wales Today* carries interviews with Christopher Eccleston, Billie Piper and Russell T Davies—and the Ninth Doctor's look is revealed for the first time.

1 January 2005 The first teaser trailer for the new series of *Doctor Who* is broadcast on BBC One. It is almost time—but not yet…

26 March 2005 With audiences promised 'the trip of a lifetime', the first new episode of *Doctor Who* for nine years, *Rose*, is broadcast at 7pm. It attracts an average audience of 10.8 million

viewers. As well as Christopher Eccleston and Billie Piper, *Rose* also features first appearances from Noel Clarke as Mickey Smith and Camille Coduri as Jackie Tyler. The Autons, last seen in 1971's *Terror of the Autons*, are the first monsters encountered by the new Doctor, and a new orchestral arrangement of the theme tune is provided by composer Murray Gold.

30 March 2005 After the success of *Rose*, the BBC announces that *Doctor Who* has been commissioned for a second series. While Billie Piper will return as Rose, the news that Christopher Eccleston will not be continuing as the Doctor is also revealed.

16 April 2005 A BBC press release confirms that lifelong *Doctor Who* fan David Tennant has been cast as the Tenth Doctor.

30 April 2005 The first appearance of the Daleks (or, at least, a Dalek) in the new series.

21 May 2005 John Barrowman makes his debut as Captain Jack Harkness. Steven Moffat contributes his first script to the new series with *The Empty Child*.

11 June 2005 *Bad Wolf* features the first on-screen reference to Torchwood in *Doctor Who*.

15 June 2005 At a special BAFTA screening of *The Parting of the Ways*, executive producer Russell T Davies reveals to an ecstatic audience that *Doctor Who* has been re-commissioned for a third series and a second Christmas special.

Sarah Jane Smith for the first time since *The Five Doctors*. K-9 Mark III is destroyed to be replaced by Mark IV and Mickey Smith becomes the first non-white companion to join the Doctor.

13 May 2006 The first appearance of the Cybermen in the new series.

1 July 2006 Catherine Tate makes her first, surprise appearance as (the unnamed) Donna Noble in the closing moments of *Doomsday*.

14 September 2006 Press announcement that Elisabeth Sladen will star in a new *Doctor Who* spin-off, *The Sarah Jane Adventures*, created for the children's channel CBBC by Russell T Davies.

18 June 2005 Christopher Eccleston makes his final appearance as the Ninth Doctor, and David Tennant appears, briefly, as the Tenth.

17 October 2005 Press announcement that BBC Three will air a post-watershed *Doctor Who* spin-off, *Torchwood*. The series will star John Barrowman as Captain Jack.

18 November 2005 David Tennant's second appearance as the Tenth Doctor is watched by 10.8 million viewers as part of the BBC Children in Need telethon, in a special episode later titled *Born Again* by writer Russell T Davies.

25 December 2005 The broadcast of *The Christmas Invasion* sees David Tennant make his full debut as the Doctor.

29 April 2006 *School Reunion* sees the Doctor reunited with Elisabeth Sladen's

13 October 2006 Director James Strong shoots establishing shots in New York for the upcoming *Daleks in Manhattan*—the first time the series has ever been shot in the United States of America.

22 October 2006 *Torchwood* debuts on BBC Three.

1 January 2007 Elisabeth Sladen stars in the debut episode of *The Sarah Jane Adventures*, ahead of the hugely successful series that will run for five years.

31 March 2007 The first appearance of the Judoon, a rhino-faced alien police force, in *Smith and Jones*.

9 June 2007 The first appearance of the Weeping Angels, in *Blink*.

16 June 2007 The first appearance of the Master in *Doctor Who* since the 1996 TV movie. Sir Derek Jacobi briefly plays the latest incarnation, before John Simm assumes the role at the climax of *Utopia*.

16 November 2007 Classic and modern *Doctor Who* come together in *Time Crash*. The Tenth Doctor meets the Fifth Doctor, both with brainy specs, in a timey-wimey special episode written especially for Children in Need night by Steven Moffat.

25 December 2007 13.3 million viewers tune in to watch pop star Kylie Minogue guest star as Astrid alongside David Tennant in the annual Christmas special, *Voyage of the Damned*. It is the second highest-rated television programme of 2007.

5 April 2008 Catherine Tate returns to *Doctor Who* as Donna Noble—this time joining the Doctor as his new companion for an entire series. Billie Piper makes a surprise reappearance as Rose Tyler in *Partners in Crime*.

26 April 2008 The first appearance of the Sontarans in the new series.

31 May 2008 The first appearance by Alex Kingston as River Song. But who is she?

28 June 2008 Davros appears for the first time in 20 years, now played by Julian Bleach.

5 July 2008 For the first time in its history, *Doctor Who* is the most-watched television programme of the week: 10.6 million viewers tune in to *Journey's End* to see if the Tenth Doctor will regenerate following the cliffhanger ending to the previous week's *The Stolen Earth*. He doesn't.

29 October 2008 David Tennant wins the award for Outstanding Drama Performance at the National Television Awards. He accepts the award live from Stratford-Up-on-Avon where he is appearing in *Hamlet* for the Royal Shakespeare Company. During his acceptance speech, he announces that he will be leaving *Doctor Who*.

3 January 2009 Matt Smith's casting as the Eleventh Doctor is announced in a special edition of *Doctor Who Confidential*.

11 April 2009 Broadcast of *Planet of the Dead*, the first episode of *Doctor Who* to be shot in the High Definition format.

⬛ The 2010s

1 January 2010 David Tennant makes his final appearance as the Doctor and Matt Smith takes over. Geronimo!

3 April 2010 9.6 million viewers watch *The Eleventh Hour*, Matt Smith's first full adventure as the Doctor. He is joined on his

travels by Karen Gillan as Amy Pond. Future companion Rory Williams makes his first appearance, played by Arthur Darvill.

17 April 2010 A 'new paradigm' of Daleks makes its first appearance, sporting a revamped design and colourful livery.

24 April 2010 Alex Kingston returns as River Song—the first of many appearances opposite Matt Smith—along with the Weeping Angels.

22 May 2010 The Silurians' first appearance in the series since *Warriors of the Deep* 26 years before.

26 January 2011 The Doctor makes his first official appearance on rival commercial channel ITV1, as Matt Smith plays the Doctor in a pre-credits scene specially written by Steven Moffat for the *National Television Awards 2011*.

14 May 2011 Novelist Neil Gaiman contributes his first script to *Doctor Who*, in which the TARDIS is given a short-lived human embodiment in the form of Idris, played by Suranne Jones.

4 June 2011 The truth is out there! River Song is revealed to be Melody Pond, the daughter of Amy and Rory, in *A Good Man Goes to War*. Following her dual role as Alaya and Restac in *The Hungry Earth* and *Cold Blood*, Neve McIntosh makes her first appearance as Vastra, with Catrin Stewart as Jenny and Dan Starkey as Strax.

21 March 2012 Press conference announcing Jenna-Louise Coleman as the Doctor's new companion.

1 September 2012 *Asylum of the Daleks* sees the surprise first appearance of Jenna-Louise Coleman, in this story playing Oswin Oswald (aka 'soufflé girl').

29 September 2012 Amy and Rory depart from the Doctor's life for ever, leaving the Time Lord heartbroken.

25 December 2012 Jenna-Louise Coleman makes her second appearance in *Doctor Who*. *The Snowmen* sees her playing Clara Oswin Oswald—but how is she linked to soufflé girl? The Great Intelligence encounters the Doctor for the very first time.

18 May 2013 A new incarnation of the Doctor is revealed when John Hurt is introduced as the War Doctor in the closing moments of *The Name of the Doctor*.

4 August 2013 In a special programme, *Doctor Who Live: The Next Doctor*, Peter Capaldi is revealed to the world as the Twelfth Doctor, due to take over from Matt Smith on Christmas Day 2013.

14 November 2013 Paul McGann makes a surprise return as the Eighth Doctor when the 50th Anniversary minisode *The Night of the Doctor* is made available online, showing his regeneration into the War Doctor.

21 November 2013 Mark Gatiss' *An Adventure in Space and Time* is broadcast, a drama chronicling the behind-the-scenes story of *Doctor Who*'s earliest days. David Bradley is BAFTA-nominated for his sensitive portrayal of William Hartnell.

23 November 2013 *Doctor Who* celebrates its 50th anniversary with the broadcast of *The Day of the Doctor*, uniting Matt Smith's Eleventh Doctor with David Tennant as the Tenth, and featuring John Hurt as the War Doctor. The episode is broadcast worldwide in 94 countries (and in selected cinemas), making it a Guinness World Record holder for the largest ever simulcast of a TV drama. Peter Capaldi makes his surprise debut as the Twelfth Doctor in an eye-opening cameo, while Tom Baker plays the Curator...

25 December 2013 Matt Smith makes his final regular appearance in *The Time of the Doctor*, with 11.1 million viewers tuning in to see the bow-tie loving Eleventh Doctor regenerate into Peter Capaldi's kidney-critical Twelfth Doctor.

23 August 2014 Peter Capaldi makes his full debut as the Doctor in *Deep Breath*, seeking an answer to the question: "Am I a good man?" The episode features a cameo from Matt Smith as the Eleventh Doctor and marks the first appearance of Michelle Gomez as Missy.

1 November 2014 In the climax of *Dark Water*, Missy is revealed to be a new incarnation of the Master. Michelle Gomez becomes the tenth actor to portray the Doctor's arch nemesis.

14 November 2015 *Sleep No More* airs, the first story not to feature the *Doctor Who* title sequence.

5 December 2015 Jenna Coleman makes her last regular appearance as Clara Oswald in *Hell Bent*, heading off into time and space with Ashildir (Maisie Williams) in her own TARDIS.

25 December 2015 Matt Lucas makes his first appearance as Nardole in *The Husbands of River Song*, a Christmas special, which marks the final appearance to date of Alex Kingston as River Song.

23 April 2016 During half-time coverage of the 2016 FA Cup Final, Pearl Mackie is announced as new companion Bill Potts in the special minisode, *Friend from the Future*.

30 January 2017 During an interview on BBC Radio 2 with Jo Whiley, Peter Capaldi announces that the next series of *Doctor Who* will be his last in the role of the Doctor.

15 April 2017 The tenth series of *Doctor Who* since 2005 begins transmission with *The Pilot*, seeing the full debut of Pearl Mackie as Bill, joining the regular cast of Peter Capaldi and Matt Lucas.

24 June 2017 *World Enough and Time* features two returns to *Doctor Who*: John Simm reprises the role of the Master after a seven-year absence, joining Michelle Gomez as Missy; Peter Capaldi fulfils his ambition to face the original Mondasian Cybermen, making their return to *Doctor Who* for the first time in over half a century.

1 July 2017 A regenerating Twelfth Doctor faces his past and future in the closing moments of *The Doctor Falls* as David Bradley appears as the First Doctor – the original, you might say.

16 July 2017 After months of speculation, the identity of the Thirteenth Doctor is revealed following the Wimbledon Men's Singles final. Jodie Whittaker will take over the role of the Doctor from Peter Capaldi on Christmas Day 2017.

25 December 2017 Peter Capaldi says farewell to *Doctor Who* in *Twice Upon A Time*, a Christmas special that sees the Doctor team up with his first incarnation, as played by David Bradley. In the closing moments, the Twelfth Doctor regenerates into the Thirteenth. Jodie Whittaker is the Doctor, and what started as a mild curiosity in a junkyard continues with a great spirit of adventure…

TWO

EVERYONE'S FAVOURITE TIME LORD

THE MANY LIVES AND CHANGING FACES OF THE DOCTOR

'I'm the Doctor. Well, they call me "the Doctor", I don't know why; I call me "the Doctor" too, still don't know why.'

The Doctor, *The Lodger*

For a man of mystery, we know an awful lot about the Doctor. His lucky number is 7 (or 74,384,338 depending on when you ask him), his favourite type of jazz is straight blowing, and he tries never to land the TARDIS on a Sunday. But what else is known about Gallifrey's most famous child?

FIRST AND LAST WORDS

THE FIRST DOCTOR

- First: 'What are you doing here?'
- Last: 'Ah, yes! Thank you. It's good. Keep warm.'

THE SECOND DOCTOR

- First: 'Slower! Slower! Concentrate on one thing. One thing!'
- Last: 'No! Stop! You're making me giddy! No, you can't do this to me! No, no, no, no, no, no, no, no, no, no, no, no…'

THE THIRD DOCTOR

- First: 'Shoes. Must find my shoes.'
- Last: 'A tear, Sarah Jane? No, don't cry. While there's life there's…'

THE FOURTH DOCTOR

- First: '… typical Sontaran attitude… stop Linx… perverting the course of human history… I tell you, Brigadier, there's nothing to worry about. The brontosaurus is large and placid… And stupid! If the square on the hypotenuse equals the sum of the square on the other two sides, why is a mouse when it spins? Never did know the answer to that one.'
- Last: 'It's the end. But the moment has been prepared for.'

THE FIFTH DOCTOR

- First: 'I… Oh.'
- Last: 'Might regenerate. I don't know. Feels different this time… Adric?'

THE SIXTH DOCTOR

- First: 'You were expecting someone else?'
- Last: Unknown (although he is heard uttering 'Carrot juice, carrot juice, carrot juice' at the end of *The Trial of a Time Lord*)

THE SEVENTH DOCTOR

- First: 'Oh no, Mel.'
- Last: 'Timing malfunction! The Master, he's out there! He's out there… I know… I've got to stop… him…'

THE EIGHTH DOCTOR

- First: 'Who am I? Who am I?'
- Last: 'Physician, heal thyself.'

THE WAR DOCTOR

- First: 'Doctor no more.'
- Last: 'I hope the ears are a bit less conspicuous this time.'

THE NINTH DOCTOR

- First: 'Run!'
- Last: 'Rose… before I go, I just wanna tell you, you were fantastic. Absolutely fantastic. And do you know what? So was I!'

THE TENTH DOCTOR

- First: 'Hello! Okay—oh. New teeth. That's weird. So, where was I? Oh, that's right. Barcelona!'
- Last: 'I don't want to go!'

THE ELEVENTH DOCTOR

- First: 'Legs! Still got legs, good!! Arms, hands. Ooh, fingers. Lots of fingers. Ears? Yes. Eyes: two. Nose… I've had worse. Chin—blimey! Hair… I'm a girl! No! No! I'm not a girl! And still not ginger! There's something else. Something… important, I'm… I'm-I'm… Ha-ha! Crashing! *Geronimo!!*'
- Last: 'Hey…'

THE TWELFTH DOCTOR

- First: 'Kidneys. I've got new kidneys. I don't like the colour.'
- Last: 'Doctor… I let you go.'

DOCTOR WHO—
THE ORIGINAL TRAILER

'My name is William Hartnell and, as Doctor Who, I make my debut on Saturday the 23rd of November at 5.15.

The Doctor is an extraordinary old man from another world who owns a time and space machine.

He and his granddaughter, Susan (played by Carole Ann Ford) have landed in England and are enjoying their stay, until Susan arouses the curiosity of two of her schoolteachers (played by William Russell and Jacqueline Hill). They follow Susan and get inside the Ship and Doctor Who decides to leave Earth, starting a series of adventures which I know will thrill and excite you every week.'

Doctor Who radio trailer, November 1963

Doctor	Era	Stories	Episodes	First full episode	
First	1963–1966	29	134	*An Unearthly Child* I	
Second	1966–1969	21	119	*The Power of the Daleks* I	
Third	1970–1974	24	128	*Spearhead from Space* I	
Fourth	1974–1981	41	172	*Robot* I	
Fifth	1982–1984	20	69	*Castrovalva* I	
Sixth	1984–1986	8	31	*The Twin Dilemma* I	
Seventh	1987–1989	12	42	*Time and the Rani* I	
Eighth	1996	1	1	*Doctor Who*	
War	2013	1	1	*The Day of the Doctor*	
Ninth	2005	10	13	*Rose*	
Tenth	2005–2010	37	47	*The Christmas Invasion*	
Eleventh	2010–2013	39	44	*The Eleventh Hour*	
Twelfth	2013–2017	32	40	*Deep Breath*	

THE DOCTOR BY NUMBERS

In how many stories or episodes does each Doctor appear? Not counting images from brain scans, mind-wrestling contests or data stamps, here's a rundown for each incarnation—plus the various other times they popped up in televised minisodes, red-button stories and animated adventures.

Final full episode	Additional appearances
The Tenth Planet 4	The Three Doctors (1972), The Five Doctors (1983), Dimensions in Time* (1993), The Name of the Doctor (2013), The Day of the Doctor (2013), The Doctor Falls (2017), Twice Upon a Time (2017)
The War Games 10	The Tenth Planet 4 (regeneration, 1966), The Three Doctors (1972), The Five Doctors (1983), The Two Doctors (1985), Dimensions in Time* (1993)
Planet of the Spiders 6	The Five Doctors (1983), Dimensions in Time (1993)
Logopolis 4	Planet of the Spiders 6 (regeneration, 1974), The Five Doctors (1983), Dimensions in Time (1993)
The Caves of Androzani 4	Logopolis 4 (regeneration, 1981), Dimensions in Time (1993), Time Crash (2007)
The Trial of a Time Lord 14	The Caves of Androzani 4 (regeneration, 1984), Time and the Rani (regeneration, 1987), Dimensions in Time (1993)
Survival 3	Dimensions in Time (1993), Doctor Who (regeneration, 1996)
Doctor Who	The Night of the Doctor (2013)
The Day of the Doctor	The Name of the Doctor (2013), The Night of the Doctor (regeneration, 2013)
The Parting of the Ways	
The End of Time, Part Two	The Parting of the Ways (regeneration, 2005), Born Again (2005), Attack of the Graske (2005), The Infinite Quest (2007), Time Crash (2007), Music of the Spheres (2008), Dreamland (2009), The Sarah Jane Adventures: Wedding of Sarah Jane Smith (2009), The Day of the Doctor (2013)
The Time of the Doctor	The End of Time, Part Two (regeneration, 2010), The Sarah Jane Adventures: Death of the Doctor (2010), Death Is the Only Answer (2011), Space / Time (2011), Good as Gold (2012), Pond Life (2012), The Great Detective (2012), A Night With the Stars (2013), Deep Breath (2014)
Twice Upon A Time	The Day of the Doctor (2013) Class: For Tonight We Might Die (2016)

* Well, their heads make an appearance!

WHO'S WHO –
THE FOURTEEN DOCTORS

From William Hartnell to Jodie Whittaker, each actor to play the Doctor has brought their own unique take on the part. But what other roles are on their CV, and how were they cast as the Doctor?

🔹 WILLIAM HARTNELL—THE FIRST DOCTOR

- Full Name: William Henry Hartnell
- Born: 8 January 1908, St Pancras, London
- Died: 23 April 1975, Marden, Kent
- First Screen Appearance: *Say it with Music* (1932)
- First regular *Doctor Who* appearance: *An Unearthly Child* Episode 1 (1963)
- Final regular *Doctor Who* appearance: *The Tenth Planet* Episode 4 (1966)
- Final guest *Doctor Who* appearance: *The Three Doctors* Episode 4 (1973)

Before settling on acting, William 'Billy' Hartnell trained for various careers, includ-

ing boxer and jockey. He made his theatre debut in the mid-1920s, and clocked up numerous screen roles from the early 1930s. Hartnell himself claimed he was stereotyped in hard-man roles, with a starring turn as Dallow in *Brighton Rock* (1947) amongst his notable work.

In 1958, Hartnell played the title role in *Carry on Sergeant*, the film that spawned the popular comedy series. It was a role not unlike Sgt Major Bullimore that Hartnell played in the ITV comedy *The Army Game* between 1957 and 1961. It was this role and that of a sports agent in the film *This Sporting Life* (1963) that brought Hartnell to the attention of a young BBC producer, Verity Lambert, who was casting the lead in a new family drama series in 1963.

William Hartnell defined *Doctor Who*, and *Doctor Who* defined his career away from the hard men he had been known for. He was a hero to a generation of children and over three years he laid the foundations for his ten successors.

Ill health ultimately forced Hartnell to give up the role he loved so much in 1966. Appropriately enough, his final TV work would see him return to *Doctor Who* in 1973 to celebrate the series' 10th anniversary in *The Three Doctors*, alongside Patrick Troughton and Jon Pertwee.

> Until the broadcast of *The Snowmen*, the First Doctor was the incarnation that boasted the most televised stories set in the past. The Eleventh Doctor finally took that historic crown with *Cold War*.

⬛ PATRICK TROUGHTON—THE SECOND DOCTOR

- Full Name: Patrick George Troughton
- Born: 25 March, 1920, Mill Hill, London
- Died: 28 March 1987, Columbus, Georgia, USA
- First Screen Appearance: *Hamlet* (1947)
- First regular *Doctor Who* appearance: *The Tenth Planet* Episode 4 (1966)
- Final regular *Doctor Who* appearance: *The War Games* Episode 10 (1969)
- Final guest *Doctor Who* appearance: *The Two Doctors* Part 3 (1985)

Performing in a production of JB Priestley's *Bees on the Boat Deck* while a pupil at Mill Hill School gave a young Patrick Troughton his passion for acting. He attended the Embassy School of Acting, which ultimately led to a scholarship in New York.

Troughton returned to Britain at the outbreak of the Second World War, briefly entering theatre rep before joining the Royal Navy. After the war, the actor wasted no time getting back to the theatre, before film and television roles appeared on his CV. Television was his first love, and he had the distinction in 1953 to be the first actor to play Robin Hood on TV.

In 1966, he was offered the chance to take over from William Hartnell in *Doctor Who*. Troughton possibly had the most difficult task of any incoming Doctor, being the

first to follow the original and much-loved first Doctor. It was a huge success and the concept of regenerating the Doctor was established.

Troughton remained in the role for three years, but his fear of typecasting and the punishing schedule influenced his decision to leave in 1969. Just as he had before *Doctor Who*, the actor worked tirelessly, for example clocking up roles in the children's drama *The Feathered Serpent* (1976), as Father Brennan in *The Omen* (1976) and as Cole Hawkins in *The Box of Delights* (1984).

Always a private man, Troughton largely shied away from the publicity that *Doctor Who* brought, although he reprised the Doctor a total of three times. He passed away in 1987 while attending a *Doctor Who* convention in America.

📍 JON PERTWEE—THE THIRD DOCTOR

- Full Name: John Devon Roland Pertwee
- Born: 7 July 1919, Chelsea, London
- Died: 20 May 1996, Timber Lake, Connecticut, USA
- First Screen Appearance: *A Yank at Oxford* (1938)
- First regular *Doctor Who* appearance: *Spearhead from Space* Episode 1 (1970)
- Final regular *Doctor Who* appearance: *Planet of the Spiders,* Part 6 (1974)
- Final guest *Doctor Who* appearance: *Dimensions in Time*, Part 2 (1993)

Jon Pertwee was expelled from the Royal Academy of Dramatic Arts (RADA), but that didn't stop him becoming a huge star of stage, screen and radio before *Doctor Who*. Following time in the Royal Navy during the Second World War, Pertwee made a name for himself as a comedy actor in the radio series *Waterlogged Spa* and as Chief Petty Officer Pertwee in *The Navy Lark*, also on radio between 1959 and 1977.

In 1963, Pertwee appeared on stage with Frankie Howerd in *A Funny Thing Happened on the Way to the Forum*, and would appear in the big screen version of the musical, as well as four appearances in the *Carry On* series.

It was Pertwee himself who asked his agent to go after the role of the Doctor when it became known that Patrick Troughton was leaving in 1969. To his surprise, he was already high on the shortlist and was ultimately successful. *Doctor Who* relaunched—in colour—in 1970, with Pertwee at the helm as a debonair man of action.

Throughout Pertwee's five years in the TARDIS, *Doctor Who* would see its popularity soar and, despite a tough schedule, the actor found time for other work, and would continue in *The Navy Lark* at the same time as *Doctor Who*. In 1974, he took over as host of the ITV quiz programme *Whodunnit?*

Leaving *Doctor Who* in 1974, Pertwee gave life to another popular children's character, *Worzel Gummidge*, between 1979 and 1981, with a brief revival in 1987.

The actor never cut his ties to *Doctor Who*, returning for the series' 20th-anniversary special, *The Five Doctors*, in 1983 and the Children in Need charity special, *Dimensions in Time* in 1993. He also reprised the role on stage for *The Ultimate Adventure* in 1996 and in two BBC radio series broadcast in 1993 and 1996.

> If the UNIT stories are set in the near future (which seems to have been the intention of the production team at the time) then, other than the Eighth, the Third is the only Doctor never to have had a televised story set in the present day.

█ TOM BAKER—THE FOURTH DOCTOR

- Full Name: Thomas Stewart Baker
- Born: 20 January 1934, Liverpool
- First Screen Appearance: *The Winter's Tale* (1967)
- First regular *Doctor Who* appearance: *Planet of the Spiders* Part 6 (1974)
- Final regular *Doctor Who* appearance: *Logopolis* Part 4 (1981)
- Final guest *Doctor Who* appearance: *The Day of the Doctor* (2013)

Tom Baker followed a spiritual road in his early life, leaving school to become a novice monk in the Catholic faith at the age of 15. After six years, Baker turned his back on his training and served his National Service with the Royal Army Medical Corps, where he first developed a love for performing. After a brief stint in the Merchant Navy, the future Time Lord attended Rose Bruford College of Speech and Drama, and eventually found himself in Laurence Olivier's National Theatre company in the late 1960s.

Olivier was instrumental in Baker landing his first major film role, as the monk Rasputin

in *Nicholas and Alexandra* in 1971. His performance earned him a Golden Globe nomination for Best Supporting Actor.

Baker hit hard times in 1973, and worked as a labourer on a London building site. In desperation, he wrote to BBC Head of Serials Bill Slater, enquiring about work opportunities. It happened that Slater was due to meet with *Doctor Who* producer Barry Letts about casting Jon Pertwee's successor. After Letts viewed the actor's performance in 1973's *The Golden Voyage of Sinbad*, and several meetings, Tom Baker was unveiled as the new Doctor in early 1974.

Tom Baker holds the record as the longest-serving Doctor, appearing in seven seasons and 172 episodes, his unpredictable performance scoring a hit with audiences around the world. He left the role in 1981, claiming there was nothing left to achieve in the part. He would eventually return to the Doctor in 2009 to record brand new audio adventures for both the BBC and Big Finish Productions, while a surprise appearance at the end of *The Day of the Doctor* saw him play the mysterious Curator. Was the Curator a future incarnation of the Doctor? In the words of the great man himself: Who knows?

Tom Baker remains much loved by audiences to this day, his subsequent roles in *The Chronicles of Narnia*, *The Life and Loves of a She-Devil*, *Monarch of the Glen*, *Randall & Hopkirk (Deceased)* and as the distinctive voice of *Little Britain* maintaining his status as a national treasure. In 2016, he made the jump to a galaxy far, far away, providing the voice of the Bendu in *Star Wars Rebels*.

> The Fourth Doctor holds the record for the most televised stories set on or visiting alien worlds—28. The other Doctors have a long way to go to beat him: the Tenth Doctor can rustle up 12 stories, while the First comes third with 11.

⏺ PETER DAVISON—THE FIFTH DOCTOR

- Full Name: Peter Moffett
- Born: 13 April 1951, Streatham, London
- First Screen Appearance: *Warship* (TV series, 1974)
- First regular *Doctor Who* appearance: *Logopolis* Part 4 (1981)
- Final regular *Doctor Who* appearance: *The Caves of Androzani* Part 4 (1984)
- Final guest *Doctor Who* appearance: *Time Crash* (2007)

In 1981, at the age of 29, Peter Davison was the youngest actor to be cast as the Doctor—a record he held until the casting of Matt Smith in 2009.

Born Peter Moffett and later adopting the stage name Davison, he attended the Central School of Speech and Drama, and on graduating worked as a stage manager at Nottingham Playhouse. His first major television work was on the ITV children's drama *The Tomorrow People*—where he met his future wife Sandra Dickinson. A role in the drama *Love for Lydia* followed, but it was the rebellious Tristan Farnon in *All Creatures Great and Small* that made Davison a household name. He played Tristan on and off for 12 years.

In the early 1980s, sitcoms *Holding the Fort* and *Sink or Swim* strengthened Davison's reputation as one of Britain's leading television actors, making him *Doctor Who* producer John Nathan-Turner's top choice to take over from Tom Baker.

Initially reluctant, believing he was too young, Davison eventually agreed to take on the part, affording him his first true leading man role. His Doctor was a youthful, vulnerable figure that, like his predecessors, scored a hit with audiences, and took *Doctor Who* to its 20th-anniversary season. Davison decided to leave after three seasons—at the time of his casting, a chance meeting with Patrick Troughton had seen the former Doctor advising him to do no more than three years.

Following *Doctor Who*, Davison has remained a popular face on British TV, adding lead roles in *A Very Peculiar Practice, Campion, At Home with the Braithwaites, The Last Detective* and *Law and Order: UK*. He has also maintained a high-profile on the stage, most recently appearing in acclaimed productions of *Spamalot, Legally Blonde* and *Gypsy*. In 2007 Davison became the first 20th-century Doctor to appear in *Doctor Who* since its 2005 return, joining his future son-in-law David Tennant in the TARDIS for the Children in Need special *Time Crash*. Since 1999, Davison has continued to play the Doctor in Big Finish Production's range of original audio dramas. He also wrote, directed and starred in *The Five(ish) Doctors Reboot*, an affectionate send up of the production of *Doctor Who*'s 50th Anniversary story, broadcast via the BBC's Red Button service in 2013.

RICHARD HURNDALL – THE OTHER FIRST DOCTOR

- Full Name: Richard Gibbon Hurndall
- Born: 3 November 1910, Darlington
- Died: 13 April 1984, London
- First Screen Appearance: *Androcles and the Lion* (TV, 1946)
- *Doctor Who* appearance: *The Five Doctors* (1983)

After training at the Royal Academy of Dramatic Arts (RADA) Richard Hurndall started treading the boards first in repertory and later with the Royal Shakespeare Company where his roles included Bassanio in *The Merchant of Venice* and Orlando in *As You Like It*. Later he shifted to radio, becoming a member of the BBC Radio Drama repertory company in 1952, going on to play Sherlock Holmes seven years later in a five-part adaptation of *The Sign of Four*.

Even though Hurndall had made his television debut in 1946, it wasn't until the 1960s that he regularly started appearing on the small screen. The next two decades saw him guesting on a number of cult TV shows including *Steptoe and Son*, *Ripping Yarns*, *The Avengers*, *Callan*, *The Persuaders* and *Jason King*.

It was a 1981 appearance in *Blake's 7* that gave Hurndall a unique place in the *Doctor Who* hall of fame. At the time, series producer John Nathan-Turner was planning *The Five Doctors*, the 90-minute 20th-anniversary special. There was only one snag. William Hartnell had passed away in 1975. Who could play the First Doctor? Watching Hurndall's performance as Nebrox in *Assassin*, an episode from *Blake's 7*'s fourth season, the producer saw in him someone who could mimic Hartnell's idiosyncratic performance. And so Hurndall became the first actor to be cast in a previous Doctor's role. At 73, he was 18 years older than William Hartnell had been when he originally played the First Doctor.

Sadly, Hurndall died of a heart attack just five months after his interpretation of the First Doctor was broadcast.

COLIN BAKER—THE SIXTH DOCTOR

- Full Name: Colin Baker
- Born: 8 June 1943, London
- First Screen Appearance: *The Adventures of Don Quick* (TV, 1970)
- First regular *Doctor Who* appearance: *The Caves of Androzani* Part 4 (1984)
- Final regular *Doctor Who* appearance: *The Trial of a Time Lord* Part 14 (1986)
- Final guest *Doctor Who* appearance: *Dimensions in Time* Part 2 (1993)

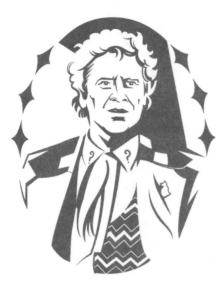

Following training at the London Academy of Music and Dramatic Arts, Colin Baker made his television debut at the beginning of the 1970s, winning early roles in *The Adventures of Don Quick*, *Happy Ever After* and a noted supporting appearance in a BBC adaptation of *The Road to Freedom*. During this period, Baker shared a flat with David Troughton, the son of Second Doctor Patrick Troughton, and was best man at his wedding.

Two years later, Baker starred opposite Anthony Hopkins in the acclaimed *War and Peace*, playing Anatole Kuragin. It was his casting in 1974 as Paul Merroney in the popular BBC drama *The Brothers* that gave Baker long-lasting TV notoriety. His villainous turn as the ruthless businessman made him a star, with the character voted the most hated man in Britain.

Baker's reputation for playing villains led to the space pirate Bayban the Butcher in a 1980 episode of *Blake's 7*. In 1983 he became the first actor to appear as a different character in *Doctor Who* on television prior to being cast as the Doctor. The arch Commander Maxil in *Arc of Infinity* led in turn to his casting as the Sixth Doctor when Peter Davison left the role. Baker's sharp wit kept guests entertained at a wedding attended by members of the *Doctor Who* production team, including producer John Nathan-Turner, who knew he'd found his Doctor.

The colourful sixth incarnation of the Time Lord made his debut in 1984. Baker played the Doctor for three years, and has remained connected to the series through regular convention appearances and as a mainstay of Big Finish's *Doctor Who* audio adventures, appearing during the 50th Anniversary year as himself in *The Five(ish) Doctors Reboot*. He is a regular face on British television, with credits in *Jonathan Creek*, *Casualty* and *Hustle* adding to his lengthy CV. Following on from his success in *Come Dine With Me* in 2011, Baker took part in the ITV reality show *I'm a Celebrity... Get Me Out Of Here!* in 2012. He works extensively in the theatre, and writes a regular column for his local newspaper, the *Bucks Free Press*.

🚪 SYLVESTER McCOY—THE SEVENTH DOCTOR

- Full Name: Percy James Patrick Kent-Smith
- Born: 20 August 1943, Dunoon, Scotland
- First Screen Appearance: *Vision On*
- First regular *Doctor Who* appearance: *Time and the Rani* Part 1 (1987)
- Final regular *Doctor Who* appearance: *Doctor Who* (1996)

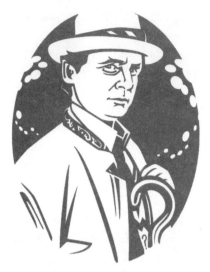

Like Tom Baker before him, Sylvester McCoy toyed with following a religious life by training as a priest, but swapped this for an insurance job, before working in the box office of the Roundhouse in London. Here he was spotted by the visionary theatre director and actor Ken Campbell, who invited him to join his performing troupe, the Ken Campbell Roadshow.

McCoy created the character of stuntman Sylveste McCoy during his time with Campbell, famous for slapstick routines that involved ferrets and hammering nails up his nose. An 'r' was later added to the name, providing Percy Kent-Smith with his more familiar stage name.

McCoy's mastery of physical comedy led to his working relationship with producer Clive Doig, who employed him on shows ranging from *Vision On* to *Jigsaw*. Doig was instrumental in McCoy's casting as the Seventh Doctor after phoning producer John Nathan-Turner to recommend his friend as the ideal successor to Colin Baker. Following several screen tests, McCoy was offered the role.

McCoy remained with *Doctor Who* until it ceased production in 1989, returning happily in 1996 to hand over the TARDIS keys to Paul McGann, filming several sequences, including a regeneration scene, in the *Doctor Who* TV movie filmed in Canada. He now appears regularly in the *Doctor Who* audio dramas produced by Big Finish.

Work following *Doctor Who* has seen McCoy appear regularly on stage, screen and radio. In 2007 he appeared as the Fool opposite Ian McKellen in an RSC production of *King Lear*. Four years later he would join McKellen in New Zealand to play Radagast in a three-part film adaptation of *The Hobbit*.

⏳ PAUL McGANN—THE EIGHTH DOCTOR

- Full Name: Paul McGann
- Born: 14 November 1959, Liverpool
- First Screen Appearance: *Play for Today: Whistling Wally* (TV, 1982)
- First *Doctor Who* appearance: *Doctor Who* (1996)
- Final *Doctor Who* appearance: *The Night of the Doctor* (2013)

As one-quarter of the McGann acting brotherhood (along with Joe, Mark and Stephen), Paul McGann was considered one of Britain's most exciting young actors following his graduation from RADA in the early 1980s. His breakthrough role was opposite Robert Lindsay in the comedy drama *Give Us a Break* in 1983, but two subsequent roles would seal his reputation as a star to watch.

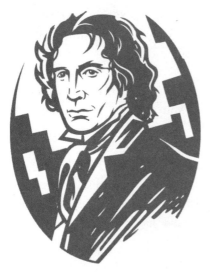

In 1986 he was BAFTA-nominated for his acclaimed performance as Percy Toplis in the BBC's controversial First World War drama *The Monocled Mutineer*, and he earned a cult following for his turn as 'I' in the comedy film *Withnail and I* in 1987 with Richard E. Grant.

Roles in Hollywood movies *Alien 3* and *The Three Musketeers* followed in the early 1990s, then in 1993 he was cast as Richard Sharpe in a TV adaptation of Bernard Cornwall's *Sharpe* novels—a role he was forced to abandon after injuring his knee playing football just weeks into the shoot. His next major casting would see him travel to Canada in 1996 to become the eighth incarnation of the Doctor in a TV movie that was intended to relaunch *Doctor Who* for an international audience. McGann sought the advice of his friend Sylvester McCoy, who encouraged him to take the role, and the two soon found themselves filming a regeneration scene in an abandoned hospital in Vancouver.

While the TV movie failed to secure a commission for a full series, McGann has recorded many audio dramas as the Eighth Doctor for Big Finish Productions. Appearing regularly at conventions, McGann made a surprise return to televised *Doctor Who* in 2013 with *The Night of the Doctor*, chronicling the Eighth Doctor's final moments. He also made a cameo in Peter Davison's *The Five(ish) Doctors Reboot* (work permitting, obviously...).

McGann is never away from TV screens for long. He starred in the BBC drama *Fish* in 2000 and played Lieutenant Bush in the second series of *Hornblower* shortly after. Recent television work has included *Ripper Street*, *Bletchley Circle* and *The Musketeers*.

◖ JOHN HURT—THE WAR DOCTOR

- Full Name: John Vincent Hurt
- Born: 22 January 1940, Shirebrook
- Died: 25 January 2017, Cromer
- First screen appearance: *The Wild and the Willing* (1962)
- First *Doctor Who* appearance: *The Name of the Doctor* (2013)
- Final *Doctor Who* appearance: *The Day of the Doctor* (2013)

With a voice that made him one of the world's most recognisable actors, Sir John Hurt made a surprise appearance as a hitherto unknown incarnation of the Doctor in 2013. While he would return as the battle-worn War Doctor in a series of Big Finish audio dramas two years later, the Time Lord was just one role in a career that spanned six decades and straddled both television and cinema.

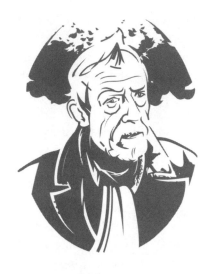

After dropping out of St Martin's College of Art and Design in London, Hurt won a scholarship at the Royal Academy of Dramatic Arts. On leaving college, he was awarded a critics award for Most Promising Newcomer, an accolade he quickly proved with stage performances including *Little Malcolm and His Struggle Against The Eunuch* and on screen with *A Man For All Seasons* (1966).

His role as Quentin Crisp in Thames Television's *The Naked Civil Servant* (1975) brought Hurt firmly to the public eye, followed a year later with a memorable performance in the BBC's *I, Claudius*. He soon carved himself a niche playing outsiders and misfits from his Oscar-nominated turn as junkie Max in *Midnight Express* (1978) and Winston Smith in *Nineteen Eighty-Four* (1984) to the tragic John Merrick in *The Elephant Man* (1980).

Never one to shy away from genre films, Hurt secured his place in the science-fiction hall of fame by becoming the first victim of a 'chestburster' in Ridley Scott's *Alien* (1979). Over the course of his career, he also enchanted generations of fantasy fans with appearances in such children's classics as Jim Henson's *The Storyteller* (1987) and the *Harry Potter* series of movies, as well as the voice of Kilgharrah the Great Dragon in BBC One's *Merlin* (2008).

☂ CHRISTOPHER ECCLESTON—THE NINTH DOCTOR

- Full Name: Christopher Eccleston
- Born: 16 February 1964, Salford
- First Screen Appearance: *Blood Rights* (TV, 1990)
- First regular *Doctor Who* appearance: *Rose* (2005)
- Final regular *Doctor Who* appearance: *The Parting of the Ways* (2005)

Christopher Eccleston grew up in Salford, Lancashire, and harboured dreams of playing football for Manchester United until it was clear his talent lay with acting. He trained at the Central School of Speech and Drama and made his stage debut in a production of *A Streetcar*

Named Desire at the Bristol Old Vic in 1988. More stage work followed, but film and TV proved elusive.

Eccleston's breakthrough screen role was as Derek Bentley in the film *Let Him Have It* (1991), but it was his performance as DCI Billborough in *Cracker* (1993) that really brought him to the attention of TV audiences. Eccleston has combined film, TV and stage work throughout his career. He played Trevor Hicks in Jimmy McGovern's *Hillsborough*, and was BAFTA-nominated in 1997 for his work in the critically acclaimed drama *Our Friends in the North*. Film work, on both sides of the Atlantic, includes *Elizabeth* (1998), *Gone in 60 Seconds* (2000) and *28 Days Later* (2002).

In 2003, Eccleston played Stephen Baxter in *The Second Coming* and, shortly after, the actor emailed the drama's writer, Russell T Davies. Davies was working on a new series of *Doctor Who* for the BBC, and Eccleston was keen to be considered for the part of the Doctor. A few months later it was confirmed that Christopher Eccleston would be the ninth actor to play the Doctor.

Eccleston left *Doctor Who* after one series, saying he had done what he wanted to do with the part. Like William Hartnell over 40 years previously, he had redefined his career away from weighty roles to become a hero for a new generation of children.

Christopher Eccleston has maintained his exhausting work schedule since leaving *Doctor Who*, with roles in US drama series *Heroes* and *The Leftovers*, plus homegrown dramas including *Fortitude, The A Word* and *Come Home*. On the big screen he has been seen in *G.I. Joe: the Rise of Cobra* (2009) and as villain Malekith in Marvel superhero sequel *Thor: The Dark World* (2013).

> Like the Eighth Doctor before him, the Earth-loving Ninth never had a televised story set on an alien world.

⬛ DAVID TENNANT—THE TENTH DOCTOR

- Full Name: David John McDonald
- Born: 18 April 1971, Bathgate, West Lothian
- First Screen Appearance: *Dramarama: The Secret of Croftmore* (TV, 1988)
- First regular *Doctor Who* appearance: *The Parting of the Ways* (2005)
- Final regular *Doctor Who* appearance: *The End of Time, Part Two* (2010)
- Final guest *Doctor Who* appearance: *The Day of the Doctor* (2013)

When he grew up, young David McDonald told his parents, he wanted to be an actor because he was a big fan of *Doctor Who*. Over 30 years later, not only would he have achieved his dream and become an actor—he would also be the Doctor!

At the age of 16, Tennant would be one of the youngest students to be accepted by the Royal Scottish Academy of Music and Drama. Following graduation, he appeared in several productions for the 7:84 Theatre Company, and appeared in TV sitcom *Rab C Nesbitt* in 1993. Tennant's first major TV role was as manic depressive Campbell in *Takin' Over the Asylum* (1994) with Ken Stott, and he would continue to work steadily throughout the 1990s, combining TV and theatre work.

Film roles included *Jude* (with Christopher Eccleston) in 1996 and *Bright Young Things* (2003), while television took in *Randall & Hopkirk (Deceased)*, *People Like Us* and *Blackpool*. In 2005 he was cast as the young *Casanova* in a major BBC production, written by Russell T Davies, who was also working on the first series of *Doctor Who*. When Christopher Eccleston left the series, Davies immediately turned to his Casanova and offered Tennant the chance to play the Tenth Doctor. Tennant's reaction was to laugh—then ask if he could have a long coat.

Tennant's time aboard the TARDIS would see *Doctor Who* as popular as ever with audiences, and he claimed it was a difficult decision to leave the programme after four years—a decision he announced to a live TV audience during the interval while performing *Hamlet* for the Royal Shakespeare Company.

Tennant has worked on both sides of the Atlantic since leaving *Doctor Who*, starring in *St Trinians 2* (2009), *Fright Night* (2011) and *Nativity 2* (2012), and on television in *Broadchurch*, *Jessica Jones* and Disney's *DuckTales*. In 2011, Tennant married Georgia Moffett, who had guest-starred in the episode *The Doctor's Daughter*. Moffett is the daughter of Peter Davison, making the Fifth Doctor the Tenth Doctor's father-in-law!

The Tenth Doctor has a surprising claim to fame. This incarnation boasts the most stories set in the future. But hang on, what about all those stories set on present-day Earth? Well, thanks to the events of *Aliens of London*, they all take place about 12 months in the future.

█ MATT SMITH—THE ELEVENTH DOCTOR

- Full Name: Matthew Robert Smith
- Born: 28 October 1982, Northampton
- First Screen Appearance: *The Ruby in the Smoke* (TV, 2006)
- First regular *Doctor Who* appearance: *The End of Time, Part Two* (2010)
- Final regular *Doctor Who* appearance: *The Time of the Doctor* (2013)
- Final guest *Doctor Who* appearance: *Deep Breath* (2014)

Matt Smith wanted to be a professional footballer, but a back injury forced him to rethink his career choice. He was encouraged by his drama teacher to attend the National Youth Theatre, where he was seen performing by former *Doctor Who* companion Wendy Padbury—at that time a theatrical agent. She was impressed by Smith's natural ability, and sent him for an audition at the Royal Court theatre, an audition in which he was successful.

His first TV work had another *Doctor Who* connection when he played Jim Taylor alongside former companion Billie Piper in *The Ruby in the Smoke* (2006). More stage work followed, and Smith received an Olivier Award nomination for his celebrated performance in *That Face*, once again at the Royal Court. He worked with Billie Piper again in an episode of *Secret Diary of a Call Girl*, and 2007 saw Smith take on his biggest TV role as Danny Foster in *Party Animals*.

On 3 January 2009, Matt Smith was revealed to the nation as the new Doctor in a special edition of *Doctor Who Confidential*. It would be nearly a year before he made his brief *Doctor Who* debut on 1 January 2010, and another three months before the Eleventh Doctor would declare that bow ties are cool in *The Eleventh Hour*.

After a busy anniversary year, Smith bowed out of the TARDIS in 2013. He would go on to appear in such genre films such as *Terminator: Genisys, Pride and Prejudice and Zombies* and *Patient Zero*. On television, Smith would win acclaim for his performance as Philip Mountbatten in Netflix's landmark series, *The Crown* (2017).

█ PETER CAPALDI—THE TWELFTH DOCTOR

- Full Name: Peter Dougan Capaldi
- Born: 14 April 1958, Glasgow, Scotland
- First screen appearance: *Living Apart Together* (1982)
- First Regular *Doctor Who* appearance: *The Time of the Doctor* (2013)
- Final Regular *Doctor Who* appearance: *Twice Upon A Time* (2017)

A fan of *Doctor Who* from a young age, Glasgow-born Peter was the son of ice cream parlour owners, Gerald and Nancy Capaldi. A flair for drawing led him to the Glasgow School of Art, where he formed punk band *The Dreamboys*. However, a career as an artist or musician gave way to acting when a chance meeting with film director Bill Forsyth saw Capaldi cast in *Local Hero* (1983). Following the film's success, Capaldi moved to London and started to pick up TV work in series such as *Crown Court* and *Minder*.

Capaldi is also an accomplished writer and director, with *Strictly Sinatra* (2001), *The Cricklewood Greats* (2012) and the Oscar-winning short film *Frank Kafka's It's a Wonderful Life* (1993) on his CV.

Prior to his casting as the Doctor, Capaldi had already appeared in the series in 2008's *The Fires of Pompeii*, as well as taking the role of John Frobisher in *Torchwood: Children of Earth* a year later. Other high-profile roles included Randall Brown in *The Hour* (2012) and Cardinal Richelieu in *The Musketeers* (2014), although he was most widely known as foul-mouthed spin doctor Malcolm Tucker in both *The Thick of It* (2005–12) and spin-off movie, *In The Loop* (2009). Other film appearances include *The Lair of the White Worm* (1988), *World War Z* (2013) and *Paddington* (2014).

> The Twelfth Doctor has more regular stories set on present day Earth—15. His predecessor takes second place with, appropriately, 11!

📺 DAVID BRADLEY—THE OTHER, OTHER FIRST DOCTOR

- Full Name: David John Bradley
- Born: 17 April 1942, York, Yorkshire
- First screen appearance: *Nearest and Dearest* (1971)
- First regular *Doctor Who* appearance: *The Doctor Falls* (2017)

A graduate of the Royal Academy of Dramatic Arts, David Bradley made his debut as Second Policeman in an episode of hit ITV comedy *Nearest and Dearest* entitled *Barefaced in the Park*. The same year saw him winning a regular role on *A Family at War*, which led to appearances in *The Professionals* (1978), *Coronation Street* (1980), *Between the Lines*

(1992), *The Buddha of Suburbia* (1993) and *Martin Chuzzlewit* (1994)

In 1996, Bradley played Labour MP Eddie Wells in BBC 2's award-winning drama, *Our Friends in the North*, before being immortalised for an entire generation of children as Hogwart's sinister caretaker Argus Filch in 2001's *Harry Potter and the Philosopher's Stone*, a role he reprised in five of the seven blockbuster sequels. He was now a familiar face on television, with roles in such high-profile series as The Tudors (2009), *Game of Thrones* (2011–17), *Broadchurch* (2013) and *The Strain* (2017).

Following a villainous turn alongside Matt Smith's Eleventh Doctor in 2012's *Dinosaurs on a Spaceship*, Bradley portrayed William Hartnell in *An Adventure in Space and Time*, Mark Gatiss' 50th Anniversary drama about the creation of *Doctor Who*. When out-going showrunner Steven Moffat decided to bring back the Doctor's original incarnation for Peter Capaldi's swansong, there was only one actor who could once again fill Mr Hartnell's shoes…

> And there are yet more First Doctors. Voice artist John Guilor provided the voice of the First Doctor in both the recreation of the fourth episode of *Planet of the Giants* for the 2012 DVD release and then a year later in *The Day of the Doctor*.
>
> 2014's *Listen* would also see a glimpse of the Doctor as a young boy. Although we never saw his face, Michael Jones became the third actor to play the First Doctor on screen, comforted by Clara Oswald in the Gallifreyan barn first seen in *The Day of the Doctor*.

JODIE WHITTAKER—THE THIRTEENTH DOCTOR

- Full Name: Jodie Whittaker
- Born: 3 June 1982, Skelmanthorpe, Yorkshire
- First screen appearance: *Venus* (2006)
- First regular *Doctor Who* appearance: *Twice Upon A Time* (2017)

After training at the Guildhall School of Music and Drama, 23-year-old Jodie Whittaker made her screen debut in 2006, starring against screen legend Peter O'Toole in *Venus*. She had already appeared on stage at Shakespeare's Globe Theatre in the 2005 performance of *The Storm* and would go on to star in cult science-fiction hits such as *Attack the Block* (2010) and *Black Mirror* (2011). Earlier, she

displayed a talent for broad comedy as school secretary Beverley in *St Trinian's* (2007) and *St Trinian's 2: The Legend of Fritton's Gold* (2009).

Prior to becoming the first female Doctor, Whittaker's most prominent role had been grieving mother Beth Latimer opposite David Tennant in Chris Chibnall's *Broadchurch* (2013–2017), although soon after the historic announcement that she would be stepping into the TARDIS, she would also appear in BBC medical thriller, *Trust Me* (2017).

WHAT'S IN A NAME?

According to Dorium Maldovar, the question that must never be answered is 'Doctor Who?' While we've never learnt the Doctor's real name in 50 years, he's adopted a lot of monikers, both on TV and beyond.

NAMES THE DOCTOR CALLS HIMSELF

- The Architect—an alias adopted by the Twelfth Doctor to arrange the robbery of the Bank of Karabraxos (*Time Heist*)
- Bad Penny—apparently the Doctor's middle name (*The God Complex*)
- Basil—the Doctor's first name. At least that's what he tells Osgood. (*The Zygon Inversion*)
- The Bringer of Darkness—a name the Tenth Doctor calls himself (*The Day of the Doctor*)
- Captain Grumpy—the Eleventh Doctor's name for the War Doctor (*The Time of the Doctor*)
- The Caretaker—an alias he adopted while looking after the Arwell Family in 1941 (*The Doctor, the Widow and the Wardobe*)
- Chinny—the Tenth Doctor gives as good as he gets against the Eleventh Doctor (*The Day of the Doctor*)
- The Curator—assuming that the gentleman the Eleventh Doctor meets in the Under Gallery is his future self (*The Day of the Doctor*)
- Dick van Dyke—yet another term of endearment from the Eleventh to the Tenth Doctor (*The Day of the Doctor*)
- Doctor Caligari—the alias the First Doctor used while visiting Tombstone, USA in 1881 (*The Gunfighters*)
- Doctor Disco—what the Doctor calls himself in a voicemail message to Clara (*The Zygon Invasion*)
- Doctor Funkenstein—how he introduces himself to Walsh (*The Zygon Invasion*)
- Doctor Idiot—how the Twelfth Doctor berates himself (*In the Forest of the Night*)

- Doctor Puntastic—a name the Doctor gives himself after a particularly painful bit of wordplay (*The Zygon Inversion*)
- Get Off This Planet—a name the Doctor claims he's often called, although he instantly acknowledges that it probably isn't a name, strictly speaking (*The Doctor, the Widow and the Wardrobe*)
- Captain Troy Handsome of International Rescue—when talking to the hologram of a crashed time ship in Colchester (*The Lodger*)
- Doctor James Macrimmon—how the Doctor introduced himself to Queen Victoria in 1879 (*Tooth and Claw*)
- Granddad—a term of endearment used by the Eleventh Doctor for the War Doctor (*The Day of the Doctor*)
- The King of Okay—a title the Doctor soon dismissed as rubbish. (*The Impossible Astronaut*)
- Matchstick Man—a name the Eleventh Doctor calls the Tenth (*The Day of the Doctor*)
- Maximus Pettulian—the Doctor assumed the identity of a murdered lute player while visiting the court of Emperor Nero (*The Romans*)
- Merlin—an identity yet to be adopted by a future incarnation of the Doctor (*Battlefield*)
- Doctor Noble of the Noble Corporation—while investigating suspicious goings on at Ood Industries (*Planet of the Ood*)
- Odin—of *course*, the Doctor is Odin. He has a yo-yo. That's a sign of the All-Father, isn't it? (*The Girl Who Died*)
- The President of Earth—using his official title when introducing himself to Walsh (*The Zygon Invasion*)
- Sand Shoes—the Eleventh Doctor really had a lot of names to call his Tenth incarnation (*The Day of the Doctor*)
- John Smith—various (see 'John Who?')
- Spartacus—the Doctor called himself Spartacus while visiting Pompeii in AD 79, as did Donna in a tongue-in-cheek reference to the 1960 film of the same name (*The Fires of Pompeii*)
- Special Agent Dan Dangerous, Scotland Yard—he really has a name for every occasion, doesn't he? (*The Return of Doctor Mysterio*)
- Doctor Vile of the Mantasphid—the Doctor pretends to be a Pirate Master to try and avoid a war between humans and a race of insectoid aliens (*The Infinite Quest*)
- Doctor von Wer—the name the Doctor adopted in 1746 during a visit to Inverness, Scotland. Translated from German it means 'Doctor of Who' (*The Highlanders*)

NAMES OTHER PEOPLE HAVE GIVEN THE DOCTOR

- Sir Doctor of TARDIS—by Royal Appointment of her Majesty, Queen Victoria (*Tooth and Claw*)
- The Beast of Trenzalore—how the enemies of the Doctor will refer to him in the future (*The Name of the Doctor, Twice Upon A Time*)

- Doctor Bowman—an alias adopted to get access to Professor Wagg's Atomic Clock on 31 December 1999 (*Doctor Who*)
- The Bringer of Darkness—one of Testimony's names for the Doctor (*Twice Upon A Time*)
- The Butcher of Skull Moon—part of Testimony's summary of the Doctor's life (*Twice Upon A Time*)
- Caesar—by a Roman, but only because he was under the thrall of River Song's Hallucinogenic lipstick (*The Pandorica Opens*)
- The Cruel Tyrant—the Great Intelligence's epitaph to the Doctor at his graveside (*The Name of the Doctor*)
- Curator of the Under Gallery—a title bestowed on the Doctor by Queen Elizabeth I (*The Day of the Doctor*)
- Damsel in Distress—River Song's codename for the Doctor (*The Husbands of River Song*)
- The Destroyer of Skaro—well, he did blow it up (*Twice Upon A Time*)
- The Destroyer of Worlds—a title Davros used to describe the Doctor (*Journey's End*)
- Doctor Mysterio—young Grant says this is what the Doctor would be called if he was in a comic (*The Return of Doctor Mysterio*)
- The Doctor of War—he walks in blood (*Twice Upon A Time*)
- John Doe—on the name tag tied to the Seventh Doctor's toe after his 'death' in San Francisco (*Doctor Who*)
- The Evil One—used by the Tribe of the Sevateem, unaware that the terrible god they worshipped was a supercomputer which had taken the Doctor's face. Identity theft taken to the extreme, that (*The Face of Evil*)
- False Odin—because real Vikings know that a yo-yo doesn't maketh a god (*The Girl Who Died*)
- Doctor Foreman—mistakenly used by Ian Chesterton on their first meeting (*An Unearthly Child*)
- Grandad—Bill passes the Doctor off as her gramps, and later the Master sneers this term of endearment at him (*Knock Knock, The Doctor Falls*)
- The Great Exterminator—how the Emperor Dalek addresses the Doctor (*The Parting of the Ways*)
- Grey Old Man—a bit of banter from Robin Hood (*Robot of Sherwood*)
- The Imp of the Pandorica—another name given to the Doctor by Testimony (*Twice Upon A Time*)
- The Mad Monk—what the Monks call the Doctor (*The Bells of Saint John*)
- The Man to End It All—how Ohila described the Eighth Doctor when he crashed on Karn during the Time War (*The Night of the Doctor*)
- The Man Who Lies—the Whisper Men's name for the Doctor. Colonel Manton thought the same (*The Name of the Doctor, A Good Man Goes to War*)
- The Man Who Runs Away—Lady Me has the measure of the Doctor (*The Woman Who Lived*)

- Monster—Ada Gillyflower's pet name for the petrified Doctor (*The Crimson Horror*)
- The Old One—according to Balazar, reader of the Books of Knowledge on Ravolox, much to the Doctor's chagrin (*The Trial of a Time Lord*)
- The Oncoming Storm—one of the Daleks' many names for their arch-enemy (*The Parting of the Ways*)
- Penguin with its arse on fire—a lovely description given by Bill (*Smile*)
- The Predator—those Daleks really were petrified of the Doctor (*Asylum of the Daleks*)
- The President of Earth—the Doctor's official title after the Incursion Protocols were triggered (*Death in Heaven*)
- Prisoner 177781—the designation given to the Doctor when he was arrested for looting during the evacuation of London (*Invasion of the Dinosaurs*)
- The Great Wizard Quiquaequod—a mystical moniker given by white witch Olive Hawthorne (*The Daemons*)
- Raggedy Man—Amy Pond's nickname for the Eleventh Doctor. Also, the Raggedy Doctor (Various)
- The Slaughterer of Ten Thousand souls—another of Testimony's pet names for the Doctor (*Twice Upon A Time*)
- The Slaughterer of the Ten Billion—Ten Billion? That's quite an advance on Ten Thousand! (*The Name of the Doctor*)
- Mr Spock—how Rose Tyler first introduces the Time Lord to Captain Jack Harkness (*The Empty Child*)
- Sweetie—River Song's pet-name for her hubby (*Silence in the Library*)
- Theta Sigma—the Doctor's nickname while at the Academy (*The Armageddon Factor*, *The Happiness Patrol*)
- The Traveller from Beyond Time—how the Doctor is greeted by the Elders of the far future (*The Savages*)
- The Vessel of the Final Darkness—the Great Intelligence really didn't like the Doctor (*The Name of the Doctor*)
- The Watcher—how the Doctor's companions described his spectral future self (*Logopolis*)
- Doctor Who—by super computer WOTAN. (Also see 'Doctor Who?') (*The War Machines*)
- Zeus—the First Doctor was mistaken for the Greek god by Achilles *c.*1200 BC (*The Myth Makers*)

> ### ALL IN A TITLE
> The Doctor has no problem adopting or being given titles as well as names. In his time he's been an Examiner (twice—*The Power of the Daleks*, *The War Games*), Chairman Delegate from Earth (*The Curse of Peladon*) and an Ajak (*The Sun Makers*).

JOHN WHO?

Just as Earth is the Doctor's favourite planet, John Smith is his favourite alias. Here are just some of the many times he's used it on his travels:

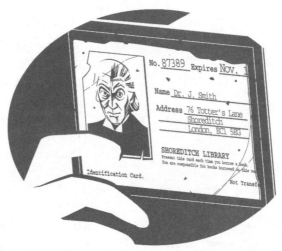

- The First Doctor used it on his Shoreditch library card. (*The Vampires of Venice*)
- The Second Doctor was introduced as John Smith on Space Station W3—although in this case it was Jamie who gave him the nom de plume (*The Wheel in Space*). The Doctor had picked up the habit by the time of *The War Games*.
- When asked his name at the end of *Spearhead from Space*, the Third Doctor replies (in typically Bondian fashion): 'Smith. Doctor John Smith.' In *The Time Warrior*, the Doctor introduces himself as John Smith to fellow scientist Professor Rubeish.
- When filling out his hospital forms, the Seventh Doctor was given the name John Smith by Chang Lee. Coincidence? Probably, unless you're one of those humans who always see patterns in things that aren't there. (*Doctor Who*)
- The psychic paper introduced the Ninth Doctor as Dr John Smith from the Ministry of Asteroids in *The Empty Child*.
- The Tenth Doctor was particularly fond of the alias. He first used it signing on as a science teacher by the name of John Smith at Deffry Vale High School (*School Reunion*). He would later use it while pretending to be a patient at Royal Hope Hospital (*Smith and Jones*), posing as a health and safety officer investigating Adipose Industries (*Partners in Crime*) and impersonating a policeman (*The Unicorn and the Wasp*).

- Unfortunately, the Tenth Doctor would come unstuck on an ill-fated bus trip on the planet Midnight. When he gave the name, his fellow passengers immediately recognised it as false. Luckily neither the memory-wiped Donna Noble (*Journey's End*) nor Jackson Lake (*The Next Doctor*) had problems swallowing the alias.
- The Doctor literally became John Smith—and a human to boot—when hiding from the Family of Blood in England, 1913 (*Human Nature, The Family of Blood*).
- The name came in handy for the Ganger Doctor in *The Almost People*.
- Armed with a dubious Yorkshire accent, Doctor and Mrs Smith (aka Clara) applied to join the Sweetville community (*The Crimson Horror*).
- Coal Hill School acquired a new Caretaker by the name of John Smith, although this particular man of mystery said that most people just called him 'the Doctor' (*The Caretaker*).

THE TIME LORD OATH

'I swear to protect the ancient law of Gallifrey with all my might and main and will to the end of my days with justice and with honour temper my actions and my thoughts.'

Time Academy Induction Ceremony (*Shada*)

THE DOCTOR'S HEIGHT

Just how tall are each of the Doctor's incarnations?

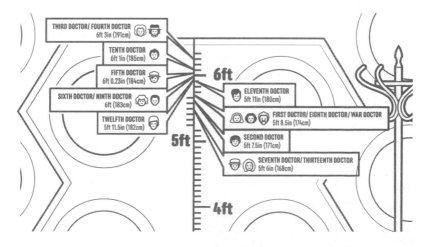

WHO GOES THERE?

Sometimes you need more than barefaced cheek or psychic paper to get by in the universe. Here are just a number of the many disguises employed by our devious Doctor…

- A regional officer of the Provinces (*The Reign of Terror*)
- The Monk (*The Time Meddler*)
- Zephon (*The Daleks' Master Plan*)
- A Redcoat (*The Highlanders*)
- A washerwoman (*The Highlanders*)
- A German doctor (*The Highlanders*)
- A gypsy (*The Underwater Menace*)
- Salamander (*The Enemy of the World*)
- The Karkus (*The Mind Robber*)
- An alien student (*The War Games*)
- A British soldier (*The War Games*)
- A technician (*Inferno*)
- A Dalek (*Frontier in Space*)
- A Spiridon (*Planet of the Daleks*)
- A milkman (*The Green Death*)
- A cleaning lady (*The Green Death*)
- A medieval monk (*The Time Warrior*)
- A robot knight (*The Time Warrior*)
- A Thal guard (*Genesis of the Daleks*)
- A robot mummy (*Pyramids of Mars*)
- Himself—well, his android double at least (*The Android Invasion*)
- Harrison Chase's driver (*The Seeds of Doom*)
- Hieronymous (*The Masque of Mandragora*)
- A fellow Time Lord (*The Deadly Assassin*)
- A soldier in the Graff Vynda-K's personal guard (*The Ribos Operation*)
- Meglos (*Meglos*)
- A Sea Base guard (*Warriors of the Deep*)
- A miner (*The Mark of the Rani*)
- A waiter (*Rose, Rise of the Cybermen*)

- A Roboform (*The Runaway Bride*)
- John Smith (*Human Nature, Family of Blood*)
- A Headless Monk (*A Good Man Goes to War*)
- Sherlock Holmes (*The Snowmen*)
- A Punch and Judy man (*The Snowmen*)
- A doctor (*The Crimson Horror*)
- A clockwork droid (*Deep Breath*)
- A temporary caretaker (*The Caretaker*)

DOCTOR DOUBLES

The Doctor may be a unique individual but doubles of the great man turn up with alarming regularity.

The robot Doctor (*The Chase*)
Created by the Daleks to 'infiltrate and kill' the Doctor and his companions. This was the only Doctor double not to be played by the actor playing the Doctor himself. The robot Doctor was played by Edmund Warwick, who had previously been a stand-in for William Hartnell in *The Dalek Invasion of Earth* after the lead actor had injured himself. Hartnell did, however, dub the robot Doctor's lines, as well as appearing in close-ups.

The Abbot of Amboise (*The Massacre of St Bartholomew's Eve*)
By cosmic coincidence, the anti-Huguenot Abbot of Amboise was a double of the First Doctor. The resemblance was so striking that Steven believed the holy man was the Doctor in disguise.

Salamander (*The Enemy of the World*)
Mexican dictator Salamander bore a close resemblance to the Second Doctor—so much so that Time Lord and despot could easily impersonate each other.

The android Fourth Doctor (*The Android Invasion*)
One of the many pod-produced androids used by the Kraals in their invasion of Earth. So good that even the bad guys couldn't tell the difference between the fake Doctor and the real deal.

● **The carbon-based imprint Doctor (*The Invisible Enemy*)**
The Doctor duplicated himself—and Leela—so that his double could be shrunk to microscopic size using the TARDIS's dimensional stabiliser and injected into his own body to combat the Nucleus of the Swarm.

● **An army of Doctors (*The Leisure Hive*)**
The Doctor tricked Pangol into creating an army of Doctor clones using the Tachyon Recreation Generator.

● **Meglos (*Meglos*)**
Using the body of an abducted human, megalomaniac space-cactus Meglos imperson-ated the Doctor—even when he started sprouting spikes.

● **Omega (*Arc of Infinity*)**
The Gallifreyan temporal engineer based his new body on the Fifth Doctor.

● **Kamelion (*The King's Demons*)**
The shape-shifting android briefly took on the Time Lord's form.

● **The duplicate Fifth Doctor (*Resurrection of the Daleks*)**
A duplicate created by the Daleks in order to assassinate the High Council of Time Lords.

● **The android Fifth Doctor (*The Caves of Androzani*)**
A robot double created by Sharaz Jek to face General Chellak's firing squad.

● **The Other Doctor (*Journey's End*)**
Grown out of the Doctor's severed hand by means of an instantaneous biological metacrisis.

● **The Ganger Doctor (*The Rebel Flesh/The Almost People*)**
Accidentally created when the Doctor touched a vat of living programmable matter the Flesh during a solar storm on 22nd-century Earth.

● **The Teselecta Doctor (*The Impossible Astronaut, The Wedding of River Song*)**
Justice Department Vehicle Number 6018 impersonated the Doctor so that he could be murdered by River Song on the shores of Lake Silencio and restore estab-lished history.

Spoonhead (*The Bells of Saint John*)

Miss Kizlet used one of her spoonhead base stations to impersonate the Doctor and download Clara to the cloud. The Doctor later hacked this spoonhead and used it to infiltrate Miss Kizlet's base in The Shard.

Cyberplanner/Mr Clever (*Nightmare in Silver*)

The Cyberplanner took over the Doctor's mind, leading to a mind battle in which the Doctor faced a mental double of himself as the Cyberplanner—AKA Mr Clever.

Ghost Doctor (*Before the Flood*)

A hologram created by the Doctor of himself to emulate the Fisher King's 'Ghosts' and lure them into the Faraday Cage on The Drum undersea base.

Computer Simulated Doctor (*Extremis*)

A version of the Doctor generated in the computer simulation created by the Monks, which achieved self-awareness of its true nature.

DOCTOR... WHO?

'Doctor Who is required.'

WOTAN, *The War Machines*

The programme is called *Doctor Who* while the character is just 'the Doctor'. That hasn't stopped the name of the show popping up. A lot.

Story	Episode	Who says it?	How?
An Unearthly Child	2	The Doctor	'Eh? Doctor who? What's he talking about?'
An Unearthly Child	2	Ian Chesterton	'Who is he? Doctor who? Perhaps if we knew his name we might have a clue to all of this.'
The Keys of Marinus	5	Ian Chesterton, when asked if someone can speak for him at a tribunal	'Who? He's a doctor.'

Story	Episode	Who says it?	How?
The Chase	5	No one—but it's included in the episode's title	'The Death of Doctor Who'
The Chase	5	The Doctor after pretending to be his own robot double.	'Now they know who's Who.' The second 'who' was even capitalised in the script!
The Gunfighters	1	Masterson, when the Doctor tells him his name is Doctor Caligari	'Doctor Who?' to which the Doctor replies: 'Yes, quite right.'
The War Machines	1	WOTAN	'Doctor Who is required.'
The War Machines	2	Professor Brett and WOTAN	'Top priority is to enlist Doctor Who. He has advanced knowledge which WOTAN needs. Doctor Who must be enlisted into our services tonight.' 'Doctor Who is required.'
The War Machines	2	WOTAN	'Where is Doctor Who?'
The Highlanders	1	Redcoat Sergeant, after the Doctor tells him his name is Doctor von Wer.	'Doctor Who?' to which the Doctor replies: 'That's what I said.'
The Underwater Menace	1	The Doctor	The Doctor signs a note to Zaroff as 'Doctor W'.
Doctor Who and the Silurians	Every episode	The opening titles	Whoever gave the story its title!
The Curse of Peladon	4	Amazonia, the confused Earth delegate.	'Doctor? What Doctor? Doctor Who?'
The Mutants	6	The Investigator	'Doctor… who did you say?'
Logopolis	2	Tegan	'You can take me right back where you found me, Doctor whoever-you-are.'
Black Orchid	2	Lady Cranleigh	'Doctor who?'
The Five Doctors	-	UNIT Sergeant and Colonel Crichton	Crichton: 'What the blazes is going on? Who was that strange little man?' Sergeant: 'The Doctor.' Crichton: 'Who?'
Silver Nemesis	3	Lady Peinforte	'Doctor who? Have you never wondered where he came from, who he is?'

Story	Episode	Who says it?	How?
Silver Nemesis	3	Ace	'Doctor, who are you?'
Rose	-	A search engine when Rose is searching for 'Doctor Blue Box.'	'Doctor Who? … do you know this man'. It's also the main title on Clive's website.
The Empty Child	-	Rose	'You don't have a name. Don't you ever get tired of Doctor? Doctor who?'
Boom Town	-	Idris Hopper	Idris: 'Doctor who?' The Doctor: 'Just the Doctor. Tell her exactly that. The Doctor.'
The Christmas Invasion	-	Jackie	'What do you mean, that's the Doctor. Doctor who?'
The Girl in the Fireplace	-	Reinette, after an intimate Time Lord mind meld.	'Doctor. Doctor who? It's more than just a secret, isn't it.'
Blink	-	Larry	Larry: 'OK, there he is.' Sally: 'The Doctor.' Larry: 'Who's the Doctor?'
The Next Doctor	-	Rosita	'Doctor who?'
The Impossible Astronaut	-	Matilda	'Doctor who?'
The Impossible Astronaut	-	Canton—although the answer is classified.	'Yes, Doctor who exactly.'
Let's Kill Hitler	-	The Doctor, on hearing that River had done away with, well, him.	'Sorry, did you say she killed the Doctor? The Doctor? Doctor who?'
The Wedding of River Song	-	Dorium	'The question you've been running from all your life. Doctor who? Doctor who?'
Asylum of the Daleks	-	Darla, the Dalek Prime Minister and hundreds of Daleks	'Doctor who?'
Asylum of the Daleks	-	A rather gleeful Doctor	'Doctor who. Doctor who. Doctor who.'
The Angels Take Manhattan	-	River, after the Doctor playfully asked if she was the woman who killed the Doctor.	'Doctor who?'

Story	Episode	Who says it?	How?
The Snowmen	-	Clara	'Doctor who?'—twice in the same story no less. According to the Doctor it's a dangerous question.
The Snowmen	-	Jenny	'Doctor who?'
The Snowmen	-	Mr Punch (well, the Doctor really!)	'Doctor who?'
The Bells of Saint John	-	Clara	'Doctor who?' (x3)
The Name of the Doctor	-	The Great Intelligence	'Doctor who?'
The Time of the Doctor	-	Handles	'Translation follows: Doctor who? Doctor who? Doctor who? Doctor who? Doctor who?'
The Time of the Doctor	-	Time Lord	'Doctor who? Doctor who?'
Dark Water	-	The Doctor	'Doctor who?'
The Return of Doctor Mysterio	-	Lucy	'You never explained. Doctor who?'
World Enough and Time	-	Missy	'Hello, I'm Doctor Who.'
World Enough and Time	-	Missy	'I am that mysterious traveller in all of time and space, known only as Doctor Who.'
World Enough and Time	-	Bill	'So why do you keep calling yourself Doctor Who?'
World Enough and Time	-	Missy	'He says "I'm the Doctor", and they say "Doctor who?"'
World Enough and Time	-	Missy	'I do, because I grew up with him, and his real name is Doctor Who.'
World Enough and Time	-	Bill	'Is your real name Doctor Who?'
World Enough and Time	-	The Doctor	'Her name isn't Doctor Who. My name is Doctor Who.'
Twice Upon A Time	-	The Doctor	'Doctor who?'

Other instances:

- From *An Unearthly Child* to *The War Games* the end credits gave the name as 'Dr. Who' or 'Doctor Who'. From *Spearhead from Space* to *Logopolis* it was 'Doctor Who'. This changed to simply 'The Doctor' from *Castrovalva* onwards. When the show returned in 2005, it was back to 'Doctor Who' for the Ninth Doctor adventures. Since *The Christmas Invasion*, it's been plain old 'The Doctor' again.
- Bessie's number plate was WHO 1 (although when the Seventh Doctor turned up in *Battlefield* someone had conveniently changed it to WHO 7!)
- In *K-9 and Company: A Girl's Best Friend*, Brendan asks 'Who is the Doctor?' to which K-9 replies, 'Affirmative.'
- The novelisation *Doctor Who and the Zarbi* refers to the Doctor as 'Doctor Who' throughout, as do the officially licensed comic strips that appeared in *TV Comic*, *Countdown* and *TV Action* during the 1960s and 1970s, and the annuals published by World Distributors during the same period.
- It's not actually *Doctor Who*, but in *Carry on Screaming* Doctor Watt gives his name to Constable Slobotham who asks, 'Doctor Who, sir?' The reply comes back: 'Watt. Who was my uncle, or was—I haven't seen him in ages.' Saying that, the Doctor seems to be happy to go by Doctor What in *Hide*.

A DOCTOR OF WHAT?

Does the Doctor have any qualifications at all? It seems even he can't make up his mind…

- The First Doctor states that he's not a doctor of medicine. (*An Unearthly Child*)
- He also tells Kublai Khan that he cannot cure his pains as he's not a doctor of medicine. (*Marco Polo*)
- When Ian thanks him, rather sarcastically, for a thorough medical, the Doctor says it is a pity he didn't get his degree. (*The Rescue*)
- The Second Doctor thinks he was once a medical Doctor, having taken a degree in Glasgow in 1888 under Joseph Lister. (*The Moonbase*). According to Clara he accidentally graduated in the wrong century. (*Death in Heaven*).
- Then again, not long after that, he's back to saying he's not a medical doctor. (*The Krotons*)
- The Third Doctor tells the Investigator on Solos that he is a doctor qualified in practically everything. (*The Mutants*) This claim is also made by the Fifth and Tenth Doctors. (*Four to Doomsday*, *Utopia*)

- The Fourth Doctor defers to a real medical doctor on board the Ark, saying that his doctorate is purely honorary. (*The Ark in Space*)
- The Doctor once again points out Harry's credentials on Nerva Beacon, adding that he himself is a doctor of 'many things'. (*Revenge of the Cybermen*)
- Runcible (the Fatuous) thought the Doctor got expelled from the Prydonian Academy due to some sort of scandal. (*The Deadly Assassin*)
- Romana claimed the Doctor scraped through to graduation with 51 per cent on his second attempt, information the Doctor believed was confidential. She, on the other hand, graduated with a triple first. (*The Ribos Operation*)
- Drax thought it was good that the Doctor got his doctorate from the Academy. Like Drax, the Doctor was in 'the year of '92'. (*The Armageddon Factor*)
- The Fourth Doctor received an honorary degree from St Cedd's, Cambridge in 1960. (*Shada*)
- The Doctor failed the TARDIS flying test. (*The Shakespeare Code*)
- The Eleventh Doctor claims he has degrees in medicine and cheese-making. (*The God Complex*)
- The Twelfth Doctor tells Captain Quell that he's a doctor of intestinal parasites. (*Mummy on the Orient Express*)

THE DOCTOR IS IN

'Doctor. The word for healer and wise man throughout the universe. We get that word from you, you know?'

River Song, *A Good Man Goes to War*

The programme has featured some real doctors in its time—although not all of them have been particularly wise. Here's a selection.

Character	Played by	Appeared in
Dr Beavis	Henry McCarthy	*Spearhead from Space*
Dr Black	Bill Nighy	*Vincent and the Doctor*
Dr Carter	Rex Robinson	*The Hand of Fear*
Dr Chang	Andrew Leung	*Dark Water*

Character	Played by	Appeared in
Nasreen Chaudhry	Meera Syal	The Hungry Earth/Cold Blood
Dr Chester	Ian Fairbairn	The Seeds of Doom
Dr Constantine	Richard Wilson	The Empty Child/The Doctor Dances
Dr Humphrey Cook	Neville Barber	The Time Monster
Dr Gemma Corwyn	Anne Ridler	The Wheel in Space
Cruikshank	Roderick Smith	The Invisible Enemy
Damon	Colin Jeavons	The Underwater Menace
Dr Evans	Alan Rowe	The Moonbase
Dr Fendelman	Denis Lill	Image of the Fendahl
Dr Gachet	Howard Lee	The Pandorica Opens
Grigory	Stephen Flynn	Revelation of the Daleks
Hedges	Kenneth Waller	The Invisible Enemy
Dr Henderson	Anthony Webb	Spearhead from Space
Doc Holliday	Anthony Jacobs	The Gunfighters
Dr Grace Holloway	Daphne Ashbrook	Doctor Who
Dr Ruth Ingram	Wanda Moore	The Time Monster
Intern	Renu Setna	The Hand of Fear
Tarak Ital	Chook Sibtain	The Waters of Mars
Sharaz Jek	Christopher Gable	The Caves of Androzani
Martha Jones	Freema Agyeman	Various
Dr Judson	Dinsdale Landen	The Curse of Fenric
Dr Kendrick	Paul Antony-Barber	Rise of the Cybermen
Dr Lawrence	Peter Miles	Doctor Who and the Silurians
Dr Lennox	Cyril Shaps	The Ambassadors of Death
Abi Lerner	Vinette Robinson	42
Dr Lomax	Ellis Jones	Spearhead from Space

Character	Played by	Appeared in
Malokeh	Richard Hope	*The Hungry Earth/Cold Blood/ The Wedding of River Song*
Merak	Ian Saynor	*The Armageddon Factor*
Dr Meredith	Ian Cunningham	*Doctor Who and the Silurians*
Dr Tom Milligan	Tom Ellis	*The Last of the Time Lords*
Dr Moon	Colin Salmon	*Silence in the Library/Forest of the Dead*
Oliver Morgenstern	Ben Righton	*Smith and Jones*
Physician	Ronald Pickup	*The Reign of Terror*
Dr John Quinn	Fulton McKay	*Doctor Who and the Silurians*
Dr Ramsden	Nina Wadia	*The Eleventh Hour*
Range	William Lucas	*Frontios*
Dr Reeves	Eric Hillyard	*The Daemons*
Dr Renfrew	Kerry Shale	*Day of the Moon*
Dr Runciman	Roger Hammond	*Mawdryn Undead*
Dr Ryder	Adrian Rawlins	*Planet of the Ood*
Dr Salinger	John Novak	*Doctor Who*
Dr Toshiko Sato	Naoko Mori	*Aliens of London*
Dr Elizabeth Shaw	Caroline John	*Various*
Dr Sim	Aleksander Jovanavic	*The Return of Doctor Mysterio*
Dr Walter Simeon	Richard E. Grant	*The Snowmen / The Name of the Doctor*
Dr Skarosa	Nicholas Briggs (voice actor)	*Dark Water*
Lavinia Smith	Mary Wimbush	*K-9 and Company*
Dr Mehendri Solon	Philip Madoc	*The Brain of Morbius*
Dr Solow	Ingrid Pitt	*Warriors of the Deep*
Dr River Song	Alex Kingston	*Various*
Stoker	Roy Marsden	*Smith and Jones*
Dr Styles	Rula Lenska	*Resurrection of the Daleks*

Character	Played by	Appeared in
Surgeon-Lieutenant Harry Sullivan	Ian Marter	Various
Dr Roland Summers	Michael Sheard	*The Mind of Evil*
Dr Taltalian	Robert Cawdron	*The Ambassadors of Death*
Dr Tyler	Rex Robinson	*The Three Doctors*
Dr Warlock	Peter Copley	*Pyramids of Mars*
Dr Petra Williams	Sheila Dunn	*Inferno*

UNSEEN ADVENTURES

What do the Doctor and his companions get up to when we're not watching? All sorts of things—and here's just a small, random selection.

- The Doctor and Susan visited the planet Quinnis 'in the Fourth Universe' four or five journeys before *The Edge of Destruction* and nearly lost the TARDIS.
- They also saw the metal seas of Venus. (*Marco Polo*)
- Some time before *An Unearthly Child*, they encountered telepathic plants on the planet Esto. If you stood between the plants they made a screeching sound when they detected another mind. (*The Sensorites*)
- They experienced a Zeppelin air raid during the First World War. (*Planet of Giants*)
- The Doctor visited the planet Dido before the events of *The Rescue*.
- He also visited Rome prior to *The Romans* and claimed to have taught the Mountain Mauler of Montana how to fight.
- He'd had a previous encounter with the Celestial Toymaker. (*The Celestial Toymaker*)
- He was present at the Relief of Mafeking in 1900. (*The Daleks' Master Plan*)
- The Doctor watched the 'magnificent folly' of the Charge of the Light Brigade. (*The Evil of the Daleks*)
- Prior to the events of *The Abominable Snowmen*, the Doctor visited the Det-Sen monastery at various times—at least once in his second body—and commented that the place always seemed to be in some kind of trouble. In 1630 he took the bell known as the Holy Ghanta into his care.

- The Doctor once holidayed on Dulkis, finding it an extremely peaceful place. (*The Dominators*)
- The Cyber Controller recognised the Doctor from a previous encounter on 'Planet 14'. (*The Invasion*)
- The Doctor compared a noise he heard during the Inferno drilling project to the sound of Krakatoa in 1883. (*Inferno*)
- The Vandals were apparently 'quite decent chaps'. (*Invasion of the Dinosaurs*)
- The Doctor once crashed a Medusoid's mind probe by insisting that he was on the way to meet a giant rabbit, a pink elephant and a purple horse with yellow spots. The machine didn't believe him, even though he was telling the truth, as the unlikely trio of animals were delegates for the third Intergalactic Peace Conference. The Medusoids, a race of monopod, hairy jellyfish with claws and teeth, used up all their mind probes trying to get to the truth. (*Frontier in Space*)
- The Doctor was made a noble of Draconia after helping the 15th Draconian Emperor in the 21st century. (*Frontier in Space*)
- A captain in Cleopatra's bodyguard taught the Doctor how to fence. (*The Masque of Mandragora*)
- Prior to the events of *The Face of Evil*, the Doctor tried to use his own brainwaves to repair the Mordee computer that became Xoanon.
- The Doctor witnessed moving mines on Korlano Beta. (*The Robots of Death*)
- He saw the Fifth World War and was with the Filipino army in the final advance on Reykjavik in the 51st century. (*The Talons of Weng-Chiang*, *The Unquiet Dead*)
- The Doctor once angered the Droge of Gabrielides so much that a bounty of an entire star system was placed on his head. (*The Sun Makers*)
- The Doctor has visited both Aberdeen and Blackpool. (*Underworld*)
- He has seen opera singer Nellie Melba's party piece. (*The Power of Kroll*)
- The Doctor learnt how to walk over hot coals from firewalkers in Bali. (*The Armageddon Factor*)
- The Doctor witnessed the Big Bang. (*Destiny of the Daleks*)
- Tryst's mentor, Professor Stein, was a friend of the Doctor's. (*Nightmare of Eden*)
- The Doctor told Seth that he'd been to the 'charming' planet Aneth, just not yet. (*The Horns of Nimon*)
- The Fourth Doctor visited Tigella and met Zastor 50 years prior to the events of *Meglos*.
- The Logopolitans offered to complete the TARDIS's chameleon conversion on his previous visit to Logopolis. (*Logopolis*)
- The Doctor once played for New South Wales cricket team, taking five wickets. He used to bowl a very good chinaman (a left-handed googly in case you were wondering). (*Castrovalva*, *Four to Doomsday*)

- The Second Doctor once faced the terrible Zodin, a woman of rare guile and devilish cunning whose race was covered in hair and hopped like kangaroos. The Brigadier wasn't involved. (*The Five Doctors, Attack of the Cybermen*)
- The Doctor recognised Silurian battle cruisers and the Myrka and thought Icthar was dead. (*Warriors of the Deep*)
- The Doctor had visited Androzani Minor previously. (*The Caves of Androzani*)
- Azmael was the best teacher the Doctor ever had. His fourth incarnation got Azmael drunk at their last meeting. (*The Twin Dilemma*)
- Before leaving Gallifrey, the Doctor attended the inauguration of the Space Station Camera. (*The Two Doctors*)
- He had also visited Seville before the events of *The Two Doctors*.
- The Third Doctor and Jo Grant saved the planet Karfel from disaster and reported Magellan (aka the Borad) to the Inner Sanctum for unethical experimentation on the Morlox creatures. When greeting the Doctor, Tekker commented that there were 'only the two of you', to which the Doctor replied that he was 'travelling light this time', indicating that there may have been more than just the Doctor and Jo on board the TARDIS back then. (*Timelash*)
- The agronomist Arthur Stengos was an old friend of the Doctor. (*Revelation of the Daleks*)
- Before the events of *The Trial of a Time Lord: Mindwarp*, the Doctor and Peri visited Thordon, where the Mentors of Thoros Beta had supplied the primitive warlords with energy weapons.
- Captain 'Tonker' Travers got wrapped up in 'a web of mayhem and intrigue' when he met the Sixth Doctor. The Doctor at least saved Travers' ship. (*The Trial of a Time Lord: Terror of the Vervoids*)
- The Doctor met a Stigorax in 25th-century Birmingham. (*The Happiness Patrol*)
- On 23 November 1638, the Doctor launched a rocket sled containing a Validium statue of Lady Peinforte into space. (*Silver Nemesis*)
- The Doctor visited Windsor castle when it was being built. (*Silver Nemesis*)
- The Doctor defeated Fenric at chess in the third century, banishing him to a shadow dimension. The Time Lord also met the Ancient One in the far future. (*The Curse of Fenric*)
- The Ninth Doctor was photographed in the crowd when Kennedy was assassinated in 1963, and his picture was drawn on the island of Sumatra soon after the eruption of Krakatoa in 1883. (*Rose*)
- On the eve of the *Titanic*'s maiden voyage, the Ninth Doctor had his photo taken with the Daniels family in Southampton. They subsequently missed the trip (*Rose*) but the Doctor later recalled sailing on an 'unsinkable' ship—he ended up clinging to an iceberg. (*The End of the World*)
- The assembled hordes of Genghis Khan once tried to get through the TARDIS doors—and failed. (*Rose*)

- He pushed boxes at the Boston Tea Party. (*The Unquiet Dead*)
- The Doctor vaporised the 51st-century weapons factories on Vilenguard by making the main reactor go critical. There's a banana grove there now. (*The Doctor Dances*)
- Rose visited Justicia, the Glass Pyramid of San Kaloon, and a planet called Woman Wept, where she witnessed the sea freeze in the middle of a storm on a beach a thousand miles across. She walked with the Doctor under a hundred-foot wave at midnight. (*Boom Town*)
- Before arriving on the Game Station, the Doctor, Rose and Captain Jack had been to Raxacoricofallapatorius, then Kyoto, Japan in 1336, from which they only just escaped. (*Bad Wolf*)
- The Ninth Doctor and Rose once had to hop for their lives. (*Born Again*)
- The Doctor nearly lost his thumb when he helped Skylab fall to Earth. (*Tooth and Claw*)
- When the Doctor previously met the Krillitanes they resembled humanoids with long necks. (*School Reunion*)
- On an asteroid, a 'weird munchkin lady' with big eyes nearly frazzled Rose with her fiery breath. (*Rise of the Cybermen*)
- The Doctor watched the 1948 Olympic opening ceremony—twice. (*Fear Her*)
- Rose bought Jackie a bazoolium trinket from an asteroid bazaar. The metal got cold when rain was due and heated up when sun was on its way. (*Army of Ghosts*)
- Martha and the Doctor watched the Moon landing four times. (*Blink*)
- The Doctor and Martha got in a bit of a pickle with 'four things and a lizard'. Sally Sparrow saw them running off with a bow and a quiver of arrows with only 'twenty minutes to Red Hatching'. (*Blink*)
- The Doctor was present at the birth of Christ. He got the last room in the inn. (*Voyage of the Damned*)
- The Sibyl had a bit of a thing for the Doctor. The Doctor thought she was a hell of a woman. She had lovely teeth and could dance the tarantella. (*The Fires of Pompeii*)
- The Doctor witnessed the war between China and Japan. (*Planet of the Dead*)
- He visited the Court of King Athelstan in AD 924 when the King of the Welsh presented the Cup of Athelstan. (*Planet of the Dead*)
- When summoned to the planet of the Ood, the Doctor went on a bit of a detour—he saw the Phosphorous Carousel of the Great Magellan Gestalt, saved a planet from the Red Carnivorous Maw, named a galaxy Alison and got married. To someone quite important (see 'The Many Wives of the Doctor'). (*The End of Time, Part One*)
- The Doctor once had dinner with the Aplan chief architect of Alfava Metraxis. He had two heads. The Architect, not the Doctor, that is. (*The Time of Angels*)
- The Doctor and River had an unspecified adventure on Easter Island that ended with the islanders raising the famous statues in his honour. (*The Impossible Astronaut*)
- The Doctor met the Silurian Madame Vastra while she was avenging the death of her sisters by killing workers in the London Underground at some point after 1863.

(*A Good Man Goes to War*). He saved Jenny Flint's life on the very same day (*The Name of the Doctor*).

- The Doctor arranged a birthday party for River under London Bridge in the Frost Fair of 1814. Stevie Wonder sang for them. (*A Good Man Goes to War*)
- He played triangle in the recording of *Carmen* played by Oswin in the Asylum. (*Asylum of the Daleks*)
- The Doctor rescued Queen Nefertiti from a swarm of alien locusts. He also met a big game keeper by the name of John Riddell. (*Dinosaurs on a Spaceship*)
- The Doctor entered the Anti-Gravity Olympics of 2074, in which he rode his anti-gravity motorbike. He came last. (*The Bells of Saint John*)
- The Doctor once invented an android boyfriend. It was a nightmare to get rid of. (*The Time of the Doctor*)
- The Doctor took Clara to visit the Fish People, not long after they escaped a desert full of Sand Piranhas. (*The Caretaker*)
- The Doctor and River Song lived among otters for a month. They argued. The Doctor and River Song that is. Not the otters. (*The Caretaker*)
- The Doctor and Clara went to dinner in Berlin in 1937. (*Kill the Moon*)
- A gas-masked Doctor enjoyed a picnic on Thedion Four, despite the acid rain. (*Mummy on the Orient Express*)
- Clara Oswald met and, apparently, snogged Jane Austen. They enjoy pranking each other. (*The Magician's Apprentice, Face the Raven*)
- The Doctor escaped a nest of vampire monkeys. (*The Witch's Familiar*)
- The Doctor and Clara visited a planet where people with long necks had been celebrating New Year for two centuries. Clara left her sunglasses there—and most of her dignity. (*Under the Lake*)
- The Doctor saved the Velosians' planet from four-and-a-bit attack fleets. During the adventure Clara found herself in a spider mine. (*The Girl Who Died*)
- Clara once went into battle armed with a sword. The Doctor wasn't aware of this. (*The Girl Who Died*)
- The Doctor almost had to marry a sentient plant in the second most beautiful garden in creation. (*Face the Raven*)
- Nardole had a stop-off in 12th-century Constantinople when he was trying to materialise around the Doctor in the Harmony Shoal skyscraper. (*The Return of Doctor Mysterio*)
- The Doctor once met an Emperor made of algae... who fancied him. (*Smile*)

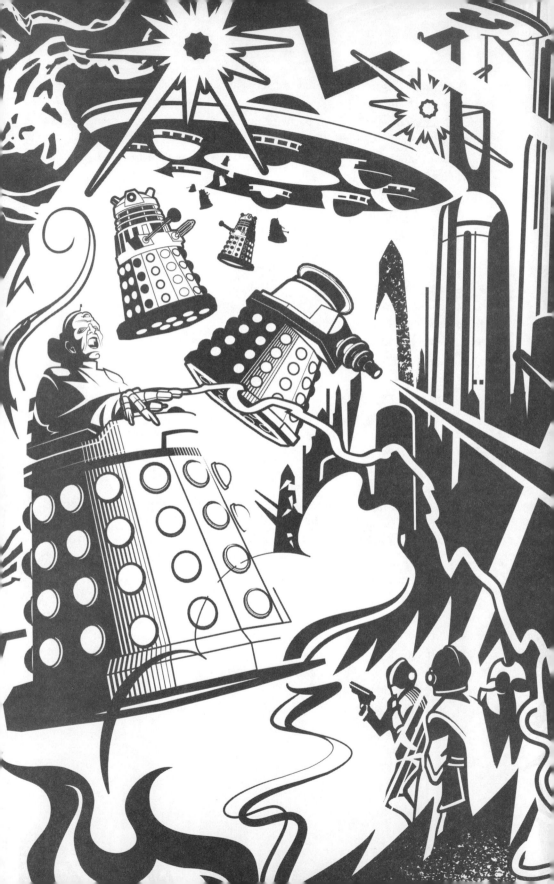

THE LAST GREAT TIME WAR

'There was a war. A Time War. The Last Great Time War. My people fought a race called the Daleks, for the sake of all creation. And they lost. They lost. Everyone lost. They're all gone now. My family, my friends, even that sky.'

The Doctor, *Gridlock*

Before meeting Rose Tyler, the Doctor fought in a mighty war between his people and the Daleks. Much of what happened is lost in the mists of time, but some things are known:

- Millions died in every second of the conflict. (*The End of Time*)
- The Doctor fought on the front line. It's how he survived. (*Doomsday*)
- He witnessed the fall of Arcadia—something he hoped to come to terms with one day. (*Doomsday*)
- The Gelth lost their physical forms during the War, existing only as gaseous beings from that day forth. (*The Unquiet Dead*)
- All of the Nestene Consciousness's food stock was destroyed in the War. The Doctor couldn't save the Nestene's world. (*Rose*)
- Sontaran legends say that the Doctor led the battle in the Time War. The Sontarans weren't allowed to take part. (*The Sontaran Stratagem*)
- Davros died in the first year of the Time War at the Gates of Elysium when his command ship flew into the jaws of the Nightmare Child. The Doctor tried to save him. (*The Stolen Earth*)
- The Master was resurrected by the Time Lords during the War when they recognised he was the perfect warrior. He wasn't—he ran when the Dalek Emperor took the Cruciform. (*The Sound of Drums*)
- In the last days of the War, the Doctor witnessed such horrors as the Skaro Degradations, the Horde of Travesties, the Nightmare Child, and the Could-Have-Been King and his army of Meanwhiles and Never-weres. (*The End of Time*)
- President Rassilon aimed to end the War by destroying the universe itself. The Final Sanction would see the creation of a paradox so great it would rip the Time Vortex apart. The Time Lords would survive by becoming creatures of consciousness alone. (*The End of Time*)
- It was Rassilon's intent to use the Final Sanction that spurred the Doctor into action to end the War himself, sealing the conflict's events within a time lock. (*The End of Time*)
- The Doctor ended the Time War by using the Moment. (*The End of Time*)
- All those fighting, including ten million Dalek ships, were wiped out in one second. (*Dalek*)

- The Doctor was not the only survivor of the Time War. A lone Dalek crashed to Earth on the Ascension Islands, eventually ending up in the collection of Henry van Statten (*Dalek*); the Dalek Emperor fell through time and began rebuilding the Dalek Empire from human DNA (*Bad Wolf / The Parting of the Ways*); the Cult of Skaro escaped into the Void, having stolen the Genesis Ark, a Time Lord prison full of Daleks (*Army of Ghosts / Doomsday*); Dalek Caan of the Cult of Skaro penetrated the timelock and rescued Davros (*The Stolen Earth / Journey's End*).
- Due to the devastation caused by the Time War, the Time Lords became just as hated as the Daleks. (*The Night of the Doctor*)
- The Zygon homeworld burned in the first days of the Time War. (*The Day of the Doctor*)
- The Doctor stole The Moment from the Omega Arsenal and intended to use it to destroy Time Lord *and* Dalek forces. (*The Day of the Doctor*)
- The Moment had developed a conscience and showed the War Doctor a future where he had pressed the button. (*The Day of the Doctor*)
- The Doctor's first 13 incarnations, including the War Doctor, were present when Gallifrey was frozen in a moment of time, leading to the destruction of the Dalek fleet and the end of the War. The War Doctor was truly the Doctor after all. (*The Day of the Doctor*)
- The War Doctor and his subsequent incarnations up to the Eleventh Doctor still believes he used the Moment to end the War once the timelines re-synched. It was the Curator who told the Eleventh Doctor that the plan to freeze Gallifrey in time had succeeded. (*The Day of the Doctor*)
- Skull Moon—a Gallifreyan soldier tells the Doctor they served together here during the Time War. By this point, the Doctor is hailed as a war hero on Gallifrey. (*Hell Bent*)

MID-LIFE CRISIS: THE CHANGING AGE OF THE DOCTOR

As River told Amy, rule number one is that the Doctor lies – but has he been lying about his age all these years? The Doctor never seems to be sure how old he is. Perhaps he doesn't want to know…

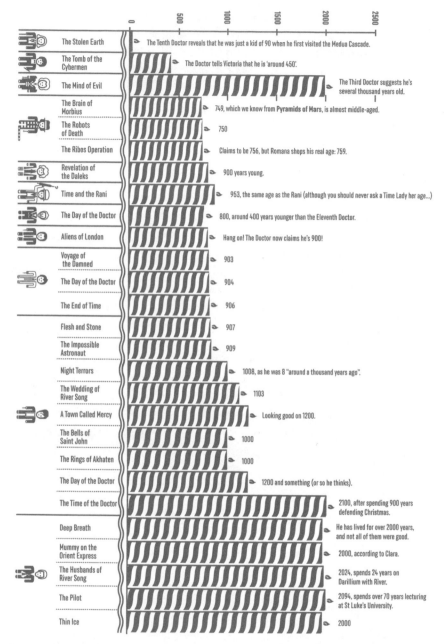

The Stolen Earth		The Tenth Doctor reveals that he was just a kid of 90 when he first visited the Medua Cascade.
The Tomb of the Cybermen		The Doctor tells Victoria that he is 'around 450'.
The Mind of Evil		The Third Doctor suggests he's several thousand years old.
The Brain of Morbius		749, which we know from **Pyramids of Mars**, is almost middle-aged.
The Robots of Death		750
The Ribos Operation		Claims to be 756, but Romana shops his real age: 759.
Revelation of the Daleks		900 years young.
Time and the Rani		953, the same age as the Rani (although you should never ask a Time Lady her age…)
The Day of the Doctor		800, around 400 years younger than the Eleventh Doctor.
Aliens of London		Hang on! The Doctor now claims he's 900!
Voyage of the Damned		903
The Day of the Doctor		904
The End of Time		906
Flesh and Stone		907
The Impossible Astronaut		909
Night Terrors		1008, as he was 8 "around a thousand years ago".
The Wedding of River Song		1103
A Town Called Mercy		Looking good on 1200.
The Bells of Saint John		1000
The Rings of Akhaten		1000
The Day of the Doctor		1200 and something (or so he thinks).
The Time of the Doctor		2100, after spending 900 years defending Christmas.
Deep Breath		He has lived for over 2000 years, and not all of them were good.
Mummy on the Orient Express		2000, according to Clara.
The Husbands of River Song		2024, spends 24 years on Darillium with River.
The Pilot		2094, spends over 70 years lecturing at St Luke's University.
Thin Ice		2000

Other clues to the Doctor's age:

- The Doctor was just 8 years old when he entered the Time Lord academy, as was the Master. (*The Sound of Drums*)
- In *The Ribos Operation*, Romana notes that the Doctor has been piloting the TARDIS for 523 years. If he's really 759 by this point, that means he went joyriding at the tender age of 236.

- This is backed up by Idris in *The Doctor's Wife*. She says that the Doctor has been travelling with her for 700 years. If we believe he's 909 in this story, they left Gallifrey not long into his 200s.
- Before the Doctor faced his apparent death in Utah, 2011, he went on a 'farewell tour' lasting almost 200 years. That was some tour.

A MERE SLIP OF A GIRL?

Romana may have mocked the Doctor for massaging his true age, but the Time Lady has been economical with the truth herself at times. In *The Ribos Operation* she admits to being 140 (nearly), but by *City of Death* is running around claiming to be a mere 125. Is the 150 years stated in *The Leisure Hive* nearer the truth, Miss Romanadvoratrelundar?

A YOUNG, OLD FACE

Being involved with the Doctor can make you old before your years, and sometimes younger too.

- Space agent Sara Kingdom was aged to death by the Daleks' terrible Time Destructor on the planet Kembel. (*The Daleks' Master Plan*)
- Stuart Hyde, a scientist at the Newton Institute, was aged by the trans-dimensional being known as Kronos. (*The Time Monster*)
- Sergeant Benton was reverted to a bouncing baby boy by the Master's TOMTIT (Transmission of Matter Through Interstitial Time) experiment. (*The Time Monster*)
- A chicken was hatched and fully grown in an artificial time bubble. Then popped back in its egg. (*City of Death*)
- Professor Theodor Nikolai Kerensky was aged to death in the same temporal field generator. (*City of Death*)
- The Argolin race was prematurely aged thanks to the radioactive atmosphere on the planet Argolis. (*The Leisure Hive*)
- The Fourth Doctor was turned old and grey in the Leisure Hive's Tachyon Recreation Generator on Argolis. (*The Leisure Hive*)

- Tegan and Nyssa, the Doctor's companions, contracted a virus from the rogue scientist Mawdryn and both aged rapidly when travelling in time, and also regressed to children. (*Mawdryn Undead*)
- Professor Richard Lazarus created a Genetic Manipulation Device to rejuvenate himself. He succeeded but unfortunately became a hideous, cannibalistic monster. (*The Lazarus Experiment*)
- John Smith didn't exactly age, but the Doctor's human counterpart experienced a vision of himself as an old man, dying in his bed. (*The Family of Blood*)
- The Tenth Doctor was aged 100 years by the Master, using stolen DNA and Richard Lazarus's technology. (*The Sound of Drums*)
- The Tenth Doctor's ability to regenerate was suspended by the Master, transforming him into a pathetic, wizened creature. (*Last of the Time Lords*)
- Amy Pond was trapped in an accelerated time stream for 36 years. (*The Girl Who Waited*)
- Rory Williams was trapped in a secondary time stream when the entity known as House took over the TARDIS. Rory aged and died there in a matter of minutes. (*The Doctor's Wife*)
- Along with the Doctor, River and Amy, Rory met a naturally aged version of himself in New York. (*The Angels Take Manhattan*)
- While protecting the town of Christmas on Trenzalore, the Doctor aged to the point of death. (*The Time of the Doctor*)
- Clara appeared as an aged version of herself in the final dreamscape while under the influence of the Kantrafarri. (*Last Christmas*)

FISH FINGERS AND CUSTARD

'Box falls out of the sky. Man falls out of a box. Man eats fish custard.'
The Doctor, *The Eleventh Hour*

Food the Doctor loves… and loathes

LIKES:

- Apples (Fourth, Eleventh, Twelfth)
- Bananas (Ninth, Tenth)
- Celery—it turns purple in the presence of certain gases in the Praxis range of the spectrum. And it's good for your teeth. (Fifth)
- Chinese Food (Twelfth)
- Chips (Tenth, Twelfth)
- Chocolate Easter Eggs (Tenth)
- Cocoa (First)
- Coffee (Third, Ninth)
- Crisps (Twelfth)
- Fish fingers and custard (Eleventh)
- Fruitcake (Fourth)
- Garlic (Fourth)
- Ginger beer (Fourth)
- Gorgonzola (Third)
- Gumblejack (Sixth)
- Ice cream (Second)
- Jammy dodgers (Eleventh)
- Jelly babies (Second, Fourth, Seventh, Eighth)
- Lemon sherbets (Second)
- Lemonade (Twelfth)
- Lime and soda (Tenth)
- Liquorice Allsorts (Fourth)
- Marshmallows, especially the pink ones (Eleventh)
- Mexican food (Twelfth)
- Milk (Eleventh)
- Mutton broth and bread (Third)
- Non-toxic, non-hallucinogenic luminous blue fruit, high in free radicals (Eleventh)
- Offal (Twelfth)
- Patty cake biscuit (Second)
- Pomegranates (First)
- Pontefract cake (Eleventh)
- Pork, potatoes, carrots (Second)
- Porridge with a dash of salt (Fourth)
- Prawn crackers (Twelfth)
- Scones (Eleventh)
- Sherbet lemons (Twelfth)
- Soda pop (Twelfth)
- Soup (Twelfth)

- Sushi (Twelfth)
- Tea—the Third Doctor liked a cup of tea so much that only the Brigadier and the tea lady were allowed into his lab. Nardole used to add coffee into the Doctor's tea. (Second, Third, Fourth, Fifth, Seventh, Eighth, Ninth, Tenth, Eleventh, Twelfth)
- Wine (Third, Tenth)

DISLIKES:

- Apples (Eleventh)
- Bacon (Eleventh)
- Baked beans (Eleventh)
- Bread and butter (Eleventh)
- Burnt toast (Seventh)
- Carrot juice (Sixth)
- Fish (Twelfth)
- Liver (Twelfth)
- Carrots (Eleventh)
- Pears (Tenth, Twelfth)
- Tangerines (Twelfth)
- Wine (Eleventh)
- Yoghurt (Eleventh)

ONE LUMP OR TWO?

- The Third Doctor's sweet tooth sees him stirring a very worrying four spoons (at least!) of sugar into his hot, sweet UNIT tea. (*Invasion of the Dinosaurs*)
- The Ninth Doctor has just two lumps of sugar in his tea. (*The Unquiet Dead*)
- The Twelfth Doctor adds seven sugars to his coffee on board Boat One. (*Death in Heaven*)

FOOD THE DOCTOR CLAIMS HE INVENTED

- Banana Daiquiri (*The Girl in the Fireplace*)
- Pasta (*Pond Life*)
- Yorkshire pudding (*The Power of Three*)

THE DOCTOR'S ABILITIES

'Dramatic recitations, singing, tap dancing. I can play the *Trumpet Voluntary* in a bowl of live goldfish.'

The Doctor, *The Talons of Weng-Chiang*

Over the years the Doctor has displayed all manner of talents. Although different incarnations have different skills, so far the Doctor has been seen to:

- Hypnotise people, with or without fob watches (various)

- Perfectly mimic other beings (*The Celestial Toymaker*)
- Regenerate into an entirely new body when his old one is damaged beyond repair or 'wearing a bit thin' (various, see *The Regeneration Game*)
- Regenerate the very clothes he's wearing (*The Tenth Planet*). He even manages to regenerate a pair of boots into shoes in *Logopolis* too!
- Sense danger. When Dalek agents stole his TARDIS in 20th-century London, the Doctor claimed he could feel his enemies 'closing in all around'. Of course, he may have just been melodramatic (*The Evil of the Daleks*). He'd previously sensed that there was something alien about the Post Office Tower in *The War Machines*, saying his skin had a pricking sensation, just as it did when Daleks were near.
- Resist alien truth machines (*The War Games*)
- Place himself into a coma to recover from certain injuries, such as being grazed by a bullet (*Spearhead from Space*)

- Transmigrate objects such as reels of tape (*The Ambassadors of Death*)
- Withstand considerably more G-force than mere humans (*The Ambassadors of Death*)
- Survive extreme drops in temperature (*The Daemons*)
- Experience premonitions through the medium of dreams (*The Time Monster*)
- React ten times faster than a human—or so he claimed while driving Bessie at speed (*The Time Monster*)
- Telepathically communicate with his TARDIS (*The Time Monster*)
- Link minds with other Time Lords (*The Three Doctors*)
- Reduce his body temperature to speed up the healing process (*Planet of the Daleks*)
- Escape the effects of manipulated time fields (*Invasion of the Dinosaurs*)
- Put himself into a trance-like complete sensory withdrawal (*The Monster of Peladon*)
- Type faster than any secretary, human or otherwise (*Robot*)
- Withstand strangulation thanks to his respiratory bypass system (*Pyramids of Mars*)
- Understand foreign and alien languages (*The Masque of Mandragora*), a Time Lord gift he can share with his companions—although the TARDIS is later revealed to play a part in this (*The End of the World*)
- Survive extreme heat (*The Hand of Fear*)
- Shatter glass by singing a single note (*The Power of Kroll*)
- Detect jumps in time (*City of Death*)
- Mirror-write (*City of Death*)
- Speed-read (*City of Death, Rose*)
- Survive the sub-zero temperatures of space for six minutes (*Four to Doomsday*)
- Bowl a left handed googlie (*Four to Doomsday*)
- Cure concussion in others by tweaking their earlobe (*Remembrance of the Daleks*)
- Convince people to obey his will through the power of words alone (*Battlefield*)
- Render people helpless by simply applying his fingers to their heads (*Battlefield, Survival, Listen*)
- Ease pain with a mere touch (*The Curse of Fenric*)
- Write different things with two hands simultaneously (*The Curse of Fenric*)
- Forge signatures from memory (*The Curse of Fenric*)
- Expel foreign bodies such as a medical probe from his cardiovascular system, even breaking his skin in the process (*Doctor Who*)
- Pick pockets (various)
- Slow down his perception of time to negotiate obstacles such as giant fan blades (*The End of the World*)
- Speak five billion languages (*The Parting of the Ways*)

- Identify human blood types by taste (*The Christmas Invasion*) as well as viscum album, the oil of the mistletoe plant (*Tooth and Claw*), iron (*The Idiot's Lantern*), the age of paint on a shed (*The Eleventh Hour*), and the mineral composition of grass (*The Hungry Earth*). He can also identify where an envelope was manufactured by licking it (*Day of the Moon*)
- Re-grow appendages using residual regeneration energy—so long as the said appendage gets hacked off within the early hours of a regeneration (*The Christmas Invasion*)
- Absorb Roentgen radiation, channel it through his body and expel it—a trick he learnt with Roentgen bricks in the nursery (*Smith and Jones*)
- Hear the TARDIS's operations from a considerable distance (*The Sound of Drums*)
- Identify the decade by smelling the air (although the appearance of a vintage car may help) (*The Unicorn and the Wasp*)
- Expel a dose of cyanide by stimulating the inhibited enzymes into reversal. All he needs is some added protein, ginger beer, salt and a snog. From Donna. (*The Unicorn and the Wasp*)
- Open the TARDIS with a click of his fingers (*Forest of the Dead*)
- Wipe memories (*Journey's End*)
- Play football to a surprisingly high standard (*The Lodger*)
- Transfer memories by means of a head-butt (*The Lodger*)
- Share his regenerative energy with other Time Lords (*The Angels Take Manhattan*), an ability shared by River Song (*Let's Kill Hitler*)
- Establish psychic links with other minds (*The Girl in the Fireplace*, *The Lodger*, *Deep Breath*)
- Speak baby (*A Good Man Goes to War*, *Closing Time*, *The Girl Who Died.*)
- Speak horse (*A Town Called Mercy*)
- Speak dinosaur (*Deep Breath*)
- Judge the passage of time by sticking his finger in a cup holding a hot drink (*Under the Lake*)
- Divine the century—and even day of the week—by licking his finger and touching his ear (*Sleep No More*)
- Establish a telepathic link with a door and ask it to open (*Heaven Sent*)
- Retreat into a mental 'storm room', a representation of the TARDIS console room in his mind, to work out problems (*Heaven Sent*)
- Shoplift (*Thin Ice*)
- Tell a person's age and iron-content via a punch to the subject's face (*Thin Ice*)
- Forge a 19th Century document (*Thin Ice*)
- Survive prolonged exposure to the vacuum of deep space (*Oxygen*)
- Work out his location by tasting the snow, especially if it's minty (*Twice Upon A Time*)

OTHER TIME LORD ABILITIES

- Susan shows evidence of telepathy in *The Sensorites*.
- The Time Lords in *The War Games* are able to inflict extreme pain with just the power of their minds.
- The Master shares the Doctor's mimicry talents. He is able to perfectly impersonate the Brigadier in *The Time Monster*.
- Morbius shields his mind from the psychic probing of the Sisterhood of Karn. (*The Brain of Morbius*)
- Romana feigns death by stopping both her hearts. (*Destiny of the Daleks*)
- Professor Chronotis manipulates the beating of his twin hearts in time to Gallifreyan Morse. (*Shada*)
- The Master merges his decaying Time Lord body with that of another life form. (*The Keeper of Traken*) He subsequently transforms his mortal remains into a gloopy, slime-snake that inhabits and reanimates Bruce the ambulance driver's body. In this form he also spits out deadly, paralysing mucus. (*Doctor Who*)
- According to the Doctor, the Time Lords have no dress sense, dreadful hats, but are smart. (*Journey to the Centre of the TARDIS*)
- The Time Lords invented chess. (*Nightmare in Silver*)
- Time Lord art freezes a moment of time. (*The Day of the Doctor*)
- They can move with preternatural speed. (*Death in Heaven*)
- They can remove individuals from their time streams at the moment of death in an Extraction Chamber. (*Hell Bent*)
- They can change gender during regeneration. (*Hell Bent*)
- They don't need sleep—unless they've regenerated or had a big lunch. (*Knock Knock*)

THE MANY WIVES
OF DOCTOR WHO

'Look, sorry. I've got a bit of a complex life. Things don't always happen to me in quite the right order. Gets a bit confusing at times. Especially at weddings. I'm rubbish at weddings. Especially my own.'

The Doctor, *Blink*

▌ THE DOCTOR'S FIRST MARRIAGE

The Doctor very rarely mentions his family but, over the years, he has let slip a few details. In *The Tomb of the Cybermen*, the Second Doctor tells Victoria that the memory of his family sleeps in his mind, while years later, in *The Curse of Fenric*, the Seventh Doctor admits he doesn't know if he has any family any more. In *The Empty Child*, Doctor Constantine confides that he has been a father and a grandfather but the Second World War has left him as neither. The Doctor comments that he knows the feeling.

When he left Gallifrey, the First Doctor was travelling with his granddaughter, Susan Foreman (*An Unearthly Child*), and the Tenth Doctor tells Rose Tyler that he 'was a dad once' (*Fear Her*). It's fair to assume that he had a partner, maybe even a wife, and that she was probably Gallifreyan, as Susan was brought up on the Doctor's home planet.

Later, when faced with his new daughter, Jenny (see Other Notable Relations) the Doctor says that he can see his family in her, the hole they left and the pain that filled it. He claims that when they died, part of him died with them.

▌ MARRIAGE TO QUEEN ELIZABETH I

In *The End of Time*, the Doctor boasts that he married 'Good Queen Bess'. He later suggests, in *The Wedding of River Song*, that 'Liz the First' waited in a glade to elope with him.

Others are aware of this royal wedding, too. On Starship UK (*The Beast Below*), Queen Liz 10 needles the Time Lord about his relationship with the Virgin Queen (he's 'a bad, bad boy' apparently) while the Dream Lord points out the Doctor's love of redheads, specifically mentioning poor old Lizzy (*Amy's Choice*).

For whatever reason, the liaison, it seems, did not go well. Elizabeth herself doesn't seem too happy to see her former hubby at the Globe theatre in 1599. In fact, as soon as she claps eyes on the Tenth Doctor she orders his decapitation! That must have been some break-up (*The Shakespeare Code*).

If all this wasn't complicated enough, at one point Amy Pond (the Doctor's mother-in-law from his fourth marriage) accidentally married Henry VIII (the Doctor's father-in-law from his second marriage) while she was still married to Rory. To add insult to injury, the muddled matrimony happened on the Ponds' wedding anniversary.

> The First Doctor uses a Time-Space Visualiser to spy on a conversation between Queen Elizabeth I and William Shakespeare in *The Chase*. Little does the old rogue know he's looking at his future trouble and strife.

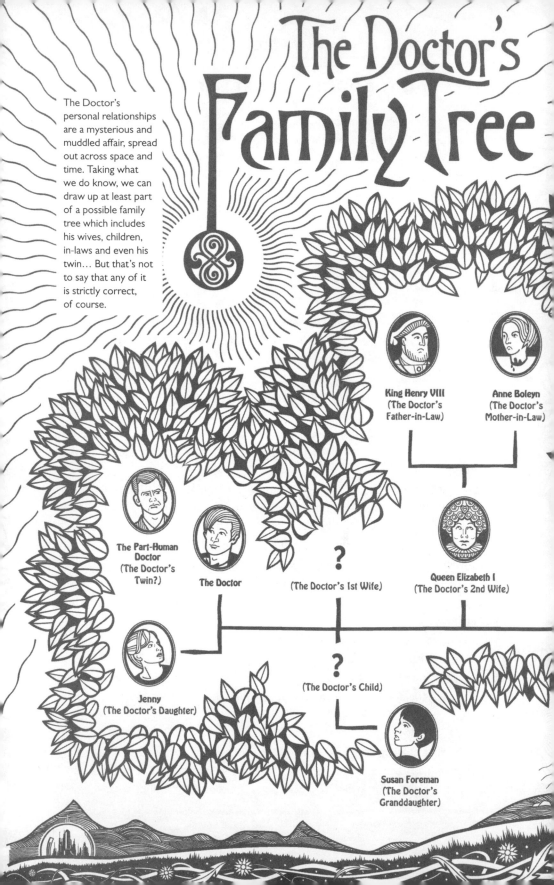

The Doctor's Family Tree

The Doctor's personal relationships are a mysterious and muddled affair, spread out across space and time. Taking what we do know, we can draw up at least part of a possible family tree which includes his wives, children, in-laws and even his twin… But that's not to say that any of it is strictly correct, of course.

King Henry VIII
(The Doctor's Father-in-Law)

Anne Boleyn
(The Doctor's Mother-in-Law)

The Part-Human Doctor
(The Doctor's Twin?)

The Doctor

?
(The Doctor's 1st Wife)

Queen Elizabeth I
(The Doctor's 2nd Wife)

Jenny
(The Doctor's Daughter)

?
(The Doctor's Child)

Susan Foreman
(The Doctor's Granddaughter)

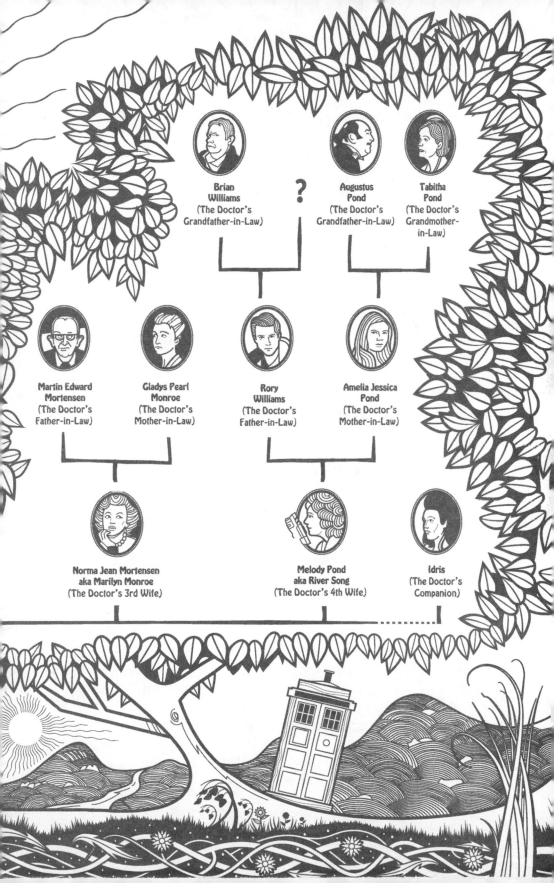

MARRIAGE TO MARILYN MONROE

24 December 1952. The Doctor attends a party in Hollywood, California with the young Kazran Sardick and his sweetheart, Abigail. Just as he is about to sing a duet with Frank Sinatra, the Doctor somehow manages to 'accidentally' get engaged to Marilyn Monroe. The Time Lord tries to skedaddle, but there is no escape—Marilyn has already booked a cab to the chapel. The Doctor reluctantly slopes off to marry the model-turned-actress.

Do they go through with the wedding? Well, when Marilyn later manages to phone the TARDIS, the Doctor questions the chapel's legitimacy... (*A Christmas Carol*)

> **'Yes, I made some cocoa and got engaged.'**
>
> **The Doctor, *The Aztecs***

This isn't the first time the Doctor has accidentally got engaged. The First Doctor cosies up to an elderly Aztec woman called Cameca, making her a nice cup of cocoa. Little does he know that such an act is a proposal of marriage. The man just can't help himself. Although the Doctor reveals a lovable sentimental streak as he leaves Mexico with the brooch his fiancée gave him—harrumphing all the way, of course. (*The Aztecs*)

MARRIAGE TO RIVER SONG

How many times have we heard this story? Boy meets girl, girl kills boy, girl tries to stop herself killing boy and so creates a slowly disintegrating bubble universe where all time is happening at once, boy tries to persuade girl to really kill him after all in order to save the universe, boy marries girl to seal the deal (revealing the extent of his cunning plan in the middle of the ceremony). Boy kisses girl. Girl kills boy. Boy survives by encasing himself in a robot double of his own body. They live happily ever after. (*The Wedding of River Song*)

But if the Doctor married River in an aborted time line, in front of alternative versions of her parents, did the wedding actually take place? Then there's the fact that he didn't actually tell her his name—possibly invalidating the ceremony in the first place. Nothing's straightforward when it comes to the Doctor and weddings.

RELATIONSHIP WITH CLEOPATRA

There is no record of the Doctor marrying the last Pharaoh of Egypt, but according to River Song they were at least attached, much like her relationship with Stephen Fry!

THE DOCTOR'S TWIN— THE OTHER DOCTOR

While on the run from Harold Saxon, Martha thought the Doctor was about to admit that the Master was his evil brother. However, a year later, the Doctor was about to be blessed with a brother—of sorts. And it all started with a swordfight on an alien ship…

LONDON, 25 DECEMBER 2006

The newly regenerated Tenth Doctor gets his hand chopped off by the Sycorax Leader on a spaceship hovering above London. The severed appendage tumbles down into the capital. (*The Christmas Invasion*)

LONDON

The hand is recovered, possibly by Torchwood, and finds itself in the care of Captain Jack Harkness, who is looking for a way to escape from Earth. He pops it in a jar and keeps it close to him—his very own 'Doctor Detector'.

CARDIFF, FEBRUARY 2008

The TARDIS materialises in Cardiff to refuel. In Torchwood's base beneath Cardiff Bay, the nutrients around the Doctor's hand start bubbling, indicating that the Time Lord is nearby. Hearing the TARDIS, Jack stashes the hand's jar in his backpack and finds the time machine just as it dematerialises. Jack clings on to the side of the Police Box and hitches a lift. (*Utopia*)

MALCASSAIRO, 100 TRILLION

The Doctor is reunited with his former hand, which stays on board the TARDIS after the Time Lord, Jack and Martha defeat the Master back on 21st-century Earth. (*Last of the Time Lords*)

LONDON, 2009

During the Dalek occupation of Earth, the Doctor is shot by a Dalek and is dragged into the TARDIS by his companions, where he starts to regenerate. As soon as the regenerative energy has repaired the damage to his body, the Doctor siphons the additional energy into his handy spare hand—a perfect bio-match. (*Journey's End*)

THE CRUCIBLE, THE MEDUSA CASCADE, 2009

The Daleks drop the TARDIS containing Donna and the Doctor's spare hand into a core of Z-neutrino energy to destroy it. Instead, the hand comes into contact with Donna and, packed with all that regenerative juice, triggers an instantaneous biological metacrisis. In layman's terms, the hand grows into a partial copy of the Doctor, part Time Lord, part human—his twin. While the new Doctor shares the original Doctor's memories and feelings, he also inherits some of Donna's personality, only has one heart, cannot regenerate and will age like a normal human. Isn't that wizard?

BAD WOLF BAY, ALTERNATIVE EARTH, 2009

After the new Doctor commits genocide by wiping out the Daleks, the Doctor entrusts him to the care of his former companion Rose Tyler. As the TARDIS leaves the alternative universe, the new Doctor and Rose kiss. (*Journey's End*)

THE DOCTOR'S COMPANION— THE TARDIS

> 'Look at you pair. It's always you and her, isn't it, long after the rest of us have gone. A boy and his box, off to see the universe.'
>
> **Amy, *The Doctor's Wife***

There is one constant in the Doctor's life—his TARDIS. Over the years we've learnt a few things about this particular madman's relationship with his Type 40 TT-capsule:

- The TARDIS is an eleven-dimensional matrix and was already a museum piece when the Doctor was young.
- Originally the Doctor was all set to steal a different TT capsule, until a fragment of Clara Oswald's existence pointed him in the right direction.
- The first time he touched the TARDIS console, he said she was the most beautiful thing he had ever known.
- When they're alone, the Doctor calls the TARDIS 'sexy'.
- In the past, when they've materialised where the Doctor didn't want to be, it was because the TARDIS was taking him where he needed to go.
- The TARDIS thinks of the Doctor's other companions as 'strays'. She thinks of the Doctor as 'her thief'.
- According to the Doctor the TARDIS is like a cat, slow to trust.
- Only lava can destroy a TARDIS key.

THE DOCTOR'S DAUGHTER—JENNY

The Tenth Doctor unexpectedly became a father again on the planet Messaline in the year 6012 (*The Doctor's Daughter*). Captured by human soldiers, the Doctor was forced to give a tissue sample against his will. The soldier's progenation machine extrapolated the Doctor's DNA, creating a female soldier whose first words—after being handed a rifle—were 'Hello, Dad'.

When the Doctor described his new daughter as a 'generated anomaly', his companion Donna christened her Jenny, a name which the Doctor thought was as good as anything. However, as they tried to unravel the mystery of the Messaline war, the Doctor began to build a connection with Jenny, only to have her cruelly snatched away when she took a bullet meant for him. He left the planet, believing her dead, but Jenny revived after his departure. Taking a shuttle, she blasted off into the universe, ready to follow in Dad's footsteps—saving planets, rescuing civilisations, defeating creatures and running an awful lot.

HOW TO GROW SOLDIERS USING A MESSALINE PROGENATION MACHINE

1. Take a sample of diploid cells.
2. Split the diploid cells into haploids.
3. Recombine haploids into new diploids in a different arrangement.
4. Accelerate growth into full adult.
5. Download strategic, tactical and military protocols straight into cerebral cortex.
6. Give soldier gun.

EXTENDED FAMILY

Away from the television screens, the Doctor's family gets even bigger!

John and Gillian: the Doctor's other grandchildren
Travelled with the First and Second Doctors in the pages of *TV Comic*. They made their first appearance in *The Klepton Parasites* (issue 674, 14 November 1964) and left the TARDIS in *Invasion of the Quarks* (issue 876, 28 September 1968) when the Doctor enrolled them at Zebadee University.

Miranda Dawkins: the Doctor's adopted daughter
Introduced in the novel *Father Time*, Miranda was the daughter of an assassinated Time Lord, the Emperor. The Eighth Doctor adopted her as his daughter. She would go on to become supreme ruler of the entire universe before being killed in the novel *Sometime Never…*

█ **Zezanne: the Doctor's adopted granddaughter**
The daughter of Miranda Dawkins.

█ **Alexander David Campbell: the Doctor's great-grandson**
In *An Earthly Child* (Big Finish audio adventure, 2009) the Doctor discovers that Susan married David Campbell and had a half-human son, Alex. He died defending the Earth from the Daleks.

█ **Irving Braxiatel: the Doctor's brother**
First introduced in the novel *Theatre of War*, the Doctor's older brother would go on to found the Braxiatel Collection, the foremost art gallery in the known universe (and according to Romana, better than the Louvre).

█ **Scarlette: the Doctor's wife**
In *The Adventuress of Henrietta Street* (novel, 2001) the Doctor married an 18th-century woman called Scarlette to symbolically bind himself to Earth. She died soon after the wedding.

HALF-HUMAN?

The Doctor once claimed he was half-human on his mother's side, something apparently confirmed by the Master after the renegade Time Lord invaded the Doctor's TARDIS when it landed in San Francisco in 1999. But the truth remains unclear. (*Doctor Who*)

THE DOCTOR'S PHYSIOLOGY

- Binary Vascular System (two hearts to you and me).
- Normal pulse rate: 170 beats per minute.
- Body temperature: 60 degrees.
- Left and right sides of the brain work in unison via a specialised neural super-ganglia. The reflex link, which allowed him to 'tune himself' into the thousand super-brains of the Time Lord intelligentsia was cut off when the Doctor was exiled by his people.

- Short-sighted in his right eye (in his fifth body at least).
- Vulnerable to certain gases in the Praxis range of the spectrum.
- Can travel through time thanks to the Rassilon Imprimatur, a form of symbiotic print.
- Aspirin intolerant. Thanks to his metabolism the common drug would probably kill him.
- Has size 10 feet in his eleventh body. They are also quite wide.
- Has *very* high blood pressure due to his two hearts.

CAPACIOUS POCKETS

The Doctor's pockets are bigger on the inside. They'd have to be. Look at some of the stuff he's pulled out of them:

- A pen light (*An Unearthly Child, The Edge of Destruction, The Monster of Peladon*)
- Contracts (*The Highlanders*)
- Conkers (*The Highlanders*)
- Magnifying glass (*The Highlanders, Genesis of the Daleks*)
- Lemon sherbets (*The Wheel in Space*)
- Pins (*The Space Pirates*)
- Marbles (*The Space Pirates*)
- A tuning fork (*The Space Pirates*)
- Sample jars (*Colony in Space*)
- Freedom of the city of Skaro (*Robot*)
- Pilot's licence for the Mars-Venus Rocket Run (*Robot*)
- Honorary membership card for the Alpha Centauri Table Tennis Club (*Robot*)
- Cricket ball (*The Ark in Space*)
- Yo-yo (*The Ark in Space, Genesis of the Daleks*)
- Handcuffs (*Genesis of the Daleks*)
- Rocks (*Genesis of the Daleks*)
- Etheric beam locator (*Genesis of the Daleks*)
- French picklock given to him by Marie Antoinette (*Pyramids of Mars*)
- Expanding cane (*The Hand of Fear*)

- Clockwork egg timer (*The Face of Evil*)
- Telescopic breathing tube (*The Robots of Death*)
- Stuffed mouse (*The Talons of Weng-Chiang*)
- Toy Batmobile (*The Talons of Weng-Chiang*)
- Hammer (*The Power of Kroll*)
- Golden star stickers (*The Horns of Nimon*)
- Safety pin (*The Visitation*)
- Firework (Galactic Glitter) (*The Five Doctors*)
- Alien coins (*Planet of Fire, Battlefield*)
- Conjuror's flowers (*The Trial of a Time Lord: Terror of the Vervoids*)
- Electronic picklock (*The Trial of a Time Lord: Terror of the Vervoids*)
- Catapult (*Battlefield, The Hungry Earth*)
- Robot Santa remote control (*The Runaway Bride*)
- Christmas decorations (*The Runaway Bride*)
- Toothbrush—containing Venusian toothpaste (*The Shakespeare Code*)
- Ultraviolet lamp (*The Vampires of Venice*)
- Doll (*Cold War*)
- Ball of string (*Cold War*)
- A machine that goes 'ding!' (*The Day of the Doctor*)
- Flask of tea (*The Day of the Doctor*)
- Spoon (*Robot of Sherwood*)
- Rubber glove (*Robot of Sherwood*)
- Antique syringe (*Robot of Sherwood*)
- Packet of sandwiches (*Robot of Sherwood*)
- Jelly baby case (*Mummy on the Orient Express*)
- Glass of water (*The Return of Doctor Mysterio*)
- A burger (*The Return of Doctor Mysterio*)

Not pockets, but the Doctor has sometimes kept the TARDIS key in one of his shoes (*Spearhead from Space, Robot*) and the Seventh Doctor kept the UNIT passes belonging to his third incarnation and Liz Shaw in his hat. (*Battlefield*)

THE FINEST SWORDSMAN
IN ALL OF GALLIFREY

The Doctor claimed to have learned the art of sword fighting from a captain of Cleopatra's guard. In which stories has he swashed his buckle?

Story	Against
The Sea Devils	The Master
The Time Warrior	Irongron and Bloodaxe (while pretending to be a robot knight)
The Masque of Mandragora	Count Federico's guards.
The Androids of Tara	Count Grendel of Gracht
The King's Demons	The Master
Battlefield	Mordred—well, sort of. The Doctor threatened to decapitate the son of Morgaine with his own sword, but was bluffing.
The Christmas Invasion	The Sycorax Leader
The Next Doctor	A pair of Cybermen (who, granted, don't have swords)
Robot of Sherwood	The Doctor took on Robin Hood in a daring fight across a log, armed with nothing but a spoon. He claimed to have experience dueling against Richard the Lionheart, Cyrano de Bergerac and Errol Flynn (who had an enormous ego).

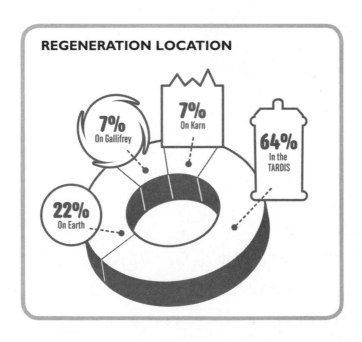

REGENERATION LOCATION

7% On Gallifrey

7% On Karn

64% In the TARDIS

22% On Earth

REASONS FOR REGENERATION

'We can live for ever, barring accidents.'

The Doctor, *The War Games*

What doesn't kill you...

- First regeneration—Old age (*The Tenth Planet*)
- Second regeneration—Forcibly regenerated by the Time Lords prior to his exile on Earth (*The War Games*)
- Third regeneration—Exposure to Metebelis III crystal radiation in the cave of the Great One (*Planet of the Spiders*)
- Fourth regeneration—Fall from a great height, specifically the Pharos Project radio telescope (*Logopolis*)
- Fifth regeneration—Fatal contraction of Spectrox Toxaemia after handling raw spectrox (*The Caves of Androzani*)

SYMPTOMS OF SPECTROX TOXAEMIA
- Rash
- Cramp
- Spasms
- Slow paralysis of the thoracic spinal nerve
- Thermal death

ONLY KNOWN CURES OF SPECTROX TOXAEMIA
- The milk of a queen bat
- Regeneration

- Sixth regeneration—TARDIS shot down by the Rani, who then tried to confuse and control the Doctor in his befuddled post-regenerative state (*Time and the Rani*)
- Seventh regeneration—Shot by local gang and operated upon by Grace Holloway, who accidentally administered a lethal anaesthetic (*Doctor Who*)
- Eighth regeneration—Regeneration triggered by Sisterhood of Karn elixir following the Doctor's death (*The Night of the Doctor*)

- Ninth regeneration—Body wearing a bit thin (*The Day of the Doctor*)
- Tenth regeneration—Absorbing the Time Vortex to save Rose Tyler, and nobody's meant to do that (*The Parting of the Ways*)
- Eleventh regeneration—Shot by Dalek (*The Stolen Earth*)
- Twelfth regeneration—Radiation poisoning (*The End of Time, Part Two*)
- Thirteenth regeneration—Given a new regeneration life-cycle by the Time Lords (*The Time of the Doctor*)
- Fourteenth regeneration—Death by Cyberman (*Twice Upon A Time*)

EQUIPMENT TO AID REGENERATIVE CRISIS

- TARDIS Zero Room
- Metamorphic Symbiosis Regenerator
- Flask of tea
- The Sisterhood of Karn's Elixir of Life

STUFF TO DO IF YOU ONLY HAVE MINUTES TO LIVE

- Watch TV
- Read books
- Play chess
- Knit

THREE

THE DOCTOR'S
BEST FRIENDS
COMPANIONS AND OTHER ALLIES

COMPANIONS BY NUMBERS

Companions come and go, but which have made the most appearances? Overleaf is a rundown on the Doctor's travelling companions based on the number of regular stories they appeared in. Where there's a tie, we use the number of episodes as a tiebreaker—the *Doctor Who* equivalent of goal difference.

If we were ordering companions by episode number alone the top ten would be:

1. Jamie Macrimmon
2. Sarah Jane Smith
3. Ian Chesterton
4. Barbara Wright
5. Jo Grant
6. Tegan Jovanka
7. K-9 Mark II
8. Susan Foreman
9. Zoe Heriot
10. Nyssa

Companion	Era	Stories	Episodes	First full episode	
Clara Oswald		2012–2015	31	36	*The Snowmen*
Amy Pond	2010–2012	28	33	*The Eleventh Hour*	
Rose Tyler	2005–2008	26	33	*Rose*	
Jamie Macrimmon	1966–1969	20	113	*The Highlanders* 1	
Rory Williams	2010–2012	20	24	*The Eleventh Hour* (2010)	
Tegan Jovanka	1981–1984	19	65	*Logopolis* 1	
Sarah Jane Smith	1973–1976	18	80	*The Time Warrior* 1	
Ian Chesterton	1963–1965	16	77	*An Unearthly Child* 1	
Barbara Wright	1963–1965	16	77	*An Unearthly Child* 1	
Josephine (Jo) Grant	1971–1973	15	77	*Terror of the Autons* 1	
K-9 Mark II	1978–1981	14	55	*The Ribos Operation* 1	
Nyssa	1981–1983	13	47	*The Keeper of Traken* 1	
Martha Jones	2007–2008	13	18	*Smith and Jones*	
Nardole	2016–2017	12	13	*The Return of Doctor Mysterio*	
Bill Potts	2017	12	13	*The Pilot*	
Adric	1980–1982	11	42	*Full Circle* 1	
Donna Noble	2006, 2008	11	14	*Partners in Crime*	
Mickey Smith	2005–2006	11	14	*Rose*	
Susan Foreman	1963–1964	10	51	*An Unearthly Child* 1	
Steven Taylor	1965–1966	10	45	*The Chase* 6	

Final full episode	Additional appearances
Hell Bent	Asylum of the Daleks (2012), Clara and the TARDIS (2013), She Said, He Said (2013) Twice Upon A Time (2017)
The Angels Take Manhattan	Space / Time (2011) Pond Life (2012) The Time of the Doctor (2013)
Journey's End	Born Again (2005) The End of Time, Part Two (2010)
The War Games 10	The Five Doctors (1983) The Two Doctors (1985)
The Angels Take Manhattan	Space / Time (2011) Pond Life (2012)
Resurrection of the Daleks 2	The Caves of Androzani 4 (1984)
The Hand of Fear 4	The Five Doctors (1983) Dimensions in Time (1993) School Reunion (2006) The Stolen Earth / Journey's End (2008) The End of Time, Part Two (2010)
The Chase 6	-
The Chase 6	-
The Green Death 6	-
Warriors' Gate 4	-
Terminus 4	The Caves of Androzani 4 (1984) Dimensions in Time (1993)
Journey's End	The End of Time, Part Two (2010)
The Doctor Falls	The Husbands of River Song (2015), Twice Upon A Time (2017)
Twice Upon A Time	Friend from the Future (2016)
Earthshock 4	Time Flight 2 (1982) The Caves of Androzani 4 (1984)
Journey's End	Doomsday (2006) The Runaway Bride (2006) The End of Time (2010)
Doomsday	Journey's End (2008) The End of Time, Part Two (2010)
The Dalek Invasion of Earth 6	The Five Doctors (1983) Dimensions in Time (1993)
The Savages 4	-

Companion	Era	Stories	Episodes	First full episode
Romanadvoratrelundar II	1979–1981	10	40	Destiny of the Daleks 1
Perpugilliam (Peri) Brown	1984–1986	10	33	Planet of Fire 1
Vislor Turlough	1983–1984	10	31	Mawdryn Undead 1
Leela	1977–1978	9	40	The Face of Evil 1
Polly Wright	1966–1967	9	40	The War Machines 1
Ben Jackson	1966–1967	9	40	The War Machines 1
Vicki	1965	9	38	The Rescue 1
Ace	1987–1989	9	31	Dragonfire 1
Zoe Heriot	1968–1969	8	49	The Wheel in Space 2
Victoria Waterfield	1967–1968	7	40	Evil of the Daleks 2
Romanadvoratrelundar I	1978–1979	6	26	The Ribos Operation 1
Harry Sullivan	1974–1975	6	24	Robot 1
Dorothea (Dodo) Chaplet	1966	6	19	The Massacre 4
Captain Jack Harkness	2005–2008	6	10	The Empty Child
Wilfred Mott	2007–2010	6	9	Voyage of the Damned
Melanie (Mel) Bush	1986–1987	5	20	The Trial of a Time Lord 9
K-9 Mark I	1977–1978	5	19	The Invisible Enemy 2
Elizabeth (Liz) Shaw	1970	4	25	Spearhead from Space 1
Kamelion	1983–1984	2	6	The King's Demons 1
Katarina	1965	2	5	The Myth Makers 4
Adam Mitchell	2005	2	2	Dalek
Sara Kingdom	1965–1966	1	9	The Daleks' Master Plan 4
Grace Holloway	1996	1	1	Doctor Who
Astrid Peth	2007	1	1	Voyage of the Damned
Jackson Lake	2008	1	1	The Next Doctor
Lady Christina de Souza	2009	1	1	Planet of the Dead
Captain Adelaide Brook	2009	1	1	The Waters of Mars

Final full episode	Additional appearances
Warriors' Gate 4	The Five Doctors (1983) Dimensions in Time (1993)
The Trial of a Time Lord 8	Dimensions in Time (1993)
Planet of Fire 4	The Caves of Androzani 4 (1984)
The Invasion of Time 6	Dimensions in Time (1993)
The Faceless Ones 6	-
The Faceless Ones 6	-
The Myth Makers 4	-
Survival 3	Dimensions in Time (1993)
The War Games 10	The Five Doctors (1983)
Fury from the Deep 6	Dimensions in Time (1993)
The Armageddon Factor 6	-
Terror of the Zygons 4	The Android Invasion (1975)
The War Machines 2	-
Journey's End	The End of Time, Part Two (2010)
The End of Time, Part Two	-
Dragonfire 3	Dimensions in Time (1993)
The Invasion of Time 6	Dimensions in Time (1993)
Inferno 7	The Five Doctors (1983) Dimensions in Time (1993)
Planet of Fire 4	The Caves of Androzani 4 (1984)
The Daleks' Master Plan 4	-
The Long Game	-
The Daleks' Master Plan 12	
Doctor Who	-
Voyage of the Damned	-
The Next Doctor	-
Planet of the Dead	-
The Waters of Mars	-

BOYS AND GIRLS COME OUT TO PLAY

The percentage of girls, boys and mechanical companions over the years.

FEMALE MALE ROBOT

62% 33% 5%

COMPANION ROLL CALL:
THE 1960s

IAN CHESTERTON
played by WILLIAM RUSSELL

- First regular *Doctor Who* appearance: *An Unearthly Child* Episode 1 (1963)
- Final regular *Doctor Who* appearance: *The Chase* Episode 6 (1965)

Thanks to his starring role in *Sir Lancelot*, William Russell Enoch was a familiar face on British television by the time he was cast as Ian Chesterton. With a career spanning

seven decades, Russell has worked extensively in the theatre and on TV, appearing as Ted Sullivan in *Coronation Street* in the 1990s.

History teacher Ian was a dependable, heroic and loyal member of the TARDIS crew—even if the Doctor did abduct him! Always willing to tackle any new monstrous threat, Ian enjoyed his travels, but when the opportunity came to return to Earth, he took it without hesitation.

And another thing: Russell almost returned in 1983's *Mawdryn Undead*, although scheduling conflicts meant that the role was rewritten for the Brigadier.

◗ BARBARA WRIGHT
played by JACQUELINE HILL

- First regular *Doctor Who* appearance: *An Unearthly Child* Episode 1 (1963)
- Final regular *Doctor Who* appearance: *The Chase* Episode 6 (1965)

Jacqueline Hill worked on stage and screen before and after *Doctor Who*, collaborating with her future husband, director Alvin Rakoff on a 1957 TV play for which she recommended Sean Connery for a role. She guest starred in 1980 *Doctor Who* story *Meglos*, and her final screen role was as Mrs Mallard-Greene in *Paradise Postponed*, again directed by her husband. She passed away in 1993.

Barbara's adventures with the Doctor brought the history she loved as a teacher to life before her eyes—even passionately clashing with the Doctor on wanting to change the destiny of the Aztecs. Like Ian, she always wanted to return home, and happily took the chance to return to Earth in a Dalek time machine.

And another thing: Barbara was the first character in the series to actually see a Dalek.

◗ SUSAN FOREMAN
played by CAROLE ANN FORD

- First regular *Doctor Who* appearance: *An Unearthly Child* Episode 1 (1963)
- Final regular *Doctor Who* appearance: *The Dalek Invasion of Earth* Episode 6 (1964)

Final guest *Doctor Who* appearance: *The Five Doctors* (1983) (She also appeared in the Children in Need special, *Dimensions in Time* in 1993.)

Carole Ann Ford had already clocked up appearances in *Emergency Ward 10*, *Z-Cars*, *Dixon of Dock Green* and the film *The Day of the Triffids* before her casting as Susan in *Doctor Who*. She appeared in *The Great St Trinian's Train Robbery* in 1966, and returned to the role of Susan for Big Finish in 2003, going on to play the Doctor's granddaughter opposite the Eighth Doctor, Paul McGann.

Susan was the Doctor's granddaughter and original companion, fleeing their home world in the TARDIS with him to become wanderers in the fourth dimension. The Doctor knew Susan would never leave him voluntarily. When she fell in love with David Campbell, it was the Doctor who locked her out of the TARDIS, urging her to live her life.

And another thing: Carole Ann Ford's official BBC publicity photo omitted the 'e' from her first name—so she added it herself while signing autographs.

ⓘ VICKI
played by MAUREEN O'BRIEN

- First regular *Doctor Who* appearance: *The Rescue* Episode 1 (1965)
- Final regular *Doctor Who* appearance: *The Myth Makers* Episode 4 (1965)

Merseyside-born actress Maureen O'Brien had never seen *Doctor Who* when she was cast as the Doctor's surrogate granddaughter Vicki, her first television role. Never particularly pleased with her character, Maureen was quite relieved when Vicki was written out of the series and she returned to her first love, theatre. O'Brien starred as Elizabeth Straker in BBC One's *Casualty* from 1986 to 1987. She published her first crime novel in 1989.

After her mother died in 2493, Vicki set out on spacecraft 201 with her father to start a new life on the planet Astra. But the ship crashed, and the crew were all killed except for Vicki and a man called Bennett. When it was revealed that Bennett had murdered the other survivors to cover up previous crimes, Vicki decided to travel with the Doctor, Ian and Barbara.

And another thing: The producers of *Doctor Who* originally asked O'Brien to dye her hair black to mimic Carole Ann Ford. She refused.

ⓘ STEVEN TAYLOR
played by PETER PURVES

- First regular *Doctor Who* appearance: *The Chase* Episode 6 (1965)
- Final regular *Doctor Who* appearance: *The Savages* Episode 4 (1966)

Before being cast in *Doctor Who*, first as hillbilly tourist Morton Dill and then as Steven Taylor, Peter Purves appeared in many popular TV series including *Z-Cars*, *The Saint*, *Dixon of Dock Green* and *World of Wooster*. In 1967, Purves joined *Blue Peter* as a presenter, appearing in over 850 editions of the legendary children's magazine programme until he left just over ten years later in 1978.

After crashing in the jungles of the planet Mechanus, Pilot Flight Red Fifty Steven Taylor was captured by the robot Mechonoids and spent two years in solitary confinement. Brave and headstrong, Steven was helped to escape by the Doctor, Ian, Barbara and Vicki and stumbled into the TARDIS before it dematerialised.

And another thing: The only other 'survivor' of Steven's crash was his mascot, a cuddly panda he called Hi-Fi.

⬚ KATARINA
played by ADRIENNE HILL

- First regular *Doctor Who* appearance: *The Myth Makers* Episode 4 (1965)
- Final regular *Doctor Who* appearance: *The Daleks' Master Plan* Episode 4 (1965)

Born in Plymouth, Adrienne Hill impressed production assistant Viktors Ritelis while acting as understudy for Maggie Smith in a performance of *Mary Mary* and was invited to read for the role of Joanna in *The Crusade*. While Jean Marsh eventually won the role, Hill was cast as Katarina later the same year. Following *Doctor Who*, Hill took a major role in BBC Radio's long-running *Waggoners' Walk*. She died in 1997.

Handmaiden to Cassandra, High Priestess of Troy, Katarina met the Doctor when the TARDIS landed in 1184 BC. Befriending Vicki, the servant helped carry the seriously injured Steven back to the TARDIS and was carried away from Earth when the ship dematerialised.

And another thing: In 1983, Adrienne Hill made a rare appearance on Children in Need with her fellow *Doctor Who* companions.

⬚ DOROTHEA 'DODO' CHAPLET
played by JACKIE LANE

- First regular *Doctor Who* appearance: *The Massacre* Episode 4 (1966)
- Final regular *Doctor Who* appearance: *The War Machines* Episode 2 (1966)

In 1963, Jackie Lane auditioned for the role of Susan Foreman. Three years later she was approached by producer John Wiles to play Dodo, although her character disappeared off-screen just five stories later. After an appearance in American spy comedy *Get Smart*, Hill gave up acting, moving to Paris to work as a secretary at the Australian Embassy. On returning to England, she became a theatrical agent, representing Tom Baker and Janet Fielding among others.

In 1966, Dodo witnessed a little boy getting hurt in an accident on Wimbledon Common and ran to what she thought was the nearest police box to summon the authorities, only to be whisked off on board the TARDIS. Not that she cared—the independent young woman soon admitted that she lived with a great aunt who wouldn't care if she never saw her again!

And another thing: Later in life, former *Doctor Who* producer Innes Lloyd asked Jackie Lane to find him work. Remembering how she had been dropped from the series, she declined.

▮ BEN JACKSON
played by MICHAEL CRAZE

- First regular *Doctor Who* appearance: *The War Machines* Episode 1 (1966)
- Final regular *Doctor Who* appearance: *The Faceless Ones* Episode 6 (1967)

Discovered through an appearance in a Boy Scout Gang Show, 12-year old Craze went on to win understudy roles at Drury Lane theatre. TV and film work followed including a leading role in the 1960 ABC science fiction series *Target Luna*. After leaving *Doctor Who*, Craze would appear in episodes of *Z-Cars*, *Dixon of Dock Green*, *Armchair Theatre* and *Crossroads*. In 1974, Craze moved into the catering and hotel industry. He occasionally returned to acting, his last television role before his death in 1998 being a one-off play entitled *The Healer*.

Able Seaman Ben Jackson's life changed in 1966 when he met a pretty secretary by the name of Polly in a nightclub called the Inferno. After helping the Doctor foil the rogue computer system, WOTAN, the courageous cockney sailor inadvertently hitched a lift on board the TARDIS back to 17th-century Cornwall.

And another thing: Michael Craze met his wife Edwina while filming *The Tenth Planet*. Before joining the *Doctor Who* cast Craze underwent surgery to repair a badly broken nose. He was worried that the polystyrene snow from a fake snow machine might hurt his nose and asked for it to be angled away from him. Edwina, the Production Assistant operating the machine, blew it right at him. He forgave her and they were married three years later.

▮ POLLY WRIGHT
played by ANNEKE WILLS

- First regular *Doctor Who* appearance: *The War Machines* Episode 1 (1966)
- Final regular *Doctor Who* appearance: *The Faceless Ones* Episode 6 (1967)

One of the actresses considered for the Doctor's granddaughter Susan, Anneke Wills had made her acting debut at the age of eleven. Later, after dropping out of the Royal Academy of Dramatic Arts, the former child actor took roles in *Armchair Theatre*, *The Saint* and *The Avengers*. Following *Doctor Who*, Wills starred as Evelyn McLean in *Strange Report*, before giving up acting. Following times living in India, America and Canada, Wills settled in Devon.

Polly met the Doctor while she was working as Secretary to Professor Brett, creator of the WOTAN computer. Like Ben, Polly accidentally joined the Doctor on his travels while trying to return his TARDIS key. Practical and level-headed, blonde bombshell Polly was a Sixties girl through and through.

And another thing: Anneke Wills' first husband, Michael Gough, played the Celestial Toymaker against William Hartnell's First Doctor.

◉ JAMIE MACRIMMON
played by FRAZER HINES

- First regular *Doctor Who* appearance: *The Highlanders* Episode 1 (1966)
- Final regular *Doctor Who* appearance: *The War Games* Episode 10 (1969)
- Final guest *Doctor Who* appearance: *The Two Doctors* Episode 3 (1985)

A familiar face on British television before joining *Doctor Who*, Frazer Hines appeared in such programmes as *The Silver Sword*, *Smuggler's Bay*, *Emergency Ward 10* and *Coronation Street*. In 1972, three years after leaving the TARDIS, Hines joined Yorkshire TV's *Emmerdale Farm* as Joe Sugden, a role he would play until 1994. He now breeds racehorses at his stud farm in Nottingham.

Born in the early 18th century, James Robert Macrimmon (or McCrimmon, as some sources have it) was constantly bamboozled by technology but enthusiastically threw himself into adventure and became one of the Doctor's most loyal friends. Practical and resourceful, Jamie often put himself in great peril to keep the Time Lord safe and sound.

And another thing: The Doctor only let Jamie come on board the TARDIS if the highlander agreed to teach him how to play the bagpipes.

◉ VICTORIA WATERFIELD
played by DEBORAH WATLING

- First regular *Doctor Who* appearance: *The Evil of the Daleks* Episode 2 (1967)
- Final regular *Doctor Who* appearance: *Fury from the Deep* Episode 6 (1968)
- Final guest *Doctor Who* appearance: *Dimensions in Time* Part 2 (1993)

Born into an acting family, Deborah originally wanted to be a dentist before failing her O Levels. Walking out of drama school after just three weeks, she secured an agent and soon scored roles in ITC's *William Tell* and *The Invisible Man*. A 1965 *Radio Times* cover photograph of Watling as Alice drew her to the attention of *Doctor Who* producer Innes Lloyd. Considered too inexperienced for the role of Polly, she was recalled to audition for Victoria. Watling went on to appear in numerous TV shows including *Danger UXB*, *Rising Damp* and *Doctor in Charge* as well as countless theatre roles. She passed away in 2017.

When her father Edward Waterfield accidentally created a link between 1866 London and the planet Skaro, Victoria was taken prisoner by the Daleks. When Waterfield was killed, the Doctor promised to take care of her. Never a natural adventurer, Victoria didn't react well to the dangers life with the Doctor brought.

And another thing: Deborah's father, Jack Watling, appeared as Professor Edward Travers in *The Abominable Snowman* and *The Web of Fear*.

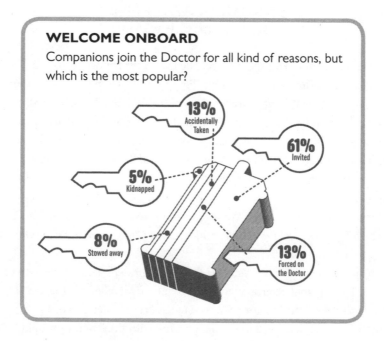

▍ ZOE HERIOT
played by WENDY PADBURY

- First regular *Doctor Who* appearance: *The Wheel in Space* Episode 2 (1968)
- Final regular *Doctor Who* appearance: *The War Games* Episode 10 (1969)
- Final guest *Doctor Who* appearance: *The Five Doctors* (1983)

After a flurry of early TV appearances, Wendy Padbury won a regular role on the ATV soap *Crossroads*. On leaving *Doctor Who*, Padbury appeared in *Z-Cars*, *Freewheelers*, *Emmerdale* and the 1971 horror film *The Blood on Satan's Claw*. Before retiring and moving to France, she worked as a theatrical agent, representing Nicholas Courtney, Colin Baker, Mark Strickson and, more recently, Matt Smith.

An astrophysicist, astrometricist (first class) and librarian on board the space station known as the Wheel, Zoe Heriot stowed away on board the TARDIS following the Doctor's victory over the Cybermen. Highly intelligent, and gifted with almost total recall, Zoe often seemed to out-think the Doctor himself—although her inexperience and a distinct stubborn streak often got her into trouble.

And another thing: While on *Doctor Who*, Troughton, Hines and Padbury were known by the nicknames Fluff, Cough and Fart respectively.

WELCOME ONBOARD
Companions join the Doctor for all kind of reasons, but which is the most popular?

13% Accidentally Taken

61% Invited

5% Kidnapped

8% Stowed away

13% Forced on the Doctor

HELLO, GOODBYE

The first and last things the Doctor ever said to his companions.

Companion	First thing said	Last thing said
Susan Foreman*	'Close the door!'	'Come along, Susan.'
Ian Chesterton	'What are you doing here?'	'Follow me, come along.'
Barbara Wright	'What do you want?'	'Follow me, come along.'
Vicki	'That's better, that's better. Now blow your nose and wipe your face. That's it. I don't like saying it, my dear, but you do look a bit of a mess, you know.'	'Oh, yes, but just be patient, will you.'
Steven Taylor	'Well, I'm glad to know you, Steven Taylor.'	'Goodbye, Steven, and good luck.'
Katarina	'We must all go and find him. Come along.'	'Katarina, check up on that door and see that it's secure.'
Dodo Chaplet	'Who are you?'	'One, two, three, four, five.'
Polly Wright	'Ah, I thought I'd find you both here.'	'The Commandant's car is waiting.'
Ben Jackson	'Ah, yes, how do you do, my boy.'	'The Commandant's car is waiting.'
Jamie Macrimmon	'And now, gentlemen.'	'Don't go blundering into too much trouble, will you?'
Victoria Waterfield	'I'm trying to puzzle out a problem, Victoria.'	'No, that's all right.'
Zoe Heriot	'Guard?'	'Now, Zoe, you and I know, time is relative, isn't it?'
Elizabeth Shaw**	'Thank you. Oh No!'	'The rubbish tip.'
Jo Grant	'Not today, thank you.'	'You know me, stuff to do.'
Sarah Jane Smith	'Doctor John Smith. How do you do, Miss Smith?'	'Yes. Till we meet again, Sarah.'

Companion	First thing said	Last thing said
Leela	'Hello. Hello, did I startle you? Don't be afraid. I won't hurt you.'	'Yes?' (Although to himself he says: 'I'll miss you too, savage.')
K-9 Mark I	'How are you?'	'Why?'
K-9 Mark II	'It works, K-9. It works. Listen, I've got a little surprise for you.'	'No, K-9. K-9!'
Romana	'I'm so sorry about that. Is there anything we can do?'	'I'll miss you. You were the noblest Romana of them all.'
Adric	'Who are you?'	'Good luck, Adric.'
Nyssa	'Hello.'	'Then you're a very brave person. I wish you every luck.'
Tegan Jovanka	'Your aunt? Woman in the white hat, red sports car?'	'No, no, don't leave. Not like this.'
Vislor Turlough	'Who are you?'	'Better to go back while you're a bit of a hero, eh?'
Peri Brown	'Er, I'm not sure yet, but I promise I'll get you back to Earth just as soon as I can.'	'I must do what I think is best.'
Mel Bush*	'Twenty-six, twenty-seven, twenty-eight…'	'But I don't have an address.'
Ace**	'Ah, two of your best strawberry milkshakes, if you please.'	'Come on, Ace, we've got work to do!'
Grace Holloway	'Whatever you're about to do, stop.'	'No, no. Thank you, Doctor.'
Rose Tyler	'Run.'	'Does it need saying?'
Adam Mitchell	'No. It just looks silly.'	'Good luck.'
Captain Jack Harkness	'What kind of Chula ship landed here?'	'I told you, no teleport.'
Mickey Smith	'Ricky.'	'What will you do?'
Martha Jones	'Like so. See?'—at least, from Martha's perspective. From the Doctor's, it's: 'Sorry?'	'Save the world one more time.'
Donna Noble	'What?'	'Donna? I was just going.'
Amy Pond	'Could I have an apple?'	'Come along, Pond, please.'

Companion	First thing said	Last thing said
Rory Williams	'Man and Dog. Why?'	'I love video games.'
Clara	'Hello.'	'I'll tell you something though – you were always my favourite.'
Handles	'Handles''	'Thank you, Handles, and well done. Well done, mate.'
Nardole	'Is there anything on my head?'	'I'll tell you something though – you were always my favourite.'
Bill	'Potts.'	'I'll tell you something though – you were always my favourite.'

* As both Susan and Mel's first encounters happen off-screen we don't know his actual greetings. These are the first things we hear him say to both of them. The same goes for Handles too.

** Again, as Liz and Ace left the Doctor's side off-screen we don't know the last thing he ever said to them.

HAVEN'T I SEEN YOU SOMEWHERE BEFORE?

Want to be the new companion or even the Doctor him/herself? Then sometimes it helps to have appeared in *Doctor Who* before...

🛈 PETER PURVES

First: Morton Dill **Later: Steven Taylor**

Blue Peter may have been a few years in the future for Peter Purves in 1965, but it was a matter of just weeks between the actor's first *Doctor Who* appearance and his second. He was cast as American tourist Morton Dill in the third episode of *The Chase*, encountering the Daleks at the top of the Empire State Building. The young actor got on well with William Hartnell and Maureen O'Brien and was offered the part of new companion, space pilot Steven Taylor, appearing just three weeks after his original debut.

☺ NICHOLAS COURTNEY

First: Bret Vyon **Later: The Brigadier**
Nicholas Courtney's first appearance in *Doctor Who* was as dashing Space Security
Agent Bret Vyon in *The Daleks' Master Plan*, opposite William Hartnell. He very nearly
missed out on being cast as Colonel Lethbridge-Stewart in 1967 when the role went to
future *Upstairs Downstairs* star David Langton, with Courtney booked to play Captain
Knight. Langton was forced to pull out at the last minute due to other work commit-
ments, leading to Courtney's subsequent promotion to Colonel. One false moustache
later and *Doctor Who* history was made!

☺ JOHN LEVENE

First: Monsters **Later: Sergeant Benton**
John Levene played uncredited roles in two Patrick Troughton stories—as a Cyber-
man in *The Moonbase* and a Yeti in *The Web of Fear*. He was scheduled to once again
don a Cyber-suit for *The Invasion*, but the tardiness of another actor saw him cast as
Corporal Benton. The rest is history.

☺ IAN MARTER

First: Lieutenant John Andrews **Later: Harry Sullivan**
Ian Marter had narrowly missed out on playing the role of Captain Mike Yates in
1971, but producer Barry Letts later cast him as Andrews in *Carnival of Monsters*. In
1974, he became the Fourth Doctor's first male companion.

☺ LALLA WARD

First: Princess Astra **Later: Romana**
Having decided to leave *Doctor Who*, Mary Tamm suggested Lalla Ward, who had
appeared as Princess Astra in *The Armageddon Factor*, as her replacement. Two
months later, Ward was cast as the new Romana.

☺ COLIN BAKER

First: Commander Maxil **Later: The Sixth Doctor**
Colin Baker feared that his guest appearance as Maxil in *Arc of Infinity* would prevent
him from playing the Doctor. Thankfully this was not the case, and the Sixth Doctor
stepped into the TARDIS on a full-time basis the following year.

▮ FREEMA AGYEMAN

First: Adeola Ashodi **Later: Martha Jones**

Freema Agyeman so impressed the *Doctor Who* production team when she played Adeola in 2006's *Doomsday* that she was invited back to audition for the role of Martha Jones—under the pretence she was testing for a role in *Torchwood* to maintain secrecy. When Martha appeared in 2007, her resemblance to Adeola was explained by revealing the two girls were cousins.

▮ KAREN GILLAN

First: Soothsayer **Later: Amy Pond**

Former model Karen Gillan had a small supporting role as a Soothsayer in 2008's *The Fires of Pompeii*. Two years later, she was making her debut as the Doctor's future mother-in-law.

▮ DAVID BRADLEY

First: Solomon **Later: The First Doctor**

After crossing Matt Smith's Eleventh Doctor in *Dinosaurs on a Spaceship* in 2012, David Bradley surprised viewers by appearing as the Doctor's first incarnation in the closing minutes of *The Doctor Falls* some five years later.

And one more…

▮ PETER CAPALDI

First: Lobus Caecilius **Later: The Twelfth Doctor**

Long-time fan Peter Capaldi was thrilled to play a survivor of Volcano Day in *The Fires of Pompeii*. He would never forget Caecilius … and neither would the Doctor who later adopted the Roman's face for his Twelfth incarnation.

RETURN PERFORMANCES

Sometimes former companions even come back as someone new!

🕮 JACQUELINE HILL

First: Barbara Wright **Later: Lexa**

Fifteen years after Barbara Wright, her first *Doctor Who* role, left the TARDIS, Jacqueline Hill returned to the series as high priestess Lexa in *Meglos*.

🕮 BERNARD CRIBBINS

First: Tom Campbell **Later: Wilfred Mott**

Veteran actor Bernard Cribbins was elevated to guest companion as Wilfred Mott for the Tenth Doctor's final adventure, *The End of Time* after several semi-regular appearances. Bernard's time playing Donna's 'gramps' was his second brush with *Who* fame—although his first wasn't a role in the BBC series. In the 1966 film *Daleks—Invasion Earth 2150 A.D.* he played PC Tom Campbell, companion to Peter Cushing's Dr Who. Forty-one years later, he appeared as a newspaper vendor in *Voyage of the Damned*—a role that was later expanded to become Wilfred Mott.

🕮 JOHN LEESON

First: K9 **Later: Dugeen**

OK, bending the rules a bit here. John Leeson was still voicing the Doctor's best mechanical friend when he also played Dugeen, a methane refiner in *The Power of Kroll*.

🕮 BILLIE PIPER

First: Rose Tyler **Later: The Moment**

Every Gallifreyan superweapon needs a conscience. The Moment delved into the War Doctor's future to adopt the likeness of Rose Tyler, providing Billie Piper with a timey-wimey return to *Doctor Who*.

HAPPY BIRTHDAY TO WHO

A month-by-month guide to the companions' birthdays.

JANUARY

Deborah Watling	2 January 1948
Richard Franklin	15 January 1936
Daphne Ashbrook	30 January 1963

FEBRUARY

Elisabeth Sladen	1 February 1946
Peter Purves	10 February 1939

MARCH

Matt Lucas	5 March 1974
Freema Agyeman	20 March 1979
Bruno Langley	21 March 1983
Mary Tamm	22 March 1950
John Leeson	16 March 1943

APRIL

Mark Strickson	6 April 1959
Louise Jameson	20 April 1951
Gerald Flood	21 April 1927
Michelle Ryan	22 April 1984
Jenna Coleman	27 April 1986

MAY

Catherine Tate	12 May 1968
Kylie Minogue	28 May 1968
Pearl Mackie	29 May 1987

JUNE

Carole Ann Ford	8 June 1940
Arthur Darvill	17 June 1982

David Morrissey	21 June 1964
Lalla Ward	28 June 1951
Maureen O'Brien	29 June 1943

JULY

Jean Marsh	1 July 1934
Jackie Lane	10 July 1947
Adrienne Hill	22 July 1937
Bonnie Langford	22 July 1964

AUGUST

| Sophie Aldred | 20 August 1962 |

SEPTEMBER

Janet Fielding	9 September 1953
Frazer Hines	22 September 1944
Billie Piper	22 September 1982

OCTOBER

Caroline John	11 October 1940
Nicola Bryant	11 October 1960
Katy Manning	14 October 1949
Anneke Wills	20 October 1941
Ian Marter	28 October 1944

NOVEMBER

Lindsay Duncan	7 November 1950
William Russell	19 November 1924
Karen Gillan	28 November 1987
Michael Craze	29 November 1942

DECEMBER

Noel Clarke	6 December 1975
Wendy Padbury	7 December 1947
Sarah Sutton	12 December 1961
Nicholas Courtney	16 December 1929
Jacqueline Hill	17 December 1929
Matthew Waterhouse	19 December 1961
John Levene	24 December 1941
Bernard Cribbins	29 December 1928

COMPANION ROLL CALL:
THE 1970s

LIZ SHAW
played by CAROLINE JOHN

- First regular *Doctor Who* appearance: *Spearhead from Space* Episode 1 (1970)
- Final regular *Doctor Who* appearance: *Inferno* Episode 7 (1970)
- Final guest *Doctor Who* appearance: *Dimensions in Time* Part 2 (1993)

Following her time at the Central School of Speech and Drama, Caroline John toured with both the Royal Shakespeare Company and the National Theatre, where she was directed by Sir Laurence Olivier. In 1970 she was cast as the Doctor's new companion, only staying with *Doctor Who* for one series. She continued to work solidly, appearing in many TV series, including *The Hound of the Baskervilles* with Tom Baker and in the film *Love, Actually*. She passed away in 2012.

Dr Elizabeth 'Liz' Shaw was a brilliant Cambridge academic, co-opted into UNIT as a scientific adviser. Highly intelligent and not afraid of action, Liz eventually headed back to Cambridge, claiming that all the Doctor needed was somebody to pass him test tubes and tell him how brilliant he was!

And another thing: Caroline John was married to actor Geoffrey Beevers, who played a UNIT private in *The Ambassadors of Death* and the Master in *The Keeper of Traken*.

JO GRANT
played by KATY MANNING

- First regular *Doctor Who* appearance: *Terror of the Autons* Episode 1 (1971)
- Final regular *Doctor Who* appearance: *The Green Death* Episode 6 (1973)

Katy Manning was beginning to earn a name for herself on British television with appearances in *Softly, Softly: Taskforce* and *Man at the Top*, before being cast as Jo Grant in *Doctor Who*. Manning left the series after two years and moved with her two children to Australia where she hosted her own chat show. She returned to the United Kingdom in 2009, and reprised the role of Jo Grant in *The Sarah Jane Adventures* in 2010.

Josephine Grant was a feisty, loyal and capable UNIT operative assigned to the Doctor as his new assistant. Caring and resourceful, Jo would never hesitate to put herself danger to help others—including offering her own life for the Doctor's on more than one occasion. She left UNIT to marry environmentalist Professor Clifford Jones.

And another thing: While living down under, Katy toured the Australian outback with her one-woman show about Bette Davis, *Me and Jezebel*.

SARAH JANE SMITH
played by ELISABETH SLADEN

- First regular *Doctor Who* appearance: *The Time Warrior* Part 1 (1973)
- Final regular *Doctor Who* appearance: *The Hand of Fear* Part 4 (1976)
- Final guest *Doctor Who* appearance: *The End of Time, Part Two* (2010)

Z-Cars, *Doomwatch* and a six-episode stint in *Coronation Street* were all on Elisabeth Sladen's CV by the time she was cast as Sarah Jane Smith in *Doctor Who*. Appearing alongside both Jon Pertwee and Tom Baker, Elisabeth became the most popular and recognisable *Doctor Who* companion in the history of the programme. Largely stepping back from acting in the late 1980s to bring up her daughter, Elisabeth returned to *Doctor Who* in 2006 and went on to star in *The Sarah Jane Adventures* until her death in 2010.

Journalist Sarah Jane Smith first met the Third Doctor under an assumed identity, posing as her virologist aunt, Lavinia Smith. Investigative instincts made her the ideal companion for the Doctor, capable of getting into as much trouble as the Time Lord. The bond between the two friends strengthened after the Doctor regenerated, but Sarah was heartbroken when he practically kicked her out of the TARDIS. However, the Doctor was true to his word—he never forgot Sarah Jane Smith.

And another thing: Elisabeth presented the ITV children's programmes *My World* and *Stepping Stone* in the late 1970s.

▮ HARRY SULLIVAN
played by IAN MARTER

- First regular *Doctor Who* appearance: *Robot* Part 1 (1974)
- Final regular *Doctor Who* appearance: *Terror of the Zygons* Part 4 (1975)
- Final guest *Doctor Who* appearance: *The Android Invasion* Part 4 (1975)

After leaving University in 1969, 25-year-old Ian Marter secured a job as Acting Stage Manager at the Bristol Old Vic. One of his first television auditions was for UNIT's Captain Yates, a role he won but couldn't play due to prior commitments. After *Doctor Who*, Marter appeared in such series as *The Brothers*, *Crown Court*, *Shine on Harvey Moon* and *Bergerac* before his untimely death in 1986.

Poor old Harry. You have to pity the physician put in charge of the newly regenerated Fourth Doctor. The rather befuddled Surgeon Lieutenant later found himself on board the TARDIS as it took off for the Nerva Beacon. Brave, if not a little clumsy at times, Harry was charming and polite but infuriated Sarah by often calling her 'old girl' or 'old thing'. Despite the Doctor's assertion in *Revenge of the Cybermen* that 'Harry Sullivan is an imbecile', the Time Lord owed his life to the Naval officer on more than one occasion.

And another thing: In the 1970s and 1980s, Ian Marter novelised nine *Doctor Who* stories for Target Books.

▮ LEELA
played by LOUISE JAMESON

- First regular *Doctor Who* appearance: *The Face of Evil* Part 1 (1977)
- Final regular *Doctor Who* appearance: *The Invasion of Time* Part 6 (1978)
- Final guest *Doctor Who* appearance: *Dimensions in Time* Part 2 (1993)

After winning the prestigious Shakespeare Memorial Prize, Louise Jameson left RADA in 1971 and joined the Royal Shakespeare Company. Her long-lasting TV career began with four lines in a BBC production of *Cider With Rosie,* followed by appearances in *Tom Brown's Schooldays*, *Z-Cars*, *Emmerdale and Space: 1999*. Following *Doctor Who*, Jameson remained a familiar face on television playing major roles in *The Omega Factor*, *Tenko*, *Bergerac*, *EastEnders* and *Doc Martin*.

When the Doctor first met Leela she was wild, untamed and had just been exiled from her tribe. After helping him defeat the mad computer Xoanon, the leather-clad Sevateem warrior insisted the Doctor took her with him. Despite his best intentions, this savage Eliza Doolittle often reverted back to her violent roots. Primitive but no fool, Leela never waited to be asked before jumping into action.

And another thing: Looking for a familiar face to bridge the move from Tom Baker to Peter Davison, producer John Nathan-Turner asked Jameson to return as Leela for the Fifth Doctor's first season. As she was only happy to return for a maximum of three stories, the idea was dropped.

▮ K-9 MARK I & MARK II
voiced by JOHN LEESON and DAVID BRIERLEY

- First regular *Doctor Who* appearance: *The Invisible Enemy* Part 1 (1977)
- Final regular *Doctor Who* appearance: *Warriors Gate* Part 4 (1981)
- Final guest *Doctor Who* appearance: *Journey's End* (2008)

A RADA graduate, John Leeson holds the distinction of being the original Bungle the bear in *Rainbow*. In the late 1970s, Leeson bumped into an old friend, director Derrick Goodwin, who subsequently asked him to play a couple of voices in *The Invisible Enemy*—namely an alien virus and K-9. Leeson temporarily left the series after *The Armageddon Factor* and was replaced by David Brierley. After an accident in rehearsal ended his ballet-dancing career, Brierley had moved into stage managing, picking up acting roles as he transferred from theatre to theatre. His TV work included three separate parts in *Coronation Street*, most notably as a friend of Ken Barlow in episodes 6 to 14 of the legendary soap opera. Brierley voiced K-9 for four stories, including the untelevised *Shada*, before Leeson was persuaded to return for K-9's imminent departure. Brierley went on to appear in *Threads*, *Juliet Bravo*, *The Tripods* and *Howard's Way* before passing away in June 2008, while Leeson made appearances in *Minder*, *Doctors* and *ChuckleVision*. He returned to *Doctor Who* in 2006 for *School Reunion*, reprising his role in the subsequent spin-off series *The Sarah Jane Adventures*, and again in Australian TV's *K9* series.

Given to the Doctor by his creator Professor Marius, mobile computer K-9 travelled on board the TARDIS until he opted to remain on Gallifrey with Leela. The Doctor had obviously been preparing for the possibility that his robot dog might leave—he already had a box containing the components for K-9 Mark II.

And another thing: John Leeson provided the voice of the Dalek Battle Computer in *Remembrance of the Daleks*.

▮ ROMANADVORATRELUNDAR (ROMANA) I
played by MARY TAMM

- First regular *Doctor Who* appearance: *The Ribos Operation* Part 1 (1978)
- Final regular *Doctor Who* appearance: *The Armageddon Factor* Part 6 (1979)

After attending RADA, Mary Tamm joined the Birmingham repertory theatre in 1971 appearing alongside Ronnie Barker and Derek Jacobi. She made the move into tele-

vision two years later, winning roles in *The Donati Conspiracy* and *Coronation Street*, where she played Hilda Ogden's daughter-in-law. Her first major role after leaving *Doctor Who* was as Jill Frazer in the 1980 TV thriller *The Assassination Run* and its sequel *The Treachery Game*. Tamm would go on to appear as Penny Crosbie in Channel 4's *Brookside* from 1993 to 1995 and guest starred in such popular series as *Heartbeat*, *Jonathan Creek*, *Wire in the Blood* and *EastEnders*. She passed away in July 2012.

Romana was thrust upon the Doctor by the White Guardian to help the Time Lord gather the six segments of the Key to Time. Hyper-intelligent yet naïve, the original Romana was a force to be reckoned with, glamorous and absolutely convinced of her own superiority. Several centuries younger than the Doctor, she still considered herself his intellectual and academic superior—although relations between the two Gallifreyans thawed over time.

And another thing: Mary Tamm attended RADA at the same time as Louise Jameson.

⬛ ROMANADVORATRELUNDAR (ROMANA) II
played by LALLA WARD

- First regular *Doctor Who* appearance: *Destiny of the Daleks* Episode 1 (1979)
- Final regular *Doctor Who* appearance: *Warriors Gate* Part 4 (1981)
- Final guest *Doctor Who* appearance: *Dimensions in Time* Part 2 (1993)

Even though she was painfully shy and had never even taken part in a school play, the Honourable Sarah Ward dared herself to go to drama school. Winning a place at the Central School of Speech and Drama, she graduated three years later and immediately secured a role in Hammer's *Vampire Circus*. She left *Doctor Who* in 1980, just prior to her brief marriage to Tom Baker, and worked extensively in the theatre before retiring from acting in 1992. Ward now balances a successful career as an illustrator with charity work.

After completing the quest for the Key to Time, Romana regenerated. Having tried on a few bodies for size, she settled on the image of Princess Astra of Atrios, despite the Doctor's protestations. In her new incarnation, Romana was more playful but still brimmed with confidence, unable to resist any opportunity to rib the Doctor about his shortcomings.

And another thing: Lalla Ward met second husband Richard Dawkins at Douglas Adams's 40th birthday party. They were married six months later.

> ### THE FOURTH DOCTOR'S RULES FOR COMPANIONS
> Rule 1: 'Do exactly as I say.'
> Rule 2: 'Stick close to me.'
> Rule 3: 'Let me do all the talking.'

MUSTERING THE TROOPS—THE CREATION OF UNIT

'We deal with the odd, the unexplained, anything on Earth or even beyond.'

The Brigadier, *Spearhead from Space*

Earth-bound military group UNIT has been a mainstay of *Doctor Who* since the late 1960s. What led to the creation of this much-loved facet of the Doctor's lives?

- When, in the summer of 1968, Patrick Troughton having announced his intention to leave *Doctor Who*, producer Peter Bryant and script editor Derrick Sherwin cast their eyes to the future, with a revamp for the series very much on the cards.
- The scripts for the Cyberman story *The Invasion* provided the germ of an idea for that revamp, with Derrick Sherwin fleshing out the concept of UNIT and the return of the Lethbridge-Stewart character, now promoted to Brigadier.
- Bryant and Sherwin saw in *The Invasion* the opportunity to revamp their series to a more contemporary setting, something that had proved popular in *The Web of Fear* the previous year. Time travel and alien planets were out, cheaper Earth-bound adventure was in, with UNIT as a central concept.
- During production of *The Invasion* in September 1968, the production team sounded out Nicholas Courtney about returning to *Doctor Who* as the Brigadier on a regular basis for the following series. The actor readily agreed.
- With a new Doctor, Jon Pertwee, in place and the series moving into colour, it was all change for *Doctor Who* on 3 January 1970, and UNIT and the Brigadier were firmly established as a core part of the series.

UNIT PERSONNEL

LENGTH OF SERVICE

The boys (and girls) of UNIT have come and gone, but who has served the longest on screen? Here we rank the great and good in order of the number of stories we've seen them defending the Earth as a member of the Unified Intelligence Taskforce. No guessing who's top of the list…

Personnel	Rank	Dept	Killed In action	Actor	Stories
John Smith	Doctor	Scientific	Sort of	Jon Pertwee, Tom Baker, Sylvester McCoy, David Tennant, Matt Smith, Peter Capaldi	Various
Alistair Gordon Lethbridge-Stewart	Brigadier	Military	No	Nicholas Courtney	Various
Benton	Corporal / Sergeant / RSM	Military	No	John Levene	Various
Michael Yates	Captain	Military	No	Richard Franklin	Various
Josephine Grant		Military	No	Katy Manning	Various
Elizabeth Shaw	Doctor	Scientific	No	Caroline John	Various
Harry Sullivan	Surgeon-Lieutenant	Military	No	Ian Marter	Various
Kate Stewart		Scientific	No	Jemma Redgrave	*Various*
Bell	Corporal	Military	No	Fernanda Marlowe	*The Mind of Evil, The Claws of Axos*

Personnel	Rank	Dept	Killed In action	Actor	Stories
Carl Harris	Private	Military	No	Clive Standen	*The Sontaran Stratagem / The Poison Sky, Turn Left*
Jac	None	Science	Yes	Jaye Griffiths	*The Magician's Apprentice, The Zygon Invasion*
Martha Jones	Doctor	Medical	No	Freema Agyeman	*The Sontaran Stratagem / The Poison Sky, The Stolen Earth / Journey's End*
Petronella Osgood	None	Science	Yes/No	Ingrid Oliver	*The Day of the Doctor, Death in Heaven, The Zygon Invasion / The Zygon Inversion*
Erisa Magambo	Captain	Military	No	Noma Dumezweni	*Turn Left, Planet of the Dead*
Adams	Corporal	Military	No	Max Faulkner	*The Android Invasion*
Ahmed	Colonel	Military	Yes	Sanjeev Bhaskar	*Death in Heaven*
Atkins	None	Security	No	Tom Keller	*The Day of the Doctor*
Winifred Bambera	Brigadier	Military	No	Angela Bruce	*Battlefield*
Beresford	Major	Military	No	John Acheson	*The Seeds of Doom*
Betts	Private	Military	No	David Billa	*The Green Death*
Richard Blake	Major	Military	Yes	Chu Omambala	*The Christmas Invasion*
Bryson	Private	Military	No	Colin Bell	*Invasion of the Dinosaurs*
Calhoun	Sergeant	Military	No	–	*Planet of the Dead*
Champion	Corporal	Military	No	James Haswell	*The Ambassadors of Death*
Cosworth	Colonel	Military	No	Patrick Godfrey	*The Mind of Evil*

Personnel	Rank	Dept	Killed In action	Actor	Stories
Charles Crichton	Colonel	Military	No	David Savile	The Five Doctors
Faraday	Colonel	Military	No	Patrick Newell	The Android Invasion
Forbes	Corporal	Military	Yes	George Lee	Spearhead from Space
Frost	Major	Military	Yes	–	Aliens of London
Steven Gray	Private	Military	No	Wesley Theobald	The Sontaran Stratagem / The Poison Sky
Hart	Sergeant	Military	Yes	Richard Steel	Doctor Who and the Silurians
Hawkins	Captain	Military	Yes	Paul Darrow	Doctor Who and the Silurians
Henderson	Sergeant	Military	No	Ray Barron	The Seeds of Doom
Johnny Hitchley	Unknown	Military	Yes	Todd Kramer	The Zygon Invasion
Husak	Major	Military	No	Paul Tomany	Battlefield
Sally Jacobs		Technician	No	Anita Briem	The Christmas Invasion
Jalandra	Private	Military	No	Mike Freeman	The Stolen Earth
Ross Jenkins	Private	Military	Yes	Christian Cooke	The Sontaran Stratagem / The Poison Sky
Jenkins	Private	Military	No	–	The Daemons
Johnson	Private	Military	No	Geoffrey Beevers	The Ambassadors of Death
Alex Klein		Civilian liaison	No	Adam Garcia	The Christmas Invasion
Latimer	Private	Military	No	David Simeon	Inferno
Françoise Lavel	Flight Lieutenant	Military	Yes	Dorota Rae	Battlefield
Lisa (Drone Operator)	Unknown	Military	No	Jill Winternitz	The Zygon Invasion

Personnel	Rank	Dept	Killed In action	Actor	Stories
Alan Mace	Colonel	Military	No	Rupert Holliday Evans	*The Sontaran Stratagem / The Poison Sky*
McGillop	None	Science	No	Jonjo O'Neill	*The Day of the Doctor*
Mike	Unknown	Unknown	No	Harki Bhambra	*The Magician's Apprentice*
James Munro	Captain	Military	No	John Breslin	*Spearhead from Space*
Nutting	Corporal	Military	No	Alan Mason	*Doctor Who and the Silurians*
Ogden	Private	Military	No	George Bryson	*Invasion of the Dinosaurs*
Osgood	Sergeant	Military	No	Alec Linstead	*The Daemons*
Palmer	Corporal	Military	No	Denys Palmer	*The Three Doctors*
Pandovski	Private	Military	No	–	*Planet of the Dead*
Perkins	Private	Military	Yes	Stacy Davies	*The Invasion*
Marion Price	Captain	Military	No	Bridget Hodgson	*The Sontaran Stratagem / The Poison Sky*
Robins	Private	Military	No	Harry Swift	*Doctor Who and the Silurians*
William Rutlidge	Major-General	Military	No	Edward Dentith	*The Invasion*
Sanchez	Lieutenant-General	Military	Yes	Michael Brandon	*The Stolen Earth*
Malcolm Taylor	Doctor	Scientific	No	Lee Evans	*Planet of the Dead*
James Turner	Captain	Military	No	Robert Sidaway	*The Invasion*
Tracy	Corporal	Military	No	Geoffrey Cheshire	*The Invasion*
Upton	Private	Military	Yes	–	*Doctor Who and the Silurians*
Walsh	Colonel	Military	No	Rebecca Front	*The Zygon Invasion*

Personnel	Rank	Dept	Killed In action	Actor	Stories
Wright	Private	Military	Yes	Derek Politt	*Doctor Who and the Silurians*
Wyatt	Private	Military	Yes	Derek Ware	*Inferno*
Zbrigniev	Sergeant	Military	No	Robert Jezek	*Battlefield*

Other UNIT personnel include:

- Sir John Sudbury—the Doctor's contact within department C19 (*Time-Flight*)
- Major Walton—fought the Silurians on Wenley Moor under Lethbridge-Stewart (*Doctor Who and the Silurians*)
- Mr Campbell—worked in the scientific supplies section during the second Auton invasion. Jo Grant thought he was a dolly Scotsman. (*Terror of the Autons*)

THE UNKNOWN SOLDIERS

Not all UNIT squaddies and officers are lucky enough to have names. We salute the actors who played these unnamed protectors of Earth:

SQUADDIES

- Brian Haughton, Mark Johnson, John Spradbury, Alex Donald, David Melbourne (*Doctor Who and the Silurians*)
- Steve Smart, Geoff Brighty, Ron Conrad, Les Conrad, Tom Laird, Doug Roe, Roy Brent, David Aldridge, Clive Rogers, Alan Chuntz, Steve Kelly, Keith Simons, Derek Chafer, Ron Gregory, Rod Peers, Stewert Myers, David Pike, Jo Santos (*The Ambassadors of Death*)
- Les Conrad (*Terror of the Autons*)
- Charles Marrior, Stuart Fell, Nick Hobbes, Dennis Balcombe, Roger Marsden (*The Mind of Evil*)
- Roy Brent, Bill Hughes, Douglas Roe, Clive Rogers, Pierce McAvoy, Michael Stainer (*The Claws of Axos*)
- David Melbourne (*Day of the Daleks*)
- Pat Gorman, Leslie Bates, Terence Deville, Terry Sartain, David Billa, David Melbourne (*The Three Doctors*)
- Leslie Bates, David Billa (*The Green Death*)

- David Cleeve, Stephen Ismay (*The Time Warrior*)
- Brian Nolan, Geoff Witherick, Dennis Plenty, David Billa, Ian Elliot, Louis Souchez, Leslie Bates, John Cash, James Muir (*Invasion of the Dinosaurs*)
- James Muir, Barry Summerford, Alan Clements, Rowland Greall, Patrick Glinter, David Selby (*Terror of the Zygons*)
- Alan Clements, Christopher Woods, Alf Coster, Mark Allington, Pat Milner, Derek Hunt, Roy Pearch, Terry Sartain, Peter Brace (*The Android Invasion*)
- Rowland Geall, Patrick Glinter, Tony Snell, Barry Summerford, Derek Wayland, Peter Bailey (*The Seeds of Doom*)
- Stephen Woodhouse, Laurie Goode, Craig Gilmans, Mark Tony, Howard Buttress, Paul Dore, Andrew Davoile, Garry Haig, Adrian Bean, Garry Lovini, Mark Warren, Peter Davoile, Kevin Malfby, Dean Foy, Anthony Hayworth, Phil Player, Daniel Spacer, Andrew Jones, Peter Oliver (*Battlefield)*
- Vaughn Joseph (*The Return of Doctor Mysterio*)

CORPORALS
- Bill Horrigan (*The Mind of Evil*)
- Clinton Morris (*The Claws of Axos*)
- Derek Martin (*The Claws of Axos*)
- Patrick Milner (*The Daemons*)
- Pat Gorman (*Invasion of the Dinosaurs*)
- Bernard G. High (*Terror of the Zygons*). Terrance Dicks named High's character Palmer in the novelisation, *Doctor Who and the Loch Ness Monster*.

SERGEANTS
- Anthony Moss, Ken Lee (*Battlefield*)

CHAUFFEUR
- Michael Ely (*The Mind of Evil*)

OPERATORS
- Bara Chambers, Leon Maybank (*Day of the Daleks*)

RADIO VOICE
- John Dearth (*The Green Death*)

TYPIST
- Richard King (*Invasion of the Dinosaurs*)

RADIO OPERATOR
- Gypsie Kemp (*Day of the Daleks*). Writer Gary Russell named her Corporal Maisie Hawke in his 1996 *Doctor Who* novel *The Scales of Injustice*.

RESEARCHER

- David Hartley (*The Power of Three*)

TECHNICIAN

- Ellis Jones (*Spearhead from Space*)

UNIT CALL SIGNS

Call sign	Allocation	Episode
UNIT Leader	Brigadier Lethbridge-Stewart	*Doctor Who and the Silurians*
UNIT Commander	Brigadier Lethbridge-Stewart	*Doctor Who and the Silurians*
Greyhound	Brigadier Lethbridge-Stewart	*The Green Death, The Time Monster, Battlefield*
Greyhound Leader	Brigadier Lethbridge-Stewart	*Robot, Terror of the Zygons*
Greyhound One	Brigadier Lethbridge-Stewart	*The Invasion of the Dinosaurs*
Greyhound Two	Brigadier Lethbridge-Stewart	*The Daemons*
	Captain Yates	*Day of the Daleks*
	Sergeant Benton	*The Time Monster*
Greyhound Three	Captain Yates	*The Time Monster*
	Sergeant Benton	*The Green Death*
Greyhound Four	Jo Grant	*The Green Death*
Greyhound Six	Doctor Martha Jones	*The Sontaran Stratagem*
Greyhound Seven	Unidentified Soldier	*The Mind of Evil*
Greyhound Sixteen	Private Steve Gray	*The Sontaran Stratagem*
Greyhound Seventeen	Private Harris	*Turn Left*
Greyhound Forty	Private Ross Jenkins	*The Sontaran Stratagem*
Watchtower	UNIT HQ	*Doctor Who and the Silurians*

Call sign	Allocation	Episode
Trap One	Jo Grant at UNIT HQ	Terror of the Autons
	Major Cosworth at UNIT mobile HQ	The Mind of Evil
	Captain Yates at UNIT HQ	The Claws of Axos
	Sergeant Benton at UNIT HQ	Robot
	UNIT HQ	Day of the Daleks
	UNIT HQ	The Green Death
	Colonel Mace at UNIT HQ	The Sontaran Stratagem / The Poison Sky
	UNIT HQ	Turn Left
Trap Two	Captain Yates	The Daemons
	UNIT Emergency HQ	Invasion of the Dinosaurs
Trap Three	Sergeant Benton	The Daemons
Jupiter	Brigadier Lethbridge-Stewart	The Mind of Evil
Venus	Captain Yates	The Mind of Evil
Watchdog	Captain Hawkins	Doctor Who and the Silurians
Seabird One	Brigadier Bambera	Battlefield
Salamander Six Zero	Lieutenant Richard, Nuclear Convoy	Battlefield
Windmill 123	UNIT helicopter	Doctor Who and the Silurians
Windmill 347	UNIT helicopter	The Mind of Evil
Eagle	Air strike	Terror of the Autons
Eagle	UNIT helicopter	The Green Death
Uniform November Nine Zero	UNIT helicopter	Battlefield
Hawk Major	The Valiant	The Poison Sky
Bluebottle Three	The police	Terror of the Autons
Blue Eagle	UNIT Helicopter	The Day of the Doctor

THE LIFE AND TIMES OF NICHOLAS COURTNEY

As Brigadier Alistair Gordon Lethbridge-Stewart, Nicholas Courtney played one of *Doctor Who*'s best-loved characters. Over a period of 40 years, he appeared on and off as the most gentlemanly of gentleman soldiers, never quite taking retirement—either on or off screen. Here is the *Who-ology* timeline of the actor's unique contribution to *Doctor Who*.

16 December 1929—William Nicholas Stone Courtney born in Cairo, Egypt

13 November 1965—first appearance in *Doctor Who* as Space Security Agent Bret Vyon (*The Daleks' Master Plan*)

17 December 1967—films his first scenes as the then Colonel Lethbridge-Stewart for *The Web of Fear*, on location near Old Covent Garden in London

17 February 1968—first full on-screen appearance as Lethbridge-Stewart (*The Web of Fear* Episode 3)

9 November 1968—with a promotion to Brigadier, returns to *Doctor Who* as Lethbridge-Stewart, now heading up the United Nations Intelligence Taskforce— UNIT. A blueprint for the future is set. (*The Invasion* Episode 2)

3 January 1970—*Doctor Who* moves into colour and a new era of Earth-bound adventures commences for the series. Nicholas makes his third appearance as the Brigadier, beginning a run of 40 episodes as a full series regular throughout Season 7 and into Season 8. (*Spearhead from Space* Episode 1)

19 June 1971—The Brigadier utters his most famous line as he orders one of his men to tackle an advancing gargoyle: 'Chap with the wings there, five rounds rapid.' All in a day's work for UNIT. (*The Daemons* Episode 5)

20 September 1975—makes what was to be his final 'regular' appearance as the Brigadier (*Terror of the Zygons* Part 4)

1 February 1983—Nicholas makes his first appearance in eight years as the now-retired Brigadier, invited back as part of *Doctor Who*'s 20th-anniversary celebrations, adding Peter Davison to his checklist of Doctors. (*Mawdryn Undead* Part 1)

25 November 1983—appears as the just-retired Brigadier in the *Doctor Who* 20th-anniversary special (*The Five Doctors*)

23 November 1988—Never one to miss an anniversary, Courtney creeps into the background of a scene set at Windsor Castle for *Doctor Who*'s 25th birthday as an uncredited extra. (*Silver Nemesis* Part 1)

6 September 1989—Nicholas returns to *Doctor Who* as the Brigadier once more, this time adding Sylvester McCoy to his Time Lord tally. (*Battlefield* Part 1)

27 November 1993—joins the cast of a *Children in Need* special to celebrate *Doctor Who*'s 30th anniversary—this time appearing with the Sixth Doctor (*Dimensions in Time*)

1997—made honorary president of the *Doctor Who* Appreciation Society (DWAS)

17 April 2001—Big Finish Productions releases *Doctor Who* audio adventure *Minuet in Hell*, starring Courtney alongside Eighth Doctor Paul McGann for the first time.

1 December 2008—joins Elisabeth Sladen to make a guest appearance as the Brigadier—now a knight of the realm—in two episodes of *The Sarah Jane Adventures*. It's the end of an era as the Brig makes his final *Doctor Who* appearance, 40 years and 10 months after the character's first appearance in *The Web of Fear* Episode 3 in February 1968.

22 February 2011—Nicholas Courtney passes away at the age of 81.

1 October 2011—The Eleventh Doctor is devastated to be informed that his old friend Alistair has died peacefully. (*The Wedding of River Song*)

THE MEN FROM UNIT

Surname	Lethbridge-Stewart	Yates	Benton
First name(s)	Alistair Gordon	Michael	(Unspecified, but often assumed to be John)
First *Doctor Who* appearance	*The Web of Fear*	*Terror of the Autons*	*The Invasion*
Rank	Colonel / Brigadier	Captain	Corporal / Sergeant / Warrant Officer / Regimental Sergeant Major
Known family	Second wife, Doris Daughter from first marriage, Kate	None	Younger sister
Hobbies	Enjoying a pint!	Rugby	Ballroom dancing, International rugby
Reason for leaving UNIT	Retired	Resigned after being revealed as part of the Operation Golden Age conspiracy.	Unknown
Life after UNIT	Taught A-level Maths at Brendon Public School. Married Doris. Was knighted for services to the entire planet. Worked on and off for UNIT until his death in a nursing home. Was resurrected as a Cyberman during the 3W Incident and saved the Doctor from executing Missy. Current whereabouts: unknown.	Joined a Buddhist meditation centre to get his life back on track.	Became a used car salesman
Last *Doctor Who* appearance	*Death in Heaven*	*Dimensions in Time*	*The Android Invasion*

COMPANION ROLL CALL:
THE 1980s

ADRIC
played by MATTHEW WATERHOUSE

- First regular *Doctor Who* appearance: *Full Circle* Part 1 (1980)
- Final regular *Doctor Who* appearance: *Earthshock* Part 4 (1981)
- Final guest *Doctor Who* appearance: *The Caves of Androzani* Part 4 (1984)

Former BBC news clerk Matthew Waterhouse made his acting debut in the 1980 TV adaptation of *To Serve Them All My Days*. A lifelong fan of *Doctor Who*, Waterhouse even entered a competition in *TV Action* to design a monster—although his creation didn't win. A bigger prize came when he secured the role of boy genius Adric. Waterhouse stayed with the show until his dramatic exit in *Earthshock*, moving on to a career in theatre. In 1998, he moved to Connecticut, USA and has written two novels set in New York.

Adric grew up on the planet Alzarius in E-Space, a pocket universe only accessible via a Charged Vacuum Emboitment (CBE). A mathematical genius, Adric struggled to fit in with the inhabitants of the crashed Starliner and instead joined a gang with his brother, Varsh. When the chance came, Adric stowed away on board the TARDIS, eventually travelling back to the Doctor's own universe. Awkward and arrogant, Adric proved his mettle when he made the ultimate sacrifice.

And another thing: At 18, Matthew Waterhouse was—and is—the youngest actor to play a *Doctor Who* companion. Not counting the performers who have played other companions as children, of course!

◉ NYSSA
played by SARAH SUTTON

- First regular *Doctor Who* appearance: *The Keeper of Traken* Part 1 (1981)
- Final regular *Doctor Who* appearance: *Terminus* Part 4 (1983)
- Final guest *Doctor Who* appearance: *Dimensions in Time* Part 2 (1993)

Sarah Sutton's early stage debut in a West End pantomime led to a number of television appearances including the titular role in 1972's *Alice Through the Looking Glass*. However, it was Sutton's performance as a blind girl in *The Moon Stallion* by *Doctor Who* stalwart Brian Hayles that pushed the young actress into the spotlight. Originally hired to play Nyssa for just one story, Sutton so impressed producer John Nathan-Turner that she was invited to stay on as a companion. After *Doctor Who*, Sutton largely retired from acting to raise her daughter.

The daughter of Traken aristocrat Consul Tremas, Nyssa first met the Doctor as her father was preparing to become the new Keeper, with all the power and privilege that went with the position. Unfortunately, the Master had already arrived on Traken and was manipulating events to secure a new regenerative cycle. Skilled in cybernetics and bioengineering, Nyssa was orphaned when the Master absorbed her father's body. Prior to the Fourth Doctor's regeneration, the Trakenite was reunited with the Time Lord on Logopolis, thus saving her from the destruction of Traken itself.

And another thing: Sarah Sutton spent her honeymoon at a San Francisco-based *Doctor Who* convention.

◉ TEGAN JOVANKA
played by JANET FIELDING

- First regular *Doctor Who* appearance: *Logopolis* Part 1 (1981)
- Final regular *Doctor Who* appearance: *Resurrection of the Daleks* Part 2 (1984)
- Final guest *Doctor Who* appearance: *The Caves of Androzani* Part 4 (1984)

After studying at the University of Queensland, Australian-born Janet Fielding came to the UK with a three-month tour of *White Man's Mission*. Joining Ken Campbell's Science Fiction Theatre in Liverpool, Fielding worked alongside Jim Broadbent and Sylvester McCoy and went on to win a small role in *Hammer House of Horror* in 1980. In the 1990s, Fielding took up an administrative position with Women in Film and Television UK and latterly became a theatrical agent, representing Paul McGann at the time of the 1996 *Doctor Who* TV movie.

When her car broke down on the way to her first day as an air stewardess, Tegan Jovanka entered the TARDIS thinking it was a real police box. The first to admit that she was a 'mouth on legs', outspoken Tegan became increasingly frustrated with the Doctor's inability to get her back to Earth. When she was accidentally left at Heathrow,

Tegan was happy to be reunited with the Doctor in Amsterdam—although the Time Lord himself didn't seem so keen!

And another thing: Janet Fielding played a villain opposite several hopefuls in the Seventh Doctor screen tests—including Sylvester McCoy.

VISLOR TURLOUGH
played by MARK STRICKSON

- First regular *Doctor Who* appearance: *Mawdryn Undead* Part 1 (1983)
- Final regular *Doctor Who* appearance: *Planet of Fire* Part 4 (1984)
- Final guest *Doctor Who* appearance: *The Caves of Androzani* Part 4 (1984)

Following his graduation from RADA, Mark Strickson made his TV debut as ambulance driver, Terry, in *Angels*. After five episodes, producer Julia Smith offered Strickson a regular part in the medical drama. However, the young actor had another offer on the table—Turlough. After his departure from *Doctor Who* in 1984, Strickson would go on to appear in episodes of *Bergerac*, *David Copperfield*, *Casualty* and *Minder*. 1988 saw him emigrating to Australia, where he studied Zoology and went on to produce and direct natural history films. He currently lives in New Zealand with his wife.

While masquerading as a public schoolboy on Earth, Trion exile Turlough was offered a chance to escape by the Black Guardian—all he had to do was kill the Doctor. Following the Guardian's defeat, Turlough stayed on board the TARDIS, although it would be a while until his true origins were revealed: Turlough had fought in a civil war that had claimed his mother's life and condemned his father and brother to a life of imprisonment on the inhospitable planet of Sarn.

And another thing: Strickson directed Steve Irwin in *The Ten Deadliest Snakes in the World*, one of the Crocodile Hunter's first UK TV appearances.

KAMELION
voiced by GERALD FLOOD

- First regular *Doctor Who* appearance: *The King's Demons* Part 1 (1983)
- Final regular *Doctor Who* appearance: *Planet of Fire* Part 4 (1984)
- Final guest *Doctor Who* appearance: *The Caves of Androzani* Part 4 (1984)

A wartime wireless operator, Gerald Flood escaped from his post-war filing clerk job by joining the Farnham Repertory. In 1960 he won the role of journalist Conway Henderson in *Pathfinders in Space*. He would return as Henderson in *Pathfinders to Mars* and *Pathfinders to Venus* and regularly appeared on television in such series as *Man in a Suitcase*, *Crown Court*, *Raffles* and *Return of the Saint*. He last appeared in an adaptation of *Bleak House*, before his death in 1989.

Kamelion was a shape-changing android discovered by the Master on the planet Xeraphas. The weak-willed robot was forced to impersonate King John in order to prevent the Magna Carta from being signed. When the Master's plot was foiled, Kamelion joined the TARDIS crew, only to come under the control of the Doctor's former friend once more in 20th-century Lanzarote.

And another thing: *Pathfinders in Space* was produced by Sydney Newman, co-creator of *Doctor Who*.

█ PERPUGILLIAM (PERI) BROWN
played by NICOLA BRYANT

- First regular *Doctor Who* appearance: *Planet of Fire* Part 1 (1984)
- Final regular *Doctor Who* appearance: *The Trial of a Time Lord* Part 8 (1986)
- Final guest *Doctor Who* appearance: *Dimensions in Time* Part 2 (1993)

Nicola Bryant was spotted by agent Terry Carney during a drama school performance that saw the young actress play an American. When a casting call came through for an American companion for *Doctor Who*, Carney put Bryant through, under the mistaken impression that she was from the States rather than Surrey. After *Doctor Who*, Bryant moved straight into a nine-month run in *Killing Jessica* with Patrick Macnee at the Savoy Theatre and continued to appear on both the stage and television in such shows as *The Biz*, *Holby City*, *Doctors* and *My Family*.

Following an argument with her stepfather while holidaying in Lanzarote, 18-year-old botany student Peri leapt from his boat and, attempting to swim to shore, nearly drowned. She was rescued by Turlough and taken aboard the TARDIS which almost immediately took off for the planet Sarn. Peri stayed with the Time Lord, although her relationship with the newly regenerated Sixth Doctor was prickly at best.

And another thing: Talent scout Terry Carney was William Hartnell's son-in-law.

█ MELANIE (MEL) BUSH
played by BONNIE LANGFORD

- First regular *Doctor Who* appearance: *The Trial of a Time Lord* Part 9 (1986)
- Final regular *Doctor Who* appearance: *Dragonfire* Part 3 (1987)
- Final guest *Doctor Who* appearance: *Dimensions in Time* Part 1 (1993)

After winning *Opportunity Knocks* at 6 years old, Bonnie Langford made her Broadway debut opposite Angela Lansbury just 12 months later in *Gypsy Girl*. TV and films followed with Langford appearing in London Weekend Television's *Just William*, plus films such as *Bugsy Malone* and *Wombling Free*. She won the role of Mel after a long run in *Peter Pan*, but left *Doctor Who* the following season, disenchanted with playing 'Little Miss Sweetie Pie'. Returning to the theatre, Langford played in *Charlie Girl*,

Me and My Girl and *Pirates of Penzance* in quick succession. Today she still appears regularly on stage and in 2006 skated into third place in ITV's *Dancing on Ice*. In 2015, Langford joined the cast of soap opera *EastEnders* in the role of Carmel Kazemie.

Mel's introduction to the Doctor was unique. On trial for his lives, the Doctor presented an adventure from his future as evidence, thus introducing the universe – and himself—to the bubbly computer programmer from Pease Pottage. The Time Lords then plucked Mel from a later point in her life and reunited her with the Doctor—even though in his eyes they'd yet to meet. When the charges against the Doctor were dropped the older Mel left on board the TARDIS. Confused yet? She was still travelling with him when he underwent his sixth regeneration.

And another thing: Bonnie Langford is the first companion who was born after the start of *Doctor Who*.

🕪 ACE
played by SOPHIE ALDRED

- First regular *Doctor Who* appearance: *Dragonfire* Part 1 (1987)
- Final regular *Doctor Who* appearance: *Survival* Part 3 (1989)
- Final guest *Doctor Who* appearance: *Dimensions in Time* Part 2 (1993)

Sophie Aldred won the role of Ace while appearing in *Fiddler on the Roof* in Manchester and impressed producer John Nathan-Turner so much that her last scene was hastily rewritten so Ace left with the Doctor. Since the original series' cancellation in 1989, Aldred has worked extensively in children's television and radio. 2012 saw the launch of *Tree Fu Tom*, an animated CBeebies series with Sophie voicing the lead alongside David Tennant as her character's assistant, Twigs.

A troubled teenager with a natural talent for chemistry, Ace was suspended from school after she blew up class 1C's prize-winning pottery pig collection with a lump of home-made gelignite. At 16, during an experiment with nitro-glycerine, she was transported to Iceworld by what she thought was a freak time storm. Ace would later discover that it was all the work of an evil cosmic entity by the name of Fenric.

And another thing: Russell T Davies planned to bring Ace back in *The Sarah Jane Adventures*. She would have been revealed to be a tough but classy businesswoman.

THE SEVENTH DOCTOR'S RULES FOR COMPANIONS
Rule 1: 'I'm in charge.'
Rule 2: 'I'm not the Professor, I'm the Doctor.'
Rule 3: 'Well, I'll think up the third by the time we get back to Perivale.'

THE SORRY BALLAD
OF KAMELION

In November 1981, during the recording of *Earthshock*, free-lance effects designer Richard Gregory, whose company had constructed the Cybermen costumes, told producer John Nathan-Turner about a fully work-ing robot that had been created by Chris Padmore and Mike Power of CP Cybernetics. Originally built as a promotional tool, the 'android' could make gestures and deliver dialogue provided by pre-recorded cassette. Excited by the concept, Nathan-Turner and script editor Eric Saward visited CP Cybernetics' workshop. They were greeted by a robot dressed in a swimming costume and rubber cap to disguise the parts that had yet to be finished. On hearing plans to make the robot walk, Nathan-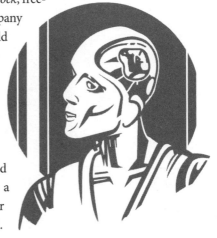
Turner commissioned Terence Dudley to write Kamelion's debut story, *The King's Demons*.

When it came to filming, Kamelion proved to be nothing short of a disaster. Every scene required 15 minutes of extensive programming and even then the robot's pre-recorded speeches repeatedly went out of sync. It also couldn't walk. The final straw came when Kamelion's hydraulic arms jammed beyond repair.

Kamelion officially joined the TARDIS as a companion at the end of *The King's Demons*, although he effectively vanished until his departure in *Planet of Fire*, some six stories later. New scenes with the robot were filmed for *The Awakening* but hit the cutting-room floor before transmission.

OFF-SCREEN COMPANIONS

As well as his TV assistants, the Doctor has been joined by a whole host of companions in books, comics, audio dramas and stage plays. Here are the most significant.

Name	Actor	Doctor	Medium
Abby (aka Amy)	Ciara Janson	Fifth Doctor	Audios
Antimony	Kevin Eldon	Seventh Doctor	Webcast
ARC	-	Eleventh Doctor	Comics
Lysandra Aristedes	Maggie O'Neill	Seventh Doctor	Audios
Arnold	-	Third Doctor	Comics
Will Arrowsmith	Christian Edwards	Seventh Doctor	Audio
Thomas Brewster	John Pickard	Sixth Doctor	Audios
Catherine Broome	-	Seventh Doctor	Books
Emily Chaudhry	Siri O'Neal	Sixth Doctor	Audios / Books
Liv Chenka	Nicola Walker	Eighth Doctor	Audio
Cinder	-	War Doctor	Books
Claudia	-	Eighth Doctor	Books
Devina Collins	-	Twelfth Doctor	Comics
Jess Collins	-	Twelfth Doctor	Comics
Lloyd Collins	-	Twelfth Doctor	Comics
Maxwell Collins	-	Twelfth Doctor	Comics
Compassion	-	Eighth Doctor	Books
Rachel Cooper	Lenora Crichlow	Seventh Doctor	Audios
Raine Creevy	Beth Chalmers	Seventh Doctor	Audios
C'rizz	Conrad Westmaas	Eighth Doctor	Audios / Books
Alison Cheney	Sophie Okonedo	Shalka Doctor	Webcast
Crystal	Rebecca Thornhill / Claire Huckle	Third and Sixth Doctors	Stage / Audio
Chris Cwej	Travis Oliver	Seventh Doctor	Books / Audios
Abslom Daak	-	Eleventh Doctor	Comics
Sharon Davies	-	Fourth Doctor	Comics
Josie Day	-	Eighth Doctor	Comics

Name	Actor	Doctor	Medium
Decky	-	Eleventh Doctor	Comics
Destrii	-	Eighth Doctor	Comics
Oliver Day	-	Fourth Doctor	Books
Tamsin Drew	Niky Wardley	Eighth Doctor	Audios
Erimem	Caroline Morris	Fifth Doctor	Audios / Books
Jeremy Fitzoliver	Richard Pearce	Third Doctor	Radio / Books
Roz Forrester	Yasmin Bannerman	Seventh Doctor	Books / Audio
Frobisher the Whifferdill	Robert Jezek	Sixth and Seventh Doctors	Comics / Audios / Books
Gabby Gonzales	-	Tenth Doctor	Comics
Gus Goodman	-	Fifth Doctor	Comics
Gemma Griffin	Lizzie Hopley	Eighth Doctor	Audios
Samson Griffin	Lee Ingleby	Eighth Doctor	Audios
Oliver Harper	Tom Allen	First Doctor	Audios
Hex	Philip Olivier	Seventh Doctor	Audios / Books
Will Hoffman	Robert Curbishley	Sixth Doctor	Audios / Books
Phillipa 'Flip' Jackson	Lisa Greenwood	Sixth Doctor	Audios
Jason	Graeme Smith / David Bingham / Noel Sullivan	Third and Sixth Doctors	Stage / Audio
Jata	-	Twelfth Doctor	Comics
Jenny	Wendy Padbury / Charlie Hayes	Unknown Doctor	Stage / Audio
Angela Jennings	-	Sixth Doctor	Books
Jimmy	James Mathews / Joe Thompson	Unknown Doctor	Stage / Audio
John and Gillian	-	First and Second Doctors	Comics
John Jones	-	Eleventh Doctor	Comics
Sam Jones	-	Eighth Doctor	Books

Name	Actor	Doctor	Medium
Sir Justin	-	Fifth Doctor	Comics
Anji Kapoor	-	Eighth Doctor	Books
Elizabeth Klein	Tracey Childs	Seventh Doctor	Audios
Fitz Kreiner	Matt Di Angelo	Eighth Doctor	Books / Audios
Kroton the Cyberman	-	Eighth Doctor	Comics
Trix MacMillan	-	Eighth Doctor	Books
Heather McCrimmon	-	Tenth Doctor	Comics
Grant Markham	-	Sixth Doctor	Books
Mila	Jess Robinson / India Fisher	Sixth Doctor	Audios
Lucie Miller	Sheridan Smith	Eighth Doctor	Audios
Tara Mishra	-	Ninth Doctor	Comics
Hattie Munro	-	Twelfth Doctor	Comics
Sally Morgan	Amy Pemberton	Seventh Doctor	Audios
Alice Obiefune	-	Eleventh Doctor	Comics
Molly O'Sullivan	Ruth Bradley	Eighth Doctor	Audios
Olla	-	Seventh Doctor	Comics
Charley Pollard	India Fisher	Sixth and Eighth Doctors	Audios / Books
Majenta Pryce	-	Tenth Doctor	Comics
Mary Shelley	Julie Cox	Eighth Doctor	Audios
Helen Sinclair	Hattie Morahan	Eighth Doctor	Audio
Izzy Sinclair	Jemima Rooper	Eighth Doctor	Comics / Audios
Dr Evelyn Smythe	Maggie Stables	Sixth Doctor	Audios / Comics / Webcast
Ssard the Ice Warrior	-	Eighth Doctor	Comics / Books
Bernice Summerfield	Lisa Bowerman	Seventh Doctor	Books / Audio / Comics
Tibbsy	-	Twelfth Doctor	Comics

Name	Actor	Doctor	Medium
Stacy Townsend	-	Eighth Doctor	Comics / Books
Fey Truscott-Sade	-	Eighth Doctor	Comics
Mrs Wibbsey	Susan Jameson	Fourth Doctor	Audios
Cindy Wu	-	Tenth Doctor	Comics
Alex Yow	-	Twelfth Doctor	Audiobook
Brandon Yow	-	Twelfth Doctor	Audiobook
Zog	Stephanie Colburn	Third and Sixth Doctors	Stage / Books

COMPANION ROLL CALL: THE 1990s

DR GRACE HOLLOWAY
played by DAPHNE ASHBROOK

- *Doctor Who* appearance: *Doctor Who* (1996)

A familiar face on US television, Long Beach-born actress Daphne Ashbrook scored two firsts in *Doctor Who*. Not only was she the first and—to date—only American to be cast as a companion, she was also the first to lock lips with the Doctor. Prior to the 1996 TV movie, she appeared in many classic cult television shows including *The A-Team*, *The Fall Guy*, *Falcon Crest* and *Star Trek: Deep Space Nine*. In 2012, she joined the cast of *Hollywood Heights*, a new teenage drama for Nickelodeon.

Dr Grace Holloway was enjoying a performance of *Madame Butterfly* when she was called back to Walker General Hospital to operate on the victim of a gangland shooting. Grace resigned after losing her patient, only to discover that the man she'd seen die the previous night had regenerated into the Eighth Doctor. After helping defeat the Master, the Doctor offered to show Grace the universe, but the feisty surgeon refused.

And another thing: If the 1996 TV movie had resulted in a full series, producer Philip David Segal planned to bring Grace back as the ongoing companion.

KISSING COMPANIONS

'Trust me, it's this or go to your room and design a new screwdriver. Don't make my mistakes.'

The Doctor, *A Christmas Carol*

As a general rule, there's never any kissing in the TARDIS. Every now and then, however, things happen, and companions lock lips with the Doctor. Here's the full rundown of amorous allies:

- Nyssa (well, on the cheek)—*Terminus*
- Dr Grace Holloway—*Doctor Who*
- Captain Jack Harkness—*The Parting of the Ways*
- Rose Tyler—*The Parting of the Ways*, *New Earth* (sort of), *Journey's End* (sort of)
- Martha Jones—*Smith and Jones*
- Astrid Peth—*Voyage of the Damned*
- Donna Noble—*The Unicorn and the Wasp*
- Lady Christina de Souza—*Planet of the Dead*
- Amy Pond—*Flesh and Stone*
- Rory Williams—*Dinosaurs on a Spaceship*
- Clara Oswald—*The Snowmen*, *The Time of the Doctor*, *Face the Raven*

AND THE REST

It isn't just companions that get to snog the Doctor:

- Jeanne Antoinette Poisson, aka Madame de Pompadour, aka Reinette—*The Girl in the Fireplace*
- Jackie Tyler—*Army of Ghosts*
- Joan Redfern—*Human Nature / The Family of Blood*
- Marilyn Monroe (there was lipstick!)—*A Christmas Carol*
- River Song—*Day of the Moon*, *Let's Kill Hitler*, *The Wedding of River Song*, *The Name of the Doctor*
- Jenny Flint—*The Crimson Horror* (She wasn't happy about it.)
- Ada Gillyflower—*The Crimson Horror* (Well, an affectionate peck on the cheek, at least)
- Emma Grayling gets some air kisses—*Hide*
- As does Clara's Gran—*The Time of the Doctor*
- Tasha Lem—*The Time of the Doctor*
- Missy—*Dark Water*, *Death in Heaven*

COMPANION ROLL CALL: THE 2000s

█ ROSE TYLER
played by BILLIE PIPER

- First regular *Doctor Who* appearance: *Rose* (2005)
- Final regular *Doctor Who* appearance: *Journey's End* (2008)
- Final guest *Doctor Who* appearance: *The End of Time, Part Two* (2010)

Swindon-born Billie Piper joined the Sylvia Young Theatre School at the age of 12. Three years later, after modelling for a poster campaign for *Smash Hits* magazine, she was signed to Innocent Records and reached number one with her first single, *Because We Want To*, in 1998. In 2001, Billie retired from music and returned to acting in the BBC's 2003 retelling of Chaucer's *The Miller's Tale*. Following her departure from *Doctor Who*, Piper played Hannah Baxter in ITV2's *Secret Diary of a Call Girl* and made her stage debut in a tour of Christopher Hampton's *Treats* which ended in London's West End in 2007.

Shop assistant Rose Tyler unwittingly first met the Doctor on 1 January 2005, when she came across the dying Tenth Doctor. Less than three months later, the Ninth Doctor rescued her from Autons hiding in the basement of Henrik's department store. Accepting the last Time Lord's invitation to join him, Rose stayed on board the TARDIS until she was trapped in an alternative universe, seemingly for ever. However, when Davros threatened to destroy all of reality, Rose found a way to cross the dimensional divides. Piper returned to *Doctor Who* to play the Moment in 2013's *The Day of the Doctor*, while later work has included three series of dark horror drama *Penny Dreadful*. In 2017, Piper's acclaimed performance in *Yerma* at the Young Vic secured an Olivier Award for Best Actress.

And another thing: Billie Piper's performance as Rose won her the National Television Award for Most Popular Actress two years running.

▮ ADAM MITCHELL
played by BRUNO LANGLEY

- First regular *Doctor Who* appearance: *Dalek* (2005)
- Final regular *Doctor Who* appearance: *The Long Game* (2005)

Bruno Langley knew little of *Doctor Who* before being cast as the Ninth Doctor's would-be male companion—he even walked straight past the TARDIS set without knowing what it was. The actor's big break came in the *Linda Green* comedy series, although he would become better known as Todd Grimshaw, *Coronation Street*'s first gay character. Following Adam's expulsion from the TARDIS, Langley appeared in *The League of Gentlemen's Apocalypse* and *Dalziel and Pascoe,* before making a return to Weatherfield in 2011.

Adam met the Doctor and Rose in Henry van Statten's secret Vault in Utah. A self-professed genius, Adam had what he considered the best job in the world—cataloguing van Statten's collection of alien artefacts. After a solitary Dalek killed everyone in the Vault, Rose asked the Doctor if Adam could join them, although his adventures in Time and Space were cut short when he foolishly tried to send information about the future back to the 21st century.

And another thing: Adam had an info-spike computer interface implanted into his head as well as a complementary Vomit-O-Matic nano-termite device.

⬛ MICKEY SMITH
played by NOEL CLARKE

- First regular *Doctor Who* appearance: *Rose* (2005)
- Final regular *Doctor Who* appearance: *Journey's End* (2008)
- Last guest *Doctor Who* appearance: *The End of Time, Part Two* (2010)

Following appearances in *Metrosexuality* and *Judge John Deed*, Noel Clarke won the role of Danny Oldfield in *Casualty* in 2001. The following year saw him cast as Wyman Norris in an *Auf Wiedersehen, Pet* revival and in 2003 Clarke walked away with the Laurence Olivier Theatre Award for Most Promising Newcomer for *Where Do We Live* at the Royal Court. Following his departure from the TARDIS, Clarke made his writing debut with 2006's *Kidulthood*, also writing, directing and starring in its two sequels – *Adulthood* (2008) and *Brotherhood* (2016).

Brought up by his grandmother, Mickey Smith had known Rose since they were kids. When she left with the Doctor, Mickey was suspected of her murder, but that was nothing compared to the pain of realising that she was alive but would constantly flit in and out of his life whenever the TARDIS brought her back to Earth. His initial distrust of the Doctor eventually turned to respect and, after alerting the time travellers to strange goings on at Deffry Vale High School, Mickey joined the TARDIS crew. After fighting Cybermen in an alternative reality, Mickey eventually returned home where he married Martha Jones.

And another thing: Mickey is the first non-Caucasian companion in the history of the TV show (although the Doctor's first black companion was actually Sharon Davies who appeared in the *Doctor Who Weekly* comic strips from 1980 to 1981).

⬛ MARTHA JONES
played by FREEMA AGYEMAN

- First regular *Doctor Who* appearance: *Smith and Jones* (2007)
- Final regular *Doctor Who* appearance: *Journey's End* (2008)
- Final guest *Doctor Who* appearance: *The End of Time, Part Two* (2010)

Before *Doctor Who*, Freema Agyeman had made appearances in *The Bill*, *Casualty@ Holby City* and, most notably, as Lola Wise in *Crossroads*. Martha would go on to appear in *Torchwood* while Agyeman would become one of the stars of *Law and Order UK* in 2009 and the *Sex and the City* prequel *The Carrie Diaries* in 2013. From 2015–2018, Agyeman starred in the Netflix science-fiction series *Sense8*.

Martha Jones was training as a doctor at Royal Hope Hospital when it was transported to the Moon by the Judoon. Attracted to the Doctor from their first meeting, Martha eagerly joined the Time Lord on his travels but soon realised that he would never feel the same way. Exceptionally compassionate and loyal, Martha was repeatedly asked to go the extra mile, watching over him when he became human or travelling

the world for a year after the Master conquered the Earth. After leaving the Doctor, Martha was soon recruited to UNIT and finally achieved her doctorate.

And another thing: Freema Agyeman also appeared in the 2008 remake of Terry Nation's *Survivors*.

█ CAPTAIN JACK HARKNESS
played by JOHN BARROWMAN

- First regular *Doctor Who* appearance: *The Empty Child* (2005)
- Final regular *Doctor Who* appearance: *Journey's End* (2008)
- Final guest *Doctor Who* appearance: *The End of Time, Part Two* (2010)

Born in Scotland, John Barrowman was brought up in the USA, where he studied performing arts in San Diego—training that would bring him back to London and his West End stage debut in the musical *Anything Goes*. A skilled singer and dancer, Barrowman has played many stage roles, but his casting as Captain Jack Harkness in *Doctor Who* in 2005 turned him into an international screen star. As the lead in *Doctor Who* spin-off *Torchwood*, the actor has amassed a huge fan following, and has since appeared in TV series on both sides of the Atlantic including *Hustle*, *Desperate Housewives* and *Arrow*, released bestselling albums and books, and presented the Saturday night BBC entertainment show *Tonight's the Night*.

Captain Jack Harkness is a conman, rogue and 51st-century Casanova in one. Killed by the Daleks on the Game Station, the former Time Agent was brought back to life by Rose's Vortex powers, and this left him unable to die. Jack's adventures throughout time brought him to Cardiff and command of Torchwood, where he continued to defend the Earth.

And another thing: Jack came from the Boeshane Peninsula, where he claims his nickname was 'the Face of Boe'.

█ DONNA NOBLE
played by CATHERINE TATE

- First *Doctor Who* appearance: *The Runaway Bride* (2006)
- First regular *Doctor Who* appearance: *Partners in Crime* (2008)
- Final regular *Doctor Who* appearance: *Journey's End* (2008)
- Last guest *Doctor Who* appearance: *The End of Time, Part Two* (2010)

Catherine Tate is one of Britain's foremost character actors, with the award-winning *Catherine Tate Show* showcasing her talent for character comedy with creations such as the foul-mouthed Nan and schoolgirl Lauren. Following her guest appearance as Donna Noble in the 2006 *Doctor Who* Christmas special, Catherine was tempted back for a full-time TARDIS residency in 2008. She has since appeared in the film *Gulliver's*

Travels (2010) and in the American version of *The Office*. In 2016, Tate took her comedy creations—including Nan—on the road in a national stage tour of *The Catherine Tate Show Live*.

Donna Noble used to be oblivious to the world around her—she was more excited about a new flavour of crisps than a spaceship hanging over London on Christmas Day. Then she met the Doctor. Long after her first adventure in the TARDIS, Donna finally tracked the Doctor down and they travelled the universe together, encountering Adipose, Pyroviles, Vespiforms and Agatha Christie—but not Noddy. Without Donna, Davros and the Daleks would have destroyed reality itself, but there was a price. If Donna ever remembers her adventures with the Doctor, it will destroy her mind.

And another thing: In 2011, Catherine Tate and David Tennant reunited in the Wyndham Theatre's production of *Much Ado About Nothing*.

THE TENTH DOCTOR'S RULES FOR COMPANIONS
Rule 1: 'Don't wander off.'

HELLO SWEETIE

'Shall we do diaries, then? Where are we this time?'
River Song, *Silence in the Library*

We need to talk about River Song, the most timey-wimey of the Doctor's, erm, friends. She's not exactly a companion, but her significance in the Doctor's lives is vast. As time travellers, their shared encounters are experienced out of order, which can make it all a bit confusing—for everybody, including the Doctor. Here, in full, is the timeline of River Song, aka Melody Pond, aka Melody Malone, aka the Doctor's other half. Well, as far as we can tell at the moment, anyway.

- Born as Melody Pond on Demon's Run, the daughter of Amy and Rory (52nd century—*A Good Man Goes to War*)
- Kidnapped by Madame Kovarian and raised at Graystark Hall Orphanage on Earth by the Silence as a weapon to kill the Doctor (1960s—*Day of the Moon*)
- Shot as a young girl by Amy Pond in a Florida warehouse (1969—*The Impossible Astronaut*)
- Regenerates for the first time in a back alley in New York City (1970—*Day of the Moon*)
- Travels to Leadworth and, calling herself Mels, befriends young Amy and Rory so she can grow up with them (1990s–2000s—*Let's Kill Hitler*)
- Forces the Doctor to take her back to Berlin, 1938, to kill Adolf Hitler (2011—*Let's Kill Hitler*)
- Shot by Hitler, Mels regenerates into the woman who will become River Song (1938—*Let's Kill Hitler*)
- Attempting to complete the mission she was trained for, River tries to poison the Doctor. Shortly before the Doctor's death, she uses her remaining regenerations to save him. (1938—*Let's Kill Hitler*)
- Taken by the Doctor, Amy and Rory to the best hospital in the universe. When she wakes, she finds a police box-shaped diary next to her bed. (52nd century—*Let's Kill Hitler*)
- Enrols to study archaeology at the Luna University, gaining a Doctorate (52nd century—*Let's Kill Hitler*)
- Madame Kovarian returns, forcing River to complete the task she was trained to do (52nd century—*Closing Time*)
- At Lake Silencio, while wearing the NASA spacesuit, River fails to kill the Doctor (22 April 2011—*The Wedding of River Song*)
- This leads to all sorts of timey-wimey problems, involving Emperor Churchill, secret agents, the Silence and pyramids (22 April 2011, probably—*The Wedding of River Song*)
- River marries the Doctor—possibly (22 April 2011—*The Wedding of River Song*)
- The timeline is put right and River kills the Doctor at Lake Silencio (we'll explain later) (22 April 2011—*The Wedding of River Song*)
- Imprisoned at the Stormcage facility for killing the best man she's ever known. The Doctor immediately springs her to go on a date to Calderon, although it doesn't go to plan as two older versions of herself gate-crash the party—including a River from the future who is about to visit Darillium. (52nd century—*The Wedding of River Song, First Night, Last Night*)

- Continually breaks out of prison to have lots of exploits with the Doctor. These (possibly) include a picnic at Asgard, trips to Easter Island and the Bone Meadows, and other adventures involving the dam-building Jim the Fish, a euphonium, a biplane and Marilyn and a transmuted Queen of England. (52nd century—various)
- The Doctor throws River a surprise birthday party during the 1814 London Frost Fair. Stevie Wonder provides the tunes. (1814—*A Good Man Goes to War*)
- On the day Melody is taken from Demon's Run by Madame Kovarian, adult River arrives to say hi to her shocked mum and dad—Amy and Rory (52nd century—*A Good Man Goes to War*)
- A TARDIS-blue envelope arrives, summoning River to Lake Silencio where she witnesses herself killing the Doctor (22 April 2011—*The Impossible Astronaut*)
- Assists the Doctor in defeating the Silents' invasion of Earth (1969—*The Impossible Astronaut / Day of the Moon*)
- Back to prison at Stormcage. Big snog with the Doctor! (52nd century—*Day of the Moon*)
- Receives phone call from Winston Churchill at Stormcage, warning her that the TARDIS will explode (52nd century—*The Pandorica Opens*)
- Steals a Van Gogh painting from Starship UK (33rd century—*The Pandorica Opens*)
- Leaves a message for the Doctor on Planet One, then travels to Stonehenge on Earth and poses as Cleopatra to wait for the Doctor (AD 102—*The Pandorica Opens*)
- Opens the Pandorica (AD 102—*The Pandorica Opens*)
- Gets trapped in a time loop inside the TARDIS as it begins to explode (2010—*The Pandorica Opens*)
- With the universe dying around them, is rescued from the exploding TARDIS by the Doctor (1996—*The Big Bang*)
- Kills a stone Dalek and helps the Doctor sacrifice himself to restart the universe (1996—*The Big Bang*)
- Witnesses the wedding reception of her soon-to-be parents in Leadworth (2010—*The Big Bang*)
- Back to Stormcage (51st century)
- Recruited by the Church to investigate the starship *Byzantium* and its deadly cargo (51st century—*Time of the Angels / Flesh and Stone*)
- Summons the Doctor to help defeat the Weeping Angel in the hold of the *Byzantium* on the planet Alfava Metraxis (51st century—*Time of the Angels / Flesh and Stone*)
- Pardoned and becomes a professor of archaeology (51st century)

- Zips back to 1938 to investigate a suspected Weeping Angel invasion of New York. Sets up the Melody Malone Detective Agency and gets trapped due to temporal disturbances caused by the Angels. (1938—*The Angels Take Manhattan*)
- Not long after leaving Manhattan, River marries her associate Ramon, but wipes his memories of the matrimony when she started to find him annoying. Also hires a duffel coat-wearing minion by the name of Nardole. They get into the habit of 'borrowing' the TARDIS when the Doctor isn't looking, even going so far as to install a secret drinks cabinet. (*The Husbands of River Song*)
- Visits Darillium to dig up the wreckage of *Harmony and Redemption* (*The Husbands of River Song*)
- Hired by the Halassi to recover the most-valuable diamond in the universe from the brain of King Hydroflax. Now 200 years old, River marries Hydroflax to get near the precious stone, and plans to remove the King's head in an elaborate plan involving a crashed spaceship and a surgeon of dubious morals. The plan goes awry when the Doctor becomes involved. (5343—*The Husbands of River Song*)
- Is on the *Harmony and Redemption* when it crashes on Darillium in front of the Singing Towers. Awakes to be taken for dinner on Christmas Day where the Doctor gives her a modified version of his sonic screwdriver. The couple spend their last night together, a night that lasts 24 years. (*The Husbands of River Song*)
- Before leaving Darillium, River sends Nardole after the Doctor with instructions to "kick his arse" and prevent him from executing Missy (*Extremis*)
- Hired to lead an expedition to The Library, which has been invaded by the Vashta Nerada (51st century—*Silence in the Library*)
- At The Library, River meets the Tenth Doctor. She's shocked to see how young he is. For him, it is their first chronological meeting. For her, it's the last. (51st century—*Silence in the Library*)
- River Song dies, but the Doctor makes a computer back-up of her personality and memories, like a book on the shelf (51st Century—*Forest of the Dead*)
- River Song's stored consciousness communicates with Madame Vastra and finally says goodbye to her sweetie... Doesn't she? (*The Name of the Doctor*)

COMPANION ROLL CALL: THE 2010s

AMELIA (AMY) POND
played by KAREN GILLAN

- First regular *Doctor Who* appearance: *The Eleventh Hour* (2010)
- Final regular *Doctor Who* appearance: *The Angels Take Manhattan* (2012)

Karen Gillan developed a love of acting at an early age, and trained at the Italia Conti Academy of Theatre Arts. Following graduation, Karen worked successfully as a model, but acting remained her first love and TV roles soon came her way, including *The Kevin Bishop Show* and a small role in the 2008 *Doctor Who* episode *The Fires of Pompeii*. Two years later she beat fierce competition to win the role of companion Amy Pond opposite Matt Smith as the Eleventh Doctor. Karen left *Doctor Who* in 2012, moving on to an already lengthy list of movie and television roles, including TV drama *We'll Take Manhattan*, the comedy series *A Touch of Cloth* and the film *Not Another Happy Ending* (2013). Gillan made the leap to Hollywood with her role as Nebula in the smash-hit Marvel movie *Guardians of the Galaxy* in 2013 and its 2017 follow up, along with *Jumanji: Welcome to the Jungle* (2017).

Amelia Pond was the girl who waited... waited for the raggedy man who had appeared in her garden when she was just a child. Amy's travels with the Doctor were everything she'd hoped for and more, and when her fiancé Rory joined the TARDIS

crew, her life was complete. She may have been a trap set by the Doctor's enemies to prevent the universe being destroyed, but that didn't matter. Amy was never going to give up her adventures with the Doctor—something terrible would have to tear them apart. Something terrible, like a Weeping Angel…

And another thing: Karen Gillan's mum, a massive *Doctor Who* fan, tried to persuade her to change her mind and stay on the TARDIS.

🚪 RORY WILLIAMS
played by ARTHUR DARVILL

- First regular *Doctor Who* appearance: *The Eleventh Hour* (2010)
- Final regular *Doctor Who* appearance: *The Angels Take Manhattan* (2012)

Thomas Arthur Darvill's love of performing stemmed from accompanying his mother on tours around the country with the Cannon Hill Puppet Theatre. He landed a job as an in-vision continuity announcer for ITV children's television in 2000, before moving on to stage roles and then TV, including *Little Dorrit* in 2008. Following his two-and-a-half year stint as Rory in *Doctor Who*, Arthur appeared opposite Billie Piper's husband Laurence Fox on the London stage in *Our Boys*. Like co-stars Karen Gillan and Matt Smith, Darvill made the move to Hollywood in 2016 when he starred as another time traveller, Rip Hunter, in the hit DC superhero series *Legends of Tomorrow*.

Nurse Rory Williams was always in love with Amy Pond. It took a while for the penny to drop for Amy, but she eventually cottoned on, and fell in love with him. After a rocky start involving the near-end of the universe, Rory was delighted when he finally married Amy, and they remained friends and companions of the Doctor as husband and wife. Rory's time with the Doctor was only brought to an end when a Weeping Angel blasted him back in time, but he would always be with Amy Pond, the girl he waited for.

And another thing: Arthur Darvill has continued his *Doctor Who* connections appearing in ITV's *Broadchurch* (2013), written by *Who* writer Chris Chibnall and starring David Tennant.

🚪 CLARA OSWALD
Played by JENNA COLEMAN

- First regular *Doctor Who* appearance: *The Snowmen* (2012)
- Last regular *Doctor Who* appearance: *Hell Bent* (2015)
- Final guest *Doctor Who* appearance: *Twice Upon A Time* (2017)

Blackpool-born Jenna-Louise Coleman took dancing lessons from the age of four, making her professional stage debut in a production of *Summer Holiday* aged 10.

Side-stepping drama school, in 2005 she won the role of Jasmine Thomas in popular soap opera *Emmerdale* at the age of 19. After leaving the world of soap, Coleman appeared in *Waterloo Road* and other TV dramas before winning the coveted role of *Doctor Who* companion Clara Oswald. During her time with *Doctor Who*, the actress adopted the professional name Jenna Coleman, and has gone on to great success, starring in the title role in the lavish ITV drama *Victoria*, about the life of young Queen Victoria.

Clara Oswald was the impossible girl, her destiny to save the Doctor. After being given a phone number by a mysterious woman, Clara was flung headlong into the world of the Doctor. Following a series of terrifying adventures, on Trenzalore she willingly flung herself into the Doctor's corrupted timeline to stop the Great Intelligence from wiping the Time Lord from existence. Scattered through time, fragments of Clara were present at key moments in the Doctor's lives, including Dalek convert Oswin and Victorian governess Clara. With the Doctor saved, Clara found herself travelling with a new incarnation of the Time Lord...

And another thing: Jenna Coleman's movie debut was a small role in Marvel's superhero adventure *Captain America: The First Avenger* (2011).

◉ NARDOLE
Played by MATT LUCAS

- First regular *Doctor Who* appearance: *The Husbands of River Song* (2015)
- Last regular *Doctor Who* appearance: *The Doctor Falls* (2017)
- Last guest *Doctor Who* appearance: *Twice Upon A Time* (2017)

Matt Lucas is one of the Britain's most versatile actors. Best known for his collaborations with David Walliams on *Rock Profiles, Come Fly with Me* and the phenomenally successful *Little Britain*, he achieved cult status as George Dawes, the score-keeping, drum-playing man-baby in the panel show Shooting Stars. Lucas has performed on stage (notably as Thérnardier in a stint in *Les Misérables*), in Hollywood movies (including *Alice in Wonderland* and *Bridesmaids*), and has presented his own shows such as *The Matt Lucas Awards*. In 2005 he appeared with soon-to-be Tenth Doctor David Tennant in Russell T Davies' *Casanova* among many other screen appearances.

A former nefarious employee of Dr River Song, Nardole was beheaded by King Hydroflax, but was later reassembled by the Doctor. The Doctor and Nardole had a spiky, master-and-servant relationship, although Nardole never shied away from telling the Doctor what he thought, and kept him focused on the task of guarding Missy's vault. Mostly. From a life of crime to saving the universe, Nardole was a better man from having known the Doctor.

And another thing: Matt Lucas and David Walliams appeared as their Little Britain characters Andy and Lou in a 2007 episode of Australian soap *Neighbours*.

BILL POTTS
Played by PEARL MACKIE

- First regular *Doctor Who* appearance: *The Pilot* (2017)
- Final regular *Doctor Who* appearance: *Twice Upon A Time* (2017)

From the age of five, Pearl Mackie was desperate to act. Eventually studying drama at Bristol University, she then attended the Bristol Old Vic's two-year foundation course, where she graduated in 2010. Prior to *Doctor Who*, Mackie's work has taken in theatre and short films. In 2014, she made her television debut in an episode of BBC One's *Doctors*. The following year, while appearing in a year-long run of the National Theatre's acclaimed production of *The Curious Incident of the Dog in the Night-Time*, Mackie successfully auditioned for the role of companion Bill Potts in *Doctor Who*.

Orphan Bill Potts was a down-to-earth kitchen assistant at St Luke's University. She served chips, but was desperate to learn and was taken on as a student by the eccentric lecturer called the Doctor. Naturally curious, Bill often said the wrong thing, but thrived during her travels with the Doctor, and struck up a firm friendship with Nardole after a rocky start. There were traumatic times ahead for Bill, but she was determined to enjoy every last second of her time in the TARDIS.

And another thing: Pearl Mackie is the granddaughter of the late Anthony Mackie, who wrote the acclaimed TV drama *The Naked Civil Servant*, starring future War Doctor John Hurt.

THEY KEEP KILLING RORY

It's very unusual that a companion of the Doctor is killed in action. But Rory Williams seems to make a habit of it—except, he kept coming back to life.

1. *Amy's Choice*—killed in a cloud of green gas by Mrs Poggit (an alien Eknodine), though this was in a dream world.
2. *Cold Blood*—blasted by a Silurian's energy weapon, then absorbed by the crack in time and erased from existence. Rory later came back to life as an Auton duplicate of a Roman Centurion in AD 102. Which also died.
3. *Day of the Moon*—shot down by US agents and taken away in a body bag. But it turned out to be a ruse and he was all right really.

4. *The Doctor's Wife*—aged to death in the corridors of the TARDIS, a trick played by the evil entity House several times.
5. *The Angels Take Manhattan*—leapt to certain death from an apartment block rooftop, erasing the time line and arriving back in 2012.
6. *The Angels Take Manhattan*—blasted back in time by a Weeping Angel, eventually dying for real at the age of 82 in the 1980s. The discovery of his gravestone caused him to be caught by the Angel in the first place. Wibbly-wobbly timey-wimey.

> **THE ELEVENTH DOCTOR'S RULES FOR COMPANIONS**
> Rule 1: 'The Doctor lies.'
> Rule 7: 'Never run when you are scared.'
> Rule 27. 'Never knowingly be serious.'
> Rule 408. 'Time is not the boss of you.'

OCCASIONAL COMPANIONS

Every now and then the Doctor meets that special someone on his wanderings. They may not leave with him, but they make as much impact as his regular companions.

∎ SARA KINGDOM played by JEAN MARSH
Sara was a Space Special Security agent sent by Mavic Chen, the treacherous Guardian of the Solar System, to assassinate the Doctor and his friends. After killing her own brother, agent Bret Vyon, Sara realised the error of her ways and helped the Doctor defeat Chen and his allies the Daleks. She was killed by the Daleks' Time Destructor.

∎ ASTRID PETH played by KYLIE MINOGUE
Astrid was a waitress aboard the doomed *Titanic* star cruiser. When asteroids scuppered the ship, she helped the Doctor get survivors to safety and sacrificed herself to stop the villainous Max Capricorn.

∎ JACKSON LAKE played by DAVID MORRISSEY
When 19th-century mathematics tutor Jackson took his family to Victorian London, a chance encounter with the Cybermen changed his life for ever. When his wife was

killed, Jackson attempted to rescue his son by discharging an infostamp containing data about the Doctor. Instead, the information, stolen from the Daleks, flooded his mind. Unable to accept the loss of his family, Jackson retreated into a fugue state, believing that he was a newly regenerated incarnation of the Time Lord. Adopting his very own companion, Rosita, Jackson encountered the real Doctor and eventually faced the truth about himself, and was reunited with his son.

◉ LADY CHRISTINA DE SOUZA played by MICHELLE RYAN

A professional thief who stole for the thrill of the chase, Christina stole the Cup of Athelstan from the International Gallery in London. Running from the police, she jumped onto the number 200 bus but found herself transported to a distant planet as the vehicle plunged through a wormhole. Luckily for Christina—and the other passengers—the Doctor was also on board.

◉ CAPTAIN ADELAIDE BROOKE played by LINDSAY DUNCAN

A survivor of the 2009 Dalek invasion of Earth, Adelaide Brooke dreamt of exploring space. Following stints at Cambridge and Rice Universities, she joined NASA and became the first woman to land on Mars. 17 years later, in 2058, she established the first human colony, Bowie Base One, on the red planet. According to established history the colony was lost the following year. When the Tenth Doctor landed on the very day Bowie Base One was due to be destroyed—a fixed point in time—the Doctor decided to play god and returned Adelaide to Earth. Appalled by the Doctor's flawed arrogance, Adelaide took her own life, thus protecting future history. Stunned, the Doctor realised that he'd finally gone too far.

◉ WILFRED MOTT played by BERNARD CRIBBINS

The Doctor first met Donna Noble's grandfather during a transmat outing from the *Titanic*. The newspaper seller, who had served in the army as a young man but was proud never to have taken a life, missed Donna's first wedding due to a bout of Spanish flu. He met the Time Lord again after his granddaughter visited home during her travels in the TARDIS. In December 2010, Wilf started having nightmares about the Master and, believing the Doctor could help, formed the 'Silver Cloak', a crack team of OAPs, to find the Time Lord. Together, the two old soldiers stopped the return of Gallifrey, although Wilf become trapped in a radiation booth. The Doctor saved him, absorbing a fatal dose of radiation that triggered his regeneration.

◉ HANDLES voiced by KAYVAN NOVAK

Picked up by the Doctor at the Maldovarium Market, Handles was a battered Cyberman head cleared of all its organic components, with only its basic computer intelligence remaining. The Doctor used Handles as a personal assistant while investigating the

mysterious signal above Trenzalore. Handles stayed with the Doctor during the first 300 years of the Time Lord's self-inflicted exile on the planet, until his systems finally gave up the ghost. Spending three centuries beside the Doctor technically makes Handles the Doctor's longest-serving companion.

FAMILY TIES

'I was going to do shepherd's pie. All of us, a proper sit down…'

Jackie Tyler, *World War Three*

They say you can pick your friends but you can't pick your family—and some of the Doctor's companions would travel to the other end of time to avoid a family reunion. From Jackie Tyler to Lavinia Smith, we have seen some formidable on-screen relatives since 1963—starting with the Doctor himself. Here's a list of them—formidable or not.

Companion	Relative	What relation?	Played by
Susan Foreman	The Doctor	Grandfather	William Hartnell
Dodo Chaplet	Anne Chaplet	Ancestor (possibly)	Annette Robinson
Victoria Waterfield	Edward Waterfield	Father	John Bailey
Brigadier Lethbridge-Stewart	Doris	Second wife	Angela Douglas
	Kate Stewart	Daughter	Jemma Redgrave

Companion	Relative	What relation?	Played by
Jo Grant	Clifford Jones	Husband	Stewart Bevan
	Santiago Jones*	Grandson	Finn Jones
Sarah Jane Smith	Eddie Smith*	Father	Christopher Pizzey
	Barbara Smith*	Mother	Rosanna Lavelle
	Lavinia Smith	Aunt	Mary Wimbush
	Luke Smith	Adopted son	Tommy Knight
	Sky *	Adopted daughter	Sinead Michael
Leela	Sole	Father	Colin Thomas
	Andred	Husband	Chris Tranchell
Adric	Varsh	Brother	Richard Willis
Nyssa	Tremas	Father	Anthony Ainley
	Kassia	Stepmother	Sheila Ruskin
Tegan	Vanessa	Aunt	Delore Whiteman
	Andrew Verney	Grandfather	Frederick Hall
Turlough	Malkon	Brother	Edward Highmore
Peri	Howard Foster	Stepfather	Dallas Adams
Ace	Kathleen Dudman	Grandmother	Cory Pullman
	Audrey Dudman	Mother	Aaron Hanley (as baby)
Rose Tyler	Jackie Tyler	Camille Coduri	Mother
	Pete Tyler	Shaun Dingwall	Father
Adam Mitchell	Mrs Mitchell (presumably)	Mother	Judy Holt
Mickey Smith	Martha Jones	Wife	Freema Agyeman
	Rita-Anne Smith	Grandmother	Mona Hammond
Donna Noble	Geoff Noble	Father	Howard Attfield
	Sylvia Noble	Mother	Jacqueline King
	Wilfred Mott	Grandfather	Bernard Cribbins
	Shaun Temple	Husband	Karl Collins

Companion	Relative	What relation?	Played by
Martha Jones	Mickey Smith	Husband	Noel Clarke
	Francine Jones	Mother	Adjoa Andoh
	Clive Jones	Father	Trevor Laird
	Tish Jones	Sister	Gugu M'batha-Raw
	Leo Jones	Brother	Reggie Yates
	Adeola Ashodi	Cousin	Freema Agyeman
Jackson Lake	Caroline Lake	Wife	Lara Goodison
	Frederick Lake	Son	Tom Langford
Adelaide Brooke	Mr Brooke	Father	Charlie De-Ath
	Emily Brooke	Daughter	Lily Bevan
	Susie Fontana Brooke	Granddaughter	Jenette de Vlieger
Rory Williams	Amy Pond	Wife	Karen Gillan
	Brian Williams	Father	Andy Elvin / Mark Williams
	Mrs Williams	Mother	Helen Irving
	River Song	Daughter	Alex Kingston
Amy Pond	Rory Williams	Husband	Arthur Darvill
	Augustus Pond	Father	Halcro Johnston
	Tabetha Pond	Mother	Karen Westwood
	Sharon	Aunt	Susan Vidler
	Melody Pond (aka Mels Zucker, River Song and Melody Malone)	Daughter	Sydney Wade / Maya Glace-Green / Nina Toussaint-White / Alex Kingston
Clara Oswald	Elena 'Ellie' Alison Ravenwood	Mother	Nicola Sian
	Dave James Oswald	Father	James Buller
	Linda Oswald	Step-Mother	Elizabeth Rider
	Name unknown	Gran	Sheila Reid

Companion	Relative	What relation?	Played by
Bill Potts	Name unknown	Mum	Rosie Jane
	Moira	Foster Mum	Jennifer Hennessy

* These relatives all appear in episodes of *The Sarah Jane Adventures* rather than *Doctor Who*.

EXTENDED (UNSEEN) FAMILIES

Some of the companions' family members have popped up on screen, and there have also been many mentions of relatives that have never appeared.

- **Vicki**—Her mother died in 2493 on Earth, while her father was murdered by Bennett on the planet Dido. (*The Rescue*)
- **Dodo**—She had a great aunt who she claimed wouldn't miss her. (*The Massacre*)
- **Victoria**—Her father claimed she looked just like her late mother at the same age. (*The Evil of the Daleks*)
- **The Brigadier**—He finally married Doris, but it's implied the Brig was previously married, to the mother of his daughter, Kate. (*The Power of Three*)
- **Jo Grant**—Jo's uncle pulled some strings to get her the job at UNIT. (*Terror of the Autons*)
- **Tegan**—Her father owned a farm in Australia—which was hardly the Outback, according to Auntie Vanessa. (*Logopolis*)
- **Peri**—She and her stepfather were on holiday with her mother, who had taken up with a Mrs van Gysegham. (*Planet of Fire*)
- **Mickey**—Mickey's mum couldn't cope after he was born and after his dad 'wandered off' he was brought up by his gran. (*Rise of the Cybermen*) His mum obviously remained a part of his life, as Rose worried about how she would tell her that Mickey had died during the Auton invasion. (*Rose*)
- **Captain Jack**—Jack's brother, Gray, appears in an episode of spin-off series *Torchwood*, though he's never mentioned in *Doctor Who*.
- **Lady Christina de Souza**—Christina's aristocratic father lost the family fortune after investing his money in the Icelandic banks. (*Planet of the Dead*)
- **Captain Adelaide Brooke**—During the Dalek invasion of Earth in 2009, Adelaide Brooke's father went to search for her missing mother. She never saw her parents again. (*The Waters of Mars*)
- **Amy and Rory**—In an unmade, but scripted scene, Rory's father Brian discovers that Amy and Rory adopted a son, Anthony, in 1946. Arthur Darvill recorded a voiceover for this scene which was featured on the BBC *Doctor Who* website (www. bbc.co.uk/doctorwho).

REASONS FOR LEAVING THE DOCTOR

Companion	Love	Death	Chance To Go Home	Forced To Leave	Helping Others	It Stopped Being Fun	Reason For Leaving
Susan	X			X			Locked out of the TARDIS to create new life with David Campbell
Ian			X				To return to 1960s Earth
Barbara			X				To return to 1960s Earth
Vicki	X						To marry Troilus
Steven						X	To rebuild the civilisation of the Elders and Savages
Katarina		X					Sacrificing herself to save the Doctor and Steven
Sara Kingdom		X					Aged by the Daleks' Time Destructor
Dodo			X				To stay in swinging London
Polly			X				To stay in her own time
Ben			X				To stay in his own time
Victoria						X	To stay with Frank and Maggie Harris
Jamie				X			Returned to his own time by the Time Lords
Zoe				X			Returned to her own time by the Time Lords
Liz						X	To return to Cambridge University
Jo	X						To marry Cliff Jones
Sarah Jane				X			Abandoned by the Doctor when he's summoned to Gallifrey
Harry			X				To rejoin UNIT

Companion	Love	Death	Chance To Go Home	Forced To Leave	Helping Others	It Stopped Being Fun	Reason For Leaving
Leela	X						To stay with Andred on Gallifrey
K-9 Mark I					X		To look after his mistress Leela
Romana					X		To free the Tharils from slavery
K-9 Mark II					X		To help Romana free the Tharils
Adric		X					Died crashing into prehistoric Earth
Nyssa					X		To find a cure for Lazar's disease
Tegan						X	Sick of death
Turlough			X				To return to Trion, pardoned for his political crimes
Peri	X			X			To marry King Yrcanos. Verumic!
Mel					X		To keep Sabalom Glitz on the straight and narrow
Rose	X			X			Trapped in a parallel universe
Adam				X			Kicked out of the TARDIS for trying to profit from future tech
Mickey			X		X		To fight the Cybermen in a parallel universe. Later returned home for a brand new life
Jack		X			X		Left for dead on the Game Station, though he came back to life. Later left the Doctor to return to running Torchwood
Martha					X		To help her family after their treatment by the Master. Later left the Doctor to return to UNIT
Donna				X			To live her life after the Doctor wiped her memory
Rory				X			Transported to the past by a Weeping Angel
Amy	X			X			Sacrificing herself to a Weeping Angel to be with Rory

Companion	Love	Death	Chance To Go Home	Forced To Leave	Helping Others	It Stopped Being Fun	Reason For Leaving
Clara		X					Clara sacrificed herself to save Rigsy, although thanks to a Gallifreyan Extraction Chamber, the last woman in the universe and a stolen TARDIS, she takes the long way round to her eventual demise.
Nardole					X		The Doctor asked Nardole to help survivors of a colony ship escape advancing Cybermen.
Bill		X					Thinking the Doctor was dead, the resurrected Bill left to explore the universe with her dream girl, Heather.

FOUR

A CARNIVAL
OF MONSTERS

'There are some corners of the universe which have bred the most terrible things. Things which act against everything we believe in. They must be fought.'
The Doctor, *The Moonbase*

Yes, we all love the Doctor, but we love the monsters as well. Welcome to the *Who-ology* catalogue of Cybermen, Daleks and other foul creatures.

MONSTROUS FIRST LINES

First impressions last. If you want to cut it at the top flight of *Doctor Who* monsters, that all-important dramatic first line is an absolute must.

THE DALEKS
'You will move ahead of us and follow my directions. This way. Immediately.' *The Daleks*

THE CYBERMEN
'They will not return. It is unimportant now.' *The Tenth Planet*

THE ICE WARRIORS
'Varga.' *The Ice Warriors*

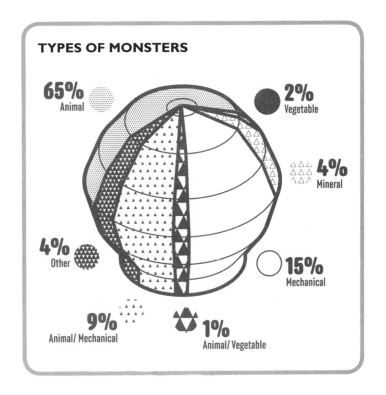

TYPES OF MONSTERS

65% Animal

2% Vegetable

4% Mineral

4% Other

15% Mechanical

9% Animal/ Mechanical

1% Animal/ Vegetable

THE SILURIANS
'Why have you come?' *Doctor Who and the Silurians*

THE SEA DEVILS
'This is our planet. My people ruled the Earth when man was only an ape.' *The Sea Devils*

THE SONTARANS
'Peace. Fear not. I shall not harm you.' *The Time Warrior*

THE OOD
'We must feed.' *The Impossible Planet*

THE JUDOON
'Bo so fo do no cro blo co so ro.' *Smith and Jones*

THE SILENCE
'Joy. Her name was Joy. Your name is Amelia. You will tell the Doctor.' *The Impossible Astronaut*

ABSENCE OF THE MONSTERS

Right from the start, BBC executives decreed that there should be 'no bug-eyed monsters' in *Doctor Who*. The success of the Daleks just a few short weeks into the programme proved they had been wrong. While it's almost impossible to imagine *Doctor Who* without monsters, a large number of stories feature no creatures at all, bug-eyed or otherwise.

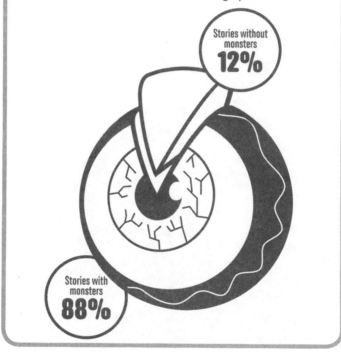

Stories without monsters
12%

Stories with monsters
88%

RETURNING MONSTERS

'You can always judge a man by the quality of his enemies.'
The Doctor, *Remembrance of the Daleks*

You can't keep a good monster down. No matter how many times the Doctor defeats them, some aliens just keep coming back for more.

Monsters	Stories	Cameos
Daleks	26	13
Cybermen	17	9
Sontarans	10	4
Silurians	8	5
Ice Warriors	6	2
Yeti and the Great Intelligence	5	1
Autons	4	1
Cybermats	4	0
Ood	3	5
Weeping Angels	3	3
Zygons	3	0
Slitheen	2	2
Ogrons	2	1
Sea Devils	2	1
The Silence	3	2
Macra	2	1
Clockwork Droids	2	0
The Mara	2	0
Sil and the Mentors	2	0
Judoon	1	6

THE SILURIANS

'They're not aliens. They're Earth-liens. Once known as the Silurian race, or, some would argue, Eocenes, or Homo reptilia. Not monsters, not evil. Well, only as evil as you are. The previous owners of the planet, that's all.'

The Doctor, *The Hungry Earth*

Millions of years ago, a race of bipedal intelligent reptiles ruled planet Earth. Possessing technology far beyond that of modern man, the Silurians were capable of space flight and developed sophisticated energy weapons. When a rogue planet was discovered entering the solar system, Silurian scientists predicted that the Earth would be ravaged by its passing. While some Silurians ventured into space in huge arks, the majority of Homo reptilia entered cryogenic sleep to escape the cataclysm. The planet, meanwhile, was drawn into Earth's orbit, becoming the Moon. The Silurians slept on and, in their absence, the apes they had considered vermin evolved into the human race.

The Doctor first encountered the Silurians when a hibernation nest reactivated beneath Wenley Moor in Derbyshire. Disgusted that the very apes that had ravished the crops in prehistoric times had infested their planet, the Silurians unleashed a biological plague designed to wipe humanity from the Earth.

Other Silurian bases were discovered beneath the London of 1888 and the Welsh village of Cwmtaff 132 years later, the latter sent back into cryo-sleep for another thousand years in the hope that humans will be ready to share Earth when the Silurians are finally revived. Peace between the two species will always be difficult, however. A faction of Silurians led by Icthar attempted to provoke a nuclear war between the humans of 2084 to regain control of Earth. It is currently unknown how many dormant Silurian cities lie beneath the surface.

DINOSAURS IN DOCTOR WHO

Story	Type of dinosaurs
Doctor Who and the Silurians	Tyrannosaurus rex
Invasion of the Dinosaurs	Tyrannosaurus rex
	Stegosaurus
	Triceratops
	Apatosaurus (referred to as Brontosaurus at the time)
Mark of the Rani	Tyrannosaurus rex
Dinosaurs on a Spaceship	Tyrannosaurus rex
	Stegosaurus
	Triceratops
	Velociraptor
Deep Breath	Tyrannosaurus rex

OTHER PREHISTORIC CREATURES

Pterodactyls, one of which attacks the Doctor and Sarah in *Invasion of the Dinosaurs*, are considered vermin in the Hyde Park of *The Wedding of River Song* and are on board the Silurian Ark in *Dinosaurs on a Spaceship*. Pterodactyls are not dinosaurs.

Red Leeches were parasitical creatures that blighted the Silurian people some 65 million years ago. Requiring salt to survive, the Leeches produced a deadly poison.

DESIGNING DINOS

BERTRAM THE FRIENDLY MONSTER

The rubber tyrannosaur-like costume seen in *Doctor Who and the Silurians* was made by visual effects assistant Anna Braybrooke. It was operated by visual effects assistant Bertram A Collacott and listed as 'Bertram, the Friendly Monster' on the script cast lists, played by 'himself'. Oxygen had to be pumped into the suit during performances.

PREHISTORIC PUPPETS

The dinosaurs featured in *Invasion of the Dinosaurs* caused the production team a great deal of trouble. Original plans had been to bring the creatures to life by means of stop-frame animation, similar to that used in the films of Ray Harryhausen. When budget restrictions ruled this out, it was decided to go for rod- and cable-controlled puppets. Five full-body models were made plus a large T-Rex head for close ups and a pterodactyl hand puppet, and these were contracted out to a model-making company. The producer was less than happy with the result, but time restraints meant that there was no option but to go with the stiff and inarticulate creatures.

DIGITAL DINOS

When prehistoric monsters returned to *Who* with *Dinosaurs on a Spaceship*, all eyes were on The Mill, the digital wizards who had handled *Doctor Who*'s digital effects since 2005. The team sat down with writer Chris Chibnall and discussed which dinosaurs to use, even toying with the notion of creating a brand new species never seen before. This idea was eventually dropped. They also gave Chibnall three rules to make the job of integrating the dinosaurs with the real-life sets and actors a little easier—when writing he had to remember the three 'f's: no fur, no flocking and no feathers! Physical versions of Tricey the Triceratops and a pterodactyl were also built by Millennium FX. The pterodactyl only took two weeks to construct, but Tricey was more tricky, racking up six weeks in the workshop.

MONSTER MAKER— THE BLUFFER'S GUIDE TO…

TERRY NATION

- Full Name: Terry Joseph Nation
- Born: 8 August 1930, Cardiff, Wales
- Died: 9 March 1997, Los Angeles, California, USA
- Famous for: Creating the Daleks.
- Came to London in 1955 looking to make it as a stand-up comedian. Failed miserably. A talent scout told him: 'Son, the jokes are funny—it's you that's not!'
- Got his big break writing an episode of *The Goon Show* for comedian Spike Milligan. The show was never recorded but Milligan's scriptwriting agency signed him immediately. Went on to write for Frankie Howerd, Eric Sykes, Peter Sellers and Tony Hancock.
- Was invited to write his first *Doctor Who* adventure—*The Daleks*—following success with stories written for ABC's *Out of This World* anthology series in 1962.
- Would write a further eight Dalek stories, plus *The Keys of Marinus* and *The Android Invasion*, as well as collaborating on the two Dalek feature films of the 1960s, the *Curse of the Daleks* stage play, and various books and annuals.
- Other notable works: Wrote 13 episodes of *The Saint* between 1964 and 1968. Contributed six episodes to *The Avengers*. Script edited *The Avengers* and *The Baron*. Acted as Story Consultant on *The Persuaders*. Created *Blake's 7* and *Survivors*. Produced and wrote for US adventure series *MacGyver*.

THE LIVES AND DEATHS OF DAVROS

BIRTH AND NEAR-DEATH

Born at the end of the thousand-year war between the Thals and the Kaleds, the young Davros finds himself trapped in a field of handmines. He is rescued by a stranger, who gives him a sonic device. Years later, Davros becomes a brilliant scientist, quickly rising through the ranks of the Kaled Elite Scientific Corps. Crippled and blinded in

a terrible laboratory accident, the now disfigured scientist desperately clings to life. Even as his internal organs fail, Davros fashions himself a mobile life-support system complete with a super-optic bionic eye, a fatigue eliminator removing the need for sleep and a mechanical heart and lungs. His injuries are so severe that Davros would die within thirty seconds if his new implants failed.

THE BIRTH OF THE DALEKS
Davros eventually becomes the head of the Scientific Elite and proceeds to experiment on Kaled DNA. Fifty years after his accident, he realises that neutronic radiation has begun to mutate the Kaleds themselves. Accelerating the process, he creates a conscience-free creature, which he places in the very first Dalek casing. When the Kaled leaders threaten an investigation into Davros's work, the scientist helps the Thals launch a full-scale nuclear attack on the Kaled dome, committing genocide against his own people.

EXTERMINATION
Davros hasn't bargained on his progeny's ruthlessness. Convinced of their own superiority, the Daleks exterminate their creator. But Davros isn't killed so easily. His secondary life-support system kicks in, placing him in a state of suspended animation.

RESURRECTION
Thousands of years later, the Daleks return to Skaro in search of their creator. Now almost completely robotic, they are locked in stalemate with the android Movellans. Believing that Davros can give them the edge, they revive the scientist, only to be foiled once again by the Doctor. Davros is cryogenically frozen and taken back to Earth to stand trial for his crimes against the entire universe.

IMPRISONMENT AND RELEASE
Ninety years later, the Daleks once again liberate Davros, this time from his cryogenic cell in an Earth prison station. At the mercy of a Movellan virus, the depleted children of Skaro task Davros with creating a cure and the scientist wastes no time in using the opportunity to regain control of his creations. Ultimately unsuccessful, Davros escapes even as he begins to show the first symptoms of his newly created Movellan virus strain.

DALEKS OF THE DEAD
Curing himself of the Movellan plague, Davros manages to install himself at the Tranquil Repose cryogenic funeral home on Necros as the self-appointed 'Great Healer'. Unbeknown to the grieving families, Davros begins mutating the remains of the near-dead humans into Daleks, creating a high-protein foodstuff from the leftovers. Even though he has

all but wiped out famine, the employees of Tranquil Repose shop him to the Daleks who take him back to Skaro for trial.

EMPEROR DAVROS

Somehow Davros manages to perform a coup on Skaro, becoming Emperor of a new breed of Imperial Daleks. His continued genetic tinkering causes a civil war and when he attempts to replicate Gallifrey's time-travel experiments Davros is tricked into destroying Skaro's sun by the Seventh Doctor. Abandoning his Imperial flagship, Davros flees in an escape pod.

THE JAWS OF DEATH

In the first year of the Time War, Davros leads the Daleks into battle at the Gates of Elysium but is thought dead when his command ship flies into the jaws of the Nightmare Child. He is rescued by Dalek Caan and creates a new race of Daleks from his own flesh. Now completely insane, and once again imprisoned by his creations, he plans to destroy the universe by use of a reality bomb. Believed dead when the Crucible is destroyed, he escapes to a renewed Skaro, surviving by leeching power from every Dalek on the planet.

Following a failed attempt to trick the Doctor into transferring his regeneration energy to the Dalek army, Davros is killed as the Dalek city sinks into its own sewer system.

Or is he?

BRINGING DAVROS TO LIFE

The creator of the Daleks has been played by four actors:

█ **Michael Wisher** *Genesis of the Daleks*
After a suggestion that Davros be based on Dan Dare's green-skinned arch-enemy the Mekon, Wisher's mask was created before the actor had been cast. Wisher's own teeth were blackened to suggest decay and his voice passed through a ring modulator to give it a Dalek edge. The actor reportedly based Davros's intonation on that of the philosopher Bertrand Russell.

█ **David Gooderson** *Destiny of the Daleks*
Wisher was unavailable, so David Gooderson was cast as Davros but the budget wouldn't run to a new mask. The badly damaged original had been on display at *Doctor Who* exhibitions in Longleat and Blackpool, and it was in such a state of disrepair that a cleaner even threw it away one night after shooting, believing it was rubbish.

Terry Molloy *Resurrection of the Daleks*
When Terry Molloy was cast as Davros in 1984, budget was allocated to the creation of a completely new mask. While it was undoubtedly more flexible than the original, Davros's new haggard visage was soon dubbed 'Ena Sharples' by the crew after the popular character from *Coronation Street* in the 1960s and 1970s. Molloy would return for two further stories, *Revelation of the Daleks* and *Remembrance of the Daleks*.

Julian Bleach *The Stolen Earth / Journey's End*
When Julian Bleach recreated Davros for the 21st century, prosthetic artist Neil Gorton looked to the 1975 original for inspiration. While Wisher had only one mask, the modern crew created a new prosthetic for every day of shooting. Other changes included strengthening the wire around Davros's head, making it look like a medical brace holding his skull together. Bleach would return as a decrepit Davros in *The Magician's Apprentice* and *The Witch's Familiar*. The two-part story revealed that Davros hadn't lost his real eyes in the explosion that crippled him centuries before. He'd just kept them closed up to now!

Joey Price *The Magician's Apprentice and The Witch's Familiar*
Although initially credited as 'Boy', Price was soon revealed to be playing none other than the young Davros.

MONSTER MAKER—
THE BLUFFER'S GUIDE TO…

RAYMOND CUSICK

- Full Name: Raymond P. Cusick
- Born: 1928, London
- Died: 21 February 2013, Horsham
- Famous for: Designing the Daleks
- Came to *Doctor Who* producer Verity Lambert's attention while working on situation comedies such as *Scott On* and *Sykes*. Was hired as one of two designers on *Doctor Who*. Barry Newberry would design the historical stories, while Cusick concentrated on the science-fiction romps.
- Inspiration struck when Terry Nation told Cusick about the Georgian State Dancers who glided around the stage wearing long skirts so you couldn't see their feet.
- The cost for making the Daleks had to be kept below £250 each, which meant Cusick had to revise some of his original ideas, such as having them mounted on

a tricycle or having the Dalek bumps in the skirts flash when the Daleks became excited or angry.

- The Daleks' iconic shape came from Cusick's realisation that the Dalek would have to have an operator concealed inside. He drew a chair and sketched the shape of the Dalek around it. The meshed grill beneath the revolving 'head' was added so they could see out.
- Cusick stayed with *Doctor Who* for a further two-and-a-half years. In this time he worked on *The Edge of Destruction*, *The Keys of Marinus*, *The Sensorites*, *Planet of Giants*, *The Rescue*, *The Romans*, *The Chase*, *Mission to the Unknown* and *The Daleks' Master Plan*.
- He was awarded the coveted *Blue Peter* Gold Badge for designing the Daleks.
- Other notable works: Designer on series such as *The Duchess of Duke Street*, *When the Boat Comes in* and *To Serve Them All My Days*.

A DALEK A-Z

In 1964, Terry Nation famously told a *Daily Mirror* reporter that he got the Dalek's name from the spine of an encyclopaedia volume labelled DAL-LEK. Naughty Terry later admitted this was complete balderdash (although volumes of the London telephone directory of the period could be arranged to read 'DALEK'). In honour of his blatant fib, we present an A-Z to the Dalek Empire.

A is for the Abomination—The word the Daleks use for anything that gives them the heebie-jeebies. The Dalek Emperor branded Rose Tyler as the Abomination after she absorbed the Time Vortex (*The Parting of the Ways*), while Dalek Caan picked up the nickname when he started predicting the future (*The Stolen Earth*).

B is for Biological Warfare—The Daleks made use of biological warfare throughout their history. When invading Earth in the 22nd century, they dropped germ bombs on the planet wiping out whole continents of humans including Africa, Asia and South America (*The Dalek Invasion of Earth*).

C is for Crucible—The spherical flagship of the new Dalek Imperial armada. Powered by a Z-Neutrino core, capable of even destroying a TARDIS, the Crucible also contained the Vault, where the Supreme Dalek kept Davros on a tight leash (*The Stolen Earth / Journey's End*).

D is for Distress Call—Most Daleks were fitted with an automatic distress call that would be activated as soon as its top was removed, even if the Dalek was already deactivated (*Planet of the Daleks*).

E is for Eyepiece—The most vulnerable point of the Dalek. Take this out and not only would it be blinded but it would often fly into a complete panic (for example in *Revelation of the Daleks*). Unfortunately, as Wilfred Mott discovered, by the time of the Dalek invasion of 2009, the Daleks had perfected ways of automatically clearing visual obstructions (*The Stolen Earth*).

F is for Force Fields—During the Last Great Time War, Daleks developed personal force fields that could melt bullets in mid-air (*Dalek*).

G is for Gunstick—Feared throughout the universe, the Daleks' personal weapon was a focused energy beam. The gun had various settings. While it obviously killed, the weapon could also paralyse its victim's legs. Hit once and your legs would eventually recover. Hit twice and the effect would be permanent (*The Daleks*). At the other end of the scale, three Daleks using maximum extermination settings could easily blow up a terraced house (*The Stolen Earth*).

H is for Hatred—The Doctor once described the Dalek mutants as a 'living, bubbling lump of hate' (*Death to the Daleks*). He later discovered that Daleks considered pure hatred to be a thing of beauty (*Asylum of the Daleks*).

I is for Incendiary Bombs—During the revolt of 2167, Dalek Supreme Command gave authorisation for the destruction of London with firebombs (*The Dalek Invasion of Earth*).

J is for the letter J—The letter J is forbidden in the Dalek language. To precede a word with the letter is considered a great insult! (At least, according to Terry Nation's 1964 *Dalek Book*.)

K is for Kaleds—The race that Davros mutated into the Daleks (*Genesis of the Daleks*). Strangely, when the Doctor first encountered the Daleks, he was told that their original race was known as Dals (*The Daleks*).

L is for Last Great Time War—The conflict sparked by the Time Lords' attempt to prevent the creation of the Daleks on Skaro. It was brought to an end by the Doctor, at the cost of both races. But for the Daleks, this was not the end…

M is for Mark III Travel Machines—The name that Davros used to describe his prototype Daleks (*Genesis of the Daleks*).

N is for Neutron Bomb—A nuclear weapon that was used in the neutronic war on Skaro that led to the creation of the Daleks. A single neutron bomb could wipe out an area of 500 square miles, destroying all organic matter, but leaving building and machinery intact (*The Daleks*).

O is for Octus—Issue 213 of Marvel UK's *Transformers* comic introduced a new Decepticon leader known as Octus. Although he was never seen to transform in the comic strip, he had very familiar bumps on his legs. Artist Lee Sullivan has since revealed that Octus transformed into a Mark III Travel Machine. Sullivan himself drew many a Dalek in *Doctor Who Magazine* comic strips such as *Nemesis of the Daleks* and *Children of the Revolution*.

P is for Polycarbide (bonded)—Dalek casings are made from bonded polycarbide (*Remembrance of the Daleks*) and Dalekanium alloy (*Daleks in Manhattan*). The

term Dalekanium originated in the 1964 *Dalek Book* and was eventually adopted into the series.

Q is for Questions—Daleks do not question. Ever (*The Evil of the Daleks*).

R is for the Reality Bomb—Davros's ultimate—and craziest—victory. The Reality Bomb broke down the electric field that holds atoms together, and Davros planned to dissolve every form of matter in the entire universe. Sheltering within the Cruciform, the Daleks would survive the cataclysm, becoming the only surviving life form (*Journey's End*).

S is for Static Electricity—Daleks were originally powered by static electricity, distributed through the metallic floors of their city on Skaro (*The Daleks*). When they began to conquer the galaxy, their juice was supplied via a disc mounted on the back of their casing (*The Dalek Invasion of Earth*). Later paradigms of Daleks were powered by the Kaled mutant's own psychokinetic power (*Death to the Daleks*).

T is for Temporal Shift—Personal time machines built into the casings of the Cult of Skaro. Only used in emergencies, the temporal shift could transport the individual Daleks to another place and time but usually depleted their power cells.

U is for Universe—The Daleks will not rest until they have conquered or destroyed all of creation. The Time Lords foresaw a time when the Daleks will have destroyed all other life forms and become the dominant creatures in the universe.

V is for Veps—According to Terry Nation's Dalek annuals of the 1960s, a vep is a Dalek measure of artificial light. The higher the vep, the quicker plants grow. In a similar way a rel was a measure of hydro-electricity. In later accounts, rels became a measure of time (*Doomsday, Evolution of the Daleks, Journey's End*).

W is for Water—Daleks are more than capable of taking a dip. At the end of the first episode of *The Dalek Invasion of Earth*, a Dalek rose from the murky waters of the Thames. It's not just the wet stuff either. *The Chase* showed that Daleks can hide under sand dunes, but groan like billy-o when rising to the surface. Well, that sand must get everywhere.

X is for X-ray—In the earliest days of *Doctor Who*, a Dalek's death ray turned the entire picture negative. During the 1970s, advances in special effects meant the negative effect was limited to the victim itself, but from *Remembrance of the Daleks*, being shot by a Dalek meant that you lit up like a glowing X-ray, your skeleton on show for all to see.

Y is for Yarvelling—The creator of the Daleks—if you believe *Genesis of Evil*, a comic strip that ran in *TV Century 21*, that is. The blue-skinned scientist developed the mutant machine Daleks to survive the events of the neutron war on Skaro. His role in Dalek history was wiped away when *Genesis of the Daleks* revealed that Davros in fact was the mastermind behind the Daleks' creation. However, in 2006, Big Finish Productions' *I, Davros* mini-series revealed that Davros's half-sister was named Yarvell.

Z is for Zeg—A Dalek inventor who accidentally created Metalert, a reinforced form of Dalekanium and went on to challenge the Emperor Dalek (*TV Century 21* comic, *Duel of the Daleks*).

ARMED AND DANGEROUS

'What you going to do? Sucker me to death?'

Simmons, *Dalek*

Don't be fooled—that's no ordinary sink plunger. The Dalek's manipulator arm is a versatile and dangerous tool. Sometimes, however, it needs replacing for something a little handier.

- **Plunger**—The first element of a Dalek we ever saw. Useful for waving in terrified teacher's faces, operating Dalek controls and pliable enough to crack the combination of electronic door locks (*Dalek*). Can also be used to suffocate or crush a person's skull (*Dalek*), scan brainwaves (*Doomsday*) or assess intelligence (*Daleks in Manhattan*). At times telescopic, the plunger unit can be removed from a deactivated Dalek and used to manipulate Dalek machinery (*Remembrance of the Daleks*).
- **Perceptor**—A seismic detector used to track and locate time machines such as the TARDIS. Can also detect other life forms (*The Chase*).
- **Electrode Unit**—An attachment similar to a radar dish that can override electronic locks without physical contact (*The Chase*).
- **Pyroflame Thrower**—Used to burn through dense vegetation (*The Daleks' Master Plan*).

- **Scoop**—Used to transfer Dalek mutants into new casings (*The Power of the Daleks*).
- **Cutting tool**—To cut through metal doors (*Planet of the Daleks*). Earlier Daleks used a long, thin tool mounted with two spheres and a protective screen (*The Daleks*), whereas after the Time War, the Emperor's Assault Daleks were fitted with vicious-looking clawed cutting tools (*The Parting of the Ways*).
- **Percussive weapon**—On worlds where the use of energy weapons is not possible, such as Exxilon, the Daleks replace their usual gunsticks with percussive projectile-firing weapons (*Death to the Daleks*). Other weapon attachments include the larger, extra gun sticks sported by selected Emperor Guard Daleks, replacing the sucker arm (*The Parting of the Ways*).
- **Syringe**—Used by the Cult of Skaro to administer chemicals such as chromatin solution (*Daleks in Manhattan*).
- **Vault attachment**—Guard Daleks on board the Crucible have special eight-pronged attachments for operating complex equipment found in Davros's Vault (*The Stolen Earth / Journey's End*).
- **Pincers**—In the two Amicus *Dr. Who* films of the 1960s, some Daleks are fitted with pincers instead of plungers (*Dr. Who and the Daleks, Daleks—Invasion Earth 2150 A.D.*).

DALEK SERVANTS

Daleks may be the supreme beings in the universe but sometimes they need a little help. They've created many a slave in their time, with varying levels of success…

Robomen (*The Dalek Invasion of Earth*)
Humans conditioned into mindless drones by use of cybernetic implants.
Weaknesses: Not the brightest plungers in the pack, plus a tendency to go insane, smash their heads against walls or drown themselves when the conditioning wears off.

Slyther (*The Dalek Invasion of Earth*)
A huge, carnivorous creature, native to Skaro, brimming with tentacles and claws. Transported to Earth to guard mines in the South of England during the 22nd-century occupation. A favourite of the Dalek Supreme.
Weaknesses: If it catches you, it will eat you. Unfortunately for the Daleks (but fortunately for its prey) it moves very, very slowly.

⏺ **Dalek Duplicates** (*The Chase, Resurrection of the Daleks, Victory of the Daleks*)
Perfect copies of humans, created by biological or mechanical means, designed to infiltrate and kill.
Weaknesses: Dalek conditioning is a bit hit and miss. Annoying human memories and conscience have a habit of bubbling to the surface.

⏺ **Varga plants** (*Mission to the Unknown, The Daleks' Master Plan*)
Prick yourself on a Varga plant and you'll transform into a homicidal half-animal, half-vegetable plant. Originally only found on Skaro, the Daleks transplanted them to act as sentries on some of their occupied worlds.
Weaknesses: Almost as slow as a Slyther. Easy to dodge.

⏺ **Ogrons** (*Day of the Daleks, Frontier in Space*)
Hulking ape-like bipeds of limited intelligence. Violent, but thick-witted, Ogrons make excellent heavies.
Weaknesses: Almost as thick as Robomen. Phobia of the flesh-eating, blobby monsters that roam their home planet.

⏺ **Pig slaves** (*Daleks in Manhattan / Evolution of the Daleks*)
Genetically spliced human-porcine hybrids, created by the Cult of Skaro from New Yorkers of low intelligence (and, presumably, pigs). Can slit a human's throat with their bare teeth.
Weaknesses: Only have a life expectancy of a few weeks.

⏺ **Dalek 'puppets'** (*Asylum of the Daleks, The Time of the Doctor, The Magician's Apprentice*)
Robomen 2.0. Humans wiped of their memories and converted into Dalek infiltrators by exposure to genetic altering nanoclouds. Have mini-Dalek eyepieces hidden in their foreheads and Dalek guns in their palms.
Weaknesses: Same as for any human, except they can't be killed as they are already dead.

⏺ **Dalek Antibodies** (*Into the Dalek*)
The ultimate servant, operating deep inside a Dalek's casing, exterminating any infection.
Weaknesses: None. Try not to be a virus.

THE ONLY DALEKS WITH NAMES

'You can talk to me, Dalek Sec. It is Dalek Sec, isn't it? That's your name? You've got a name and a mind of your own. Tell me what you're thinking right now.'

The Doctor, *Evolution of the Daleks*

- Alpha—A Dalek given the Human Factor on the instructions of the Dalek Emperor. Named by the Doctor.
- Beta—Another Dalek altered by the Human Factor
- Dalek Caan—Member of the Cult of Skaro and, at one point, the last Dalek in the universe. Driven mad by flying unprotected through the Time War. Able to predict the future. Aka the Abomination.
- Dalek Jast—A member of the Cult of Skaro
- Dalek Sec—The leader of the Cult of Skaro. Became the first of a new breed of human-Dalek hybrids.
- Arthur Stengos—An agronomist friend of the Doctor converted into a Dalek by Davros on Necros
- Dalek Thay—A member of the Cult of Skaro
- Omega—The Doctor's third Human Factor-changed Dalek
- Oswin Oswald—A starliner Junior Entertainment Manager converted into a Dalek. Liked soufflés. There was something about this one…
- Rusty—A malfunctioning Dalek captured by the crew of the *Aristotle*. He needed a Doctor.

DALEK OPERATORS

'Do you think there's someone inside them?' asks Barbara in *The Daleks*. Yes, indeed there is, Miss Wright, but who has crammed themselves into a Dalek the most times?

Operator	Episodes	Years of service to Skaro	Ever seen outside the casing?
John Scott Martin	48	1965–1988	Hughes in *The Green Death*
Robert Jewell	43	1963–1969	Bing Crosby in *The Daleks' Master Plan*
Gerald Taylor	38	1963–1967	The Baker's Man in *The Daemons*
Kevin Manser	31	1963–1964	No, but he was a Zarbi in *The Web Planet*
Peter Murphy Grumbar	25	1964–1974	No, but he lent a hand with Arcturus in *The Curse of Peladon*
Cy Town	25	1973–1988	A medical orderly in *The Mind of Evil*, gunge victim in *The Happiness Patrol*
Barnaby Edwards	18	2005–2015	No
Nicholas Pegg	14	2005–2016	No
David Hankinson	8	2005–2008	No
Tony Starr	7	1984–1988	A British soldier in *The War Games*
Anthony Spargo	6	2006–2008	No
Nick Evans	4	1964	Didius the Slave Trader in *The Romans*
Rick Newby	4	1972	No
Keith Ashley	4	1975	A Zygon in *Terror of the Zygons*
Toby Byrne	4	1984–1985	No
Mike Mungarvan	4	1979	Duty officer in *Terror of the Vervoids*, Soldier in *Resurrection of the Daleks*
Hugh Spight	4	1988	No

Operator	Episodes	Years of service to Skaro	Ever seen outside the casing?
Michael Summerton	3	1963–1964	No
Dan Barratt	2	2006	No
Stuart Crossman	2	2006	No
Ben Ashley	2	2010	No
Jon Davey	2	2010–2012	No
Matthew Doman	2	2010–2012	No
Jeremy Harvey	2	2010–2012	No
Ken Tyllsen	1	1967	Still masked as first Sensorite in *The Sensorites*
Joe White	1	2010	Various monsters, no credit
Sean Saye	1	2010	Various monsters, no credit
Colin Newman	1	2011	Various monsters, no credit
Harry Burt	1	2012	Various monsters, no credit
Chester Durrant	1	2012	Various monsters, no credit
Richard Husband	1	2012	Various monsters, no credit
Claudio Laurini	1	2012	Various monsters, no credit
Richard Knott	1	2012	Various monsters, no credit
Mickey Lewis	1	2012	Various monsters, no credit
Gwion Ap Rhisiart	1	2012	Various monsters, no credit
Alistair Sanderson	1	2012	Various monsters, no credit
Richard Roberts	1	2012	Various monsters, no credit
Mark Barton Hill	1	2012	Various monsters, no credit
Dominic Kynaston	1	2012	Various monsters, no credit
Darren Swain	1	2012	Various monsters, no credit

VOICES OF THE DALEKS

Actor	Stories	Years	Also voiced
Nicholas Briggs	15	2005–2017	Nestene Consciousness, Jagrafess, Cybermen, Judoon, Ice Warrior, Zygons
Peter Hawkins	8	1963–1967	Cybermen
Roy Skelton	7	1967–1988	Cybermen, Krotons, Monoids, Spiridons
David Graham	5	1963–1966	Mechonoids
Michael Wisher	4	1973–1974	Davros
Royce Mills	3	1984–1988	-
Brian Miller	2	1984–1988	-
Oliver Gilbert	1	1972	-
Peter Messaline	1	1972	-
David Gooderson	1	1979	Davros
Geoffrey Sax	1	1996	-

FAMILIAR VOICES

Dalek voice artists also turn up where you least expect them:

- Peter Hawkins was the voice of Zippy in the first year of the children's TV series, *Rainbow* and provided all the voices for *Captain Pugwash*. He also created Bill and Ben's idiosyncratic language, was the voice of the Martian robots in the 1970s 'For mash get Smash' adverts, and even recorded a voice track for Gromit of *Wallace and Gromit* fame before it was decided that the plasticine mutt would remain mute. He also joined fellow Dalek voice artist

David Graham in supplying vocals for the big-screen adaptations *Dr. Who and the Daleks* and *Daleks—Invasion Earth 2150 A.D.*

- David Graham was the voice of Brains and Gordon Tracy in *Thunderbirds*. As well as providing the grating voice of the Daleks in the two Peter Cushing films, he also turned up in *Doctor Who* as Charlie in *The Gunfighters* and Professor Fyodor Nikolai Kerensky in *City of Death*. He has most recently been heard as the voices of Grandpa Pig in *Peppa Pig* and the Wise Old Elf in *Ben & Holly's Little Kingdom*.
- Roy Skelton took over as the voice of *Rainbow's* Zippy in 1973, a role he would play for over 900 episodes, as well as various cameo appearances in other programmes including the BBC's *Ashes to Ashes*. He played other roles in *Doctor Who*, including the invisible Spiridon Wester in *Planet of the Daleks*, and more visible roles in *Colony in Space* and *The Green Death*. His last *Doctor Who* Dalek appearance was in the 1999 Comic Relief spoof, *The Curse of Fatal Death*.
- Brian Miller was the husband of Elisabeth Sladen and appeared with her in *The Sarah Jane Adventures* story *The Mad Woman in the Attic*. He also appeared on screen in *Doctor Who* as Dugdale in *Snakedance* and as Barney in Peter Capaldi's debut, *Deep Breath*.

DALEK VARIANTS

DALEK SUPREME

The Dalek Supreme was often a 'normal' Dalek painted predominantly black to indicate its rank and status. But there have been other designs which differ more from the standard Daleks:

Version 1 (*Planet of the Daleks*)
- Taller than standard configuration Daleks
- Gold and black livery with larger base section
- Larger dome lights
- Eyestalk lights up

Version 2 (*The Stolen Earth / Journey's End*)
- Deeper voice (much like the Emperor)
- Red and gold livery
- Gold restraining bars on upper grilling

Special Weapons Daleks (*Remembrance of the Daleks*)

- Designed for heavy combat
- White and gold livery
- Heavily armoured torso section, no eyestalk
- One large centrally mounted energy cannon

EMPEROR DALEK

Version 1 (*The Evil of the Daleks*)

- Immobile and fed by nutrient pipes
- Much taller than standard Daleks
- One elongated conical base section with a single row of black hemispheres
- Bulbous head section split into sections
- Booming voice

Version 2 (*Remembrance of the Daleks*)

- Standard white and gold Imperial Dalek base section
- Large domed upper body, no eyestalk
- It's actually Davros!

Version 3 (*The Parting of the Ways*)

- Immobile
- Mutant floating in a transparent tank
- Two mechanical arms attached to the tank's base
- Giant bronze Dalek dome head with eyestalk and lights
- Large, heavy bronze plating with gold hemispheres flanking to three sides

DALEK PRIME MINISTER

(*Asylum of the Daleks*)

- No Dalek casing or weapons
- Mutant creature encased in a single glass case

NEW DALEK PARADIGM

- Larger
- Chunkier central core
- Biological eye
- Thicker skirting

COLOUR-CODED DALEKS

Victory of the Daleks introduced a new 'officer class' of Daleks, each colour coded to their specific role.

- White = The Dalek Supreme, the new commander of the Daleks.
- Orange = The Dalek Scientist, pushing the boundaries of Dalek knowledge.
- Blue = The Dalek Strategist, always thinking, always planning, always preparing for any eventuality.
- Red = The Dalek Drone, the foot soldier of the new Dalek Empire.
- Yellow = The Dalek Eternal, enigmatic and mysterious, possibly responsible for finding ways to ensure that the Daleks never again hover on the brink of oblivion.

THE GLASS DALEK

In 1964, the very first Dalek story was novelised as *Doctor Who in an Exciting Adventure with the Daleks*, by David Whitaker. The novel differed from the original televised story in several ways, including one element that has become *Doctor Who* legend.

In the closing pages of the book, the Doctor and his friends launch their final attack on the Daleks, and discover the metal monsters have a leader—a mutant encased in a transparent glass Dalek casing. Whitaker describes the creature:

> *He was resting on a kind of dais and his casing was made of glass. Inside, I could see the same sort of repulsive creature that the Doctor and I had taken out of the machine and wrapped in the cloak. The Dalek looked totally evil, sitting on a tiny seat with two squat legs not quite reaching the floor.*

The 1964 paperback edition issued by Armada included a picture of the glass monster, but sadly this was not reproduced in subsequent editions.

In the Sixth Doctor television adventure *Revelation of the Daleks*, a glass Dalek is seen, encasing the Doctor's friend Arthur Stengos, who has been turned into a mutant.

45 WAYS TO DEFEAT A DALEK

The Supreme Beings? Who are they kidding? Turns out there's more than one way to skin a Dalek.

1. Stick mud in the Dalek's eye and push it over a Thal cape to insulate it from the power supply. After that it's a simple case of opening the top and scooping out the mutant like a soft-boiled egg! (Note to time-travelling adventurers: this only works in the Dalek city on Skaro, where Daleks pick up static power through the floor.) (*The Daleks*)
2. Feed the Daleks anti-radiation drugs knocked off from the Thals. They don't like that. (*The Daleks*)
3. Cut the power to the city. No static electricity, no Daleks. Well, in the early days at least. (*The Daleks*)
4. If all else fails, just chuck rocks at them. It might not kill them, but it's tremendously satisfying. (*The Daleks*)
5. Mob the pesky pepper pot, hoisting it up before chucking it on the floor. Just make sure you don't get stuck underneath. (*The Dalek Invasion of Earth*)
6. Ram through a squad of Daleks with an enormous refuse truck. (*The Dalek Invasion of Earth*)
7. Get together a gang of angry mine workers, grab yourself a Dalek and run screaming out of the mine to freedom, still holding the Dalek aloft. (*The Dalek Invasion of Earth*)
8. Dig a hole in the desert sand, cover it with an old threadbare cardigan (thanks, Barbara!), get a Dalek to chase you and hope it falls in. (*The Chase*)
9. Dump them in a bubbling mud bath. (*The Daleks' Master Plan*)
10. Overload them with static electricity. (*The Power of the Daleks*)
11. If your country house has been overrun with Daleks, use some rope to drag one into an open fire. (*The Evil of the Daleks*)
12. If a Dalek creeps up on you when you've just arrived on Skaro, chuck it off a cliff. Easy! (*The Evil of the Daleks*)
13. Cause a civil war on Skaro. It's the final end. (Hint: it isn't.) (*The Evil of the Daleks*)
14. Disable with a scrambler made from a TARDIS tape recorder and whatever else you find in your pockets. (*Planet of the Daleks*)

15. Carelessly leave a cooling duct open. If you're lucky a burst of molten ice will engulf passing Daleks at just the right moment. (*Planet of the Daleks*)

16. Sometimes you don't have to do anything. There's every chance a group of especially dumb Daleks may inadvertently trundle past some Thal explosives that had been rigged to explode by an earlier Dalek patrol. (*Planet of the Daleks*)

17. If a Dalek is riding up a ventilator shaft on an anti-grav disc, a well-aimed rock tumbled down the shaft should be enough to knock the Dalek back down to Earth – or Spiridon. (*Planet of the Daleks*)

18. Dipping Daleks into a sub-zero pool of molten ice instantly kills the mutant inside. Daleks can't handle sub-zero temperatures. (*Planet of the Daleks*)

19. Go for the direct approach and slide an explosive charge across the floor at a squad of advancing Daleks. (*Planet of the Daleks*)

20. Charges shoved into a crack of an ice wall should take out any advancing Dalek. (*Planet of the Daleks*)

21. Get it to make a mistake. Some Daleks are so self-critical that they'll overreact and self-destruct. (*Death to the Daleks*)

22. Blow up their ship with a big bomb. Simple but effective. (*Death to the Daleks*)

23. Throw a hat over its eyestalk and clamp a convenient bomb on its side—but make sure you shove the Dalek down a narrow corridor before it blows up! (*Destiny of the Daleks*)

24. Push it into the corner of a handily mirrored corridor. It'll no doubt fire and be exterminated by its own ricocheting death ray. (*The Five Doctors*)

25. Guarding one of the most dangerous beings in the known universe in a barely defended and poorly maintained space prison when the Daleks attack? Then stick a few mines in a corridor, it'll take out a couple of the invaders at least. (*Resurrection of the Daleks*)

26. Topple it out of a third-storey warehouse door. However, always remember to check for leftover Kaled mutants amongst the wreckage—but don't get it mixed up with *Felis catus*. (*Resurrection of the Daleks*)

27. If you're Davros you can modify the Movellan virus to eradicate your own creations. Always make sure you're not susceptible to the plague yourself though. Whoops. (*Resurrection of the Daleks*)

28. Blast it with a highly directional ultrasonic beam of rock and roll. (*Revelation of the Daleks*)

29. If that doesn't work, bullets with bastic heads will blow it sky high. Unless it's been through the Time War and has developed a personal force field, of course. (*Revelation of the Daleks / Dalek*)

30. Zap it with a Dalek gunstick. Daleks are vulnerable to their own weapons. They really need to look at that. (*Revelation of the Daleks*)

31. Rewire a transmat so it mangles any materialising Dalek. (*Remembrance of the Daleks*)

32. Whacking a Dalek with an energised baseball bat is OK if you just want to take out an eyestalk or the odd Dalek bump. What you really need is an Anti-Tank Missile. (*Remembrance of the Daleks*)

33. Trick Davros into turning Skaro's sun supernova. (*Remembrance of the Daleks*)

34. Talk it to death. Probably only works if its forces have been destroyed and Skaro is a burnt cinder circling a dead sun. (*Remembrance of the Daleks*)

35. Get it to absorb human DNA from a time traveller. Yes, it'll regenerate but ultimately it'll continue to mutate, question its own existence and self-exterminate. Job done. (*Dalek*)

36. If you're Captain Jack and find yourself in a situation where the TARDIS has materialised around Rose and a Dalek, blast said Dalek into little bits with a big ray gun. (*The Parting of the Ways*)

37. Use the Anne-Droid to fry advancing Daleks. They are the weakest link. (*The Parting of the Ways*)

38. Stare directly into the heart of the TARDIS, absorb the Vortex and then wipe the entire Dalek race from history. Thorough, less time intensive, but risky—every cell in your body is likely to die. (*The Parting of the Ways*)

39. Get history to collapse so the Daleks are deleted from existence. Any that survive the purge will be fossilised. Even if they start to reboot, a blast of Alpha Mezon energy will kill the mutant stone dead. (*The Big Bang*)

40. Identify yourself as the Doctor. Daleks are programmed to destroy the Predator and so will self-destruct, hoping to take you out in the process. A couple of caveats: only works if a) the Dalek is unarmed, b) the Doctor's identity hasn't been wiped from the Dalek Pathweb. (*Asylum of the Daleks*)

41. On the last day of the Time War, take off in the TARDIS and smash through an Arcadian wall, taking out a squad of Daleks at the same time. It'll make you feel better about that graffiti you just blasted into the wall. (*The Day of the Doctor*)

42. When the Dalek fleet are preparing to fire upon a planet, move the planet so they shoot each other instead. (*The Day of the Doctor*)

43. Blast 'em with regeneration energy. (*The Time of the Doctor*)

44. Damage a Dalek so much that you crack one of its trionic power cells. The resulting radiation leak will affect the mutant's biochemistry, resulting in morality. Then all you need do is give it a glimpse into a certain Time Lord's soul and it'll go on a crusade to kill all Daleks in the galaxy. Simple. (*Into The Dalek*)

45. Swamp their sewers with regeneration energy so the dormant sludge gets enough stretch to pull the Dalek city down into the sludgy depths. (*The Witch's Familiar*)

> ## THE DALEKS IN NUMBERS
> - The number of times the Daleks have banged on about their vision being impaired = 20
> - The number of times Daleks have insisted they will obey = 91
> - The number of times Daleks have claimed to be superior beings = 3
> - The number of times Daleks have offered someone drinks = 7
> - The number of times the Daleks have shrieked Exterminate or any of its variations = 591
> - The number of onscreen deaths caused by Daleks = 250

UNIVERSAL MONSTERS

Cinema's classics creatures in *Doctor Who*.

VAMPIRES
- The Daleks fought a Count Dracula robot in the 1996 Festival of Ghana's haunted house attraction. (*The Chase*)
- The Doctor used to be told tales of the undead by an old hermit from the mountains of South Gallifrey. In the old time, Rassilon had led a fleet of steel bolt-firing bow ships against the vampire horde that was swarming across the universe. The Doctor would later defeat the last of the Great Vampires on a planet in E-Space. (*State of Decay*)
- On the post-apocalyptic Earth of the year AD 500,000, humanity evolved into vampire-like monsters. Eventually the planet's poisoned atmosphere killed even the Haemovores, but Fenric transported the last of their kind back in time to spawn a new race of blood-suckers as part of his game against the Doctor. (*The Curse of Fenric*)
- Hiding from the Judoon in Royal Hope Hospital, a Plasmavore fugitive using the alias Florence Finnegan supped blood from her victims using a stripy straw. (*Smith and Jones*)
- The Doctor, Amy and Rory came up against Rosanna Calvierri and her school of beautiful vampire girls in Venice, 1580. The nosferatu turned out to be fish-like aliens from the planet Saturnyne breeding in the canals of Venice. (*Vampires in Venice*)

FRANKENSTEIN
- A robot version of Frankenstein's monster attacked the Daleks while they chased the Doctor through the Festival of Ghana's House of Horrors. (*The Chase*)

- Mirroring Baron Frankenstein's experiments, scientist Mehendri Solon stitched together scraps of corpses to build a new body for the brain of Time Lord criminal Morbius. (*The Brain of Morbius*)
- Universal's 1931 *Frankenstein* starring Boris Karloff as the creature was playing on 31 December 1999 as the Seventh Doctor regenerated in Walker General Hospital Morgue. (*Doctor Who*)

WEREWOLVES
- The Sixth Doctor encountered the wolf-like Lukoser in the tunnels of Thoros Beta. As Dorf, he had been equerry to King Ycranos, but he had since been experimented on by the scientist Crozier. (*The Trial of a Time Lord: Mindwarp*)
- The Seventh Doctor was trapped in the Psychic Circus ring with Mags, a werewolf from the planet Vulpana. (*The Greatest Show in the Galaxy*)
- In the 1990s, UNIT included silver bullets in their arsenal as standard. (*Battlefield*)
- In Scotland in 1879, the Tenth Doctor and Rose saved Queen Victoria from a werewolf-like alien the Doctor described as a Lupine-Wavelength-Haemovari-form. Despite the Time Lord's best intentions, Victoria may have been infected and perhaps passed the werewolf gene on to her descendants. (*Tooth and Claw*)

THE INVISIBLE MAN
- The Refusians became invisible following a massive solar flare in the vicinity of their planet, Refusis II. With invisibility came great strength, and they willingly invited refugee humans and Monoids to live in harmony on their world. (*The Ark*)
- The eight-foot-high Visians of Mira were vicious and completely invisible. (*The Daleks' Master Plan*)
- The Spiridons of the planet Spiridon could make themselves invisible by means of an anti-reflection light wave. The Daleks duplicated the ability, but it sapped their power sources rendering them invisible, but dead as a doornail. (*Planet of the Daleks*)
- On an unnamed planet, the Fourth Doctor encountered the remnants of a eugenics experiment run by the deranged computer Xoanon—which looked exactly like the Doctor! Part of the experiment included invisible monsters that Xoanon unleashed into the jungle to terrorise the Sevateem tribe. (*The Face of Evil*)
- Although they were largely invisible, a blinded Krafayis predator could be seen by the artist Vincent van Gogh in 1890s Auvers-sur-Oise, France. (*Vincent and the Doctor*)

SWAMP MONSTERS
- Like their Silurian cousins, the amphibious Earth reptile dubbed the Sea Devils by the local military, went into hibernation on prehistoric Earth but were woken in the late 20th century. (*The Sea Devils*)
- The Marshmen of Alzarius emerged from the swamps every 50 years during Mistfall. They were highly adaptable and could even evolve into a new life form. (*Full Circle*)

MUMMIES

- Osiran servitors resembled Egyptian mummies, even down to the bandages. (*Pyramids of Mars*)
- The Old God Akhaten kept a mummy as an alarm clock, set to awake if the Long Song ever ended. (*The Rings of Akhaten*)
- A legendary boogeyman known as the Foretold looked like a mummy that only its murder victims could see. Actually a long-dead soldier kept alive by malfunctioning implants, including phase camouflage and personal teleporter. (*Mummy on the Orient Express*)
- When invading Earth, the Monks chose to resemble mummified corpses, their technology and architecture seemingly based on Pyramids. (*The Pyramid at the End of the World*)

WARLORDS OF MARS

The Ice Warriors are perhaps the noblest race ever known to the universe. A proud civilisation of soldiers, the reptilian Martians' actions could often be misconstrued, with long periods of war and invasion attempts (with Earth as a target at least twice) making them feared across the galaxy. In periods of peace, the Ice Warriors became known for diplomacy and formed an important part of the Galactic Federation.

The Martians first appeared in 1967's *The Ice Warriors* by Brian Hayles. They returned for an attempt at conquering Earth via the Moon in *The Seeds of Death* (1969). During the Third Doctor's era, the Ice Warriors became a force for good in *The Curse of Peladon* (1972), but a faction of them was back to their monstrous ways for a rematch with the third Doctor in *The Monster of Peladon* (1974).

It would be nearly four decades before the Martians' rasping voices were heard again. Mark Gatiss' *Cold War* (2013) saw the Eleventh Doctor and Clara facing a solitary Ice Warrior on a Soviet submarine, and just four years later would be seen on their native planet for the first time in *Empress of Mars* (2017).

CREATING THE ICE WARRIORS

In 1967, *Doctor Who* producer Innes Lloyd and story editor Peter Bryant wanted to bolster the Doctor's rogues gallery, introducing a new monster to rival the Daleks and Cybermen.

Brian Hayles's script for *The Ice Warriors* imagined a second Ice Age, with a future Earth under attack from revived invaders from Mars. Hayles's concept of the Ice Warriors was very different to what eventually lumbered onto screen, however. Varga, the first Warrior released from the ice, was more cyborg than reptile in the original script. His hood-like, ominous helmet is fitted with electronic earpieces and a strip of photo-electronic cell glass that pulses with light. More lights are found embedded across the Martian's vast chest and he's accompanied by a high-pitched electronic whine.

Costume designer Martin Baugh had different ideas. Taking his cue from the helmet mentioned in Hayles's script, Baugh based his design on a turtle, with fibreglass armour forming part of the Warrior's body itself. Six-foot seven inch-tall *Carry On* star Bernard Bresslaw was cast as Varga and was immediately whisked off to the London Metalwork Company where the engineers who usually crafted fibreglass boats built his massive chest piece. His legs and arms were covered in heavy latex with clamp-like pincers for hands, coarse hair sprouting from every join. His mouth and jaw was smothered in a thick rubber half-mask, with a specially moulded fibreglass helmet completing the look. Baugh originally meant to install lights behind the helmet's perspex eyepieces, but decided against it as the costume was hot enough already. When suited up, Bresslaw was soon sweating enough to fill a pint glass every single hour.

The Ice Warriors would return just over a year later in *The Seeds of Death*, joined this time by Slaar, a smaller, sleeker commander, all bulbous helmet and bad teeth. Over time, Slaar and his hissing successors Izlyr and Azaxyr who appeared in the Third Doctor stories *The Curse of Peladon* and *The Monster of Peladon* respectively, would become known as Ice Lords, although the title is never actually used on screen. When addressing Izlyr and Azaxyr, you should hold the Ice, they are just Lords, plain and simple – but they both have very nice cloaks, unlike poor Slaar. All three Ice Lords were played by actor Alan Bennion.

For the return of the Ice Warriors in 2013's *Cold War*, writer Mark Gatiss was keen that although they be updated, the Martians should retain their classic look. Instead of the rigid fibreglass armour of the original 1960s/70s suits, Millennium FX created the new armour in flexible urethane rubber which was built over a cast of actor Spencer Wilding. The creature within was created in CGI, and given its distinctive hissing tones by regular monster voice artist Nicholas Briggs.

Four years later, *Empress of Mars* added another member of Martian nobility. Writer Mark Gatiss insisted that the regal Ice Queen should have a cloak to go along with her stylised Ice Lord-inspired helmet and dreadlocks. As well as new guns that crushed their victims into neat cubes of folded flesh, *Empress of Mars* also revealed for the first time that female Ice Warriors have nostrils!

BRED FOR WAR—
SONTARAN FACTOIDS

'It's all right. I've had a good life. I'm nearly 12.'

Strax, *A Good Man Goes to War*

As 12 is considered a good age for a Sontaran to reach, here are a dozen facts on the classic monster that was once described as a 'talking baked potato'.

- The Sontarans have been engaged in a war with the Rutans for thousands of years.
- Sontarans are a clone species. The Sontaran Military Academy is capable of producing over a million cadets at each muster parade, allowing their forces to sustain enormous casualties on all fronts. The Eleventh Doctor claimed that Strax was the middle child of six million.
- The Sontaran home world is Sontar, giving rise to the battle cry 'Sontar-ha!' Which they shout. A lot.
- In the high-gravity environment of Sontar, a Sontaran weighs several tonnes.
- Sontaran muscles are built for load bearing rather than leverage.
- Sontarans do not fear death. They would rather be court-martialled than show pain.
- For a Sontaran, being ordered to take care of the sick and wounded is a punishment.
- Sontarans can gene-splice their bodies for a variety of functions, including all nursing duties. Some can even produce enormous quantities of lactic fluid.
- As any space-adventuring hero knows, a Sontaran's most vulnerable spot is its probic vent. To quote Chiswick Super-Temp Donna Noble, 'Back of the neck!'

- Because of the probic vent's position at the back of the neck, Sontarans must always face their enemies, never turning their back on them.
- To enter battle open-skinned, without a helmet, is considered a great honour.
- Sontaran culture is not very progressive when it comes to equality of the sexes. They consider words to be the 'weapons of womenfolk'. No wonder they suffer so many defeats.

SONTARAN ROLL CALL

For an identical race of clones, Sontarans have come in all shapes, sizes and heights over the years—some even sporting the height of fashion in facial hair. Here's a roster of all named Sontaran personnel from on-screen skirmishes.

Sontaran	Rank	Story	Actor
Linx	Commander	The Time Warrior	Kevin Lindsay
-	Marshal	The Sontaran Experiment	Kevin Lindsay
Skorr (the bloodbringer)	Commander	The Sontaran Stratagem / The Poison Sky	Dan Starkey
Skree	Lieutenant	The Sontaran Stratagem / The Poison Sky	Dan Starkey
Staal (the undefeated)	Major	The Sontaran Stratagem / The Poison Sky	Christopher Ryan
Stark	Commander	The Pandorica Opens	Christopher Ryan
Stike	Group marshal	The Two Doctors	Clinton Greyn
Stor	Commander	The Invasion Of Time	Derek Deadman
Strax	Commander (demoted to nurse)	Various	Dan Starkey
Styre	Field major	The Sontaran Experiment	Kevin Lindsay
Varl	Major	The Two Doctors	Tim Raynham

Name	Partially	Wholly	Mondasians	Cybus	Where?	Comment	Survived?
Danny Pink	X		X		Earth	Retained mental faculties due to love for Clara Oswald. Led Cyber-Army into act of mass sacrifice to save human race.	No
Bill Potts	X		X		Colony Ship	Saved from a Cyber-existence by Heather	Yes
Ralph	X		X		Moonbase	Geologist on the Moonbase. Taken by Cybermen while in the food store	No
Shona		X	X		Earth	Store assistant at Sanderson & Grainger department store in Colchester. Converted by Cybermen from crashed spaceship beneath the city	No
Dr Skarosa		X	X		Earth	The founder of 3W and a pain in Missy's plan to cybernise the entire human race.	No
Stratton	X		X		Telos	Like Bates, put to work by Cybermen after Cybernisation failed	No
Toberman	X		X		Telos	Kaftan's servant and part of the expedition to the Tomb on Telos. Sacrificed himself by closing the electrified doors, sealing the Cybermen within	No
Jackie Tyler		X		X	Parallel Earth	An alternate version of Rose Tyler's mum. One of the first victims of mass cyber-conversion.	No
Tobias Vaughn	X		X		Earth	Partially converted by Cyber-Director but allowed to retain personality and emotions	No

Name	Partially	Wholly	Mondasians	Cybus	Where?	Comment	Survived?
Atif Ghosh		X	X		Earth	Last seen Friday before Doctor investigated Sanderson & Grainger	No
Mercy Hartigan	X			X	Earth	Villainous matron of St. Joseph Workhouse. Converted into the operator of the CyberKing	No
Yvonne Hartman		X		X	Earth	Director of Torchwood. Converted but managed to overcome conditioning through loyalty to Queen and country	No
Jules	X		X		Moonbase	Another geologist on the Moonbase	No
Alistair Gordon Lethbridge-Stewart	X		X		Earth	Resurrected after death by Cyber-Pollen, but retained humanity. Saved his daughter from falling to Earth, and the Doctor from himself.	Yes
Tom Luker		X	X		Earth	Disappeared Sunday before the Doctor arrived at Sanderson & Grainger	No
John Lumic		X		X	Parallel Earth	Creator of the Cybus Cybermen. Converted into first Cyber-Controller	No
Lytton	X		X		Telos	Former Dalek mercenary who tried to double cross the Cybermen and was cyberconverted for his actions	No
Morris		X		X	Parallel Earth	Homeless man tricked into conversion process by promise of food	No
Craig Owens	X		X		Earth	Friend of the Doctor. Fought off conversion into a Cyber Controller through love for his son	Yes
Sally Phelan		X		X	Parallel Earth	Bride-to-be converted the night before her wedding	No

CYBERSHADES (*The Next Doctor*)

- Possibly contain brain of cat or dog
- Shaggy fur
- Bronzed face-mask
- Slanted helmet bars

CYBER CONVERTS

Name	Partially converted	Wholly converted	Converted by Mondasians	Converted by Cybus Cybermen	Where?	Comment	Survived?
Bates	X		X		Telos	Body rejected the conversion process after legs and arms were replaced with artificial limbs	No
Bill		X	X		Earth	Sewer worker captured by Cybermen	No
Sheila Clark		X	X		Earth	Went missing Tuesday before the Doctor started work at Sanderson & Grainger	No
David		X	X		Earth	Captured along with co-worker Bill	No
Doctor Evans	X		X		Moonbase	Moonbase doctor who fell victim to Cybermen virus and was controlled by means of a removable head unit	Yes
Franz	X		X		Moonbase	Geologist on the Moonbase, partially cybernised	No
George		X	X		Earth	Security guard at Sanderson & Grainger and work mate of the Doctor	No

Cyber-Trooper (*Earthshock*)

- Transparent jaw plate
- Chest plate extended to shoulders
- Largely uses cyber-guns

Cyber-Trooper (*Doomsday*)

- Robotic body containing human brain
- Cybus Industries logo
- Head contains tranquilliser darts
- Wrist-mounted gun

Cyber-Trooper (*The Time of the Doctor*)

- Wooden body
- Wrist-mounted Flamethrower
- Yellow chest light

Cyber-Trooper (*Nightmare in Silver / Dark Water / Death in Heaven*)

- Contains full human skeleton
- Capable of flight
- Wrist-mounted gun
- Can cybernise humans by means of cyber-pollen

CYBERMATS

Cybermat (*The Tomb of the Cybermen*)

- Segmented bodies
- Bulbous eyes
- Base sensors
- Antennae

Cybermat (*The Wheel in Space*)

- No antennae
- Glowing eyes

Cybermat (*Revenge of the Cybermen*)

- Larger
- Longer
- No eyes
- Injects poison

Cybermat (*Closing Time*)

- Smaller
- Teardrop eye pieces
- Razor-sharp organic teeth

Cyberleader (*The Next Doctor*)
- Black helmet bars
- Black face plate
- Transparent braincase

CYBER LIEUTENANT (*Earthshock*)
- No distinguishing marks

CYBER-SCOUT (*Attack*)
- Black all over to blend into shadows (or sewers)

CYBER-TROOPER
Cyber-Trooper (*The Tenth Planet*)
- Large headlamp
- Cloth mask
- Bulky chest plate
- Human hands

Cyber-Trooper (*The Moonbase*)
- Sleeker helmet and chest unit
- External hydraulic tubing
- No individual fingers
- Can shoot electricity from wrist

Cyber-Trooper (*The Invasion*)
- Expanded helmet
- Teardrops on eyes
- Stronger build

CYBER CONTROLLER

Cyber Controller (*The Tomb of the Cybermen*)
- Taller than average Cyberman
- No helmet bars
- Enlarged translucent glowing braincase
- No chestplate

Cyber Controller (*Attack of the Cybermen*)
- No helmet bars
- Enlarged metal braincase

Cyber Controller (*The Age of Steel*)
- Transparent braincase
- Glowing Eyes
- Connection bolts on chest
- Cybus Industries logo

CYBER-PLANNER

Cyber-Planner (*The Wheel in Space*)
- Immobile unit
- Metal frame
- Transparent rods
- Egg-like braincase

Cyber-Planner (*The Invasion*)
- Immobile unit
- Metal frame
- Transparent rods
- Funny voice

CYBERLEADER

Cyberleader (*Revenge of the Cybermen*)
- Black helmet
- Black helmet bars

Cyberleader (*Earthshock*)
- Black helmet bars

⬛ Planet 14

At some point, the Cybermen apparently encountered the Second Doctor in an unseen adventure on a world they designated Planet 14.

⬛ Marinus

According to the Twelfth Doctor, Cybermen also evolved on the planet he once saved from the Voord.

⬛ Telos—Tomb world

Once home to the Cryons, Telos was chosen by the Cybermen as the ideal location for their Tomb, a huge underground citadel containing expansive cryogenic units. Five hundred years after the last sighting of a Cyberman, a human expedition financed by the devious Kaftan, who was working with the Brotherhood of Logicians, sought to explore the Tomb. The Brotherhood aimed to revive and enslave the Cybermen, but the resurrected metal horrors had other plans. The Tomb wasn't the sepulchre of the Cyber-race, it was a lure. Anyone who managed to resurrect the Cybermen would join their number and be like them.

⬛ Earth—An alternative history

On an alternative earth in a parallel universe, John Lumic, inventor and CEO of Cybus Industries, was dying. Desperate to prolong his life, he developed a means to upgrade humans to the next level. In a seemingly deserted factory in Battersea Power Station he was experimenting on London's homeless, transplanting their still-living brains into new cybernetic bodies.

When the President of Britain refused to sanction Lumic's experiments, Lumic sent a signal to every human wearing Cybus Industries' now ubiquitous earpods, forcing them to report to the Power Station for upgrade. Lumic's new race of Cybermen eventually turned on their creator, converting him into the first Cyber Controller of their reality, and began conquering the planet. Soon, they set their cold sights on other worlds—and other dimensions.

CYBER-SPOTTER

Don't know your Cyber Controller from your Cybershade? Then never leave home without our handy Cyber-spotting guide. Of course, they'll probably delete you before you find the right page…

SONTARAN FORCES

Sontaran military forces are split into distinct groups and battalions, all serving towards the honourable pursuit of victory in the war against the Rutans (Sontar-ha! etc.). Forces mentioned or seen on screen in *Doctor Who* are:

- Fifth Sontaran Battle Group—*The Time Warrior*
- G3 Military Assessment Survey—*The Sontaran Experiment*
- Sontaran Special Space Service—*The Invasion of Time*
- Ninth Sontaran Battle Fleet—*The Two Doctors*
- Tenth Sontaran Battle Fleet—*The Sontaran Stratagem / The Poison Sky*

WORLDS OF THE CYBERMEN

Once they were like us. Then they changed. They became stronger. They became more efficient. They became monsters. Now, the Cybermen want us to be like them again, but on their terms and in their image. The scourge that spread across the galaxy started very close to home.

Mondas—The original home of the Cybermen

Millions of years ago, Earth had a twin planet: Mondas. Following some unknown cosmic event, Mondas broke free of its orbit and drifted away from Earth. The effect on the planet's atmosphere was catastrophic. With their bodies weakening and lifespans becoming shorter, the Mondasians started replacing their body parts with metal and plastic cybernetic implants. Soon, they didn't know where man ended and machine began. Finally, the ruling powers of Mondas decreed that one final weakness needed to be eradicated: emotion. The Mondasians became slaves to logic. They became Cybermen.

Using an extraordinary planetary propulsion system, the Cybermen piloted Mondas back to Earth, determined to convert every human on the planet to Cyber-kind.

MAPPING THE WEB OF FEAR

In *The Web of Fear*, Central London and the Underground system was taken over by an infestation of the Great Intelligence's web fungus and its Yeti robots. Follow the handy *Who-ology* tourist guide if you fancy some Yeti spotting.

Goodge Street Fortress: Central army base in the fight against the Great Intelligence's Yeti, located beneath Goodge Street Station

Charing Cross Underground Station: Location of army explosives and the Doctor's first Yeti encounter

Covent Garden Underground Station: TARDIS landing site. 'LONDONERS FLEE! MENACE SPREADS!' sign. Location of Colonel Lethbridge Stewart's above-ground battle with the Yeti

Holborn Underground Station: Location of Yeti attack on army supply truck

Tunnel barricade: Battle with Yeti somewhere between Holborn and the Goodge Street Fortress

Kings Cross Underground Station: Yeti sighting, holding a glass control pyramid

Monument Underground Station: Web advance along the Circle Line, trapping Jamie and Evans

St Paul's Underground Station: Scene of Evans and Jamie's escape from the web advance

Piccadilly Circus Underground Station: Stronghold of the Great Intelligence where Victoria and Travers are held hostage. Location of the final battle

MONSTER MAKE-UP

How long does it take to get a monster ready for action in the new series?

- The Gunslinger—Three hours with a team of two. The gun arm was added on set due to its extreme weight.
- Dalek puppet slave—Three hours to add the Dalek eyestalks and lights. The Dalek-ised corpses were easier, being a mask pulled over the performers head, taking just one hour to apply.
- Judoon Captain—Thirty minutes to get into the costume and then another ten minutes to attach the animatronic head
- Silent—Ten minutes to add mask and gloves
- Silurian—Three hours (although a little longer if their scaly mitts are un-gloved)
- Slitheen—Three hours
- Sontaran—Three hours
- Weeping Angel—Two hours. Two make-up artists work on each Lonely Assassin, although the wings and skirts aren't added until on set or location as—ironically—it's difficult for the performers to move with them on.

FIVE

LOTS OF PLANETS
HAVE A NORTH

A ROUGH GUIDE TO EARTH
AND OTHER WORLDS

'There are worlds out there where the sky is burning, and the sea's asleep,
and the rivers dream; people made of smoke and cities made of song…'

The Doctor, *Survival*

While we may never know exactly why the Doctor left Gallifrey, one thing is certain.
He never tires of exploring strange new planets—although he can't help but be drawn
to a small blue planet in Mutter's Spiral.

'I have a place in mind that's on the way, well, more or less, give or take a
parsec or two. It's my home from home. It's called Earth.'

The Doctor, *Logopolis*

THE DOCTOR'S WORLD MAP

Earth is the Doctor's favourite planet, and he has a real fondness for Britain. But travel broadens the mind, and throughout history, the Doctor has popped up all over the globe, not just in the British Isles.

EUROPE

1 AMSTERDAM, HOLLAND 1983 – **ARC OF INFINITY**
2 AUVERS-SUR-OISE, FRANCE 1890 – **VINCENT AND THE DOCTOR**
 VERSAILLES 18TH CENTURY – **THE GIRL IN THE FIREPLACE**
3 BERLIN, GERMANY 1938 – **LET'S KILL HITLER**
4 FLORENCE, ITALY 1505 – **CITY OF DEATH**
5 SAN MARTINO, ITALY 15TH CENTURY
 – **THE MASQUE OF MANDRAGORA**
6 LANZAROTE, CANARY ISLANDS 1984 – **PLANET OF FIRE**
7 NORWAY, 9th CENTURY – **THE GIRL WHO DIED**
8 PARIS, FRANCE 1572 – **THE MASSACRE**
 PARIS, FRANCE 1794 – **THE REIGN OF TERROR**
 PARIS, FRANCE 18TH CENTURY – **THE GIRL IN THE FIREPLACE**
 PARIS, FRANCE 1979 – **CITY OF DEATH**
 PARIS, FRANCE 2010 – **VINCENT AND THE DOCTOR**
9 POMPEII, ITALY AD79 – **THE FIRES OF POMPEII**
10 ROME, ITALY AD64 – **THE ROMANS**
11 SEVILLE, SPAIN 1985 – **THE TWO DOCTORS**
12 VENICE, ITALY 1580 – **THE VAMPIRES OF VENICE**
13 THE WESTERN FRONT 1914 – **TWICE UPON A TIME**

ASIA

14 GOBI DESERT 1289 – **MARCO POLO**
15 PALESTINE c.1190 – **THE CRUSADE**
16 PEKING, CHINA 1289 – **MARCO POLO**
17 TIBET 1930s – **THE ABOMINABLE SNOWMEN**
18 TOKYO 2016 – **THE RETURN OF DOCTOR MYSTERIO**

NORTH AMERICA

19 FLORIDA 1969 – **THE IMPOSSIBLE ASTRONAUT/ DAY OF THE MOON**
20 LOS ANGELES/ HOLLYWOOD 1921
 – **THE DALEKS' MASTER PLAN**
21 NASA, CAPE CANAVERAL, FLORIDA 2017
 – **EMPRESS OF MARS**
22 NEVADA 1870 – **A TOWN CALLED MERCY**
 NEVADA 2015 – **HELL BENT**

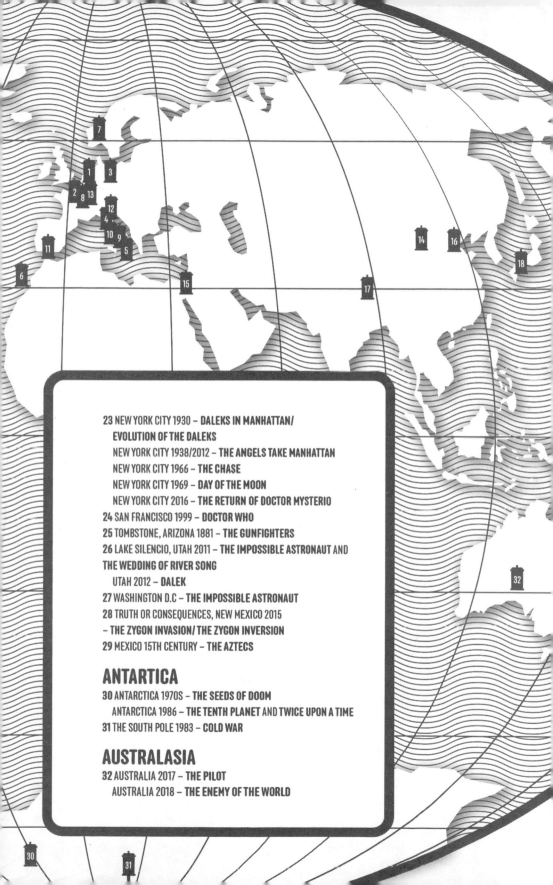

THE CHANGING FACE
OF THE OVAL OFFICE

In *The Impossible Astronaut*, the TARDIS lands in the Oval Office of President Nixon's White House. Built in Upper Boat studios near Cardiff, the set was used on a number of occasions in Series Six. Did you spot them all?

- The Oval Office (*The Impossible Astronaut*)
- The hospital spaceship (*The Curse of the Black Spot*)
- The Gangers' Acid Well Crypt (*The Rebel Flesh / The Almost People*)
- The Birthing Suite on Demon's Run (*A Good Man Goes to War*)

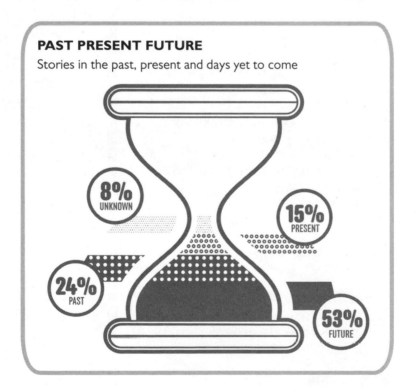

PAST PRESENT FUTURE
Stories in the past, present and days yet to come

8% UNKNOWN

15% PRESENT

24% PAST

53% FUTURE

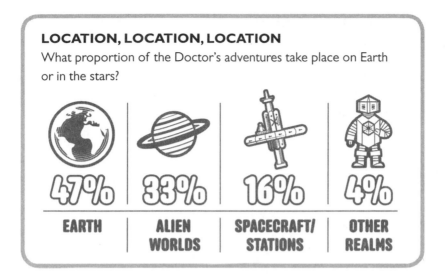

LOCATION, LOCATION, LOCATION
What proportion of the Doctor's adventures take place on Earth or in the stars?

47%	33%	16%	4%
EARTH	ALIEN WORLDS	SPACECRAFT/ STATIONS	OTHER REALMS

NAMEDROPPER

The Doctor is an incorrigible namedropper. Just look at the people he claims to have met—or even married. But as we know from River, he also lies. Maybe he was telling porkies about a few of these.

- Alexander the Great—After his third regeneration, the Fourth Doctor mistook the Brigadier for Alexander. (*Robot*)
- Dante Alighieri—The Doctor has the poet's details in his address book. (*The Two Doctors*)
- Hans Christian Andersen—The Doctor provided the Danish fairy-tale writer with the idea for *The Emperor's New Clothes*. (*The Romans*)
- Sylvia Anderson—Strictly the Doctor's dance-partner. (*Death in Heaven*)
- Marie Antoinette—The French Queen gave the Doctor a picklock. (*Pyramids of Mars*)
- Archimedes—The Doctor has the philosopher's details in his address book. He also thinks he's a bit wet. (*The Two Doctors*)
- Shirley Bassey—The Doctor recalls getting over-excited when he met the singer (*Under the Lake*)
- The Venerable Bede—The Doctor shared a salmon that he caught in the River Fleet with the Anglo-Saxon scholar. (*The Talons of Weng-Chiang*)

- Ludwig van Beethoven—The Doctor picked up how to play the organ by hanging around with Beethoven. (*The Lazarus Experiment*) Nice chap, very intense. Loves an arm wrestle. (*Before the Flood*)
- Pope Benedict IX—The Doctor had an encounter with the female Pope in 1045 as part of the Monk's computer-created world. She was a lovely girl and castanets were involved. (*Extremis*)
- Napoleon Bonaparte—The Doctor told Boney that an army marches on its stomach. (*Day of the Daleks*)
- Gioffre Borgia—The Doctor claimed that Gioffre asked him for his opinion on the Leaning Tower of Pisa, and that the young Borgia was a "mucho scary hombre". (*Time Heist*)
- Isambard Kingdom Brunel—The Doctor has the engineer's details in his address book. (*The Two Doctors*)
- George Bryan 'Beau' Brummell—The arbiter of men's fashion once told the First Doctor that he looked better in a cloak. (*The Sensorites*)
- José Raúl Capablanca—The Doctor watched the Cuban chess champion play Alekhine in 1927. (*The Androids of Tara*)
- Charlemagne—The Doctor tried to find Charlemagne in the Ardennes after the French king was kidnapped by an insane computer. (*The Unicorn and the Wasp*)
- Mr Chicken—The Doctor thought the last private occupant of Number 10 Downing Street was a nice man. (*World War Three*)
- Father Christmas—The Doctor has a photo of himself and Father Christmas (real name: Geoff) alongside Albert Einstein and a mystery blonde taken at Frank Sinatra's hunting lodge in 1952. (*A Christmas Carol*)
- John Churchill—The Doctor was at the battle of Malplaquet with the First Duke of Marlborough. (*The Android Invasion*)
- Cleopatra—The Tenth Doctor mentioned the Egyptian queen to Mickey and Rose, calling her 'Cleo'. (*The Girl in the Fireplace*)
- Christopher Columbus—The Doctor has the explorer's details in his address book. (*The Two Doctors*)
- Marie Curie—The Doctor knew Madame Curie intimately. (*Doctor Who*)
- Sir Francis Drake—The Elizabethan adventurer was a friend of the Doctor's. (*Four to Doomsday*)
- Edward VII—The Doctor knew Elizabeth II's great grandfather in Paris. (*Inferno*)
- Elizabeth I—The Doctor attended his future wife's coronation. (*The Curse of Peladon*)
- Albert Einstein—The Doctor did try to explain to the German-born physicist why his special theory of relativity wasn't right, but the scientist wouldn't listen. (*The Stones of Blood*) We later see him meet Einstein in *Time and the Rani* and *Death*

Is the Only Answer. We also learn that Einstein lent the Doctor his toothbrush—which was eventually exterminated by the Daleks.

- Pierre de Fermat—The mathematician got killed in a duel before he had a chance to write down his real Theorem—and all because the Doctor slept in. (*The Eleventh Hour*)
- Benjamin Franklin—The Doctor helped his mate Ben discover electricity. In the process he got rope burns from the kite, soaked and electrocuted. (*Smith and Jones*)
- Sigmund Freud—The Doctor met the psychologist at some point before his seventh regeneration. (*Doctor Who*)
- Gilbert and Sullivan—The light opera writers once gave the Doctor a coat. (*The Edge of Destruction*)
- The Brothers Grimm—Lovely fellas, they were in the Doctor's darts team (*Heaven Sent*)
- Hannibal—The Doctor confused the Brigadier with Hannibal after his third regeneration. (*Robot*)
- Henry VIII—The Doctor's future father-in-law threw a parson's nose at the First Doctor and the Doctor threw it back, ending up in the Tower of London for his troubles. Of course, it was all a ruse as the TARDIS was locked away in the Tower. (*The Sensorites*) Years later, Rory Williams would leave his mobile phone charger in Henry VIII's en-suite. (*A Town Called Mercy*)
- Harry Houdini—The Doctor picked up a few tricks from the famous escapologist. (*Planet of the Spiders, Revenge of the Cybermen*)
- Thomas Huxley—'Darwin's bulldog' was an old friend of the Doctor's. (*Logopolis*)
- Thomas Jefferson—The Doctor thought that Jefferson, along with two of his fellow American Founding Fathers, John Adams and Alexander Hamilton, were lovely fellows. He also claimed that two of them fancied him. (*The Impossible Astronaut*)
- Quincy Jones—the Doctor stepped in for him once when the bassist he'd hired turned out to be a Klarj Neon Death Voc-bot, who couldn't play (*Knock Knock*).
- Janis Joplin—The singer gave the Doctor the coat worn by his tenth incarnation. (*Gridlock*)
- David Lloyd George—The British Prime Minister used to drink the Doctor under the table. (*Aliens of London*)
- Michelangelo—The Doctor claimed the Renaissance painter whinged all the time he was painting the Sistine Chapel. (*Vincent and the Doctor*)
- Mao Tse-Tung—The Chinese communist gave the Doctor leave to use his personal name. (*The Mind of Evil*)
- Horatio Nelson—A close personal friend of the Doctor's. (*The Sea Devils*)
- Issac Newton—The Doctor tried to help the English scientist discover gravity by climbing up a tree and dropping apples on his head. When Newton told him to clear off the Doctor explained gravity over dinner. (*The Pirate Planet*)

- Madame Nostradamus—The wife of the French seer knitted the Fourth Doctor's scarf. She was a witty little knitter. (*The Ark in Space*)
- Emily Pankhurst—The suffragette stole the Doctor's laser spanner. (*Smith and Jones*)
- Fred Perry—The Doctor has a pair of the tennis legend's shorts. (*The Power of Three*)
- Pablo Picasso—The 'ghastly old goat' wouldn't listen when the Doctor told him where eyes go on the human face. (*Vincent and the Doctor*)
- Giacomo Puccini—The Doctor was with the composer of *Madame Butterfly* before he died. (*Doctor Who*)
- Pyrrho—The First Doctor met the founder of scepticism. (*The Keys of Marinus*)
- Sir Walter Raleigh—The Elizabethan explorer once shared a cell in the tower of London with the Doctor. (*The Mind of Evil*)
- Franz Schubert—*Fantasia in F minor for four hands* was written for Schubert and the Doctor to play together. 'Franz the hands' kept tickling the Doctor to put him off. (*Dinosaurs on a Spaceship*)
- William Shakespeare—When the Doctor met Shakespeare he thought the bard was a 'charming fellow' but a 'dreadful actor'. (*Planet of Evil*) When he was young, Will was a 'taciturn boy'. The Doctor would go on to write the first draft of *Hamlet* after Shakespeare sprained his wrist writing sonnets. He also tried to point out that 'Take arms against a sea of troubles' was a mixed metaphor but the playwright insisted that it was fine. (*City of Death*) We later see him meet Shakespeare in *The Shakespeare Code*.
- John Sullivan—The heavyweight boxing champion gave the Doctor boxing lessons. (*Carnival of Monsters*)
- William Tell—The Swiss folk hero taught the Doctor how to shoot a crossbow. (*The Face of Evil*)
- Theseus—Theseus and Ariadne were helped out of the Minotaur's maze by the Doctor and a ball of string. (*The Creature from the Pit*) The Doctor forgot to remind Theseus to paint his ship white. (*The Horns of Nimon*)
- Queen Victoria—The Doctor attended Victoria's coronation. (*The Curse of Peladon*)
- Leonardo da Vinci—Some time after *The Masque of Mandragora*, the Doctor met Leonardo and the model for the Mona Lisa, a dreadful woman with no eyebrows who wouldn't sit still. (*City of Death*) The Sixth Doctor had Leonardo's contact details in his address book. (*The Two Doctors*)
- James Watt—The First Doctor was present when the Scottish engineer discovered steam power. (*The Space Museum*)
- Issak Walton—The Doctor fished with the author of *The Compleat Angler*. (*The Androids of Tara*)

HISTORICAL CELEBRITIES

'Charles Dickens? You're brilliant, you are. Completely, one hundred per cent brilliant.'

The Doctor, *The Unquiet Dead*

When you get around the history of Earth as much as the Doctor does, sooner or later you're going to bump into some very famous celebrities. Here are some of the great and the good (and the downright evil) of history that have been portrayed during the Doctor's travels.

Name	Played by	Year met the Doctor	Story
Queen Nefertiti	Riann Steel	1334 BC	*Dinosaurs on a Spaceship*
The Ninth Legion	Various	AD 2	*Eaters of Light*
Tigilinus	Brian Proudfoot	AD 64	*The Romans*
Poppaea Sabina	Kay Patrick	AD 64	*The Romans*
Emperor Nero	Derek Francis	AD 64	*The Romans*
Robin Hood	Tom Riley	1190	*Robot of Sherwood*
Saladin	Bernard Kay	c.1190	*The Crusade*
Saphadin (Al Adil I)	Roger Avon	c.1190	*The Crusade*
Richard the Lionheart	Julian Glover	c.1190	*The Crusade*
Lady Joanna (Joan, Queen of Sicily)	Jean Marsh	c.1190	*The Crusade*
Robert de Beaumont	John Bay	c.1190	*The Crusade*
Marco Polo	Mark Eden	1289	*Marco Polo*
Kublai Khan	Martin Miller	1289	*Marco Polo*

Name	Played by	Year met the Doctor	Story
Gaspard de Coligny	Leonard Sachs	1572	*The Massacre*
Catherine de' Medici	Joan Young	1572	*The Massacre*
Charles IX of France	Barry Justice	1572	*The Massacre*
Elizabeth I	Vivienne Bennett / Angela Pleasance / Joanna Page	1562 / 1599	*The Chase / The Shakespeare Code / The Day of the Doctor*
William Shakespeare	Hugh Walters / Dean Lennox Kelly	Early 17th century / 1599	*The Chase / The Shakespeare Code*
William Kempe	David Westhead	1599	*The Shakespeare Code*
Charles II	Paul Critoph	Late 1600s	*The Impossible Astronaut*
Henry Avery	Hugh Bonneville	1699	*The Curse of the Black Spot*
Madame de Pompadour	Jessica Atkins / Sophia Miles	1727–1764	*The Girl in the Fireplace*
Louis XV of France	Ben Turner	1745–1764	*The Girl in the Fireplace*
Paul Francois Jean Nicolas, vicomte de Barras	John Law	1794	*The Reign of Terror*
Robespierre	Keith Anderson	1794	*The Reign of Terror*
Napoleon Bonaparte	Tony Wall	1794	*The Reign of Terror*
George Stephenson	Gawn Grainger	c.1813	*The Mark of the Rani*
Charles Dickens	Simon Callow	1869	*The Unquiet Dead*
Benjamin Briggs	David Blake Kelly	1882	*The Chase*
Albert Richardson	Dennis Chinnery	1882	*The Chase*
Queen Victoria	Pauline Collins	1879	*Tooth and Claw*
Virgil Earp	Victor Carin	1881	*The Gunfighters*
Ike Clanton	William Hurndall	1881	*The Gunfighters*
Wyatt Earp	John Alderson	1881	*The Gunfighters*
Johnny Ringo	Laurence Payne	1881	*The Gunfighters*
Big Nose Kate	Sheena Marsh	1881	*The Gunfighters*

Name	Played by	Year met the Doctor	Story
Doc Holliday	Anthony Jacobs	1881	*The Gunfighters*
Bat Masterson	Richard Beale	1881	*The Gunfighters*
Warren Earp	Martyn Huntley	1881	*The Gunfighters*
Billy Clanton	David Cole	1881	*The Gunfighters*
HG Wells	David Chandler	1885	*Timelash*
Vincent van Gogh	Tony Curran	1890	*Vincent and the Doctor*
Agatha Christie	Fenella Woolgar	1926	*The Unicorn and the Wasp*
Adolf Hitler	Albert Welling	1938	*Let's Kill Hitler*
Winston Churchill	Ian McNeice	1941	*Victory of the Daleks*
Richard Nixon	Stuart Milligan	1969	*The Impossible Astronaut / Day of the Moon*
Albert Einstein	Tom O'Leary / Nicolas Grace	Unknown / 1945	*Time and the Rani / Death Is the Only Answer*
Louis Pasteur	Uncredited	Unknown	*Time and the Rani*

THE NEMESIS COMET

'Listen, Ace. The Nemesis generates destruction. It affects everything around it.'

The Doctor, *Silver Nemesis*

In 1638, the Doctor launched the Validium statue known as the Nemesis Comet into space on a rocket-sled. Unfortunately, its orbit then brought it near to Earth every 25 years, causing trouble on the planet with every pass. Known effects influenced by the statue's proximity to the planet include:

- 1913: The eve of the First World War
- 1938: Adolf Hitler's annexation of Austria
- 1963: The assassination of President John F. Kennedy
- 1988: the attempted rise of the Fourth Reich and a Cyber invasion

CELEBRITY CULTURE

Everybody from newsreaders to pop stars wants to appear in *Doctor Who*. Here's a rundown of the real-life celebrities of planet Earth that have appeared as themselves in the series.

Celebrity	Type	Episode
Derek Acorah	Presenter	*Army of Ghosts*
Alistair Appleton	Presenter	*Army of Ghosts*
Matt Baker	Presenter	*Aliens of London*
Professor Brian Cox	Writer / broadcaster	*The Power of Three*
Richard Dawkins	Writer / broadcaster	*The Stolen Earth*
Huw Edwards	Newsreader	*Fear Her*
Trisha Goddard	Presenter	*Army of Ghosts*
Kenneth Kendall*	Newsreader	*The War Machines*
Alex MacIntosh	Newsreader	*Day of the Daleks*
Andrew Marr	Broadcaster / political correspondent	*Aliens of London / World War Three*
McFly	Pop group	*The Sound of Drums*
Jason Mohammad	Newsreader	*The Christmas Invasion / Voyage of the Damned / Turn Left / The Stolen Earth*
Patrick Moore	Astronomer / broadcaster	*The Eleventh Hour*
Paul O'Grady	Presenter	*The Stolen Earth*
Courtney Pine	Jazz musician	*Silver Nemesis*
Lord (Alan) Sugar	Businessman / broadcaster	*The Power of Three*
Bill Turnbull	Newsreader	*The Wedding of River Song*
Meredith Vieira	US news anchor	*The Wedding of River Song*
Kirsty Wark	Newsreader	*The Poison Sky*

Celebrity	Type	Episode
Anne Widdecombe	Politician	*The Sound of Drums*
Sian Williams	Newsreader	*The Wedding of River Song*
Nicholas Witchell	Royal correspondent	*Voyage of the Damned*

* First person to appear as themselves in *Doctor Who*.

NOT QUITE THEMSELVES

Although many celebrities from the real world have appeared in *Doctor Who*, there's a handful of famous figures that have appeared—but perhaps not exactly as themselves:

- **Anne Robinson**—The laser-tongued presenter lent her voice to the Anne-Droid, the literally laser-tongued metallic presenter of a futuristic edition of quiz show *The Weakest Link*. (*Bad Wolf*)
- **Davina McCall**—As the voice of Davinadroid, the presenter presided over the Game Station's version of *Big Brother* in the year 200,100, where the Doctor was forced to be a housemate. (*Bad Wolf*)
- **Trinny Woodall and Susannah Constantine**—In the 21st century they were the presenters of *What Not To Wear*, but by 200,100 they were Trine-e and Zu-Zana, intent on giving Captain Jack a permanent make-over. (*Bad Wolf*)
- **Barbara Windsor**—There was no Peggy Mitchell in residence in Albert Square when the TARDIS landed there in 1993's *Dimensions in Time*, but in 2006 Barbara Windsor finally appeared in *Doctor Who*—within an episode of *EastEnders*. Jackie Tyler was glued to a storyline in which Peggy tells a 'ghost' of Den Watts to 'get out of my pub'. (*Army of Ghosts*)

MEDICAL ESTABLISHMENTS
ON EARTH

'I thought you were a doctor!'

The Doctor, *Doctor Who*

Establishment	Location	Story
Albion Hospital	London	*Aliens of London, The Empty Child / The Doctor Dances*
Ashbridge Cottage Hospital	Essex	*Spearhead from Space*
Bethlem Royal Hospital (aka Bedlam)	London	*The Shakespeare Code*
Guy's Hospital	London	*Black Orchid*
Royal Hope Hospital	London	*Smith and Jones*
Royal Leadworth Hospital	Leadworth	*The Eleventh Hour*
Unnamed	Nunton	*The Hand of Fear*
Unnamed	London	*The Power of Three*
Walker General Hospital	San Francisco, USA	*Doctor Who*
Wenley Hospital	Wenley	*Doctor Who and the Silurians*

If all hospitals on Earth are full, *Who-ology* recommends you try Ward 26 of the New New York Hospital on New Earth (*New Earth*), or the Bi-Al Foundation on asteroid K4067, near the Saturn moon of Titan. Robot dogs and invading alien swarms a speciality. (*The Invisible Enemy*). However, if you find yourself on floor 1056 of a Mondasian colony ship, basically run...

THE MYSTERIOUS WORLD
OF DOCTOR WHO

'They seemed so secure and died out virtually overnight.'

The Doctor, *Earthshock*

The Doctor has had a hand in some of the Earth's greatest mysteries…

☐ WHY DID THE DINOSAURS DIE OUT?

A cataclysmic event brought about the extinction of the dinosaurs about 65 million years ago. Accepted scientific theory suggests a large celestial object collided with the Earth.

Mystery solved: The Cybermen intended to use a large space freighter to impact with the Earth in the year 2526 to destroy a peace conference. The freighter did impact with the Earth, but not in the far future. Thanks to the interference of the Doctor's companion Adric, the freighter travelled back in time some 65 million years. The rest is history. As is Adric. (*Earthshock*)

☐ ATLANTIS

First mentioned by Plato, Atlantis was a legendary city believed to have been lost beneath the waves. According to the philosopher it sank in 'a single day and night of misfortune'. But what was that misfortune?

Mystery solved: Atlantis was destroyed around 1500 BC when the Master unleashed the being known as Kronos. (*The Time Monster*) Simple. Or it would have been if Azal hadn't claimed that the Daemons destroyed Atlantis as a failed experiment. (*The Daemons*) Either way, Atlantis was rediscovered by Professor Zaroff in the latter half of the 20th century. (*The Underwater Menace*)

☐ HOW DID ANCIENT MAN BUILD THE PERUVIAN TEMPLES?

Archaeologists have long been puzzled by complex temples dating from thousands of years ago. How had primitive man built such intricate buildings?

Mystery solved: Visitors from the planet Exxilon came to Earth and taught the locals how to build, mirroring the structures on their own planet. (*Death to the Daleks*)

▓ THE MYSTERY OF THE MARY CELESTE

On 5 November 1872, American merchant ship *Mary Celeste* set sail from New York City, bound for Italy. On 4 December, the ship was discovered adrift, with the crew having mysteriously vanished without trace.

Mystery solved: Trying to elude pursuit by the Daleks, the Doctor landed the TARDIS aboard the *Mary Celeste*, the Daleks arriving soon after in their own time machine. When faced with the horror of the Daleks, the crew sensibly threw themselves overboard. Along with a Dalek. (*The Chase*)

▓ THE ABOMINABLE SNOWMAN

The world's most famous crypto-zoological mystery is that of the Yeti—aka the Abominable Snowman. Possibly bear-like, the 'Wild Man of the Snows' is said to inhabit the Himalayan mountain region near Tibet, and fleeting sightings have been made since the 19th century.

Mystery solved: The Yeti were in fact the robot slaves of the Great Intelligence, a malevolent entity that inhabited a Tibetan monastery for about 200 years. Professor Edward Travers took one back to England after his expedition near the Det-Sen monastery (*The Abominable Snowmen* / *The Web of Fear*)

▓ THE LOCH NESS MONSTER

Since the 6th century, there have been reported sightings of a strange creature in and around Loch Ness in the Scottish Highlands. Known as Nessie, this creature could be the last surviving example of a plesiosaur or other prehistoric creature. Many have searched, but Nessie has never been found…

Mystery solved: The Loch Ness Monster is a Skarasen, a cyborg hybrid creature that was released into the loch in the 12th century by the Zygons. From their ship deep beneath the loch, the aliens used the savage creature as a weapon towards their goal of world domination. (*Terror of the Zygons*)

Or

Nessie is the deformed Borad, banished by the Doctor through the Timelash from the planet Karfel. With luck, the Skarasen may have eaten him. (*Timelash*)

█ THE GREAT FIRE OF LONDON

In the early hours of Sunday 2 September 1666, a fire broke out at a bakery on Pudding Lane in the city of London. The fire raged for three days, gutting much of the capital. Was it the carelessness of a tired baker, or something more sinister that started the fire? *Mystery solved:* In the Fifth Doctor's final confrontation with the alien Terileptils in the bakery at Pudding Lane, a dropped torch started a small fire during a struggle, causing a Terileptil energy weapon to overload and explode. The fire soon spread to the adjacent buildings. (*The Visitation*)

Or

Perhaps the Fourth Doctor had a hand in the Great Fire… As he and Sarah left the burning priory belonging to the Scarman family, he said he didn't want to be blamed for starting a fire. 'I had enough of that in 1666,' he complained. (*Pyramids of Mars*)

█ THE TUNGUSKA EVENT

On the morning of 30 June 1908, a large explosion in the vicinity of the Stony Tunguska River in Siberia, Russia, flattened around 2000km² of forest. The cause of the blast has been the subject of much study and speculation, with the likely cause being the air burst of a meteoroid disintegrating in the atmosphere. But why was the devastation not more cataclysmic, and why were there no human casualties? *Mystery solved:* The Tunguska blast was contained by the sudden appearance of fully grown trees in giant forests across the entire planet. This created an enormous pocket of air around the Earth that cushioned the planet from mass devastation. With the danger passed, the trees dissipated and the event was ultimately forgotten. The Doctor and Clara experienced a similar event in present-day London when solar activity threatened to destroy the planet. (*In the Forest of the Night*)

THE MOVING EARTH

'The TARDIS is still in the same place, but the Earth has gone. The entire planet. It's gone.'

The Doctor, *The Stolen Earth*

The Earth has a habit of not staying in a fixed orbit

- 2009—The Daleks dragged the Earth light years away to the Medusa Cascade where it and 26 other planets were used to power Davros's Reality Bomb. After

Davros's defeat, the Doctor used the TARDIS to tow the planet back to its normal position in the Solar System. (*The Stolen Earth / Journey's End*)

- 2157—A near thing, but the Earth actually stayed put. The Daleks invaded Earth and used the world's population as slave workers to mine the planetary core and replace it with a power system so they could pilot it around the universe. Thankfully the Doctor pitted his wits against them and defeated them—it's only out of politeness that he didn't stop to ask them why. (*The Dalek Invasion of Earth*)

- 2,000,000—It isn't just the Daleks that have a desire to get the keys to the planet and take it for a spin. To cover up an embarrassing theft of secrets from the Matrix, the Time Lords used a Magnetron to move Earth two light years away, destroying the surface in a firestorm, renamed it Ravolox, and hoped nobody would notice. (*The Trial of a Time Lord: The Mysterious Planet*)

- c.5 billion—When solar flares finally forced the population to flee the Earth, the National Trust held back the expanding sun with gravity satellites to preserve the uninhabited planet for posterity. Once Earth was finally destroyed by the sun, New Earth was established in the M87 galaxy on a planet that had the same orbit and size as the original. Humans just hate change. (*The Ark, The End of the World, New Earth, Gridlock*)

TARDIS LOG

Roll up, roll up for a grand tour of the universe. Let us follow the footsteps of the Doctor as we visit the more notable celestial bodies, planets and moons that feature in the TV series. That madman in a box really gets around doesn't he?

Skaro
Marinus
The Sense-Sphere
Dido
Vortis
Xeros
Aridius
Mechanus
Unnamed planet in Galaxy Four
Kembel
Desperus
Mira
Tigus
Kembel
Refusis II

Unnamed planet (*The Savages*)
Mondas
Vulcan
The Moon
Unnamed colony world (*The Macra Terror*)
Telos
Dulkis
Unnamed planet (*The Krotons*)
Ta
Unnamed planet (*The War Games*)
Gallifrey
Uxarieus
Peladon
Solos

Omega's antimatter world
Inter Minor
Draconia
Ogron home world
Spiridon
Metebelis III
Exxilon
Voga
Zeta Minor
Mars
Oseidon
Karn
Kastria
Unnamed planet (*The Face of Evil*)
Unnamed planet (*The Robots of Death*)
Titan
Asteroid K4067 (the Bi-Al Foundation)
Pluto
P7E planetoid
Ribos
Zanak
Calufrax
Tara
Third moon of Delta Magna
Atrios
Zeos
Chloris
Skonnos
Crinoth
Argolis
Tigella
Zolfa-Thura
Alzarius
Unnamed planet (*State of Decay*)
Traken
Logopolis
Unnamed Phylox planet in Andromeda (*Castrovalva*)
Deva Loka
Manussa
The Eye of Orion
Frontios
Sarn
Androzani Minor
Androzani Major
Titan III
Jaconda

Varos
Karfel
Necros
Thoros Beta
Lakertya
Unnamed planet (*Paradise Towers*)
Toll Port G715
Svartos
Terra Alpha
Segonax
Unnamed planet of the Cheetah People (*Survival*)
New Earth
Krop Tor
Malcassairo
The Ood-Sphere
Messaline
The Library
Midnight
Shan Shen
Shadow Proclamation
San Helios
Alfava Metraxis
Planet One
Ember
Zaruthstra
Demon's Run
Apalapucia
Calisto B
Tree farm planet (*The Doctor, the Widow and the Wardrobe*)
Vegas 12
Dalek Asylum
Tiaanamat
Hedgewick's World of Wonders
Trenzalore
Unnamed planet, location of the Bank of Karabraxos
The Moon
An unnamed planet at the end of time
Mendorax Dellora
Darillium
A planet twenty-three million years in the future
Somewhere in the Dalek-Movellan war
Gliese 581D
The Weapon Forges of Villengard

SOLAR SYSTEM STORIES

Doctor Who stories that take place in or around the planets of the Solar System.

* Although no stories are set on Venus, it has featured heavily in the mythos of *Doctor Who*. The popular Mars-Venus Games were broadcast across the Solar System in the year 4000 (*The Daleks' Master Plan*). The First Doctor and Susan once saw the metal seas of Venus (*Marco Polo*). The Dalek

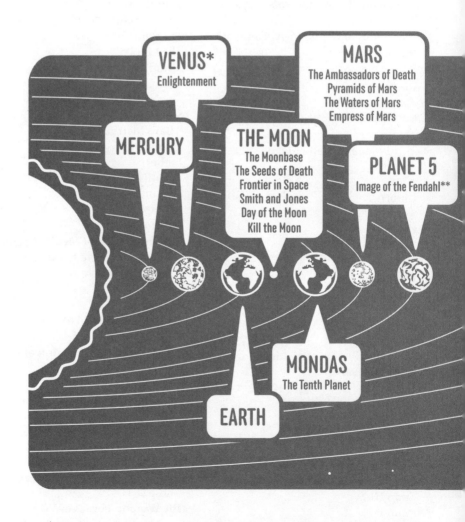

VENUS*
Enlightenment

MARS
The Ambassadors of Death
Pyramids of Mars
The Waters of Mars
Empress of Mars

MERCURY

THE MOON
The Moonbase
The Seeds of Death
Frontier in Space
Smith and Jones
Day of the Moon
Kill the Moon

PLANET 5
Image of the Fendahl**

MONDAS
The Tenth Planet

EARTH

alliance planned to conquer Venus (*Mission to the Unknown*). Mavic Chen ordered Carlton to take a party (of soldiers presumably) to Venus (*The Daleks' Master Plan*). Duggan had floating flower seeds from Venus (*The Wheel in Space*). The Third Doctor knew Venusian measurements and proverbs (*The Time Monster*), said you should 'never trust a Venusian shanghorn with a perigosto stick' (*The Green Death*) and was well versed in Venusian aikido and lullabies. The Fourth Doctor had a pilot's licence for the Mars-Venus rocket run (*Robot*). Venus was the first obstacle in the race for Enlightenment (*Enlightenment*). The Tenth Doctor had a toothbrush containing Venusian spearmint (*The Shakespeare Code*).

** Home planet of the Fendahl. The Time Lords placed the planet in a time loop, its existence wiped from history.

*** Uranus was the source of the rare mineral Taranium, mined by Guardian of the Solar system Mavic Chen to power the Daleks' Time Destructor.

**** Mark Gatiss' found-footage story takes place on the Le Verrier space station above Neptune. When the station's grav-shields start to fail, the rest of the action almost takes place on it.

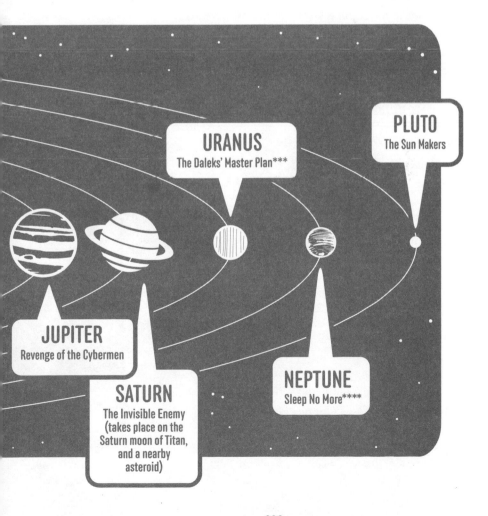

WELCOME TO GALLIFREY

'Oh, you should have seen it, that old planet. The second sun would rise in the south, and the mountains would shine. The leaves on the trees were silver, and when they caught the light every morning, it looked like a forest on fire. When the autumn came, the breeze would blow through the branches like a song.'

<div align="right">

The Doctor, *Gridlock*

</div>

The visitor's guide to the Shining World of the Seven Systems.

LOCATION
- The constellation of Kasterborous, some 250 million light years from Earth
- Nowhere near Ireland
- 10-0-11-00 by 02 from Galactic Zero Centre

PLANET
- At least twice the size of Earth
- Orange-tinted atmosphere
- Twin suns

FLORA & FAUNA
- Silver-leaved trees
- Flutterwing (a flying insect)
- Mice
- Cats
- Small fuzzy creatures, no bigger than a thumbnail, live in the snow of Gallifrey's mountains. These Plungbolls cling to any source of heat and can only be removed by anti-Plungboll spray. According-ing to the radio series *The Paradise of Death*, anyway.

NEIGHBOURING WORLDS
- Karn and the Five Planets (well, a couple of million parsecs away at least)

ECONOMY

- Considered Grade Three in market surveys due to low potential of commercial development

LANDMARKS

- The Capitol or Citadel of the Time Lords, located on the Continent of Wild Endeavour in the Mountains of Solace and Solitude
- The Tower of Rassilon, found in the Death Zone
- Mount Perdition, the red grass-lined childhood home of notorious Gallifreyan criminal, the Master
- Arcadia, Gallifrey's second city and the first to fall on the last day of the Time War.
- The Doctor's Barn, a humble barn where the Doctor often slept as a child. He would return there on his darkest day.

SOCIAL SERVICES

- Maternity service, recognised by the sign of the crossed computers
- Bureau of Ancient Records, former employer of President Romanadvoratrelundar

POPULATION

- The Lords of Time—aristocratic rulers and temporal engineers
- Outsiders—Gallifreyans who lived in the plains outside the Time Lord Capitol, choosing a primitive existence, hunting for food with simple bows and arrows
- Shobogans—Gallifreyan vandals, the blight of the Chancellery Guard

PLANETARY DEFENCES

- Transduction Barrier
- Sky Trenches

NOTABLE TIME LORDS

Rassilon *played by Richard Mathews, Timothy Dalton and Donald Sumpter*

Engineer and architect. Founded Time Lord society. Mostly regarded as a hero but considered a tyrant by his opponents. Was resurrected to lead his Time Lord descendants in the fight against the Daleks in the Last Great Time War. Willing to create a paradox so strong that all creation would be destroyed and the Time Lords would elevate to beings of higher consciousness. Survived the Time War only to be banished from Gallifrey by the Doctor. Known as Rassilon the Redeemer and Rassilon the Resurrected. Completely bonkers.

Omega *played by Ian Collier, Stephen Thorne and Peter Davison*

The father of Gallifreyan time travel. As Rassilon's Solar Engineer, Omega piloted a ship into the heart of a nearby sun, transforming it into a black hole that was harnessed using the Eye of Harmony to power Gallifrey's mastery over time. Thought lost in the initial supernova, Omega was revered. In reality was lost in an anti-matter universe where he spent millennia plotting his revenge. Completely bonkers.

⬛ **Borusa** *played by John Arnatt, Angus MacKay, Leonard Sachs and Philip Latham*
The Doctor's tutor at the Time Lord Academy and later Lord President of Gallifrey.
Strict but possessing a keen mind, Borusa would ultimately be corrupted by his high
office. Longing for immortality so he could rule Gallifrey as President Eternal, risked
the planet's safety by opening the long-forbidden Death Zone and forcing four of the
Doctor's incarnations to search for the fabled Ring of Rassilon. Achieved his goal
when he was trapped for all time as a statue in the Tomb of Rassilon. Completely
bonkers.

⬛ **The Master** *played by Roger Delgado, Peter Pratt, Geoffrey Beevers, Anthony Ainley,
Gordon Tipple, Eric Roberts, Derek Jacobi, John Simm, William Hughes and Michelle
Gomez*
The Doctor's best enemy. As friends since childhood, the two Time Lords attended
the Academy together but would follow very different paths. Whereas the Doctor
left Gallifrey to explore and help the people of the universe, the Master left to enslave
others to his will. An expert at mesmerism and disguise, the Master was driven mad
the day he was made to stare into the Untempered Schism. From that day on, the
Master would endure the constant sound of drumming in his mind. He would later
learn that Rassilon himself was responsible for his unending torment and that from
birth he was destined to aid Gallifrey's return from the Time War. Following his
escape from Gallifrey, the Master regenerated into a female incarnation that went
by the name of the Mistress, or Missy. Completely bonkers (and then some).

⬛ **The Rani** *played by Kate O'Mara*
Born the same year as the Doctor, the Rani was exiled from Gallifrey after accidentally
accelerating the growth patterns of her laboratory mice. The now monstrous-sized
rodents rampaged through the Capitol, eating the President's cat and mauling the
Lord President himself. A brilliant if amoral scientist, the Rani conquered Miasimia
Goria, but her experiments on its populous removed their ability to enter R.E.M.
sleep. Later, she conquered the peaceful world of Lakertya with a mercenary band of
Tetraps from the planet Tetrapyriarbus. Completely bonkers.

⬛ **The War Chief** *played by Edward Brayshaw*
Leaving Gallifrey long after the Doctor, the War Chief allied himself with the
War Lords. Now armed with the power of time travel the warmongers kidnapped
soldiers from various points in Earth's history, pitting them against each other.
The victors would then be recruited as an army against the rest of the galaxy. He
was killed by the War Lords when they uncovered his plot to overthrow them.
Completely bonkers.

█ **The Monk** *played by Peter Butterworth*

Whereas Time Lords such as the Master or the War Chief lusted after power, the Monk simply wanted to meddle. The Doctor first encountered him attempting to prevent the Norman conquest of 1066. He then planned to provide King Harold with anachronistic technology so by the time Shakespeare wrote *Hamlet*, the tragedy appeared on television rather than the stage. He honestly believed Harold would make a better king so you could argue that his heart was in the right place, even if his motives were flawed. After foolishly teaming up with the Daleks, the Monk was stranded on a frozen planet by the Doctor. Not so much bonkers, just mischievous.

THE MASTER MAD-O-METER

To the Doctor, the Master is the quintessence of evil; to Rassilon, he's Gallifrey's most infamous child. To the Rani, however, he was an asinine cretin. But just how potty were his nefarious plans?

Terror of the Autons—Plans to take over the world using a Nestene energy unit, troll dolls, plastic chairs and a few fake daffodils.
Mad rating: 2 ●▬▬◗ ●▬▬◗

The Mind of Evil—Disguises himself as Professor Emil Keller, uses an alien mind parasite to control inmates of Stangmoor Prison so he can steal a Thunderbolt missile, blow up a peace conference and bring about World War III.
Mad rating: 3 ●▬▬◗ ●▬▬◗ ●▬▬◗

The Claws of Axos—In return for his life, plans to serve Earth up on a plate to the energy-vampire Axos.
Mad rating: 1 ●▬▬◗

Colony in Space—Posing as Earth Adjudicator, plans to steal the Uxariean Doomsday Weapon, which he can use in an almighty protection racket.
Mad rating: 2 ●▬▬◗ ●▬▬◗

The Daemons—Masquerading as Mr Magister, a local Anglican vicar, forms a cult and summons a giant horned alien in the crypt of a village church in order to receive vast cosmic powers.

Mad rating: 2 ●▬▬◗ ●▬▬◗

The Sea Devils—While pretending to languish at Her Majesty's pleasure, steals Navy equipment to revive a Sea Devil colony which he will use to take over the world.

Mad rating: 1 ●▬▬◗

The Time Monster—Assumes the role of Professor Thascales to build Transmission Of Matter Through Interstitial Time (or TOMTIT machine). Uses it to try and control the powerful, pan-dimensional entity known as Kronos.

Mad rating: 2 ●▬▬◗ ●▬▬◗

Frontier in Space—Provokes a devastating interplanetary war between the Draconian and Earth empires so his allies, the Daleks, can easily invade. Hopes to rule Earth in their name, at least.

Mad rating: 1 ●▬▬◗

The Deadly Assassin—Nothing more than a rotting corpse at the end of his regenerative cycle, works to place a puppet President in the highest office on Gallifrey so he can use the power of the Eye of Harmony to prolong his life.

Mad rating: 2 ●▬▬◗ ●▬▬◗

The Keeper of Traken—Still nothing more than a rotting corpse at the end of his regenerative cycle, works to place a puppet Keeper in the highest office on Traken so he can use the power of the Source to prolong his life.

Mad rating: 2 ●▬▬◗ ●▬▬◗

Logopolis—Starts randomly killing the mathematicians who are holding the universe together with their calculations, thus causing creation to start unravelling. Then tries to hold the entire cosmos to ransom. With a walkman.

Mad rating: 3 ●▬▬◗ ●▬▬◗ ●▬▬◗

Castrovalva—Sends the TARDIS screaming back to the Big Bang where it will be utterly destroyed. Just in case it isn't utterly destroyed, also kidnaps Adric and sets up Castrovalva, an artificial and fully recursive city to finally ensnare the Doctor forever. The ultimate Plan B.

Mad rating: 3 ●▬▬◗ ●▬▬◗ ●▬▬◗

Time-Flight—Escapes Castrovalva, but gets stranded on prehistoric Earth, his TARDIS's dynomorphic generator exhausted. Disguises himself as an alien called Kalid and tries to replace his TARDIS's generators with a powerful alien known as the Xeraphin.
Mad rating: 2 ●▬▬▬◗ ●▬▬▬◗

The King's Demons—Posing as a French swordsman, tries to stop the signing of the Magna Carta by means of a shape-shifting android and a dodgy accent.
Mad rating: 1 ●▬▬▬◗

The Five Doctors—Forced into rescuing the Doctor(s) from the Death Zone, thinks on the hoof and tries to claim immortality from Rassilon.
Mad rating: 1 ●▬▬▬◗

Planet of Fire—After accidentally shrinking himself to hamster size, seizes control of former slave Kamelion so that he can hijack the TARDIS and restore himself in the Numismaton gas of the planet Sarn.
Mad rating: 2 ●▬▬▬◗ ●▬▬▬◗

The Mark of the Rani—Teams ups with the Rani to accelerate the Industrial Revolution, but instead larks around disguised as Worzel Gummidge.
Mad rating: 3 ●▬▬▬◖∷ ●▬▬▬◖∷ ●▬▬▬◖∷

The Trial of a Time Lord: The Ultimate Foe—Sits down and watches a courtroom drama for 12 episodes then steps in when he realises that the Valeyard, the distillation of everything evil in the Doctor, might win and wipe the floor with him.
Mad rating: 1 ●▬▬▬◗

Survival—Trapped on an alien planet and slowly mutating into a Cheetah Person, uses dimension-hopping black cats to send Cheetah People to Earth to bring back humans who will turn into Cheetah people and transport him back to Earth.
Mad rating: 3 ●▬▬▬◖∷ ●▬▬▬◖∷ ●▬▬▬◖∷

Doctor Who—Seemingly exterminated by the Daleks, tricks the Doctor into taking his mortal remains back to Gallifrey, morphs into an alien death-snake thing, takes over the corpse of an ambulance driver and opens the Eye of Harmony so he can steal the Doctor's remaining regenerations, nearly destroying the Earth in the process.
Mad rating: 2 ●▬▬▬◗ ●▬▬▬◗

Utopia—Wipes his own memory and disguises himself as a human to escape the horrors of the Time War. As plans go, we can't argue with it.
Mad rating: 0

The Sound of Drums—Worms his way into politics, becomes Prime Minister, fakes first contact with an alien race, kills the President of the United States, and, using the Doctor's TARDIS to stabilise a massive paradox, becomes supreme ruler of Earth.

Mad rating: 3 ▪■■■■🎸 ▪■■■■🎸 ▪■■■■🎸

The End of Time—Uses the Immortality Gate to turn every human into a perfect copy of himself and unexpectedly brings Gallifrey back from the Time War.

Mad rating: 2 ▪■■■■🎸 ▪■■■■🎸

Dark Water / Death in Heaven—OK, strap yourself in for this one. Uploads the minds of the recently deceased into a Gallifreyan hard drive, before downloading them back into their bodies so the dead rise from their respective graves. There's only one snag, she's found a way of converting the dead into Cybermen. Oh, and all the living too. Granted that's a pretty big snag. And all to give the Doctor an army of his own, so she gets her friend back.

Mad rating: 3 ▪■■■■🎸 ▪■■■■🎸 ▪■■■■🎸

The Magician's Apprentice / The Witch's Familiar—Freezes every aeroplane above the Earth in one point of time to get UNIT's attention. Why? Because she wants to find the Doctor as she's received his last will and testament.

Mad rating: 3 ▪■■■■🎸 ▪■■■■🎸 ▪■■■■🎸

World Enough and Time / The Doctor Falls—Ends up stuck on a Mondasian colony ship that's being sucked into a black hole. Lives like a king in the city until it's an industrial wreck, then hides out in a hospital in disguise and kickstarts the genesis of the Mondasian Cybermen. But wouldn't you know it, the Doctor, Bill and future incarnation Missy turn up at the top of the ship. What are the chances? Hatches a new plot to convert Bill into a Cyberman and finally defeat the Doctor, but hasn't counted on Missy developing a conscience and literally stabbing herself in the back, before the Master blasts her with his laser screwdriver. The Master and Missy equals double the crazy!

Mad rating: 3 ▪■■■■🎸 ▪■■■■🎸 ▪■■■■🎸

THE THINGS OF RASSILON AND OTHER GALLIFREYAN STUFF

An awful lot of Gallifreyan artefacts seem to have been named after the founder of Time Lord society. Here's the complete list so far, although for all we know there could be the cheese-grater of Rassilon hidden somewhere in the Panopticon.

- **The Black Scrolls of Rassilon**—Forbidden knowledge from the Dark Time of Gallifrey. (*The Five Doctors*)

- **The Circlet of Rassilon**—Used to access the Matrix, the repository of all Time Lord knowledge. (*The Invasion of Time*)
- **The Coronet of Rassilon**—Enabled the wearer to control the minds of others. (*The Five Doctors*)
- **The Great Key of Rassilon**—Activated the De-Mat gun, Gallifrey's ultimate weapon. (*The Invasion of Time*)
- **The Gauntlet of Rassilon**—A large metal glove worn by the resurrected Rassilon, capable of disintegrating living matter. (*The End of Time*)
- **The Harp of Rassilon**—The key to a secret Time Scoop chamber in the chambers of the High Council. (*The Five Doctors*)
- **The Key of Rassilon**—Allowed Time Lords to physically enter the Matrix. Rassilon, clearly liked a good key. (*The Trial of a Time Lord: The Ultimate Foe*)
- **The Record of Rassilon**—Rassilon's own chronicle of the war against the Vampires. A copy was kept on all Type 40 TARDISes. (*State of Decay*)
- **The Ring of Rassilon**—Bestowed the wearer with the gift—or rather, the curse—of immortality. (*The Five Doctors*)
- **The Rod of Rassilon**—An ebonite staff held by the Time Lord President. Could also be used to activate the Eye of Harmony which was located beneath the Panopticon. Also, confusingly, known as the Great Key. (*The Deadly Assassin, The Invasion of Time*)
- **The Sash of Rassilon**—The Presidential chain of office. Could also protect the wearer against the forces of the Eye of Harmony. (*The Deadly Assassin*)
- **The Seal of Rassilon**—The seal of the High Council and universal crest of the Time Lords. (Various)
- **The Tomb of Rassilon**—The final resting place of the first Time Lord president. (*The Five Doctors*)

Other Time Lord artefacts:
- **The Hand of Omega**—Omega's remote stellar manipulator that created the Black Hole that powered Rassilon's time-travel experiments. (*Remembrance of the Daleks*)
- **The Genesis Ark**—A dimensionally transcendental prison used to incarcerate millions of Daleks. (*Doomsday*)
- **Validium**—Living metal created by Rassilon and Omega to defend Gallifrey. (*Silver Nemesis*)
- **The Untempered Schism**—A controlled opening in the very fabric of time and space. Gallifreyan children wanting to enter the Time Lord Academy stared into the Schism as a test of their strength and sanity. Billions of years' exposure to the vortex through the Schism gave the Time Lords the ability to regenerate. (*The Sound of Drums, A Good Man Goes to War*)
- **Confession Dial**—A Time Lord's last will and testament, to be delivered to their closest friend on the eve of their last day. (*The Magician's Apprentice*)
- **Matrix data slice**—A portable Gallifreyan hard drive (*Dark Water*)

GALLIFREYAN BEDTIME CLASSICS THE DOCTOR ENJOYED AS A TIME TOT

Blind Fury
The Three Little Sontarans
The Emperor Dalek's New Clothes
Snow White and the Seven Keys to Doomsday

THE TIME LORD PRESIDENTIAL CODE

4553916592

THE INAUGURATION PLEDGE OF THE TIME LORD PRESIDENT

Gold Usher: Do you swear to uphold the laws of Gallifrey?
President: I swear.
Gold Usher: Do you swear to follow in the wisdom of Rassilon?
President: I swear.
Gold Usher: Do you swear to protect the law and the wisdom?
President: I swear.
Gold Usher: I invest you Lord President of the Supreme Council. I wish you good fortune and strength. I give you the Matrix.

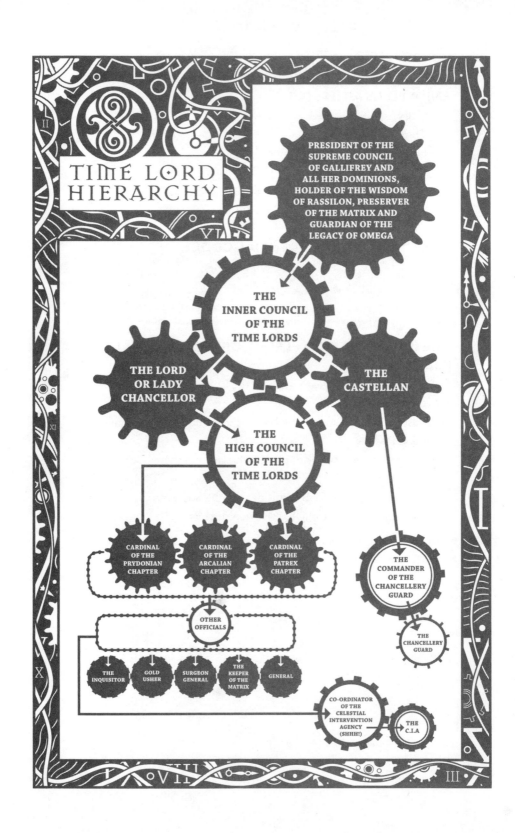

TIME LORD HIERARCHY

PRESIDENT OF THE SUPREME COUNCIL OF GALLIFREY AND ALL HER DOMINIONS, HOLDER OF THE WISDOM OF RASSILON, PRESERVER OF THE MATRIX AND GUARDIAN OF THE LEGACY OF OMEGA

THE INNER COUNCIL OF THE TIME LORDS

THE LORD OR LADY CHANCELLOR

THE CASTELLAN

THE HIGH COUNCIL OF THE TIME LORDS

CARDINAL OF THE PRYDONIAN CHAPTER

CARDINAL OF THE ARCALIAN CHAPTER

CARDINAL OF THE PATREX CHAPTER

THE COMMANDER OF THE CHANCELLERY GUARD

THE CHANCELLERY GUARD

OTHER OFFICIALS

THE INQUISITOR

GOLD USHER

SURGEON GENERAL

THE KEEPER OF THE MATRIX

GENERAL

CO-ORDINATOR OF THE CELESTIAL INTERVENTION AGENCY (SHHH!)

THE C.I.A

PLANETS ATTACKED
BY THE DALEKS

Invading planets is in the Daleks' DNA—literally. Here are the notable worlds that they've tried to get their plungers on, on TV and beyond…

Planet	Attacked	Occupied	Story	Type of story
Alvega	X		The Amaryll Challenge	TV Century 21 comic
Anhaut	X		Return of the Daleks	Doctor Who Weekly comic
Antalins		X	War of the Daleks	Novel
Archetryx	X		The Apocalypse Element	Big Finish Audio
Aridius	X		The Chase	TV
Arkeon	X		Prisoner of the Daleks	Novel
The Asylum		X	Asylum of the Daleks	TV
Auros	X		Prisoner of the Daleks	Novel
Azimuth	X		Daleks Among Us	Big Finish audio
Beltox	X		Pretty Lies	Big Finish audio
Bliss	X		Enemy of the Daleks	Big Finish audio
Callico Nine		X	We Are the Daleks	Big Finish audio
Castar	X		The Human Bombs	Dalek annual story
Carson's Planet		X	Death to the Daleks	Big Finish audio
Davy Crocket	X		The Dogs of Doom	Doctor Who Weekly comic
Earth	X	X	Various	TV

Planet	Attacked	Occupied	Story	Type of story
Emmeron	X		The Doomsday Machine	Dalek annual story
Entropica	X		Across the Dalek City	Big Finish audio
Esmera	X		The Log of 'Gypsy Joe'	Dalek annual story
Etra Prime		X	The Apocalypse Element	Big Finish audio
Exxilon	X		Death to the Daleks	TV
Eye of Orion		X	Eye of Darkness	Big Finish audio
Far		X	The Conquest of Far	Big Finish audio
Galacton	X		Mission to Galacton	Short story
Gallifrey	X		The Apocalypse Element / The End of Time / The Day of the Doctor	Big Finish audio, TV
Graxis Major		X	The Survivors	Big Finish audio
Guria		X	The Human Factor	Big Finish audio
Gurnian		X	Monsters of Gurnian	Dalek annual story
Halalka	X		Dark Eyes: Fugitives	Big Finish audio
Heaven		X	Death and the Daleks	Big Finish audio
Helatrine		X	Infection of the Daleks	Short story
Hell		X	Nemesis of the Daleks	Doctor Who Magazine comic
Hesperus	X		War of the Daleks	Novel
Hurala	X		Prisoner of the Daleks	Novel
Jupiter		X	Dalek War	Big Finish audio
Kar-Charrat	X		The Genocide Machine	Big Finish audio
Karn	X		The Seven Keys to Doomsday	Stageplay
Kembel		X	The Daleks' Master Plan	TV
Kendru 7	X		The Fearless	Big Finish audio
Keska		X	The Innocent / The Thousand Worlds	Big Finish audio

Planet	Attacked	Occupied	Story	Type of story
Knosson	X		*The Castaway*	Dalek annual story
Lethe	X		*The Juggernauts*	Big Finish audio
Lopra Minor	X		*Project Infinity*	Big Finish audio
Malite		X	*Private Investigations*	Short story
Manikis	X		*Mutually Assured Survival*	Short story
Marinus	X		*Doctor Who and the Daleks*	Sweet cigarette cards
Mazam		X	*Abslom Daak… Dalek Killer*	*Doctor Who Weekly* comic
Mechanus	X		*The Chase*	TV
Mira	X		*The Daleks' Master Plan*	TV
Mojox		X	*Dalek Soul*	Big Finish audio
Moldox		X	*Engines of War*	BBC Book
The Moon		X	*The Disintergrator*	*TV Comic* comic
Necros		X	*Revelation of the Daleks*	TV
New Earth	X		*The Dogs of Doom*	*Doctor Who Weekly* comic
New Mondas		X	*Cyber Crisis*	BBC Books comic
New Yugoslavia	X		*The Dogs of Doom*	*Doctor Who Weekly* comic
Nixyce VII		X	*The Traitor*	Big Finish audio
Omegon	X		*Terror Task Force*	Dalek annual story
Penal Planet X26	X		*The Planet That Cried 'Wolf'*	Dalek annual story
Phryne	X		*The Archives of Phryne*	*TV Century 21* comic
Proxima Major	X		*The Dalek Contract*	Big Finish audio
Red Rocket Rising	X		*Blood of the Daleks*	Big Finish audio
Rovidia	X		*The Eternity Cage*	Big Finish audio

Planet	Attacked	Occupied	Story	Type of story
Scalanis VIII		X	Various	Big Finish audio
Scottus	X		The Solution	Dalek annual story
Skardal	X		The Rogue Planet	TV Century 21 comic
Skaro		X	Various	TV
Solturis	X		The Penta Ray Factor	TV Century 21 comic
Sovavevanti	X		The Four Doctors	Big Finish audio
Spiridon		X	Planet of the Daleks	TV
Strangor		X	Dark Eyes: X and the Daleks	Big Finish audio
Strellin	X		Order of the Daleks	Big Finish audio
Sunlight 349		X	The Dalek Generation	BBC Books
Talis Minor	X		The Fearless	Big Finish audio
Terroth	X		Planet of the Serpents	Dalek annual story
Trenzalore	X		The Time of the Doctor	TV
Trodos	X		The Trodos Ambush	TV Comic comic
Vega VI		X	Invasion of the Daleks	Big Finish audio
Velyshaa	X		Various	Big Finish audio
Valkenine	X		Hostage!	Dalek annual story
Vara		X	Sara Kingdom: Space Security Agent	Dalek annual story
Venus		X	Various	Dalek annual story
Vildar	X		Legion of the Lost	Big Finish audio
Vulcan	X		The Power of the Daleks	TV
Zebus	X		Nightmare	Dalek annual story

SHOCKEYE'S KITCHEN

A feast of food from around the galaxy

STARTERS
- The Broth of Oblivion (*The Talons of Weng-Chiang*)—a warming Chinese soup, may cause drowsiness
- Chimeron Jelly (*Delta and the Bannermen*)—cleanses the palate and makes you grow nice and strong

MAIN COURSES
- Kronkburgers* (*The Long Game*)—on a lightly-toasted bun
- Gaffabeque (*Bad Wolf*)—nice and hot from the planet Lucifer
- Gumblejack (*The Two Doctors*)—cleaned, skinned and pan-fried in its own juices

- Protein One (*The Impossible Planet*)—available with or without a dash of Protein Three

Optional Staff of Life sauce available, made from the finest Herbabaculum vitae weed plants

All dishes come with chips cooked in Krillitane oil, the ultimate in brain food (not suitable for vegetarians)

DESSERTS

- Marsh Minnows (*The Trial of a Time Lord: Mindwarp*)—green and slimy, like mother used to make
- Fresh Plaup Salad (*The Greatest Show in the Galaxy*)—a Vulpana delicacy, not for those with weak stomachs

DRINKS

- Zaphic shake (*The Long Game*)—available in many flavours, including beef. Yum!
- Herbabaculum vitae Protein Shake (*Revelation of the Daleks*)—sup the staff of life
- Fizzade (*Paradise Towers*)—ice hot!
- Vitex Lite (*Rise of the Cybermen*)—new cherry flavour—Trust us on this!

ALCOHOLIC BEVERAGES

- Hypervodka (*The Doctor Dances*)—make your last requests
- Voxnic (*Slipback*)—available by the glass or per bottle
- Aldebaran brandy (*The Husbands of River Song*)—a favourite of time-travelling archaeologists. Don't tell Dad.

NOTE: Unfortunately, Alzarian Riverfruit has been taken off the menu, due to an unexpected spider infestation. The management apologises for any disappointment.

Krynoid Salad is also off due to staff shortage/mutation.

SIX

A KETTLE AND A PIECE OF STRING

TECHNOLOGY IN DOCTOR WHO

'This doesn't roll along on wheels, you know.'

The Doctor, *An Unearthly Child*

TARDISes, sonic screwdrivers, psychic papers, Whomobiles and spritely yellow road-sters—the Doctor has piloted, zapped, flashed and driven them all in 55 years of travel.

THE SEVEN TARDISES

DESIGN	DESIGN	DESIGN	DESIGN	DESIGN	DESIGN	DESIGN
0	1	2	3	4	5	6

The Doctor's TARDIS may be as unique as he is, but there have actually been six different versions of the iconic police box exterior over the last 50 years. Each underwent tweaks and new paint jobs over time, but TARDIS spotters should look out for them in the following stories.

█ DESIGN 0—*The Name of the Doctor*
The Name of the Doctor retroactively allowed viewers to see the moment when the First Doctor and Susan fled from Gallifrey, directed by Clara to an undisguised TARDIS with a 'knackered' navigation system. It was in the shape of a tall tube with a sliding metal door, and was the start of a beautiful relationship.

█ Design 1—From *An Unearthly Child* to *The Seeds of Doom*
Designed by Peter Brachacki, the original wooden TARDIS had many nips and tucks and tweaks in its lifespan, most notably in *The Smugglers*, when it received a new lower roof stack. The original prop also featured a St John Ambulance logo on the door for a time. During Season 6, the police telephone plaque even switched from the left to the right door.

█ Design 2—From *The Masque of Mandragora* to *The Horns of Nimon*
After the roof of the original prop collapsed—reportedly on Elisabeth Sladen's head—designer Barry Newbery created a new TARDIS. It was eventually retired in 1980, its last regular use being in the unfinished story *Shada*, after which it made three guest appearances, in *Logopolis*, *Castrovalva* and *Black Orchid*.

█ Design 3—From *The Leisure Hive* to *Survival*
The 1980s TARDIS was designed by Tom Yardley-Jones and constructed from fibreglass. A second prop was constructed during Season 23 and appeared in *Time and the Rani*, *Paradise Towers*, *Dragonfire*, *The Happiness Patrol* and *The Curse of Fenric*, also coming out of retirement for *Dimensions in Time* and *The Curse of Fatal Death*.

█ Design 4—*Doctor Who*
Richard Hudolin designed the police box for the 1996 *Doctor Who* TV movie. This TARDIS featured a special lock that swung aside to let the ankh-shaped TARDIS key unlock the door.

█ Design 5—From *Rose* to *The End of Time*
Constructed from timber and plywood, a number of TARDISes were built for the 2005 revival. Designed by Edward Thomas, the TARDIS panels were scorched and wire-brushed to distress them before painting.

█ Design 6—From *The Eleventh Hour*
The arrival of the Eleventh Doctor heralded a new TARDIS prop. Again designed by Edward Thomas, the current prop is built along the same lines as the Ninth and Tenth

Doctor's but boasts a new darker paint job to resemble the police box from the 1960s Peter Cushing movies, plus white window frames and the return of the St John Ambulance badge which had vanished from the original prop 45 years before. A traditional Fresnel lamp also replaces the fifth design's garden lantern on top.

TARDIS COMPONENTS AND EQUIPMENT

'That does very, very complicated. That does sophisticated. That does whoa, amazing. And that does whizz, bang, far too technical to explain!'

The Doctor, *The Curse of the Black Spot*

According to the Sixth Doctor, the TARDIS is capable of many amazing things, much like himself. Unfortunately, it's not the most reliable of machines. Here's our checklist of essential TARDIS systems, equipment, their reliability and the story in which they are first used or mentioned. Of course, this is in no way an exhaustive list. How could it be in a craft with no limits?

KEY:

 = Top notch

 = Usually reliable

 = Dodgy

0 = Absolute rubbish

- **Architectural Configuration System**—A whole room containing the component circuits to rearrange particles to your needs—a machine that makes machines (*Journey to the Centre of the TARDIS*) Reliability Rating:
- **Atom Accelerator**—Helps steer a TARDIS. (*The Curse of the Black Spot*) Reliability Rating:
- **Audio Log**—A voice-recorder to chronicle your journeys—handy if there's no one else to talk to. (*Planet of the Daleks*) Reliability Rating:
- **Basic Mode**—Disables systems (including the shield oscillators) to make lessons in flying the TARDIS easier! (*Journey to the Centre of the TARDIS*) Reliability Rating:

- **Blue Stabilisers**—Stabilise TARDIS interior dimensions while in flight. (*The Time of Angels*) Reliability Rating: 0
- **Central Console**—The TARDIS's six-sided control console, meant to be operated by six pilots. Each of the sides of the latest version, first seen in *The Snowmen*, has a different function: time co-ordination, communications, information centre, power control and helm, power setting and cerebral connection. Reliability Rating: 🚔🚔
- **Chameleon Arch**—Capable of rewriting DNA so you become a completely different species. Can also store your memories in a rather fetching fob watch—don't open it if you want to keep your identity a secret! (*Human Nature*) Reliability Rating: 🚔🚔🚔🚔
- **Chameleon Circuit**—Allows TARDIS to blend in with any environment. (*An Unearthly Child*) Reliability Rating: 0
- **Cloister Bell**—Warns of imminent—and catastrophic—danger. (*Logopolis*) Reliability Rating: 🚔🚔🚔
- **Comparator**—An essential component of the TARDIS flight mechanism. (*Planet of Fire*) Reliability Rating: 🚔🚔🚔
- **Central / Time Column**—Rises and falls as the TARDIS flies due to the power thrust of the heart of the machine that lies beneath it. If the column ever came out, the power would escape. (*The Edge of Destruction*) Reliability Rating: 🚔🚔🚔
- **Data Bank / Core**—The TARDIS's own version of *The Hitchhiker's Guide to the Galaxy*. Contains 18,348 emergency procedures. (*State of Decay*) Reliability Rating: 🚔🚔
- **Dematerialisation Circuit**—Allows the TARDIS to enter the Time Vortex. (*Terror of the Autons*) Reliability Rating: 🚔🚔
- **Dimension Dams**—Keeps a TARDIS' internal dimensions in place (*The Name of the Doctor*) Reliability Rating: 🚔🚔🚔
- **Dimensional Control**—Controls the TARDIS's dimensional transcendence. (*The Time Meddler*) Reliability Rating: 🚔🚔🚔🚔
- **Dimensional Stabiliser**—Regulates internal dimensions. Can be used to alter size of passengers. (*The Invisible Enemy*) Reliability Rating: 🚔🚔
- **Directional Unit**—Regulates TARDIS navigation systems. (*The Daleks' Master Plan*) Reliability Rating: 🚔
- **Drinks Cabinet**—Installed by River Song. Don't tell dad. (*The Husbands of River Song*) Reliability Rating: 🚔🚔🚔
- **Drive Stacks**—Need replacing. (*Mummy on the Orient Express*) Reliability Rating: 🚔
- **Echo Rooms**—the TARDIS can create echoes of rooms such as the console room to keep its occupants safe. Usually. (*Journey to the Centre of the TARDIS*) Reliability Rating: 🚔🚔
- **Emergency Oxygen Supply**—Only useful if you actually remember to keep the tanks full! (*Planet of the Daleks*) Reliability Rating: 🚔
- **Emergency Programme One**—Returns companions to their home in times of absolute danger. Can be programmed to activate after a certain time limit. (*The Parting of the Ways*) Reliability Rating: 🚔🚔🚔

- **Emergency Unit**—Moves the TARDIS out of normal space-time in times of catastrophe. (*The Mind Robber*) Reliability Rating: 🏛🏛
- **Engine Room**—The heart of the TARDIS (*Journey to the Centre of the TARDIS*) Reliability Rating: 🏛🏛🏛
- **The Eye of Harmony**—The TARDIS's primary power source. Best not opened, but a subset can be used to build a psychochronograph should you need to jump into a pocket universe. (*Doctor Who, Hide, Journey to the Centre of the TARDIS*) Reliability Rating: 🏛🏛🏛
- **Fast Return Switch**—Pressing the switch returns the TARDIS to a previous location. Unless it gets stuck, in which it'll send you hurtling back to the birth of a solar system. (*The Edge of Destruction*) Reliability Rating: 🏛
- **Fault Locator**—Detects malfunctions in TARDIS systems. (*The Daleks*) Reliability Rating: 🏛🏛
- **Fluid Link**—Small glass tubes containing mercury. Essential for TARDIS operation, but liable to get knocked out of place or explode. (*The Daleks*) Reliability Rating: 🏛
- **Food Machine**—Decide what you want to eat, check the codes in the manual, turn the dials and the food machine produces foil-wrapped cubes that taste exactly like your choices. (*The Daleks*) Reliability Rating: 🏛🏛🏛
- **Force Field Generator / Defence Field**—Protects the TARDIS from attack. (*The Three Doctors*) Reliability Rating: 🏛🏛
- **Gravitic Anomaliser**—Helpful when patching up Skonnon spaceship engines. (*The Horns of Nimon*) Reliability Rating: 🏛🏛
- **Handbrake**—The TARDIS anchor. Leaving it on can cause a terrible wheezing, groaning sound. (*Doctor Who*) Reliability Rating: 🏛
- **Heart of the TARDIS**—Located in the base of the console, contains link to the Vortex plus Huon particles. (*Terminus*) Reliability Rating: 🏛🏛🏛
- **Helmic Regulator**—Helps the TARDIS navigate to a specific point. (*The Ark in Space*) Reliability Rating: 🏛
- **Hostile Action Displacement System (HADS)**—Automatically removes the TARDIS from danger—just remember to set it. (*The Krotons*) Reliability Rating: 🏛
- **Macaroon Dispenser**—Located on the way to the toilets. (*The Pilot*) Reliability Rating: 🏛🏛🏛
- **Magnetic Chair**—Generates a force field strong enough to restrain a herd of elephants. (*The Daleks' Master Plan*) Reliability Rating: 🏛🏛🏛
- **Matrix**—A databank, but in the case of the TARDIS it contains much more than just raw data. (*The Doctor's Wife*) Reliability Rating: 🏛🏛🏛
- **Multi-Loop Stabiliser**—Unnecessary, in the Doctor's view, but essential to achieving smooth materialisations. (*The Pirate Planet*) Reliability Rating: 🏛🏛
- **Nanotech audio/visual link**—An earpiece given to Clara that hacked her optic nerve and allowed the Doctor to see and hear on the TARDIS scanner exactly what Clara was seeing and hearing (*Flatline*) Reliability Rating: 🏛🏛

- **Outer Plasmic Shell**—The 'skin' of the TARDIS manipulated by the chameleon circuit to change its outward appearance. (*Logopolis*) Reliability Rating: 🚪🚪🚪
- **Radiation Detector**—Measures radiation levels outside the TARDIS exterior. (*The Daleks*) Reliability Rating: 🚪🚪
- **Radio**—There was a radio in the TARDIS until it got stuck on Peter Andre's *Beautiful Girl* for two weeks, so the Doctor took it apart and turned into a clockwork squirrel (*Under the Lake*) Reliability Rating: 🚪
- **Randomiser**—Randomly selects destinations. Useful for evading powerful cosmic entities. (*The Armageddon Factor*) Reliability Rating: 🚪🚪
- **Recall Circuit**—Can forcibly return a TARDIS to Gallifrey. (*Arc of Infinity*) Reliability Rating: 🚪🚪🚪
- **Safeguards**—Stops the TARDIS from dematerialising when a lifeform is registered both inside and outside its real-time envelope. (*The Husbands of River Song*) Reliability Rating: 🚪🚪🚪
- **Scanner**—Allows the TARDIS crew to observe what's happening outside the ship (*An Unearthly Child*) Reliability Rating: 🚪🚪
- **Shield Oscillators**—Protects the TARDIS from Magna-Grabs (assuming they haven't been disabled by **Basic Mode**) (*Journey to the Centre of the TARDIS*) Reliability Rating: 🚪🚪
- **Siege Mode**—A protective mode that changes the outer dimensions of the TARDIS into a metal box inscribed with Gallifreyan symbols (*Flatline*) Reliability Rating: 🚪🚪🚪
- **Telepathic Circuits**—Allows telepathic contact between different TARDISes as well as Gallifrey. (*The Time Monster*) Reliability Rating: 🚪🚪
- **Telephone**—Able to receive calls from across space and time. (*World War Three*) Reliability Rating: 🚪🚪🚪
- **Terrestrial Navigation**—Does what it says on the label and moves the TARDIS around on planets—even when Central London is covered in trees (*In The Forest of the Night*) Reliability Rating: 🚪🚪🚪
- **Time Space Visualiser**—Not strictly an original TARDIS component but salvaged from the Space Museum. Allows the TARDIS crew to view any event in history. (*The Chase*) Reliability Rating: 🚪🚪🚪
- **Time Path Indicator**—Informs the pilot if another time craft is following the TARDIS's temporal pathway. (*The Chase*) Reliability Rating: 🚪🚪
- **Time Scanner**—Lets you know where you'll arrive next—and what monsters you might meet! (*The Moonbase*) Reliability Rating: 🚪🚪🚪
- **Time Sensor**—Detects disturbances in a time field—or a TARDIS sniffer-outer, as Jo Grant put it. Only works in Venusian miles. (*The Time Monster*) Reliability Rating: 🚪🚪
- **Time Vector Generator**—Similar to the Dimensional Control, stabilises the TARDIS's dimensional transcendence. (*The Wheel in Space*) Reliability Rating: 🚪🚪 (Unless it's on the blink like in *The Ambassadors of Death*)

- **Translation Circuits**—Linked to telepathic circuits. Translates most languages into the individual language of the TARDIS crewmembers. Also works on the written word. Doesn't do Gallifreyan. (*The End of the World*) Reliability Rating: 🔵🔵
- **Tribophysical waveform macro-kinetic extrapolator**—Allows the TARDIS to project force fields around itself. (*Boom Town*) Reliability Rating: 🔵🔵
- **Visual Stabilisation Circuit**—Renders the TARDIS invisible if deactivated. (*The Invasion*) Reliability Rating: 🔵🔵
- **Voice Visual Interface**—A hologram-based interface that adapts to suit the user. (*Hide*) Reliability Rating: 🔵🔵
- **Vortex Cooker**—Roasts turkeys to perfection. Just expose to the Time Winds and cook for three centuries or so. Remember to baste thoroughly first. (*The Time of the Doctor*) Reliability Rating: 🔵🔵🔵
- **Vortex Drive**—Creates anti-gravity spirals which operate like tractor beams. (*Delta and the Bannermen*) Reliability Rating: 🔵🔵🔵🔵
- **Waste Evacuation controls**—Operated from the main console. It's best to avoid level seven. (*The Husbands of River Song*) Reliability Rating: 🔵🔵🔵
- **Yearometer**—Indicates the year in which the TARDIS has landed. (*An Unearthly Child*) Reliability Rating: 🔵
- **Zeiton-7**—Rare ore used by the TARDIS transpower system. (*Vengeance on Varos*) Reliability Rating: 🔵🔵

OTHER EQUIPMENT:
- **Briode Nebuliser** (*The Two Doctors*)
- **Conceptual Geometer** (*The Horns of Nimon*)
- **Dynamorphic generator** (*Time-Flight*)
- **Emergency Power Booster Unit** (*The Mind Robber*)
- **Friction Contrafibulator** (*Vincent and the Doctor*)
- **Image Translator** (*Full Circle*)
- **Lateral Cones** (*The Visitation*)
- **Light-speed Overdrive** (*Logopolis*)
- **Nexial Tracers** (*The Face of Evil*)
- **Orthogonal Vector** (*The Curse of the Black Spot*)
- **Parametric Engines** (*The Curse of the Black Spot*)
- **Seat Belts** (*Timelash*)
- **Subneutron Circuits** (*Shada*)
- **Synchronic Feedback Checking Circuit** (*The Pirate Planet*)
- **Temporal Stabiliser** (*Planet of Fire*)
- **Thermocouplings** (*Space / Time*)
- **Vortex Shield** (*Shada*)
- **Wibbly Lever** (*Space / Time*)
- **Zig-Zag Plotter** (*The Lodger*)

HOW TO GROW A TARDIS

A deleted scene from *Journey's End* would have revealed that it is possible to grow a new TARDIS from a chunk of original TARDIS coral. Unfortunately, the process takes thousands of years. However, this can be sped up if you:

- Shatterfry the plasmic shell
- Modify the dimensional stabiliser to a foldback harmonic of 35.3.

Do this right and you'll accelerate growth by the power of 59.

STORIES THAT DON'T FEATURE THE TARDIS

- *Mission to the Unknown*
- *Doctor Who and the Silurians*
- *The Mind of Evil*
- *The Dæmons*
- *The Sea Devils*
- *The Sontaran Experiment*
- *Genesis of the Daleks*
- *Midnight*
- *The Lie of the Land*

THE TIME ROTOR

Think you know the Time Rotor? It's the central column in the middle of the console, right? Wrong! The Time Rotor is first mentioned during *The Chase* when the TARDIS approaches the Empire State Building. Vicki points to a unit near the door switch on the console itself, not the column, telling the Doctor that the Time Rotor is slowing down.

In fact, the central column is mentioned earlier, in *The Edge of Destruction*, where the Doctor explains that the heart of the machine is kept beneath the 'Control Column'. There's another brief mention of the Time Rotor in *Meglos*, but in *Logopolis* the Doctor clearly identifies the column as—wait for it, hair-splitters—'the time column'.

It was only later, through such books as *The Doctor Who Technical Manual* by Mark Harris and Peter Haining's *Doctor Who—A Celebration*, that the rotor began to be completely associated with the column.

And what of the Time Rotor's origins? Well, the device was invented by Terry Nation for his 1965 book, *The Dalek Pocketbook and Space Traveller's Guide*. The device, he explained, let the Doctor know when the TARDIS was about to land. The same year, the Dalek creator included it in his script for *The Chase*.

CONSOLE ROOM DESIGNERS

Over the years, the TARDIS control room set has regenerated almost as many times as the Doctor himself…

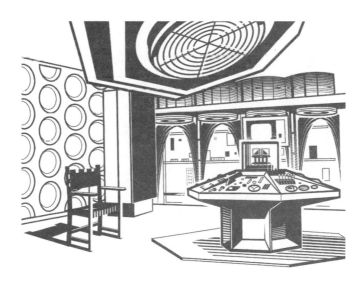

Console	From	To	Designer
The First / Second / Third Doctors' control room	*An Unearthly Child*	*The War Games* (although the original console would be used until it was replaced in *The Claws of Axos*)	Peter Brachacki
The Third Doctor's control room v.1	*The Time Monster*	*The Time Monster*	Tim Gleeson
The Third Doctor's control room v.2	*The Three Doctors*	*Death to the Daleks*	Roger Liminton
The Fourth Doctor's control room v.1	*Planet of Evil*	*Pyramids of Mars*	Roger Murray Leach
The Secondary Control Room	*The Masque of Mandragora*	*The Robots of Death*	Barry Newbery
The Fourth / Fifth Doctors' control room v.2	*The Invisible Enemy*	*The King's Demons*	Barry Newbery
The Fifth / Sixth / Seventh Doctors' console room	*The Five Doctors*	*Battlefield*	Malcolm Thornton
The Eighth Doctor's console room	*Doctor Who*	*Doctor Who*	Richard Hudolin
The Ninth / Tenth Doctors' console room	*Rose*	*The End of Time*	Edward Thomas
The Eleventh Doctor's console room v.1	*The Eleventh Hour*	*The Angels Take Manhattan*	Edward Thomas
The Eleventh Doctor's console room v.2 / Twelfth Doctor's console room	*The Snowmen*		Michael Pickwoad

The console room introduced in *The Snowmen* measures 48 feet in diameter and 28 feet high. The six sections of the new console itself each have different functions: time coordination, communications, information centre, power control and helm, power setting, and cerebral connection.

> **DIRECTIONS TO THE TARDIS WARDROBE**
> Head out of console room.
> Take first left, then second right.
> Take third left then head straight ahead.
> Go under the stairs.
> Pass the bins.
> The wardrobe is fifth door on the left.

SOME TARDIS DISGUISES

'It's still a police box. Why hasn't it changed? Dear, dear, how very disturbing.'
The Doctor, *An Unearthly Child*

Those clever old Time Lords, disguising their TARDISes to blend into the background... well, most of the time. Here are some of the forms various TARDISes have been seen to take:

THE DOCTOR'S TARDIS
- Police box—*An Unearthly Child* to *Twice Upon A Time*
- Victorian kitchen cabinet—*Attack of the Cybermen*
- Organ—*Attack of the Cybermen*
- Gate—*Attack of the Cybermen*
- Siege mode (protective metal box)—*Flatline*

THE MONK'S TARDIS
- Saxon sarcophagus—*The Time Meddler*
- Motorbike—*The Daleks' Master Plan*
- Stagecoach—*The Daleks' Master Plan*
- Tank—*The Daleks' Master Plan*
- Tree—*The Daleks' Master Plan*
- Biplane—*The Daleks' Master Plan*
- Police box—*The Daleks' Master Plan*
- Block of ice—*The Daleks' Master Plan*

THE MASTER'S TARDISES

- Circus horsebox—*Terror of the Autons*
- Large box / cupboard (maybe its natural shape)—*The Claws of Axos*
- Spaceship—*Colony in Space*
- Computer bank—*The Time Monster*
- Grandfather clock—*The Deadly Assassin, The Keeper of Traken*
- Statue of the Melkur—*The Keeper of Traken*
- Police box—*Logopolis*
- Ornate column—*Logopolis, Castrovalva*
- Potted shrub—*Logopolis*
- Marble fireplace—*Castrovalva*
- Concorde—*Time-Flight*
- Iron maiden (the torture device not the rock band)—*The King's Demons*
- Obelisk—*Planet of Fire*
- Statue of Queen Victoria—*The Trial of a Time Lord: The Ultimate Foe*
- Wooden beach hut—*The Trial of a Time Lord: The Ultimate Foe*

PROFESSOR CHRONOTIS'S TARDIS

- Cambridge college rooms—*Shada*

OMEGA'S TARDIS

- Sepulchre—*Arc of Infinity*

THE RANI'S TARDIS

- Cupboard—*Mark of the Rani*
- Pyramid—*Time and the Rani*
- The Queen Victoria public house—*Dimensions in Time*

FOR WHOM THE BELL TOLLS

The Cloister Bell sounds when the TARDIS is in imminent danger. It was originally recorded by lowering a gong into a tank of water to deaden the vibration and add weight and a lower pitch and has been heard at the following times:

- *Logopolis*—Possibly predicting the death of the Universe, or perhaps the death of the Fourth Doctor

- *Castrovalva*—As the TARDIS hurtles back to Event One
- *Resurrection of the Daleks*—As the TARDIS risks breaking up in the Daleks' time corridor
- *Doctor Who*—After the Master opens the Eye of Harmony
- *Born Again* (Children in Need special)— As the newly regenerated Tenth Doctor tries to pilot the TARDIS
- *The Sound of Drums*—After the Master has transformed the TARDIS into a paradox machine
- *Time Crash*—After the Fifth and Tenth Doctor's TARDISes collide in the Vortex
- *Turn Left*—As the walls between the universes begin to break down
- *The Waters of Mars*—After the Tenth Doctor's death is predicted
- *The Eleventh Hour*—As the TARDIS's engines phase
- *The Curse of the Black Spot*—As the Doctor loses control of the TARDIS
- *The Doctor's Wife*—As House takes over the TARDIS
- *The God Complex*—Within the room containing the Doctor's biggest fear
- *Hide*—When the Doctor finds himself in danger in a pocket universe
- *Journey to the Centre of the TARDIS*—When Clara finds herself alone after the TARDIS had been grabbed by the Van Baalen Brothers
- *The Name of the Doctor*—Rings for the last time when the Doctor enters his own tomb
- *Deep Breath*—Chimes when the Doctor passes out on the bank of the Thames in Victorian London
- *Listen*—When the Doctor is out cold at the end of the Universe
- *Flatline*—When the miniature TARDIS falls into the path of a train
- *Dark Water*—When Clara destroys the first TARDIS key and again when she destroys the last
- *The Girl Who Died*—When the Doctor saves Clara from a Love Sprite
- *Before the Flood*—When the Doctor tries to return to The Drum to rescue Clara
- *Hell Bent*—The multiple Cloister Bells in the Matrix on Gallifrey all ring
- *The Husbands of River Song*—When Hydroflax's robot body enters the TARDIS and attacks River Song
- *The Doctor Falls*—When the Doctor leaves the TARDIS after landing at the South Pole

SONIC SCREWDRIVERS GALORE

'Who looks at a screwdriver and thinks, "Oooh, this could be a little more sonic?"'

Captain Jack Harkness, *The Doctor Dances*

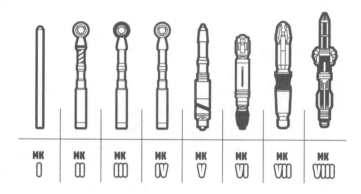

| MK Ⅰ | MK Ⅱ | MK Ⅲ | MK Ⅳ | MK Ⅴ | MK Ⅵ | MK Ⅶ | MK Ⅷ |

The Doctor's trusty sonic screwdriver, never far from his side (except for the Fifth and Sixth Doctors who went 'hands free' following the events of *The Visitation*). But how many screwdrivers has the man owned over the centuries? And is there anything it can't do?

Mark I—*Fury from the Deep* to *The War Games*
A simple silver rod, like a pocket torch

Mark II—*The Sea Devils* to *Carnival of Monsters*
Larger, with a silver handle, striped yellow shaft and number of interchangeable heads

Mark III—*Frontier in Space* to *The Visitation*
Long silver handle with a variety of heads, including black and red. Destroyed by the Terileptils in 1666

Mark IV—*Doctor Who*
Resembling the Mark III, but now completely silver

Mark V—*The Day of the Doctor*
Similar to the Mark IV, but without a head, ending in a red diode at its tip.

Mark VI—*Rose* to *The Eleventh Hour*
Smaller, with a coral handle, extendable shaft and glowing blue light. The Doctor had two versions of this model. The first was destroyed while modifying an X-ray machine on the Moon in *Smith and Jones*, while the second, identical in every way except for a grey handle, was destroyed while overloading technology in Leadworth, England.

Mark VII—*The Eleventh Hour* to *The Witch's Familiar*
Created by the TARDIS itself, complete with green light, copper plating and retractable claws. The Doctor had at least three models of this design. The first was bitten in half by a flying shark in *A Christmas Carol*, the second was given to the Ganger Doctor in *The Almost People*, and the third was abandoned on Skaro. Hey, why have a screwdriver, when you could have shades?

Mark VIII—*Heaven Sent* to who knows when…
A gift from the TARDIS following the Doctor's rediscovery of Gallifrey. Now coloured TARDIS blue with a shaft resembling the console's central column, this model pulsed with blue or green lights. Destroyed by a Ganymede System Series Twelve SmartSuit on Chasm Forge Mining Station, the Doctor created a replica on his return from Chasm Forge. He was disappointed that it still had no setting for wood, but now, at least, it included a secret pen!

USING THE SONIC SCREWDRIVER

The Doctor has used the sonic screwdriver to perform all manner of tasks—even taking out screws (in *The War Games*, for example). Here's a reminder of some of the amazing gadget's capabilities.

- Access computers (Various)
- Act as an oxyacetylene cutting tool (*The Dominators*)
- Activate carousel projectors (*Hide*)
- Activate Dalek systems (*Asylum of the Daleks*)
- Active Skovox Blitzer scanner (*The Caretaker*)

- Anti-freeze (*The Snowmen*)
- Blow up evil Christmas trees (*The Christmas Invasion*)
- Blow up archery target (*Robot of Sherwood*)
- Boost mobile internet speeds (*The Runaway Bride*)
- Boost psychic projections through the space between universes (*Doomsday*)
- Break hypnotic trances (*Death to the Daleks*)
- Burn out locking mechanisms (*The Mutants*)
- Burn through rope (*The Age of Steel, The Fires of Pompeii*)
- Change train signals from green to red (*Flatline*)
- Check for life-threatening transmundane emanations (*Hide*)
- Compromise Sontaran invisibility cloaks (*The Time of the Doctor*)
- Confuse the polarity (*The Day of the Doctor*)
- Crack glass (*Army of Ghosts*)
- Create an acoustic corridor between two people (*The Magician's Apprentice*)
- Crystal vibration (*The Face of Evil*)
- Cut through ropes (*Thin Ice*)
- Darken helmet visors and reading glass lenses (*Forest of the Dead, Planet of the Dead*)
- Deactivate Cyber implants (*The Age of Steel*)
- Deactivate robots (*The Sontaran Experiment, Four to Doomsday*)
- Destroy answerphones (*The Long Game*)
- Detect booby-traps (*Colony in Space, Death to the Daleks*)
- Detect motion (*Cold War*)
- Disable weapons (*Cold Blood*)
- Dismantle computers (*Death to the Daleks*)
- Disrupt shimmers / perception fields (*The End of Time, The Vampires of Venice*)
- Disrupt signals controlling disembodied plastic arms (*Rose*)
- Dry out clothes (*The Curse of the Black Spot*)
- Electromagnet—as long as you reverse the polarity of its power source (*Frontier in Space*)
- Flashlight (*The Beast Below, The Pandorica Opens*)
- Fuse communication systems (*Genesis of the Daleks*)
- Fuse computer controls (*The Sontaran Experiment* and others)
- Fuse locks (*Nightmare of Eden* and others)
- Give phones free calls (*The Runaway Bride*)
- Give mobile phones Universal Roaming—no matter what the price plan (*42, The Doctor's Daughter, Planet of the Dead*)
- Hack into websites (*The Runaway Bride*)
- Heal wounds (*The Vampires of Venice*)
- Heat up metal (*Let's Kill Hitler*)

- Hold telekinetic energy at bay (*The Rings of Akhaten*)
- Hologram projector (*Kill the Moon*)
- Ignite gas (*Carnival of Monsters*)
- Increase local gravity (*In the Forest of the Night*)
- Increase mesh-density of atmospheric suits (*Silence in the Library*)
- Increase X-Ray radiation (*Smith and Jones*)
- Interact with any form of communication you care to mention—unless it's made of wood (*In the Forest of the Night*)
- Interrupt forcefields (*Invasion of Time*)
- Knock over stone slabs (*The Fires of Pompeii*)
- Landmine and bomb detonation (*The Sea Devils, Robot, Doomsday*)
- Light candles (*The Girl in the Fireplace*)
- Lock and unlock doors (Various)
- Lock wifi networks (*The Bells of Saint John*)
- Lower blinds (*The End of the World*)
- Make toys work by themselves (*Night Terrors*)
- Make wired telephones wireless (*Mummy on the Orient Express*)
- Manipulate super-dense water vapour (*The Snowmen*)
- Marker pen—pull the end off for a handy tool to write with (*World Enough and Time*)
- Medical scans (*The Empty Child* and more)
- Melt gangers (*The Almost People*)
- Melt plastic (*The Android Invasion*)
- Open a frequency-modulated acoustic lock (*The Rings of Akhaten*)
- Open cracks in time (*The Eleventh Hour*)
- Open doors and picking locks (Too many to mention)
- Open manholes (*Daleks in Manhattan*)
- Open sonic barriers (*The Visitation*)
- Overload technology (*The Eleventh Hour, The Angels Take Manhattan*)
- Prime explosives (*Destiny of the Daleks*)
- Provide visual schematics for the blind Doctor [sonic specs] (*Extremis*)
- Psychic Interface—just point and think (*Let's Kill Hitler*)
- Radio interference (*Daleks in Manhattan*)
- Raise sun filters (*The End of the World*)
- Receive and send emails [sonic specs] (*Extremis*)
- Recharge a stolen android teleport (*The Magician's Apprentice*)
- Reattach barbed wire—setting 2,428 D apparently (*The Doctor Dances*)
- Recharge batteries (*Father's Day*)
- Remote control—for TARDIS systems (*The Parting of the Ways, The Eleventh Hour*) and even the odd hut door (*Inferno*)

- Remote detonation of explosive barrels (*Thin Ice*)
- Remotely delete answerphone messages (*Pond Life*)
- Remove manacles / handcuffs (Lots of times)
- Repair TARDIS systems (*Aliens of London*)
- Repel mutant maggots (*The Green Death*)
- Resonate concrete (*The Doctor Dances*)
- Reveal force fields (*The Hungry Earth*)
- Reverse teleporters (*Boom Town*)
- Reveal Vardies in the wall (*Smile*)
- Reverse the effects of prehistoric leech venom (*The Crimson Horror*)
- Rewire systems (*The Ark in Space, Gridlock* and others)
- Safe cracker (*The Sun Makers*)
- Scan computers / technology (Various)
- Scramble scribble monsters (*Fear Her*)
- Screwdriver (*Fury from the Deep, The War Games, The Ark in Space*)
- Scupper door controls / computer systems (Many, many times)
- Seal power cell breaches (*Into the Dalek*)
- Search mobile phones for apps and information (*The Runaway Bride*)
- Separate humans from an Abzorbaloff—before fusing them into paving slabs (*Love & Monsters*)
- Set off alarms (*Terror of the Zygons*)
- Shut off CCTV (*The God Complex*)
- Slice through alien spider web (*The Runaway Bride*)
- Soldering iron (*The Sound of Drums*)
- Sonic lance—capable of cutting through metal (*Robot*)
- Steal money from cashpoints (*The Long Game, The Runaway Bride*)
- Summon the TARDIS—as long as Huon particles are present (*The Runaway Bride*)
- Synch to the TARDIS' HADS (Hostile Action Displacement System) to pinpoint the TARDIS' new location (*Cold War*)
- Test for clairvoyance (*Planet of the Spiders*)
- Toll church bells (*The Time of the Doctor*)
- Torch (*Thin Ice*)
- Track trionic radiation leaks (*Into the Dalek*)
- Transmit messages (*Partners in Crime*)
- Trap psychic signals (*Last Christmas*)
- Triangulate energy sources—setting 15B (*Army of Ghosts*)
- Trigger an isolated sonic shift in molecules and disintegrate a door (after 400 years' worth of calculations—same software, different case) (*The Day of the Doctor*)
- Triplicate the flammability of alcohol—although the Doctor may have been bluffing (*World War Three*)

- Turn up the volume of church organs (*The Lazarus Experiment*)
- Uncork champagne (*Voyage of the Damned*)
- Wipe human memories (*The Caretaker*)

KNOWN LIMITATIONS

'Even the sonic screwdriver won't get me out of this one.'

The Doctor, *The Invasion of Time*

- Only works on electronic locks (*Carnival of Monsters*)—although later versions seem to have overcome this problem
- Doesn't do wood (*Silence in the Library, In the Forest of the Night*)
- Also doesn't do turkey (*The Time of the Doctor*)
- Can't open deadlock seals—unless used in conjunction with another sonic device (*School Reunion, Partners in Crime*)
- Not everything can be fixed with a screwdriver. It's not a magic wand (*In the Forest of the Night*)
- Won't work if a suppression field is present (*Mummy on the Orient Express*)

OTHER SONIC DEVICES

- Romana's sonic screwdriver—Coveted by the Doctor (*The Horns of Nimon*)
- Sonic blaster—51st-century gun from Villengard. First used by Captain Jack Harkness and later River Song (*The Empty Child*, *Silence in the Library*)
- Sonic cane—Ideal for when the Doctor wants to don top hat and tails. Can also contact the sonic screwdriver (*Let's Kill Hitler*)
- Sonic cone—A sonic mine used by the Bannermen. Step within its range and you're atomised (*Delta and the Bannermen*)
- Sonic door handle—One of the Third Doctor's 'funny gadgets', used to open his garage doors. Liz Shaw had one too. Could possibly be another variation of the sonic screwdriver but this is never made clear (*Inferno*)
- Sonic guns—Weapons employed by the Ice Warriors, can do nasty things to your insides (various stories, including *The Ice Warriors*)
- Sonic knife—Handy if you want to cut through glass and steal priceless works of art (*City of Death*)
- Sonic lance—A large industrial device used in mining operations on Peladon (*The Monster of Peladon*)
- Sonic lance—Used by the Sixth Doctor in his TARDIS repairs (*Attack of the Cybermen*)
- Ultrasonic ray gun—Mounted on a tripod and used to destroy Daleks with good old-fashioned Earth rock 'n' roll (*Revelation of the Daleks*)
- Sonic lipstick—Given to Sarah Jane Smith by the Doctor (*Journey's End*)
- Sonic pen—Wielded by Miss Foster aka Matron Cofelia, resembling a black fountain pen (*Partners in Crime*)
- Sonic probe—Constructed by the Amy Pond trapped in an alternative time stream (*The Girl Who Waited*)
- Sonic Sunglasses—As worn by the Twelfth Doctor. Can do most things the sonic screwdriver can do. Also handy when pretending you're not blind. (*The Magician's Apprentice et al*)
- Sonic Trowel—As found in Professor River Song's bag. Embarrassing. (*The Husbands of River Song*)
- Sonic Umbrella—Missy's own variation on the sonic screwdriver (*World Enough and Time*)

PSYCHIC PAPER

Almost as useful as the sonic screwdriver, the Doctor's psychic paper opens a lot of doors…

- An invitation to the Earth Death celebrations—plus one (*The End of the World*)
- Satellite Five management credentials (*The Long Game*)
- Doctor John Smith, Ministry of Asteroids (*The Empty Child*)
- Doctor James Macrimmon from the township of Balamory, trained under Doctor Bell at the University of Edinburgh, appointed by the Lord Provost as Queen Victoria's protector (*Tooth and Claw*)
- Employment papers (*Rise of the Cybermen*)
- Government official—on royal appointment (*The Idiot's Lantern*)
- The King of Belgium (*The Idiot's Lantern*)
- Police officer (*Fear Her*)
- Passes to the Empire State Building—two engineers and an architect (*Evolution of the Daleks*)
- Ticket number Red 67, plus one (*Voyage of the Damned*)
- John Smith, Health and Safety (*Partners in Crime, Hide*)
- Marble inspector (*The Fires of Pompeii*)
- Chief Inspector Smith from Scotland Yard (*The Unicorn and the Wasp*)
- Engine expert (*Midnight*)
- UNIT credentials (*Planet of the Dead*)
- Church credentials (*The Vampires of Venice*)
- References from the King of Sweden (*The Vampires of Venice*)
- The Doctor's National Insurance Number, NHS number and references (*The Lodger*)
- Meteorological Department credentials (*The Rebel Flesh*)
- Social Services credentials (*Night Terrors*)
- Special commissioner from the Chinese Emperor (*The Angels Take Manhattan*)
- Imperial Pro-Consul (*Nightmare in Silver*)
- Children's home inspector (*Listen*)
- Mystery Shopper (*Mummy on the Orient Express*)
- MI-5 ID (used by Clara in *Flatline*)
- Sweary government inspector (*Dark Water*)
- The recipient of the Dunbar Victory Medal (*The Woman Who Lived*)
- A pardon from Thomas Cromwell (*The Woman Who Lived*)

- Engineering Stress Assessors (*Sleep No More*)
- A member of the Buckingham Palace household (*Thin Ice*)
- Doctor Disco from the Fairford Club (*Thin Ice*)
- Members of the Union (*Oxygen*)
- Authorisation from the Chief, giving full access at NASA. (*Empress of Mars*)
- Stowaways on Friday's ship (*Empress of Mars*)
- Borrowed by Courtney Woods to use as fake ID (*Kill the Moon*)
- UNIT operative (*Under the Lake*)
- Dr John Disco (*The Zygon Inversion*)

The psychic paper also receives messages from time to time:

- 'Ward 26, Please Come'—from the Face of Boe (*New Earth*)
- 'The Library, come as soon as you can x'—from River Song (*Silence in the Library*)
- 'Prisoner Zero has escaped'—from the Atraxi (*The Eleventh Hour*)
- 'Please save me from the monsters'—from George (*Night Terrors*)
- Summons to the Tower of London—from Kate Stewart (*The Power of Three*)

🛈 PSYCHIC PAPER EPIC FAIL

Beware, not all are susceptible to the Paper's powers. To date, it hasn't been able to fool:

- Rose Tyler
- Captain Jack Harkness
- Trained Torchwood employees
- William Shakespeare
- Madame Rosanna Calvierri

Plus, it shorted out when the Doctor tried to claim he was universally recognised as a mature and responsible adult.

THE DOCTOR'S TOOLKIT

It's not all about screwdrivers, you know. The Doctor has used many a tool in his travels. Some are part of the TARDIS toolkit. Some he's created. Some are just common-or-garden objects. But all of them work. Well, some of them work. Mostly. Here's a selection of his most useful gadgets.

- Argon discharge globes—used with portable mu-field activators (*Frontios*)
- Astro-rectifier—helpful when repairing TARDIS thermo-couplings (*The Hand of Fear*)
- Bio-damper—a ring-like device that masks the wearer's bio-signature. Useless against Huon particles (*The Runaway Bride*)
- Chalk—for writing on TARDIS blackboards and protecting companions from magic. (*Listen, Battlefield*)
- Chronodyne generators—all you need to create a time mine, as long as a maths teacher doesn't deactivate a few along the way (*The Caretaker*)
- Cricket ball—useless if you need to activate an auto-guard cut-out (*The Ark in Space*) but handy if you find yourself floating aimlessly in space (*Four to Doomsday*)
- Cue Card—used by the Twelfth Doctor to help him apologise. (*Under the Lake, Face the Raven*)
- Curioscanner—scans for curios. That's how it got its name. (*The Woman Who Lived*)
- Dog whistle—for summoning your robot dog (*The Ribos Operation* and others)
- Drawing pins—the Second Doctor carried drawing pins with him, just because he liked them (*The Space Pirates*)
- Etheric beam locator—for those moments when you need to locate etheric beams (*Genesis of the Daleks*)
- Fireworks—a firecracker and some blue touch paper can help unblock sacred flames (*The Brain of Morbius*), while Galactic Glitters are good for maddening Yeti (*The Five Doctors*)
- Fob watch—Peri smashed the Sixth Doctor's, but the Seventh Doctor replaced it with one that contained an alarm, calculator and scanner (*Silver Nemesis, Survival*)
- Football rattle—useful when you need to spook horses (*The Masque of Mandragora*)
- Ganymede driver—used to repair the TARDIS's thermo-couplings (*The Hand of Fear*)
- Hologram clothes—perfect for appearing naked in front of the Church of the Papal Mainframe. Always remember to keep them on when meeting your companion's family over Christmas dinner. Also includes heat loss filter for when you're naked in the snow. (*The Time of the Doctor*)
- Infrared sunglasses—good for seeing in the dark (*The Hungry Earth*)
- Jammie Dodger—doubles as TARDIS self-destruct button, as long as it's not scanned by Daleks, that is (*Victory of the Daleks*)
- Jeweller's loupe/monocle—use it to examine the Veil more closely (*Heaven Sent*)
- Invisible watch—looks a tad disappointing, but reverses light waves to render its wearer invisible. (*The Caretaker*)
- Laser spanner—stolen by Emily Pankhurst (*Smith and Jones*)
- Magnetic clamp—dangerous if in the hands of a Master-controlled companion (*Doctor Who*)

- Mergin nut (*The Hand of Fear*)
- Memory worm—one touch on your bare skin and you lose the last hour of your memory. A bite will wipe out decades. (*The Snowmen*)
- Metebelis crystal—handy for creating pyschochronographs, perfect for amplifying natural psychic abilities (*Hide*)
- Mobile phone—because it's good to talk (*Boom Town*)
- Multi-quantiscope (*The Hand of Fear*)
- Nanorecorders—voice recorders implanted in your hand (*Day of the Moon*)
- Neutron ram (*Doctor Who*)
- Notebook—containing all the key codes of the machines in the TARDIS along with notes on places he's travelled to. The Doctor would never leave it behind, unless he was attacked by cavemen; to work out how to find Room 12 in the castle he finds himself trapped in after Clara's death. (*An Unearthly Child, Heaven Sent, Hell Bent*)
- Orange spacesuit (*The Impossible Planet, The Waters of Mars, Hide, Listen*)
- Parthenogenesis detector—for detecting independent creation of life forms (*Partners in Crime*)
- Reading aid (*Extremis*)
- Recorder—can destabilise antimatter universes as long as it's fallen into the TARDIS's force-field generator (*The Three Doctors*)
- Rhondium sensor—detects delta or, unsurprisingly, Rhondium particles (*The Time Warrior, Planet of the Dead*)
- Signal tracer—traces a broadcast and translates its point of origin to a map reference (*Lie of the Land*)
- Sleep patches—sends the wearer into a dream state, making them extremely susceptible to suggestion (*Dark Water*)
- Special straw—adds extra fizz to carbonated drinks (*The Impossible Astronaut*)
- Species matcher—identifies an individual's species and planet of origin based on an image or picture. Given to the Doctor by a dull godmother with two heads and bad breath. (*Vincent and the Doctor*)
- Stattenheim remote control—TARDIS remote control (*The Two Doctors*)
- Stethoscope—what Doctor worth his salt would be without a stethoscope? Especially when you can use one to listen to heartbeats in pipes (*Fury from the Deep*), identify transmitters (*The Creature From the Pit*), eavesdrop (*The Runaway Bride, Partners in Crime*) and follow signals (*The Stolen Earth*), or to check the TARDIS in flight. (*The Lodger*)
- Synestic lock—a pocket-sized clamp, also capable of absorbing energy from a Sontaran blast (*The Sontaran Experiment, The Caretaker*)
- TARDIS magnet—homing signal that helps you find the TARDIS while out and about. Just keep an eye on the green light. (*The Chase*) Other TARDIS homing devices crop up in *Full Circle, Mawdryn Undead* and *The Visitation*.

- Telescope—the Second, Third, and Fourth Doctors all kept a folding telescope handy
- The Doctor's signet ring—could open the TARDIS doors in case of power failure. Also useful for handling Zarbi, resetting TARDIS locks and hypnotising people. (*The Web Planet, The Daleks' Master Plan, The War Machines*)
- Timey-Wimey detector—goes 'Ding' when there's stuff and boils eggs at thirty paces. Best kept away from hens. (*Blink*)
- Umbrella—can be used to measure radio antennae when a tape measure isn't to hand (*Remembrance of the Daleks*)
- Vibro-cutters—never give them to your companion for safekeeping, especially if she has more than one jacket (*The Caretaker*)
- Wig—makes a handy hiding place for a key (*The Time of the Doctor*)
- Yo-yo—for taking gravity readings, pulling people to safety in zero gravity or convincing primitives that you're a god. Or just using as a yo-yo for the fun of it. (*The Ark in Space, The Brain of Morbius, The Girl Who Died, Heaven Sent*)
- Zeus plug—can also double as castanets (*The Hand of Fear, The Girl in the Fireplace*)

WHO'S DRIVING THIS THING?

When he was a lad, the Doctor always wanted to be a train driver, but as far as we know has never stepped behind the boilerplate. However, he's driven and piloted a fair few vehicles in his time. Here's a list of the notable ones. Vroom vroom!

- The TARDIS—From *An Unearthly Child* to now
- Helicopter—*Fury from the Deep*
- Transport capsule—*The Dominators*
- Military Land Rover—*The Invasion, Day of the Daleks, Invasion of the Dinosaurs, Robot, Terror of the Zygons*
- Canoe—*The Invasion, The Power of Kroll*
- Moon rocket—*The Seeds of Death*
- Ambulance—*The War Games*
- Wheelchair—*Spearhead from Space*
- Packard vintage car—*Spearhead from Space*
- Bessie—Various
- Transporter lorry—*The Ambassadors of Death*
- Recovery 7—*The Ambassadors of Death*

- IMC Buggy—*Colony in Space*
- Motorbike—*The Daemons, Delta and the Bannermen, Survival, Doctor Who*
- Motor trike—*Day of the Daleks*
- Boat—*The Sea Devils*
- The Master's ship—*Frontier in Space*
- Cargo ship—*Frontier in Space*
- Milk float—*The Green Death*
- Mine cart—*The Green Death*
- The 'Whomobile'—*Invasion of the Dinosaurs, Planet of the Spiders*
- Lorry—*Invasion of the Dinosaurs, The Two Doctors*
- Campbell Cricket autogyro—*Planet of the Spiders*
- Hovercraft—*Planet of the Spiders*
- Speedboat—*Planet of the Spiders*
- Nerva Beacon—*Revenge of the Cybermen*
- Daimler limousine—*The Seeds of Doom*
- Car—*The Hand of Fear*
- Air car—*The Pirate Planet*
- Punt—*Shada / The Five Doctors*
- Bicycle—*Shada*
- Spaceship—*The Caves of Androzani*
- Operating table—*Mark of the Rani*
- Army detector van—*Remembrance of the Daleks*
- Happiness Patrol jeep—*The Happiness Patrol*
- Scooter—*The Idiot's Lantern*
- Segway—*The Runaway Bride*
- The starship *Titanic*—*Voyage of the Damned*
- 1920s car—*The Unicorn and the Wasp*
- Bus 200—*Planet of the Dead*
- Tethered Aerial Release Developed In Style hot-air balloon—*The Next Doctor*
- Gadget—*The Waters of Mars*
- TARDIS pulled by reindeer—2009 BBC Idents
- Vinvocci spaceship—*The End of Time*
- Fire Engine—*The Eleventh Hour*
- Vortex manipulator—*The Big Bang*
- Shark-drawn carriage—*A Christmas Carol*
- TARDIS lash-up—*The Doctor's Wife*
- Jumbo jet—*The Bells of Saint John*
- Anti-gravity motorbike—*The Bells of Saint John*
- Space moped—*The Rings of Akhaten*
- Davros's Dalek chair—*The Witch's Familiar*
- People carrier—*The Zygon Inversion*

When it comes to our four-footed friends, the Doctor is also happy in the saddle. He rides horses in *Marco Polo*, *The Masque of Mandragora*, *Survival*, *The Girl in the Fireplace*, *The Pandorica Opens, A Town Call Mercy* (a horse called Susan) and *Deep Breath*. When an old mare isn't available he'll also happily jump on top of a triceratops, as *Dinosaurs on a Spaceship* showed.

GOOD OLD BESSIE

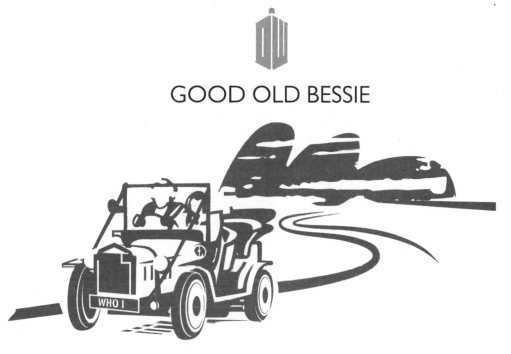

Introduced in *Doctor Who and the Silurians*, the Doctor's 'Edwardian Roadster' was in fact one of a number of limited-edition kit cars made by Siva / Neville Trinkett (Design) Limited of Blandford, Dorset.

Also available as a two-seater, the kit was designed to fit an E93A chassis, the same as the one used by Ford for its Ford Popular, Anglia and Prefect cars. The basic £160 kit purchased by the production team included the glass-fibre body, seats (four), bonnet, wheel trims, mudguards, foam cushioning, bonnet brackets, radiator, running boards and fuel tank. Numerous optional extras were also ordered including a luggage trunk, coach lamp, bulb horns, Cibie headlamps, hood (with side curtains) battery box, seat covers, carpets, screen and body straps plus the Ford chassis and engine. All of this pushed Bessie's total cost to £502.

At the time of purchase, Barry Letts' desired WHO 1 plate had already been purchased, so Bessie was registered as MTR 5. A fake WHO 1 number plate was used in the programme for close-ups and when the car could be driven around private grounds.

When Bessie was reintroduced in 1989's *Battlefield*, the number plates had mysteriously changed to WHO 7.

STORIES THAT FEATURED BESSIE

Doctor Who and the Silurians
The Ambassadors of Death
Inferno
Terror of the Autons
The Mind of Evil
The Claws of Axos
The Daemons

The Time Monster
The Three Doctors
The Green Death
Planet of the Spiders
Robot
The Five Doctors
Battlefield

Bessie also made an appearance in the 1993 Children in Need story *Dimensions in Time*, driven by Captain Yates, as well as featuring in numerous *Doctor Who* comic strips and novels.

14 FACTS ABOUT THE WHOMOBILE

1. In January 1973, Jon Pertwee opened a new Ford dealership in the Midlands. There he was impressed by the Black Widow, a custom-built black and green car. He immediately asked Pete Farries, the chairman of the Nottingham Drag and Custom Club, to make him a custom car.
2. Pertwee gave Farries two requirements: the car needed to be street legal and it needed to look like it came from outer space.
3. The result was named 'Alien', a 4.3-metre-long by 2.1-metre-wide two-seater car built on a three-wheeled Bond Bug chassis.
4. A 20-centimetre rubber skirt hid the wheels giving the illusion that Alien was some kind of hovercraft.
5. Powered by an aluminium 975cc Hillman Imp Sports Unit, especially built by Chrysler UK, Alien could reach speeds of 105mph, although 55mph was its usual cruising speed.
6. The car also included a telephone, television screen and 44 lights which made up a mock computer.
7. It was painted using silver and red Bergacryl 1/32-inc metalflake and twenty coats of lacquer.
8. Alien's official registration number was WVO 2M.
9. The Road Licensing department classified Alien as an Invalid Tricycle.

10. When Pertwee introduced Alien to the production team, a hasty rewrite saw the Doctor drive the vehicle around London in Part 4 of *Invasion of the Dinosaurs*. The sequence had been scripted to show the Doctor riding a motorbike.

11. Originally, the car had its name emblazoned along its glass fibre skin. Director Paddy Russell insisted this was removed before filming.

12. Alien wasn't quite finished when filming began. The car's canopy wasn't added until its second and last appearance in *Planet of the Spiders*.

13. Alien remained the private property of Jon Pertwee until it was purchased by a private collector at auction in the early 1980s. Bought as a gift for his son, the car went for £1,700.

14. Although the car was referred to as the Whomobile in the script, the name was never used on screen and the vehicle remains unnamed within the Whoniverse.

SEVEN

RELATIVE DIMENSIONS

DOCTOR WHO AND POPULAR CULTURE

'Books and stuff?'

The Doctor, *Castrovalva*

Doctor Who has always moved with the times, but along the way has picked up a host of cultural references and shared actors with some of the biggest TV and movie franchises on the planet.

SOAP WHO

'Well, first of all Peggy heard this noise in the cellar, so she goes down...'

Jackie Tyler, *Army of Ghosts*

Soap operas are part of the great TV viewing tradition of Great Britain. Following *Doctor Who*, Frazer Hines began a 22-year stint in the ITV soap *Emmerdale* in 1972. In 2012, *Emmerdale* repaid the favour as Jenna-Louise Coleman had previously found fame on the rural soap before playing Clara in *Doctor Who*. Connections between *Doctor Who* and the soaps are many: Freema Agyeman's first TV role was in the 2003 revival of *Crossroads*—a soap co-created by Peter Ling, writer of *The Mind Robber*. Here's a selection of other actors who have appeared in *Doctor Who* and four of the nation's favourite soaps operas currently broadcast.

☐ CORONATION STREET (ITV, 1960–PRESENT)

Actor	Doctor Who appearances
Dicken Ashworth	*Timelash* (Sezon)
Keith Barron	*Enlightenment* (Striker)
Sasha Behar	*The Fires of Pompeii* (Spurrina)
Lisa Bowerman	*Survival* (Karra)
Christopher Coll	*The Seeds of Death* (Phipps) / *The Mutants* (Stubbs)
Michelle Collins	*42* (Kath McDonnell)
Kenneth Cope	*Warriors' Gate* (Packard)
Bernard Cribbins	*Daleks—Invasion Earth 2150 A.D.* (Tom) / Various, 2007–2010 (Wilfred Mott)
Catherine Cusack	*Paradise Towers* (Blue Kang Leader)
Rachel Davies	*State of Decay* (Camilla)
Peter Dean	*The Face of Evil* (Tribe Member)
Ayesha Dharker	*Planet of the Ood* (Solana Mercurio)
Keith Drinkel	*Time-Flight* (Scobie)
Sharon Duce	*Ghost Light* (Control)
Mark Eden	*Marco Polo* (Marco Polo)
Brigit Forsyth	*The Evil of the Daleks* (Ruth Maxtible)
Sean Gallagher	*New Earth* (Chip)
Natalie Gumede	*Last Christmas* (Ashley)
Frazer Hines	Various 1966–1985 (Jamie Macrimmon)
Geoff Hinsliff	*Image of the Fendahl* (Jack Tyler) / *Nightmare of Eden* (Fisk)
Geoffrey Hughes	*The Trial of a Time Lord* (Mr Popplewick)
Annie Hulley	*The Happiness Patrol* (Newscaster)
Michael Jayston	*The Trial of a Time Lord* (The Valeyard)
Milton Johns	*The Enemy of the World* (Benik) / *The Android Invasion* (Guy Crayford) / *The Invasion of Time* (Kelner)
Suranne Jones	*The Doctor's Wife* (Idris)

Actor	Doctor Who appearances
Peter Kay	*Love & Monsters* (Victor Kennedy)
Jacqueline King	Various 2006-2010 (Sylvia Noble)
Sarah Lancashire	*Partners in Crime* (Miss Foster)
Bruno Langley	*Dalek / The Long Game* (Adam)
Rula Lenska	*Resurrection of the Daleks* (Styles)
Maureen Lipman	*The Idiot's Lantern* (The Wire)
William Lucas	*Frontios* (Range)
Joanna Lumley	*The Curse of Fatal Death* (The Doctor)
Fulton Mackay	*Doctor Who and the Silurians* (Dr Quinn)
Nichola McAuliffe	*The Sound of Drums* (Vivien Rook)
Sir Ian McKellen	*The Snowmen* (Voice of the Great Intelligence)
Bryan Mosley	*The Daleks' Master Plan* (Malpha)
Gray O'Brien	*Voyage of the Damned* (Rickston Slade)
Daphne Oxenford	*Dragonfire* (Archivist)*
Eric Potts	*Aliens of London* (Oliver Charles)
Ian Reddington	*The Greatest Show in the Galaxy* (Chief Clown)
Anne Reid	*Smith and Jones* (Florence Finnegan)
William Russell	Various 1963–1965 (Ian Chesterton)
Leonard Sachs	*The Reign of Terror* (Admiral de Coligny) / *Arc of Infinity* (Borusa)
John Savident	*The Visitation* (The Squire)
Elisabeth Sladen	Various 1974–2010 (Sarah Jane Smith)
Elizabeth Tan	*Journey's End* (Anna Zhou)
Shirin Taylor	*The Stones of Blood* (Camper) / *Dragonfire* (Shopper)
Will Thorp	*The Impossible Planet / The Satan Pit* (Toby)
Patrick Troughton	Various 1966–1985 (The Doctor)
John Woodvine	*The Armageddon Factor* (Marshal)
Helen Worth	*Colony in Space* (Mary Ashe)

* Daphne Oxenford also played an elderly Agatha Christie in deleted scenes from *The Unicorn and the Wasp*.

█ EASTENDERS (BBC, 1985–PRESENT)

Actor	Doctor Who appearances
Lynda Baron	*The Gunfighters* (vocal only) / *Enlightenment* (Captain Wrack) / *Closing Time* (Val)
Lucy Benjamin	*Mawdryn Undead* (Child Nyssa)
Hywel Bennett	*The Chase* (Rynian)
June Brown	*The Time Warrior* (Eleanor)
Michael Cashman	*Time-Flight* (Bilton)
Tony Caunter	*The Crusade* (Thatcher) / *Colony in Space* (Morgan) / *Enlightenment* (Jackson)
Michelle Collins	*42* (Kath McDonnell)
Lindsey Coulson	*Midnight* (Val Cane)
Peter Dean	*The Face of Evil* (Tribe Member)
Tom Ellis	*Last of the Time Lords* (Thomas Milligan)
Cheryl Fergison	*The Empty Child / The Doctor Dances* (Mrs Lloyd)
Jamie Foreman	*The Idiot's Lantern* (Eddie Connolly)
Don Gilet	*The Runaway Bride* (Lance)
Leslie Grantham	*Resurrection of the Daleks* (Kiston)
Cheryl Hall	*Carnival of Monsters* (Shirna)
John Hallam	*Ghost Light* (Light)
Mona Hammond	*Rise of the Cybermen* (Rita-Anne)
Jane How	*Planet of the Daleks* (Rebec)
Raji James	*Army of Ghosts / Doomsday* (Dr Rajesh Singh)
Louise Jameson	Various 1977–1978 (Leela)
Martin Jarvis	*The Web Planet* (Hilio) / *Invasion of the Dinosaurs* (Butler) / *Vengeance on Varos* (Governor)
Rory Jennings	*The Idiot's Lantern* (Tommy Connolly)
Jo Joyner	*Bad Wolf / The Parting of the Ways* (Lynda)
Michael Keating	*The Sun Makers* (Goudry)

Actor	Doctor Who appearances
Bonnie Langford	Various 1986-1987 (Mel)
Derek Martin	Uncredited roles as an extra in various stories, including *The Romans*, *The Massacre*, *The Web of Fear*, *Spearhead from Space*, *The Ambassadors of Death*, *Inferno*, *The Mind of Evil* and *The Claws of Axos* *Image of the Fendahl* (David Mitchell)
Daniel Mays	*Night Terrors* (Alex)
Michael Melia	*The Visitation* (Terileptil)
Tracy-Ann Oberman	*Army of Ghosts* / *Doomsday* (Yvonne Hartman)
Pooky Quesnel	*A Christmas Carol* (Captain)
Ian Reddington	*The Greatest Show in the Galaxy* (Chief Clown)
Lee Ross	*The Curse of the Black Spot* (Boatswain)
Michelle Ryan	*Planet of the Dead* (Lady Christina de Souza)
Pamela Salem	*The Face of Evil* (vocal only) / *The Robots of Death* (Toos) / *Remembrance of the Daleks* (Rachel Jensen)
Leslie Schofield	*The War Games* (Leroy) / *The Face of Evil* (Calib)
Adele Silva	*Survival* (Squeak)
Mary Tamm	Various 1978–1979 (Romana)
Nina Toussaint-White	*Let's Kill Hitler* (Mels)
Nina Wadia	*The Eleventh Hour* (Dr Ramsden)
Rudolph Walker	*The War Games* (Harper)
Barbara Windsor	*Army of Ghosts* (Peggy Mitchell)
Anna Wing	*Kinda* (Anatta)

DIMENSIONS IN TIME

To celebrate *Doctor Who*'s 30th anniversary in 1993, several Doctors visited Albert Square for a special *Doctor Who-EastEnders* crossover for the charity telethon Children in Need. The following *EastEnders* cast members appeared in character:

- Wendy Richard
- Gillian Taylforth
- Letitia Dean
- Pam St Clement
- Mike Reid
- Adam Woodyatt
- Steve McFadden
- Ross Kemp
- Deepak Verma
- Shobu Kapoor
- Nicola Stapleton

(Ron Tarr also appeared in his role as Big Ron, in an alternative version of Part 2, which was not broadcast.)

EMMERDALE (ITV 1972–PRESENT)

Actor	Doctor Who appearances
Bernard Archard	*The Power of the Daleks* (**Bragen**) / *The Pyramids of Mars* (**Marcus Scarman**)
Dicken Ashworth	*Timelash* (**Sezon**)
Andrew Burt	*Terminus* (**Valgard**)
Clare Clifford	*Earthshock* (**Professor Kyle**)
Jenna-Louise Coleman	Various 2012–2017 (**Clara**)
George Costigan	*Voyage of the Damned* (**Max Capricorn**)
Paul Darrow	*Doctor Who and the Silurians* (**Captain Hawkins**) / *Timelash* (**Tekker**)
Rachel Davies	*State of Decay* (**Camilla**)
Sharon Duce	*Ghost Light* (**Control**)
Lesley Dunlop	*Frontios* (**Norna**), *The Happiness Patrol* (**Susie Q**)
Richard Franklin	Various 1971–1974 (**Mike Yates**)
John Hallam	*Ghost Light* (**Light**)

Actor	Doctor Who appearances
Roger Hammond	*The Chase* (Francis Bacon) / *Mawdryn Undead* (Dr Runciman)
Frazer Hines	Various 1966–1985 (Jamie Macrimmon)
Annie Hulley	*The Happiness Patrol* (Newscaster)
Louise Jameson	Various 1977–1978 (Leela)
Michael Jayston	*The Trial of a Time Lord* (The Valeyard)
Paul Jerricho	*Arc of Infinity* / *The Five Doctors* (The Castellan)
Ronald Leigh-Hunt	*The Seeds of Death* (Radnor) / *Revenge of the Cybermen* (Commander Stevenson)
Joanna Monro	*Planet of the Spiders* (Rega)
Wendy Padbury	Various 1968–1983 (Zoe Heriot)
Susan Penhaligon	*The Time Monster* (Lakis)
Miranda Raison	*Daleks in Manhattan* / *Evolution of the Daleks* (Tallulah)
Trevor Ray	*Doctor Who and the Silurians* (Ticket Collector)
Adele Silva	*Survival* (Squeak)
Jenny Tomasin	*Revelation of the Daleks* (Tasambeker)
Wanda Ventham	*The Faceless Ones* (Jean Rock) / *Image of the Fendahl* (Thea Ransome) / *Time and the Rani* (Faroon)
John Woodvine	*The Armageddon Factor* (Marshal)

❚ HOLLYOAKS (CHANNEL 4 1995– PRESENT)

Actor	Doctor Who appearances
Colin Baker	Various 1984–1986 (The Doctor)
Yasmin Bannerman	*The End of the World* (Jabe)
Andree Bernard	*The Shakespeare Code* (Dolly Bailey)
Nicolas Chagrin	*Vengeance on Varos* (Quillam)
Tracey Childs	*The Fires of Pompeii* (Metella)
Paul Darrow	*Doctor Who and the Silurians* (Captain Hawkins) / *Timelash* (Tekker)
Elize du Toit	*42* / *The Sound of Drums* (Sinister Woman)
Sally Faulkner	*The Invasion* (Isobel Watkins)

Bernard Holley	*The Tomb of the Cybermen* (Peter Haydon) / *The Claws of Axos* (Axon Man)
Sylvester McCoy	Various 1987–1996 (The Doctor)
Edward Peel	*Dragonfire* (Kane)
Jeff Rawle	*Frontios* (Plantagenet)

CONNECTING DOCTOR WHO
AND THE ARCHERS

'I've matured. I'm 1200 years old now. Plus I don't want to miss *The Archers*.'
The Doctor, *A Town Called Mercy*

Terry Molloy, who played Davros three times in *Doctor Who* between 1984 and 1988, has played the role of Mike Tucker in *The Archers* since 1973.

Charles Collingwood ('*The Archers*' Brian Aldridge) played the Brigadier in a series of 'Dr Where' sketches for the BBC Schools pro-gramme *Mathshow* in 1975.

In the Christmas Day 2005 episode of *The Archers*, the warring brothers Ed and Will Grundy briefly called a halt on hostilities to watch *The Christmas Invasion*.

Ysanne Churchman, who provided the voice of Alpha Centauri in *The Curse of Peladon*, *The Monster of Peladon* and *Empress of Mars*, played Grace Archer from 1950 to 1955. On 22 September 1955, the character was killed in a fire, a dramatic storyline intended to keep audiences away from ITV, which launched on TV that evening.

Mary Wimbush, who played Julia Pargeter in *The Archers* between 1992 and 2005, played Sarah Jane Smith's Aunt Lavinia in *K-9 and Company*.

Tamsin Greig, the nurse in *The Long Game*, has played Debbie Aldridge since 1991, flitting in and out of storylines as her character lives in Hungary most of the year.

Aristocratic Lord Cranleigh in *Black Orchid* and Crown Saxe-Coburg-hunter Redvers Fenn-Cooper from *Ghost Light* (both played by Michael Cochrane) are better known to *Archers*' fans as former gentleman farmer Oliver Sterling. In January 2014, *Doctor Who* and *The Archers* established its most direct familial connection when David Troughton, son of Second Doctor Patrick, took over the role of Tony Archer. David Troughton had previously appeared in *Doctor Who* in *The War* Games, *The Curse of Peladon* and *Midnight*. The actor was later joined in *The Archers* by his son William, playing Tony's son Tom.

Simon Williams, who played Group Captain 'Chunky' Gilmore in *Remembrance of the Daleks* joined the cast as business magnate Justin Elliot in 2014.

THE NAME'S WHO. DOCTOR WHO

In 1986, Sylvester McCoy and Timothy Dalton worked together on a series of Shakespeare plays at the Theatre Royal Haymarket in London. Within a year Sylvester had been cast as the Doctor and Dalton as James Bond, two of the great heroes of British popular culture. With Dame Diana Rigg (Tracy in *On Her Majesty's Secret Service*) guest starring in *Doctor Who*'s 2013 series, the following is a selection of actors who have appeared in both *Doctor Who* and the James Bond films.

Actor	Doctor Who appearances	James Bond appearances
John Abineri	*Fury from the Deep* (Van Lutyens) / *The Ambassadors of Death* (General Carrington) / *Death to the Daleks* (Railton) / *The Power of Kroll* (Ranquin)	*Diamonds Are Forever* (Airline Rep)
David Ashton	*Timelash* (Kendron)	*Tomorrow Never Dies* (First Sea Lord)
Rowan Atkinson	*The Curse of Fatal Death* (The Doctor)	*Never Say Never Again* (Nigel Small-Fawcett)
George Baker	*Full Circle* (Login)	*On Her Majesty's Secret Service* (Sir Hilary) / *The Spy Who Loved Me* (Captain Benson)
Steven Berkoff	*The Power of Three* (Shakri)	*Octopussy* (General Orlov)
Honor Blackman	*Terror of the Vervoids* (Professor Laskey)	*Goldfinger* (Pussy Galore)
Hugh Bonneville	*The Curse of the Black Spot* / *A Good Man Goes to War* (Captain Henry Avery)	*Tomorrow Never Dies* (Air Warfare Officer, HMS *Bedford*)
Christopher Bowen	*Battlefield* (Mordred)	*Tomorrow Never Dies* (Commander Day)

Actor	Doctor Who appearances	James Bond appearances
James Bree	*The War Games* (**Security Chief**) / *Full Circle* (**Nefred**) / *The Trial of a Time Lord* (**The Keeper**)	*On Her Majesty's Secret Service* (**Gebruder Gumbold**)
Jeremy Bulloch	*The Space Museum* (**Tor**) / *The Time Warrior* (**Hal the Archer**)	*The Spy Who Loved Me* (**Crewman**) / *Octopussy* (**Smithers**)
Sonny Caldinez	*The Evil of the Daleks* (**Kemel**) / *The Ice Warriors* (**Turoc**) / *The Seeds of Death* (**Ice Warrior**) / *The Curse of Peladon* (**Ssorg**) / *The Monster of Peladon* (**Sskel**)	*The Man with the Golden Gun* (**Kra**)
Earl Cameron	*The Tenth Planet* (**Williams**)	*Thunderball* (**Pinder**)
Anthony Carrick	*The Masque of Mandragora* (**Captain Rossini**)	*The Living Daylights* (**Blayden Male Secretary**)
Paul Carson	*Marco Polo* (**Ling-Tau**)	*You Only Live Twice* (**Astronaut**)
Tom Chadbon	*City of Death* (**Duggan**) / *The Trial of a Time Lord* (**Merdeen**)	*Casino Royale* (**Stockbroker**)
Geoffrey Cheshire	*The Time Meddler* (**Viking Leader**) / *The Daleks' Master Plan* (**Garge**) / *The Invasion* (**Tracy**)	*On Her Majesty's Secret Service* (**Toussaint**)
John Cleese	*City of Death* (**Art Gallery Visitor**)	*The World is Not Enough* / *Die Another Day* (**Q**)
Graham Crowden	*The Horns of Nimon* (**Soldeed**)	*For Your Eyes Only* (**First Sea Lord**)
Timothy Dalton	*The End of Time* (**Rassilon**)	*The Living Daylights* / *Licence to Kill* (**James Bond**)
Paul Darrow	*Doctor Who and the Silurians* (**Captain Hawkins**) / *Timelash* (**Maylin Tekker**)	*Die Another Day* (**Doctor**)
Derek Deadman	*The Invasion of Time* (**Stor**)	*Never Say Never Again* (**Porter**)
Vernon Dobtcheff	*The War Games* (**Scientist**)	*The Spy Who Loved Me* (**Max Kalba**)
Huw Edwards	*Fear Her* (**Himself**)	*Skyfall* (**Himself**)
Max Faulkner	*Genesis of the Daleks* (**Thal Guard**) / *The Android Invasion* (**Corporal Adams**) / *The Invasion of Time* (**Nesbin**)	*Goldeneye* (**Guard**)
Leslie French	*Silver Nemesis* (**Mathematician**)	*The Living Daylights* (**Lavatory Attendant**)
Julian Glover	*The Crusade* (**Richard I**) / *City of Death* (**Count Scarlioni**)	*For Your Eyes Only* (**Kristatos**)

Actor	Doctor Who appearances	James Bond appearances
Garrick Hagon	*The Mutants* (Ky) / *A Town Called Mercy* (Abraham)	*The Spy Who Loved Me* (Crewman)
Bernard Horsfall	*The Mind Robber* (Lemuel Gulliver) / *The War Games* (Time Lord) / *Planet of the Daleks* (Taron) / *The Deadly Assassin* (Goth)	*On Her Majesty's Secret Service* (Campbell)
Robert Jezek	*Battlefield* (Sgt Zbrigniev)	*Casino Royale* (Arresting Officer)
Noel Johnson	*The Underwater Menace* (Thous) / *Invasion of the Dinosaurs* (Charles Grover)	*For Your Eyes Only* (Vice Admiral)
Norman Jones	*The Abominable Snowmen* (Khrisong) / *Doctor Who and the Silurians* (Major Baker) / *The Masque of Mandragora* (Hieronymous)	*You Only Live Twice* (Astronaut)
David De Keyser	*The Eleventh Hour* (Atraxi Voice)	*Diamonds Are Forever* (Doctor)
Gertan Klauber	*The Romans* (Galley Master) / *The Macra Terror* (Ola)	*Octopussy* (Bubi) / *The Living Daylights* (Fairground Café Owner)
Bert Kwouk	*Four to Doomsday* (Lin Futu)	*Goldfinger* (Mr Ling) / *You Only Live Twice* (Spectre 3)
Philip Locke	*Four to Doomsday* (Bigon)	*Thunderball* (Vargas)
Joanna Lumley	*The Curse of Fatal Death* (The Doctor)	*On Her Majesty's Secret Service* (The English Girl)
Helen McCrory	*The Vampires of Venice* (Rosanna)	*Skyfall* (Clair Dowar MP)
Carl McCrystal	*The Curse of the Black Spot* (McGrath)	*The World is Not Enough* (Trukhin)
Kevin McNally	*The Twin Dilemma* (Hugo Lang)	*The Spy Who Loved Me* (Crewman)
Tobias Menzies	*Cold War* (Stepashin)	*Casino Royale* (Villiers)
Christopher Neame	*Shada* (Skagra)	*Licence to Kill* (Fallon)
Michael Osborne	*The Horns of Nimon* (Sorak)	*The Man with the Golden Gun* (Naval Lieutenant)
Geoffrey Palmer	*Doctor Who and the Silurians* (Masters) / *The Mutants* (Administrator) / *Voyage of the Damned* (Captain Hardaker)	*Tomorrow Never Dies* (Admiral Roebuck)
George Pastell	*The Tomb of the Cybermen* (Eric Kleig)	*From Russia with Love* (Train Conductor)

Actor	Doctor Who appearances	James Bond appearances
Ronald Pickup	*The Reign of Terror* (Physician)	*Never Say Never Again* (Elliott)
Tim Piggot-Smith	*The Claws of Axos* (Captain Harker) / *The Masque of Mandragora* (Marco)	*Quantum of Solace* (Foreign Secretary)
George Pravda	*The Enemy of the World* (Denes) / *The Mutants* (Jaeger) / *The Deadly Assassin* (Castellan Spandrell)	*Thunderball* (Kutze)
Jonathan Pryce	*The Curse of Fatal Death* (The Master)	*Tomorrow Never Dies* (Elliot Carver)
Carl Rigg	*The Power of Kroll* (Varlik)	*The Living Daylights* (Imposter)
Shane Rimmer	*The Gunfighters* (Seth Harper)	*Diamonds Are Forever* (Tom) / *The Spy Who Loved Me* (Commander Carter)
George Roubicek	*The Tomb of the Cybermen* (Captain Hopper)	*You Only Live Twice* (Astronaut)
Leonard Sachs	*The Massacre* (Admiral de Coligny) / *Arc of Infinity* (Borusa)	*Thunderball* (Group Captain)
Pamela Salem	*The Face of Evil* (vocal only) / *The Robots of Death* (Toos) / *Remembrance of the Daleks* (Dr Rachel Jensen)	*Never Say Never Again* (Moneypenny)
Colin Salmon	*Silence in the Library / Forest of the Dead* (Dr Moon)	*Tomorrow Never Dies / The World is Not Enough / Die Another Day* (Charles Robinson)
Catherine Schell	*City of Death* (Countess Scarlioni)	*On Her Majesty's Secret Service* (Nancy)
Cyril Shaps	*The Tomb of the Cybermen* (Viner) / *The Ambassadors of Death* (Lennox) / *The Androids of Tara* (Archimandrite)	*The Spy Who Loved Me* (Dr Bechmann)
Edward de Souza	*Mission to the Unknown* (Marc Cory)	*The Spy Who Loved Me* (Sheikh Hosein)
Roy Stewart	*The Crusade* (Saracen Warrior) / *The Tomb of the Cybermen* (Toberman) / *Terror of the Autons* (Strong Man)	*Live and Let Die* (Quarell Jnr)
Colin Stinton	*The Sound of Drums* (President)	*Tomorrow Never Dies* (Dr Greenwalt)
Elize du Toit	*42 / The Sound of Drums* (Sinister Woman)	*Skyfall* (M's Assistant)
Pip Torrens	*Human Nature / The Family of Blood* (Rocastle)	*Tomorrow Never Dies* (Captain, HMS *Bedford*)
Edward Underdown	*Meglos* (Zastor)	*Thunderball* (Air Vice Marshal)

Actor	Doctor Who appearances	James Bond appearances
Philip Voss	*Marco Polo* (Acomat) / *The Dominators* (Wahed)	*Octopussy* (Auctioneer)
Terry Walsh	Various, notably *Terror of the Autons* (Auton policeman), *The Sea Devils* (Barclay), *Invasion of the Dinosaurs* (Warehouse Looter), *The Monster of Peladon* (Guard Captain), *Planet of the Spiders* (Man with Boat), *The Sontaran Experiment* (Zake), *The Power of Kroll* (Mensch), *The Creature from the Pit* (Doran)	*The Spy Who Loved Me* (stunts, and stunt double for Bryan Marshall) / *Never Say Never Again* (stunts)
Frances de Wolf	*The Keys of Marinus* (Vasor) / *The Myth Makers* (Agamemnon)	*From Russia with Love* (Vavra)
Vincent Wong	*The Talons of Weng-Chiang* (Ho)	*Die Another Day* (General Li)
David Yip	*Destiny of the Daleks* (Veldan)	*A View to a Kill* (Chuck Lee)

Actor/writer Moris Farhi pitched two unused scripts to *Doctor Who* in the 1960s—'Farewell Great Macedon' and 'The Fragile Yellow Arc of Fragrance', and appeared in *From Russia with Love* and *You Only Live Twice*.

Doctor Who and *The Sarah Jane Adventures* script editor Gary Russell appeared as an uncredited extra in *Octopussy*.

TO BOLDLY GO WHERE
NO TARDIS HAS GONE BEFORE

On 21 June 1969, *The War Games* Episode Ten concluded Patrick Troughton's time as the Doctor. Three weeks later, on 12 July, the BBC filled the slot vacated by *Doctor Who* with a new American sci-fi import—*Star Trek*. Five decades later, both *Doctor Who* and *Star Trek* remain among the most enduring television entertainment franchises in the world, and a small handful of actors share the distinction of having appeared in both.

Actor	Doctor Who appearances	Star Trek appearances
Daphne Ashbrook	Doctor Who (Grace Holloway)	DS9: Melora
Steven Berkoff	The Power of Three (Shakri)	DS9: Business as Usual
Noel Clarke	Various (Mickey Smith)	Star Trek Into Darkness
John Franklyn-Robbins	Genesis of the Daleks (Time Lord)	TNG: Preemptive Strike
Barrie Ingham	The Myth Makers (Paris) / Dr. Who and the Daleks (Alydon)	TNG: Up the Long Ladder
Christopher Neame	Shada (Skagra)	Voy: Heroes and Demons/Ent: Storm Front
Simon Pegg	The Long Game (The Editor)	Star Trek (2009) / Star Trek Into Darkness / Star Trek Beyond
Olaf Pooley	Inferno (Stahlman)	Voy: Blink of an Eye
Maurice Roeves	The Caves of Androzani (Stotz)	TNG: The Chase
Deep Roy	The Talons of Weng-Chiang (Mr Sin) / The Trial of a Time Lord: Mindwarp (Posicarian delegate)	Star Trek (2009) / Star Trek Into Darkness / Star Trek Beyond
Mark Sheppard	The Impossible Astronaut / Day of the Moon (Canton Delaware III)	Voy: Child's Play
W. Morgan Sheppard	The Impossible Astronaut / Day of the Moon (Canton Delaware III)	TNG: The Schizoid Man / ST VI / Voy / Star Trek
Guy Siner	Genesis of the Daleks (Ravon)	Ent: Silent Enemy
David Warner	Dreamland (Lord Azlok)	TNG/ ST V / ST VI

Star Trek Key:

> TOS: *The Original Series*
> TNG: *The Next Generation*
> DS9: *Deep Space Nine*
> Voy: *Voyager*
> Ent: *Enterprise*

In the *Star Trek: The Next Generation* episode *The Neutral Zone*, broadcast in 1988, a computer readout clearly shows the names of William Hartnell, Patrick Troughton, Jon Pertwee, Tom Baker, Peter Davidson (sic) and Colin Baker.

Star Trek: Deep Space Nine cast members Alexander Siddig (Dr Bashir) and Chase Masterson (Leeta) have both recorded *Doctor Who* audio adventures for Big Finish

Productions, as has Benedict Cumberbatch, who plays villain John Harrison in *Star Trek Into Darkness*.

In 2012, the fictional universes of *Doctor Who* and *Star Trek* collided in the IDW comic book series *Assimilation*[2], which saw the Eleventh Doctor, Amy and Rory battle the Cybermen and *Star Trek*'s Borg alongside the *Next Generation* crew. It also transpired that the Fourth Doctor had encountered Captain James T. Kirk in his travels. In *Oxygen*, the Twelfth Doctor gives an opening monologue that begins with the words, 'Space, the final frontier...'

CARRY ON DOCTOR

In 1958, William Hartnell played the title role at the very beginning of another well-loved British institution—the *Carry On* film series. Here is a selection of actors who have appeared in both *Doctor Who* and the *Carry Ons*...

Actor	Doctor Who appearances	Carry On appearances
William Hartnell	Various, 1963–1973 (The Doctor)	*Sergeant*
Bernard Bresslaw	*The Ice Warriors* (Varga)	14, including *Cowboy*, *Up the Jungle*, *Up the Khyber*
Peter Butterworth	*The Time Meddler, The Daleks' Master Plan* (The Meddling Monk)	16, including *Screaming, Camping*
Roy Castle	*Dr. Who and the Daleks* (Ian)	*Up the Khyber*
Kenneth Cope	*Warriors' Gate* (Packard)	*At Your Convenience, Matron*
Bernard Cribbins	*Daleks—Invasion Earth 2150 A.D.* (Tom) / Various, 2007–2010 (Wilfred Mott)	*Spying, Jack, Columbus*
Suzanne Danielle	*Destiny of the Daleks* (Agella)	*Emmanuelle*
Windsor Davies	*The Evil of the Daleks* (Toby)	*Behind, England*
Angela Douglas	*Battlefield* (Doris)	*Cowboy, Screaming, Follow that Camel, Up the Khyber*
Derek Francis	*The Romans* (Nero)	5, including *Doctor, Camping*
Hugh Futcher	*The Sea Devils* (Hickman)	7, including *Spying*
Peter Gilmore	*Frontios* (Brazen)	11, including *Cowboy, Again, Doctor* and *Columbus*

Actor	Doctor Who appearances	Carry On appearances
Julian Holloway	*Survival* (Sergeant Paterson)	7, including *Camping*, *Up the Khyber*
Gertan Klauber	*The Romans* (Galley Master), *The Macra Terror* (Ola)	7, including *Cleo*, *Doctor*, *Henry*
Maureen Lipman	*The Idiot's Lantern* (The Wire)	*Columbus*
Victor Maddern	*Fury from the Deep* (John Robson)	5, including *Constable*, *Regardless*, *Spying*
Norman Mitchell	*The Daleks' Master Plan* (Policeman)	5, including *Spying*, *Cabby*
Jon Pertwee	Various, 1970–1993 (The Doctor)	*Cleo*, *Screaming*, *Cowboy*, *Columbus*
Alexei Sayle	*Revelation of the Daleks* (DJ)	*Columbus*
June Whitfield	*The End of Time, Part One* (Mini Hooper)	*Nurse*, *Abroad*, *Girls*, *Columbus*
Barbara Windsor	*Army of Ghosts* (Peggy Mitchell)	9, including *Doctor*, *Camping*

A GALLIFREY FAR, FAR AWAY

A selection of Rebels, Imperials and Dark Lords of the Sith that have appeared in both *Doctor Who* and the *Star Wars* films.

Actor	Doctor Who appearances	Star Wars appearances
Peter Cushing	*Dr. Who and the Daleks* / *Daleks—Invasion Earth 2150 A.D.* (Dr. Who)	*Star Wars*
Sebastian Armesto	*Bad Wolf* (Broff)	*The Force Awakens*
Graham Ashley	*The Underwater Menace* (Overseer)	*Star Wars*
Ariyon Bakare	*The Woman Who Lived* (Leandro)	*Rogue One*
Brian Blessed	*The Trial of a Time Lord: Mindwarp* (Yrcanos)	*The Phantom Menace*
Jeremy Bulloch	*The Space Museum* (Tor) / *The Time Warrior* (Hal)	*The Empire Strikes Back* / *Return of the Jedi* / *Revenge of the Sith*

Actor	Doctor Who appearances	Star Wars appearances
Silas Carson	*The End of the World* (Voice of Alien) / *The Impossible Planet* / *The Satan Pit* / *The End of Time* (Voice of the Ood)	*The Phantom Menace / Attack of the Clones / Revenge of the Sith*
Aidan Cook	Various monsters 2013–2015	*Rogue One*
Warwick Davies	*Nightmare in Silver* (Porridge)	*Return of the Jedi, The Phantom Menace, Attack of the Clones, Revenge of the Sith, The Force Awakens, Rogue One*
Ayesha Dharker	*Planet of the Ood* (Solana Mercurio)	*Attack of the Clones*
Lindsay Duncan	*The Waters of Mars* (Adelaide Brooke)	*The Phantom Menace*
Sharon Duncan-Brewster	*The Waters of Mars* (Maggie Cain)	*Rogue One*
Richard Franklin	Various stories 1971–1974 (Mike Yates)	*Rogue One*
Martin Gordon	*The Mind of Evil* (Prison Officer)	*Rogue One*
Julian Glover	*The Crusade* (Richard the Lionheart), *City of Death* (Scaroth)	*The Empire Strikes Back*
Garrick Hagon	*The Mutants* (Ky) / *A Town Called Mercy* (Abraham)	*Star Wars*
Don Henderson	*Delta and the Bannermen* (Gavrok)	*Star Wars*
Nick Hobbs	*The Curse of Peladon /The Monster of Peladon* (Aggedor) / *The Ark in Space* (Wirrn Operator)	*Rogue One*
John Hollis	*The Mutants* (Sondergaard)	*The Empire Strikes Back*
Milton Johns	*The Enemy of the World* (Benik) / *The Android Invasion* (Guy Crayford) / *The Invasion of Time* (Kelner)	*The Empire Strikes Back*
Felicity Jones	*The Unicorn and the Wasp* (Robina Redmond)	*Rogue One*
Mark Jones	*The Seeds of Doom* (Keeler)	*The Empire Strikes Back*
Paul Kasey	Various roles 2005–14	*Rogue One*

Actor	Doctor Who appearances	Star Wars appearances
Oliver Maguire	*The Ribos Operation* (**Shrieve**)	*The Empire Strikes Back*
Daniel Mays	*Night Terrors* (**Alex**)	*Rogue One*
Simon Pegg	*The Long Game* (**The Editor**)	*The Force Awakens*
Dave Prowse	*The Time Monster* (**Minotaur**)	*Star Wars / The Empire Strikes Back / Return of the Jedi*
Hugh Quarshie	*Daleks in Manhattan / Evolution of the Daleks* (**Solomon**)	*The Phantom Menace*
Deep Roy	*The Talons of Weng-Chiang* (**Mr Sin**) / *The Trial of a Time Lord: Mindwarp* (**Posicarian delegate**)	*Return of the Jedi*
Alan Ruscoe	*Rose* (**Auton**) / *The End of the World* (**Lute**) / *Aliens of London / World War Three / Boom Town* (**Slitheen**) / *Bad Wolf / The Parting of the Ways* (**Anne Droid, Trine-E**) / *The Waters of Mars* (**Andy Stone**)	*The Phantom Menace / Attack of the Clones*
Leslie Schofield	*The War Games* (**Leroy**) / *The Face of Evil* (**Calib**)	*Star Wars*
Kiran Shah	*Listen* (**Figure**) / *Smile* (**Emojibot**)	*The Force Awakens / Rogue One*
Michael Sheard	*The Ark* (**Rhos**) / *The Mind of Evil* (**Roland Summers**) / *The Pyramids of Mars* (**Laurence Scarman**) / *The Invisible Enemy* (**Lowe**) / *Castrovalva* (**Mergrave**) / *Remembrance of the Daleks* (**Headmaster**)	*The Empire Strikes Back*
Michael Smiley	*Into the Dalek* (**Colonel Morgan Blue**)	*Rogue One*
Steve Spiers	*Aliens of London / World War Three* (**Strickland**)	*The Phantom Menace*
Malcolm Tierney	*Terror of the Vervoids* (**Doland**)	*Star Wars*
Pip Torrens	*Human Nature / The Family of Blood* (**Rocastle**)	*The Force Awakens*
Brian Vernal	*Lucius (Eaters of Light)*	*The Force Awakens*
Spencer Wilding	*The God Complex* (**The Creature**) / *The Doctor, the Widow and the Wardrobe* (**Wooden King**) / *Cold War* (**Skaldak**)	*Rogue One*

HARRY POTTER AND
THE BIGGER ON THE INSIDE

Many *Doctor Who* actors have also appeared in the spell-binding Harry Potter film series.

Actor	Doctor Who appearances	Harry Potter appearances
Tim Bentinck	*Extremis, The Pyramid at the End of the World / Lie of the Land* (**Monk Voice**)	*Fantastic Beasts*
David Tennant	Various, 2005–2010 (**The Doctor**)	*Goblet of Fire*
Timothy Bateson	*The Ribos Operation* (**Binro**)	*Order of the Phoenix*
Terence Bayler	*The Ark* (**Yendom**) / *The War Games* (**Barrington**)	*Philosopher's Stone*
David Bradley	*Dinosaurs on a Spaceship* (**Solomon**)	HP 1–6, 8
Jim Broadbent	*The Curse of Fatal Death* (**The Doctor**)	*Half-Blood Prince*
Gemma Chan	*The Waters of Mars* (**Mia Bennett**)	*Fantastic Beasts*
John Cleese	*City of Death* (**Art Gallery Visitor**)	*Philospher's Stone / Chamber of Secrets*
Warwick Davies	*Nightmare in Silver* (**Porridge**)	*HP 1-8*
Paul Marc Davis	*Utopia* (**Futurekind Chieftain**)	*Philosopher's Stone*
Derek Deadman	*The Invasion of Time* (**Stor**)	*Philosopher's Stone*
Simon Fisher-Becker	*The Pandorica Opens / A Good Man Goes to War / The Wedding of River Song* (**Dorium**)	*Philosopher's Stone*
Michael Gambon	*A Christmas Carol* (**Kazran Sardick / Elliot Sardick**)	HP 3–8
Jimmy Gardner	*Marco Polo* (**Chenchu**) / *Underworld* (**Idmon**)	*Prisoner of Azkaban*
Akin Gazi	*The Doctor's Daughter* (**Carter**)	*Fantastic Beasts*
Julian Glover	*The Crusade* (**Richard the Lionheart**) / *City of Death* (**Scaroth**)	*Chamber of Secrets*
Ellie Haddington	*Last of the Time Lords* (**Professor Docherty**)	*Fantastic Beasts*

Actor	Doctor Who appearances	Harry Potter appearances
Daisy Haggard	*The Lodger / Closing Time* (Sophie)	*Order of the Phoenix / Deathly Hallows Pt I*
Shirley Henderson	*Love & Monsters* (Ursula Blake)	*Chamber of Secrets / Goblet of Fire*
Jessica Hynes	*Human Nature / The Family of Blood* (Joan Redfern) / *The End of Time* (Verity Newman)	*Order of the Phoenix*
Toby Jones	*Amy's Choice* (Dream Lord)	*Chamber of Secrets / Deathly Hallows Pt I*
Roger Lloyd-Pack	*Rise of the Cybermen / The Age of Steel* (John Lumic)	*Goblet of Fire*
Helen McCrory	*The Vampires of Venice* (Rosanna Calvierri)	*Half-Blood Prince / Deathly Hallows 1 & 2*
Jim McManus	*The Invisible Enemy* (Opthalmologist)	*Order of the Phoenix*
Bill Nighy	*Vincent and the Doctor* (Dr Black)	*Deathly Hallows Pt I*
Jeff Rawle	*Frontios* (Plantagenet)	*Goblet of Fire*
Adrian Rawlins	*Planet of the Ood* (Ryder)	*HP 1–5, 7–8*
Philip Rham	*Let's Kill Hitler* (Erich Zimmerman)	*Goblet of Fire*
Elizabeth Spriggs	*Paradise Towers* (Tabby)	*Philosopher's Stone / Chamber of Secrets*
Imelda Staunton	*The Girl Who Waited* (Interface)	*Order of the Phoenix / Deathly Hallows Pt I*
Richard Trinder	*A Good Man Goes to War* (Harcourt)	*Order of the Phoenix*
Arnold Underwood	*The Power of Three* (Patient)	*Order of the Phoenix*
Zoe Wanamaker	*The End of the World / New Earth* (Cassandra)	*Philosopher's Stone*
Mark Williams	*Dinosaurs on a Spaceship / The Power of Three* (Brian Williams)	All *except The Philosopher's Stone*

POTTER PICKS

- Actor Harry Melling (Dudley Dursley) is a grandson of Patrick Troughton.
- Actor Alfie Enoch (Dean Andrews) is a son of William Russell.

TARDIS LIBRARY

Fictional books in the *Doctor Who* universe

- *101 Places to See*
 A book given to the nine-year old Clara Oswald by her mother (*The Rings of Akhaten*)
- *Advanced Quantum Mechanics*
 Read by the Eleventh Doctor at the beginning of *The Day of the Doctor*
- *Bartholomew's Planetary Gazetteer*
 Read by Romana on Gallifrey (*The Ribos Operation*)
- *The Black Orchid* by George Cranleigh
 Published in 1925, an account of Cranleigh's travels. The Doctor thought it was fascinating (*Black Orchid*, *Earthshock*)
- *The Book of the Old Time*
 The official history of the early Time Lords (*The Deadly Assassin*)
- The definitive work on the Weeping Angels (actual title unknown)
 The only book ever written about the Angels. Written by a madman, barely readable, bit boring in the middle, no pictures (*The Time of Angels*)
- *Encyclopedia Gallifrey*
 A collection of bottles found in the TARDIS library (*Journey to the Centre of the TARDIS*)
- *The Encyclopedia of World Facts*
 To be found in Clara Oswald's collection. (*Dark Water*)
- *Everest in Easy Stages*
 Tibetan text read by the Fourth Doctor in the hope of discovering tips on how to climb out of the Chloris Pit (*The Creature from the Pit*)

- *Fighting the Future* by Joshua Naismith
 Donna Noble's 2009 Christmas present for Wilf (*The End of Time*)
- *Flora and Fauna of the Universe* by Professor Thripsted
 According to the Fourth Doctor, it listed Usurians as poisonous fungi (*The Sun Makers*)
- *The French Revolution*, author unknown
 Barbara Wright lent this history book to Susan Foreman who immediately noticed inaccuracies. Not long after, Ace picked up a similarly titled tome in the very same school (*An Unearthly Child*, *Remembrance of the Daleks*)
- *A History of the Time War*
 Found (and read) by Clara in the TARDIS library (*Journey to the Centre of the TARDIS*)
- *History's Finest Exploding Restaurants.*
 Tells you how to eat for free, if you're willing to skip the coffee. (*The Husbands of River Song*)
- 'An illustrated guide to the Swampie tribe'
 How the Doctor described a heavy, bound book he found on the third moon of Delta Magna, 'A sort of Bayeux tapestry with footnotes.' Atrociously written but good pictures (*The Power of Kroll*)
- *A Journal of Impossible Things* by Verity Newman
 The story of a woman who fell in love with a man from the stars, based on the diaries of Joan Redfern (*The End of Time*)
- *The Last Chance for Man* by Charles Grover
 Environmental treatise by the politician and secret leader of Operation Golden Age (*Invasion of the Dinosaurs*)
- *The Legend of Pandora's Box*
 Amy Pond's favourite book as a child, and the basis of the Pandorica myth (*The Pandorica Opens*)
- *Melody Malone*
 A pulp detective novel from the 1930s which was in fact a message to the Doctor from his wife, River Song (*The Angels Take Manhattan*)
- *Monsters from Outer Space*
 Read by Ian while the Doctor fiddled with the Time Space Visualiser. Ian described it as good, but a bit far-fetched (*The Chase*)
- *The Origins of the Universe* by Oolon Coluphid
 The author got it wrong in the first line according to the Doctor, who wondered why he hadn't asked someone who saw it happen (*Destiny of the Daleks*)
- *Polar Base Manual*
 Instruction manual for the Polar Base inside the dreamscape created by the Kantrofarri (*Last Christmas*)

- *The Secret Books of Saxon*
 Containing instructions for how to achieve the Master's resurrection. Never published (*The End of Time*)
- *The Sibylline Oracles*
 A series of texts compiling the prophesies of the Sibyl, founder of the Sibylline Sisterhood of Pompeii. The thirteenth book foretold the Doctor's arrival (*The Fires of Pompeii*)
- *Teach Yourself Tibetan*, author unknown
 A book read by the Fourth Doctor on Chloris so that he could translate *Everest in Easy Stages* (*The Creature from the Pit*)
- *The Worshipful and Ancient Law of Gallifrey*
 Dating back to the days of Rassilon and originally kept safe in the Panopticon Archives, this dangerous tome was stolen by Chronotis and brought to 20th-century Earth (*Shada*)

Real books in the *Doctor Who* universe:
- *A Christmas Carol* by Charles Dickens
 During an 1869 reading of his ghostly little book in Cardiff, Charles Dickens was interrupted by a Gelth-possessed corpse (*The Unquiet Dead*)
- *Death in the Clouds* by Agatha Christie
 The Doctor owned an edition published in the year five billion (*The Unicorn and the Wasp*)
- *Doctor in the House* by Richard Gordon
 In Mrs Smith's boarding house, the Doctor picked up a discarded copy of the novel that spawned the film, radio and TV series (*Remembrance of the Daleks*)
- *The Doctor's Dilemma* by George Bernard Shaw
 The Doctor read Shaw's play, first staged in 1906, as he and Mel waited to be served in the milk bar that Ace was working in (*Dragonfire*)
- Gutenberg Bible
 The first major book produced from movable type on a printing press. Several of the 180 original copies were sold by Count Scarlioni to fund his time-travel experiments (*City of Death*)
- *The Lovely Bones* by Alice Sebold
 The Doctor speed-read a copy in Rose's flat, commenting on its sad ending (*Rose*)
- *Moby-Dick* by Herman Melville
 Not one of the Doctor's favourites—just shut up and get to the whale! One of the three Books of Knowledge of Ravolox (*The Trial of a Time Lord: The Mysterious Planet*)
- *Monty Python's Big Red Book*
 Just one of the books found in the planet-sized Library along with 'whole continents' of Jeffrey Archer and Bridget Jones (*Silence in the Library*)

- *The Murder of Roger Ackroyd* by Agatha Christie
 Lady Clemency Eddison's favourite Agatha Christie thriller (*The Unicorn and the Wasp*)
- *The Mystery of Edwin Drood* by Charles Dickens
 The last, and incomplete, work of Charles Dickens. After helping defeat the Gelth, Dickens planned to work aliens into the novel. (*The Unquiet Dead*)
- *Pride and Prejudice* by Jane Austen
 The Doctor read the bio at the back. No Boggons were involved. (*The Caretaker*)
- *Robinson Crusoe* by Daniel Defoe
 Inspiration for Friday the Ice Warrior's name. (*Empress of Mars*)
- *Struwwelpeter* by Heinrich Hoffmann
 A favourite of street urchins in 1814, especially *The Story of Little Suck-a-Thumb*. (*Thin Ice*)
- *A Textbook of Botany for Students* by Amy F.M. Johnson BSc
 Stumbled upon by the Fifth Doctor while in Cranleigh Hall (*Black Orchid*)
- *The Time Machine* by H.G. Wells
 The Seventh Doctor's reading matter while returning the Master's remains to Gallifrey. The Eighth Doctor unsuccessfully tried to pick up where he left off after leaving San Francisco in the year 2000. (*Doctor Who*) Professor Chronotis also relaxed with a paperback edition in *Shada*.
- *The Time Traveller's Wife* by Audrey Niffenegger
 One of the Doctor's seven hiding places for the spare TARDIS keys. (*Dark Water*)
 In Niffennegger's 2009 novel *Her Fearful Symmetry*, characters in the book watch *The Girl in the Fireplace*. (*Dark Water*)
- *Through the Looking Glass and what Alice Found There* by Lewis Carroll
 The Doctor references Carroll's poem *The Walrus and the Carpenter* from his 1871 book. (*The Rings of Akhaten*)
- *UK Habitats of the Canadian Goose* by H.M. Stationery Office
 One of the three Books of Knowledge of Ravolox (*The Trial of a Time Lord: The Mysterious Planet*)
- *The War of the Worlds* by H.G. Wells
 The Master's reading matter of choice after imprisoning the Third Doctor and Jo Grant. (*Frontier in Space*) Possibly inspired by Herbert's encounter with the Sixth Doctor (*Timelash*)
- *The Water-Babies* by Charles Kingsley
 One of the three Books of Knowledge of Ravolox (*The Trial of a Time Lord: The Mysterious Planet*)
- *Where's Wally?* By Martin Handford
 The Doctor has a habit of looking for Wally in *every* book. (*Listen*)

REAL COMICS IN THE DOCTOR WHO UNIVERSE

- *The Beano 1981 Summer Special (The Rings of Akhaten)*
- *Superman #7 (The Return of Doctor Mysterio)*
- *Superman #19 (The Return of Doctor Mysterio)*

LINKS BETWEEN DOCTOR WHO AND *A CHRISTMAS CAROL*

- Charles Dickens gave a reading from *A Christmas Carol* in *The Unquiet Dead*.
- The Eleventh Doctor riffed on Dickens's plot in *A Christmas Carol*.
- In the world created when River Song refused to kill the Doctor, Charles Dickens was interviewed about his new Christmas special on *BBC Breakfast*. All he would say was that it involved ghosts and the past, present and future all at the same time.
- The first draft of the *Doctor Who* format guide suggested that a Christmas episode could be made in which Jacob Marley was in fact a 'slightly tipsy' Doctor!
- Simon Callow, who played Charles Dickens in *The Unquiet Dead* and *The Wedding of River Song*, also played the novelist in the 2001 animated film *Christmas Carol: The Movie*. The same film also featured Michael Gambon (Kazran Sardick in the 2010 Christmas special) as the voice of the Ghost of Christmas Present.
- David Collings—who appeared in *Doctor Who* three times, as Vorus in *Revenge of the Cyberman*, Poul in *The Robots of Death* and Mawdryn in *Mawdryn Undead*—played Bob Cratchit in the 1970 musical *Scrooge*.
- Jon Pertwee played Jacob Marley in the 1992 stage revival of *Scrooge*. The cast also included Stratford Johns (*Four to Doomsday*) as the Ghost of Christmas Present.
- Richard E. Grant, who played Dr Simeon in *The Snowmen* and the Doctor in *The Curse of Fatal Death* and *Scream of the Shalka*, played Bob Cratchit in the 1999 TV movie *A Christmas Carol*. Ian McNeice (*Victory of the Daleks*) also appeared in the cast as Mr Fezziwig.
- Mark Strickson played young Ebenezer in the 1984 TV movie *A Christmas Carol*. The film also featured David Warner, the voice of Lord Azlok in *Dreamland* and Professor Grisenko in *Cold War,* as Bob Cratchit.
- Nicola Bryant played Ebenezer Blackadder's niece in 1988's *Blackadder's Christmas Carol*. The comedy special starred Rowan Atkinson and Jim Broadbent, and both later appeared in the 1999 Comic Relief *Doctor Who* spoof, *The Curse of Fatal Death*.
- A number of *Doctor Who* alumni have recorded audiobooks of *A Christmas Carol*, including Martin Jarvis, Geoffrey Palmer, Richard Wilson and Tom Baker.

SONGS FOR TWELVE

'I can take you to the Battle of Trafalgar, the first anti-gravity Olympics, Caesar crossing the Rubicon, or Ian Dury at the Top Rank, Sheffield, England, Earth, 21 November 1979.'

The Doctor, *Tooth and Claw*

Music—from pop to classical—has always played an important part in *Doctor Who*. One of the earliest scenes in the series is a discussion of the merits of popular beat combo, John Smith and the Common Men (the fictional band had gone from 19 to 2 in the hit parade), and neatly provides the first mention of 'John Smith'. Here's a list of some of the songs featured in the series.

Song / music	Artist / group	Story featured
Ticket To Ride	The Beatles	*The Chase*
Nobody Knows The Trouble I've Seen	The Seekers	*The Evil of the Daleks*
Paperback Writer	The Beatles	*The Evil of the Daleks*
Teddy Bears' Picnic	Henry Hall	*The Invasion*
Oh Well (Part One)	Fleetwood Mac	*Spearhead from Space*

Song / music	Artist / group	Story featured
It'll Never Be Me	Electric Banana	*The Green Death*
The Girl With The Flaxen Hair	Claude Debussy	*The Robots of Death*
None But The Weary Heart	Tchaikovsky	*The Robots of Death*
Home In Pasadena	The Savoy Orpheans	*Black Orchid*
The Charleston	The Savoy Orpheans	*Black Orchid*
Gentlemen Prefer Blondes	Irving Berlin	*Black Orchid*
Lazy	Irving Berlin	*Black Orchid*
Show Me The Way To Go Home	The Savoy Orpheans	*Black Orchid*
Dinah	The Savoy Orpheans	*Black Orchid*
When Erastus Plays His Old Kazoo	The Savoy Orpheans	*Black Orchid*
Blue Suede Shoes	Unknown cover version of the Elvis Presley original featured on *Smash Hits Presley Style*	*Revelation of the Daleks*
Fire	Unknown cover version of the Jimi Hendrix Experience original	*Revelation of the Daleks*
Good Vibrations	The Surfers—cover version from *Sounds Like The Beach Boys*	*Revelation of the Daleks*
Hound Dog	Unknown cover version of the Elvis Presley original featured on *Smash Hits Presley Style*	*Revelation of the Daleks*
In The Mood	The Ted Heath Orchestra—originally by Glenn Miller Orchestra	*Revelation of the Daleks*
Moonlight Serenade	The Ted Heath Orchestra—originally by Glenn Miller Orchestra	*Revelation of the Daleks*
A Whiter Shade Of Pale	Procul Harum	*Revelation of the Daleks*
Rock Around The Clock	The Lorells (cover version of the Sonny Dae and his Knights original)	*Delta and the Bannermen*
Singing The Blues	The Lorells (cover version of the Guy Mitchell original)	*Delta and the Bannermen*

Song / music	Artist / group	Story featured
Why Do Fools Fall In Love	The Lorells (cover version of the Frankie Lyman and the Teenagers original)	*Delta and the Bannermen*
Mr Sandman	The Lorells (cover version of The Chordettes original)	*Delta and the Bannermen, Sleep No More*
That'll Be The Day	The Lorells (cover version of the Buddy Holly / The Crickets original)	*Delta and the Bannermen*
Only You	The Lorells (cover version of The Platters original)	*Delta and the Bannermen*
Lollipop	The Lorells (cover version of the Ronald & Ruby original)	*Delta and the Bannermen*
Do You Want To Know A Secret	The Beatles	*Remembrance of the Daleks*
A Taste Of Honey	The Beatles	*Remembrance of the Daleks*
Lollipop	The Mudlarks (cover version of the Ronald & Ruby original)	*Remembrance of the Daleks*
Return To Sender	Keff McCulloch and Keith Murrell (cover version)	*Remembrance of the Daleks*
Apache	Keff McCulloch (cover version of The Shadows original)	*Remembrance of the Daleks*
That's The Way To The Zoo	J. F. Mitchell (Composer) Sung by Katherine Schlesinger	*Ghost Light*
In A Dream	Pat Hodge	*Doctor Who*
Sushu Tonight	Carol Ann Wood	*Doctor Who*
All Dressed Up	Jim Lathen	*Doctor Who*
Ride Into The Midnight	Chuck Duran and Jess Harnell	*Doctor Who*
Tainted Love	Soft Cell	*The End of the World*
Toxic	Britney Spears	*The End of the World*
Starman	David Bowie	*Aliens of London*
Never Can Say Goodbye	The Communards (cover version of The Jackson 5 original)	*Father's Day*
Never Gonna Give You Up	Rick Astley	*Father's Day*
Don't Mug Yourself	The Streets	*Father's Day*

Song / music	Artist / group	Story featured
It Had To Be You	Cover version of the Sam Lanin and his Orchestra original	*The Empty Child*
Moonlight Serenade	Glenn Miller	*The Empty Child / The Doctor Dances*
In The Mood	Glenn Miller	*The Doctor Dances*
Merry Xmas Everybody!	Slade	*The Christmas Invasion / The Runaway Bride / Last Christmas*
Hit Me With Your Rhythm Stick	Ian Dury and the Blockheads	*Tooth and Claw*
Love Will Tear Us Apart	Joy Division	*School Reunion*
The Lion Sleeps Tonight	Tight Fit	*Rise of the Cybermen*
Bolero	Maurice Ravel	*The Impossible Planet*
Daniel	Elton John	*Love & Monsters*
Don't Bring Me Down	Electric Light Orchestra	*Love & Monsters*
Mr Blue Sky	Electric Light Orchestra	*Love & Monsters*
Turn To Stone	Electric Light Orchestra	*Love & Monsters*
Regresa A Mi	Il Divo	*Love & Monsters*
Happy Days Are Here Again	Milton Ager and Jack Yellen	*Evolution of the Daleks*
Voodoo Child	Rogue Traders	*The Sound of Drums*
I Can't Decide	Scissor Sisters	*Last of the Time Lords*
Cryin' All Day	The Frank Ricotti All Stars	*The Unicorn and the Wasp*
Do It Do It Again	Rafaella Carra	*Midnight*
Chances	Athlete	*Vincent and the Doctor*
Crazy Little Thing Called Love	Queen	*The Big Bang*
You Give Me Something	James Morrison	*The Big Bang*
Rolling In The Deep	Adele	*The Impossible Astronaut*
Supermassive Black Hole	Muse	*The Rebel Flesh*
You Don't Have To Say You Love Me	Dusty Springfield	*The Rebel Flesh*
Feel The Love	Rudimental featuring John Newman	*Asylum of the Daleks*

Song / music	Artist / group	Story featured
Titanium	David Guetta featuring Sia	*The Power of Three*
Englishman In New York	Sting	*The Angels Take Manhattan*
As Time Goes By	Dooley Wilson (performed by Sylvester McCoy)	*The Happiness Patrol*
Ghost Town	The Specials	*The Rings of Akhaten*
Vienna	Ultravox (performed by David Warner)	*Cold War*
Hungry Like the Wolf	Duran Duran (performed by Jenna Coleman and David Warner)	*Cold War*
Another Brick in the Wall (Part 2)	Pink Floyd (performed by Peter Capaldi)	*The Caretaker*
Don't Stop Me Now	Queen (cover version by Foxes)	*Mummy on the Orient Express, Hell Bent*
Pretty Woman	Roy Orbison (performed by Peter Capaldi)	*The Magician's Apprentice*
Mickey	Toni Basil (performed by Peter Capaldi)	*The Magician's Apprentice*
Beethoven's 5th	(performed by Peter Capaldi)	*Before the Flood*
Wish You Were Here	Pink Floyd (performed by Peter Capaldi)	*The Woman Who Lived*
Amazing Grace	John Newton (performed by Peter Capaldi)	*The Zygon Invasion*
Consider Yourself	Lionel Bart (performed by Peter Capaldi)	*Sleep No More*
Black Magic	Little Mix	*Knock Knock*
Sonata #1	Bach (performed by Itzhak Perlman in G Minor for Solo Violin)	*Knock Knock*
Für Elise	Beethoven (Performed by unknown)	*Knock Knock*
Pop! Goes the Weasel	Unknown (performed by unknown)	*Knock Knock*
The Midnight, the Stars and You	Al Bowlly	*The Doctor Falls*

ORIGINAL SONGS

Songs written and composed especially for *Doctor Who*.

Title	Composer / artiste	Story
The Ballad of the Last Chance Saloon	Tristam Cary / Lynda Baron	*The Gunfighters*
Here's To The Future	Keff McCulloch	*Delta and the Bannermen*
Song For Ten	Murray Gold / Tim Phillips (extended version sung by Neil Hannon on soundtrack album)	*The Christmas Invasion*
Love Don't Roam	Murray Gold / Neil Hannon	*The Runaway Bride*
My Angel Put The Devil In Me	Murray Gold / Miranda Raison (Yamit Mamo sang a version for the soundtrack album)	*Daleks in Manhattan / The End of Time, Part Two*
The Stowaway	Murray Gold / Yamit Mamo	*Voyage of the Damned*
Abigail's Song	Murray Gold / Katherine Jenkins	*A Christmas Carol*
The Long Song	Murray Gold / Chris Anderson and Emilia Jones	*The Rings of Akhaten*

DOC OF THE POPS

'It's John Smith and the Common Men. They've gone from 19 to 2.'

Susan, *An Unearthly Child*

Pop singles released by Doctors and companions.

Actor	Title	Year
Bernard Cribbins	Folksong	1961
	Hole in the Ground	1962
	Right Said Fred	1962
	Gossip Calypso	1962
Frazer Hines	Who's Dr Who? / Punch and Judy Man	1968
Jon Pertwee	Who is the Doctor / Pure Mystery	1972
	Worzel's Song*	1982
Paul McGann (with The McGanns)	Shame About The Boy	1983
Colin Baker / Nicola Bryant / Nicholas Courtney (with Who Dares)**	Doctor In Distress	1985
Kylie Minogue	51 singles including:	
	Locomotion***	1987
	On A Night Like This	2012
Billie Piper****	Because We Want To	1998
	Girlfriend	1998
	She Wants You	1998
	Honey To The B	1999
	Day And Night	2000
	Something Deep Inside	2000
	Walk Of Life	2000
John Barrowman	What About Us	2010
	I Made It Through The Rain*****	2010

* Charted at number 33

** The group Who Dares featured Colin Baker, Nicola Bryant, Nicholas Courtney and Anthony Ainley, along with other celebrities, recording a charity single.

*** Charted at number 2

**** Billie's singles charted between number 1 and number 25

***** Charted at number 14

VARIATIONS ON A THEME

Pop singles with a *Doctor Who* theme—sometimes literally...

Name	Title	Year
The Go Gos	I'm Gonna Spend My Christmas With A Dalek	1964
Roberta Tovey	Who's Who	1965
Mankind	Dr Who*	1978
The Time Lords	Doctorin' the Tardis**	1988

* Charted at number 25

** Charted at number 1

POP PICKS

In addition to their chart single success, *Doctor Who* co-stars Billie Piper and John Barrowman have several albums on their discographies. Billie released *Honey To The B* in 1998, followed up with *Walk Of Life* in 2000. *The Best of Billie* was released in August 2005, shortly after *Doctor Who*'s return to television.

Tying into his career in stage musicals, John Barrowman released the albums *Songs From Grease* (1994), *Aspects Of Lloyd Webber* (1997), *Reflections From Broadway* (2003) and *Swing Cole Porter* (2004). Since his debut as Captain Jack Harkness in 2005, John has released a further four albums—*Another Side* (2007), *Music Music Music* (2008), *John Barrowman* (2010) and *You Raise Me Up* (2014), plus a best-of album, *Tonight's The Night* in 2011.

And not to be outdone, even a Doctor put his name to an album. Who could possibly forget 1962's *Jon Pertwee Sings Songs For Vulgar Boatmen*? No, we're not making that up.

The B-side to the Human League's 1981 single 'Boys and Girls' was titled 'Tom Baker,' in tribute to the actor's time on *Doctor Who*. The cover featured an image of Tom, with the vinyl inscribed: 'Thanks Tom'.

Hans Zimmer, famous for composing blockbuster film scores including *Pirates of the Caribbean*, *Sherlock Holmes* and *The Dark Knight*, played keyboards on the 1985 charity single 'Doctor In Distress'.

English electronic dance duo Orbital included a version of the *Doctor Who* theme on their album *Altogether* (2001), entitled 'Doctor?' They regularly perform the track live. Matt Smith joined them on stage at the Glastonbury festival in 2010.

Kylie Minogue (Astrid Peth in *Voyage of the Damned*) has released 11 albums since 1988, and 51 singles, seven of which have charted at number one. Her stage shows have featured *Doctor Who* elements, including a section titled 'Silvanemesis' in her 2002 *Fever* tour.

In 1998, at the age of 15, Billie Piper became one of the youngest artistes ever to have a debut number one single in the UK when Because We Want To went straight to the top of the charts.

Doctor Who incidental music composer Keff McCulloch was one of the minds behind novelty record 'The Birdie Song', released by The Tweets in 1981.

DESERT ISLAND DISCS

Three Doctors have so far appeared on BBC Radio 4's long-running programme. Here are their choices:

WILLIAM HARTNELL
Broadcast 23 August 1965
Interviewed by Roy Plomley
1. Paul Robeson—'Trees'
2. Alexander Borodin—'Polovtsian Dances' (from *Prince Igor*)
3. Ludwig van Beethoven—Violin Sonata No. 9 in A major, Op. 47 'Kreutzer'
4. Peggy Cochrane and Jack Payne and his Orchestra—*El Alamein Concerto*
5. Louis Armstrong—'Lawd, You Made The Night Too Long'
6. Sergey Vasilievich Rachmaninov—Piano Concerto No. 2 in C Minor
7. Flanagan and Allen—'Underneath The Arches'
8. Charlie Chaplin—'The Spring Song' from *A King in New York*
• Record: 'The Spring Song' by Charlie Chaplin
• Book: *English Social History* by G.M. Trevelyan
• Luxury Item: Cigarettes

⬛ JON PERTWEE

Broadcast 12 October 1964

Interviewed by Roy Plomley

1. Ray Charles—'Georgia On My Mind'
2. Wolfgang Amadeus Mozart—'Venite Inginocchiatevi' from *The Marriage of Figaro*
3. Choir of the Russian Church of the Metropolitan of Paris—'Multos Annos' (Russian Orthodox Liturgy)
4. Lonnie Donegan—'Love Is Strange'
5. Rafael Romero and Montoya Jarrito—'Cuatro Saetas'
6. John Lee Hooker—'Dimples'
7. Wolfgang Amadeus Mozart—'Der Hölle Rache' from *The Magic Flute*
8. Miriam Makeba—'Suliram' (Indonesian Lullaby)
- Record: 'Georgia On My Mind' by Ray Charles
- Book: *The Culture of the Abdomen: A Cure of Obesity and Constipation* by F.A. Hornibrook
- Luxury Item: Guitar

⬛ DAVID TENNANT

Broadcast 27 December 2009

Interviewed by Kirsty Young

1. The Proclaimers—'Over And Done With'
2. Elvis Costello—'Oliver's Army'
3. The Housemartins—'Me And The Farmer'
4. Deacon Blue—'Dignity'
5. Eddie Izzard—'The Starship Enterprise'
6. Kaiser Chiefs—'Ruby'
7. Tim Minchin—'White Wine In The Sun'
8. Billy Bragg—'Greetings To The New Brunette'
- Record: 'White Wine In The Sun' by Tim Minchin
- Book: *A La Recherche Du Temps Perdu* by Marcel Proust
- Luxury item: A solar-powered DVD player loaded with all seven seasons of *The West Wing*.

DOCTOR WHO, THIS IS YOUR LIFE

This Is Your Life ran on British television from 1955 to 2003, hosted by Eamonn Andrews and, later, Michael Aspel, surprising celebrities and public figures with the famous red book in hand. Over the years, three Doctors were the unsuspecting subjects…

JON PERTWEE
Broadcast 14 April 1971
On 3 March 1971, the TARDIS was erected in a BBC car park, supposedly to allow Jon Pertwee and Katy Manning to reshoot location scenes for *Colony in Space*. Jon was more than a little surprised when Eamonn Andrews (a close friend of Katy Manning's parents) arrived in an IMC buggy and presented him with the famous red book.

PETER DAVISON
Broadcast 25 March 1982
18 March 1982 saw Peter Davison in full costume on London's Trafalgar Square. He was under the impression he was to record publicity material for overseas sales of *Doctor Who*—until Eamonn Andrews emerged from the TARDIS to declare 'Peter Davison, this is your life.'

TOM BAKER
Broadcast 18 March 2000
While promoting his book *The Boy Who Kicked Pigs* at a shop in Kingston upon Thames, Tom Baker was confronted by his past when a Dalek arrived at the signing. He was even more taken aback when Michael Aspel appeared behind him with the famous book in hand.

BIG SCREEN / SMALL SCREEN

'Sorry, that's *The Lion King*.'

The Doctor, *The Christmas Invasion*

A selection of the films and television programmes referenced or seen in *Doctor Who*.

FILMS

Title	Episodes
Star Wars	*Survival / Meanwhile in the TARDIS*
Frankenstein	*Doctor Who*
Barbarella	*The Unquiet Dead*
The Lion King	*The Christmas Invasion*
The Muppet Movie	*Tooth and Claw*
Ghostbusters	*Army of Ghosts / Hide*
Back to the Future	*The Shakespeare Code*
Mary Poppins	*A Christmas Carol*
The Flying Deuces	*The Impossible Astronaut*
Pinocchio	*Cold War*
The Addams Family	*Flatline*
Alien	*Last Christmas*
The Thing From Another World	*Last Christmas*
Miracle on 34th Street	*Last Christmas*
The Terminator	*Empress of Mars*
The Thing	*Empress of Mars*
Frozen	*Empress of Mars*

● TV SHOWS

Title	Episodes
Batman	Inferno / The Talons of Weng-Chiang
The Clangers	The Sea Devils
BBC News	Rose / Aliens of London / World War Three / The Christmas Invasion / Fear Her / Army of Ghosts / Doomsday / Smith and Jones / The Lazarus Experiment / The Sound of Drums / Voyage of the Damned / The Sontaran Stratagem / The Poison Sky / Turn Left / The Stolen Earth / Journey's End
Blue Peter	Aliens of London
Star Trek	The Empty Child / The Doctor Dances / Closing Time / Extremis
Big Brother	Bad Wolf
Call My Bluff	Bad Wolf
Countdown	Bad Wolf
Ground Force	Bad Wolf
Stars in Their Eyes	Bad Wolf
The Weakest Link	Bad Wolf
What Not to Wear	Bad Wolf
Wipeout	Bad Wolf
EastEnders	Army of Ghosts
Teletubbies	The Sound of Drums
The Paul O'Grady Show	The Stolen Earth
BBC Breakfast	The Wedding of River Song
The Apprentice	The Power of Three
The Benny Hill Show	The Girl Who Died
Thunderbirds	Death in Heaven
Captain Scarlet	Death in Heaven
Game of Thrones	Last Christmas

HITCHHIKER'S GUIDE
TO THE WHONIVERSE

Some connections between *Doctor Who* and *The Hitchhiker's Guide to the Galaxy*, written by *Doctor Who* writer and script editor Douglas Adams.

- The Doctor owns a copy of *The Origins of the Universe* by Oolon Coluphid. (*Destiny of the Daleks*) In *Hitchhiker's*, Colluphid (with two 'l's) is the celebrated writer of a trilogy of philosophical blockbusters.
- The Doctor asks, 'Who was it said Earthmen never invite their ancestors round for dinner?' (*Ghost Light*) It was Douglas Adams in *The Hitchhikers Guide to the Galaxy*.
- The Doctor claims to have met *The Hitchhiker's Guide to the Galaxy*'s dressing gown-wearing hero Arthur Dent, commenting, 'Now, there was a nice man.' (*The Christmas Invasion*)
- Six weeks before his on-screen debut as the Doctor in *Logopolis* Part Four, Peter Davison had a bovine-themed cameo appearance under heavy make-up as the Dish of the Day in the fifth episode of the *Hitchhiker's* TV series.
- An early script proposal from Douglas Adams to the *Doctor Who* production office was 'The Krikkitmen', in which the Doctor and Sarah take on androids from the planet Krikkit. The script was never taken forward, although Adams would use elements from the story in the Key to Time season, and adapt the plot for the third *Hitchhiker's* book, *Life, the Universe and Everything*. *Doctor Who and the Krikkitmen* was novelised in 2018 by James Goss.
- Never one to waste a plot, Adams refurbished story elements from the *Doctor Who* stories *City of Death* and the unfinished *Shada* for his novel *Dirk Gently's Holistic Detective Agency*. Both *Shada* and *Dirk Gently* feature Professor Chronotis.

THE OTHER DOCTORS

As early as December 1963, other TV programmes were spoofing *Doctor Who*, a sure sign of its popularity. Over the years, a wide variety of actors have donned scarves and hats in the name of comedy *Who*.

Actor	Programme	Year
Clive Dunn	*It's a Square World*	1963
Don Maclean	*Crackerjack*	1974
Tony Hughes	*Mathshow (Dr Where)*	1975
Emu & Rod Hull	*Emu's Broadcasting Company*	1977
Fred Harris	*End of Part One*	1979
Ronnie Barker	*The Two Ronnies*	1983
Ian Krankie	*The Krankies' Electronic Komic*	1986
Lenny Henry	*The Lenny Henry Television Show*	1986
George Layton	*French & Saunders*	1987 (unbroadcast)
Jim Broadbent	*Victoria Wood As Seen on TV*	1987

Actor	Programme	Year
Rowan Atkinson Richard E. Grant Jim Broadbent Hugh Grant Joanna Lumley	*The Curse of Fatal Death*	1999
Mark Gatiss	*Doctor Who Night*	1999
Jon Culshaw Mark Perry Kevin Connelly Phil Cornwell	*Dead Ringers*	2000–2017

- Daleks featured in the infamous 'Pakistani Dalek' sketch from Spike Milligan's *Q* series in 1975. Dr Emu and Rod Hull battled the strangely familiar Deadly Dustbins in 1977's *Emu's Broadcasting Company*, and the Daleks themselves also appeared in a sketch featured on a BBC2 *Red Dwarf* night, discussing the merits or otherwise of the popular sitcom.

- In the 1984 Channel 4 sitcom *Chelmsford 123*, the TARDIS materialises in the background of a scene. Seen only in silhouette, the Fourth Doctor is clearly unimpressed with ancient Britain and immediately dematerialises.

- The Fourth Doctor has made three cameo appearances in *The Simpsons*.

- In *A Quack in the Quarks*, an episode of 1990s animated series *Tiny Toon Adventures* featuring characters from the 'Looney Tunes' cartoons, the TARDIS can clearly be seen in a space station loading bay. The 1960s movie Daleks also made an appearance in the cinematic *Looney Tunes Back in Action* in 2003, while familiar-looking 'British Robots' caused trouble in Gotham in *The Lego Batman Movie* in 2017 (with voices by Nicholas Briggs).

- As well as *The Web of Caves* spoof sketch in which Mark Gatiss plays the Doctor, 1999's *Doctor Who Night* featured two further sketches. *The Pitch of Fear* saw Gatiss and David Walliams 'recreating' the first pitch session for *Doctor Who*, plus *The Kidnappers*, in which Gatiss and Walliams played fans who kidnapped Peter Davison. Good sport Peter Davison appears in a non-speaking role. As himself.

EIGHT

THE MATRIX

BEHIND THE SCENES

'For some people, small, beautiful events are what life is all about.'

The Doctor, *Earthshock*

As our crazy, wibbly-wobbly, timey-wimey journey through *Doctor Who* nears its end, we salute the people who make the magic with the kind of behind-the-scenes trivia that so many *Doctor Who* fans love.

THE LONG AND SHORT OF IT

The shortest regular episode of *Doctor Who* is *The Mind Robber* Episode 5 which ran for just 18 minutes. The longest was *The Five Doctors* at 90 minutes and 23 seconds.

But how mini are those minisodes? The shortest so far is the second part of *Space / Time* at 2 minutes 54 seconds, while *Time Crash* is the relatively feature-length 7 minutes 42 seconds. As for *Dimensions in Time*, you're looking at 7 minutes 34 seconds for Part 1 and 5 minutes 27 seconds for Part 2.

THE ARCHITECTS
OF DOCTOR WHO

Who created *Doctor Who*? Certain editions of the popular board game Trivial Pursuit give the answer as 'Terry Nation', a popular misconception (although his contribution of the Daleks shouldn't be underestimated). This is a question that has no single answer; the development of the series throughout 1963 was an enormous group effort. Here are some of the names that can be considered the pioneering architects of *Doctor Who*.

Donald Baverstock—Controller of BBC Television in 1963. First identified the need for a Saturday evening family drama series.

Sydney Newman—BBC Head of Drama, 1962–1967. Canadian-born Newman arguably had the biggest influence over the creation of *Doctor Who*. He co-ordinated the efforts of the Drama department at the BBC to come up with a science fiction adventure series and provided comment on all proposals.

Donald Wilson—BBC Head of Serials in 1963, reporting directly to Sydney Newman, with a similar supervisory role in the overall development of the series.

Alice Frick—BBC Drama story editor. Contributed to various key reports on producing a science-fiction drama serial in 1962–1963.

John Braybon—BBC story editor, present for early discussions on the prospect of a sci-fi drama serial.

C.E. 'Bunny' Webber—BBC staff writer. Present at various meetings throughout 1963, and produced the first and subsequent series proposal for 'Dr. Who', along with several storylines.

Rex Tucker—'Caretaker' producer of *Doctor Who* before the appointment of Verity Lambert. Would return in 1966 to direct *The Gunfighters*.

Verity Lambert—*Doctor Who*'s first full-time producer from 1963 to 1965. Instrumental in casting William Hartnell as the Doctor and shaping the first two years of the series.

Mervyn Pinfield—associate producer, working closely with Verity Lambert throughout the first year of *Doctor Who*.

David Whitaker—*Doctor Who*'s first story editor and subsequently prolific scriptwriter.

Anthony Coburn—BBC staff writer hired to script the first *Doctor Who* story, drawing on existing proposal documents, in particular the work of C.E. Webber.

Waris Hussein—BBC director responsible for helming the first story, *An Unearthly Child*. Along with Verity Lambert, was key in the casting of William Hartnell.

Peter Brachacki—BBC staff designer on the pilot episode, *An Unearthly Child*, responsible for designing the original TARDIS control room.

William Hartnell, Jacqueline Hill, William Russell, Carole Ann Ford—The original cast. Without whom…

PROLIFIC GUEST STARS

Doctor Who has played host to some much-loved guest stars, and many have made return appearances across the decades. Here are some of the most prolific *Doctor Who* guest stars and the number of episodes they have appeared in (not including companions, their families, UNIT personnel, extras, voice artistes and monsters!)

Roger Delgado (37)	Kevin Stoney (22)
Anthony Ainley (31)	Bernard Kay (19)
Michael Wisher (24—not including voices)	Michael Sheard (17)
	Peter Miles (17)

John Abineri (17)

Graham Leaman (17)

Norman Jones (15)

Philip Madoc (15)

Bernard Horsfall (15)

Jean Marsh (15)

Milton Johns (15)

Peter Halliday (15—not including
voices)

Alan Rowe (15)

Prentis Hancock (14)

Lynda Bellingham (14)

Michael Jayston (14)

Christopher Benjamin (13)

Alex Kingston (13)

John Ringham (13)

Wanda Ventham (13)

Michelle Gomez (13)

Ronald Allen (12)

Donald Pickering (12)

David Savile (12)

George Pravda (11)

Frederick Jaeger (11)

REPEAT PERFORMANCE

Some actors have returned as the same character in different stories. Here are some examples (excluding companions, families, UNIT personnel, voice artistes and monster operators).

Character	Actor	Stories
Ashildr / Me	Maisie Williams	*The Girl Who Died* / *The Woman Who Lived* / *Face the Raven* / *Hell Bent*
Captain Henry Avery	Hugh Bonneville	*The Curse of the Black Spot* / *A Good Man Goes to War*
Toby Avery	Oscar Lloyd	*The Curse of the Black Spot* / *A Good Man Goes to War*
Margaret Blaine / Blon Fel Fotch Pasameer-Day Slitheen	Annette Badland	*Aliens of London* / *World War Three* / *Boomtown*
The Face of Boe	Struan Roger	*The End of the World* / *New Earth* / *Gridlock*
Professor Bracewell	Bill Patterson	*Victory of the Daleks* / *The Pandorica Opens*
Cassandra	Zoe Wanamaker	*The End of the World* / *New Earth*
The Castellan	Paul Jerricho	*Arc of Infinity* / *The Five Doctors*

Character	Actor	Stories
Winston Churchill	Ian McNeice	*Victory of the Daleks / The Pandorica Opens / The Wedding of River Song*
Davros	Terry Molloy	*Resurrection / Revelation / Remembrance of the Daleks*
Charles Dickens	Simon Callow	*The Unquiet Dead / The Wedding of River Song*
Jenny Flint	Catrin Stewart	*A Good Man Goes to War / The Snowmen / The Crimson Horror / The Name of the Doctor / Deep Breath*
The General	Ken Bones	*The Day of the Doctor / Hell Bent*
Sabalom Glitz	Tony Selby	*The Trial of a Time Lord / Dragonfire*
Vincent van Gogh	Tony Curran	*Vincent and the Doctor / The Pandorica Opens*
Novice Hame	Anna Hope	*New Earth / Gridlock*
Harriet Jones	Penelope Wilton	*Aliens of London / World War Three / The Christmas Invasion / The Stolen Earth*
Madame Kovarian	Frances Barber	*Day of the Moon / The Curse of the Black Spot / The Rebel Flesh / The Almost People / A Good Man Goes to War / Closing Time / The Wedding of River Song*
Liz 10	Sophie Okonedo	*The Beast Below / The Pandorica Opens*
Lytton	Maurice Colbourne	*Resurrection of the Daleks / Attack of the Cybermen*
Angie Maitland	Eve De Leon Allen	*The Bells of Saint John / The Crimson Horror / Nightmare in Silver / The Name of the Doctor*
Artie Maitland	Kassius Carey Johnson	*The Bells of Saint John / The Crimson Horror / Nightmare in Silver / The Name of the Doctor*
Dorium Maldovar	Simon Fisher-Becker	*The Pandorica Opens / A Good Man Goes to War / The Wedding of River Song*
Dr Malokeh	Richard Hope	*The Hungry Earth / Cold Blood / The Wedding of River Song*
The Master	Roger Delgado	Various (1971–1973)

Character	Actor	Stories
The Master	Anthony Ainley	Various (1981–1989)
The Master	John Simm	*Utopia / The Sound of Drums / The End of Time / World Enough and Time / The Doctor Falls*
Missy	Michelle Gomez	Various (2014–2017)
The Meddling Monk	Peter Butterworth	*The Time Meddler / The Daleks' Master Plan*
Ohila	Claire Higgins	*The Night of the Doctor / The Magician's Apprentice / Hell Bent*
Craig Owens	James Corden	*The Lodger / Closing Time*
The Rani	Kate O'Mara	*The Mark of the Rani / Time and the Rani*
Rigsy	Joivan Wade	*Flatline / Face the Raven*
Sil	Nabil Shaban	*Vengeance on Varos / The Trial of a Time Lord*
Sophie	Daisy Haggard	*The Lodger / Closing Time*
Strax	Dan Starkey	*A Good Man Goes to War / The Snowmen / The Crimson Horror / The Name of the Doctor / Deep Breath*
Professor Travers	Jack Watling	*The Abominable Snowmen / The Web of Fear*
Madame Vastra	Neve McIntosh	*A Good Man Goes to War / The Snowmen / The Crimson Horror / The Name of the Doctor / Deep Breath*

DOCTOR WHO'S MOST PROLIFIC WRITERS

The writers with the most story-writing credits between 1963 and 2017

1. Steven Moffat—39 story credits
2. Russell T Davies—25 story credits
3. Robert Holmes—15 story credits

4. Terry Nation—11 story credits
5. Bob Baker / Mark Gatiss—9 story credits each
6. David Whitaker / Dave Martin—8 story credits each
7. Malcolm Hulke—7 story credits
8. Brian Hayles/ Toby Whithouse / Gareth Roberts—6 story credits each
9. Terrance Dicks—5 story credits
10. Dennis Spooner / Louis Marks / Gerry Davis / David Fisher / Eric Saward / Chris Chibnall—4 story credits each

DIRECTOR WHO

The most prolific directors by number of episodes they are credited with directing

1. Douglas Camfield—52 episodes
2. David Maloney—45 episodes
3. Christopher Barry—42 episodes
4. Michael E. Briant—29 episodes
5. Lennie Mayne—28 episodes
6. Barry Letts / Pennant Roberts—24 episodes each
7. Richard Martin / Ron Jones—22 episodes each
8. Derek Martinus / Michael Ferguson—21 episodes each
9. Peter Moffat—20 episodes
10. Graeme Harper—19 episodes
11. Paddy Russell—18 episodes
12. Paul Bernard / Peter Grimwade / Fiona Cumming—16 episodes each
13. Chris Clough—15 episodes
14. Michael Hayes—14 episodes
15. Morris Barry / Timothy Combe—13 episodes each
16. Gerald Blake / Nicholas Mallet / Euros Lyn—12 episodes each
17. Waris Hussein—11 episodes (plus the Pilot episode)
18. Mervyn Pinfield / Hugh David / Rodney Bennett—10 episodes each
19. Julia Smith / George Spenton-Foster / Norman Stewart / Andrew Morgan / Douglas Mackinnon /—8 episodes each
20. John Crockett / Alan Wareing / James Strong / Rachel Talalay—7 episodes each
21. John Gorrie / Henric Hirsch / Gerry Mill / Tristan de Vere Cole / Michael Hart—6 episodes each

STAGE PLAYS AND PERFORMANCES

There have been all manner of amateur and unlicensed stage versions of *Doctor Who*—as well as 'guest' appearances by characters, monsters, Daleks… But there have been relatively few officially licensed live *Doctor Who* shows. Enter, stage left: The Doctor—along with some of his greatest enemies too!

The Curse of the Daleks by David Whitaker and Terry Nation
- Original run: 21 December 1965–15 January 1966, Wyndham's Theatre, London
- No Doctor but lots of Daleks (well, five at least).

Doctor Who and the Daleks in the Seven Keys to Doomsday by Terrance Dicks
- Original run: 16 December 1974–11 January 1975, Adelphi Theatre, London
- Trevor Martin stars as an alternative Fourth Doctor with former companion Wendy Padbury as Jenny.

Hot Ice '86
- Original run: 14 June–1 November 1986, Blackpool Ice Dome
- Each performance included an officially licensed eight-minute *Doctor Who* ice adventure featuring skater David McGrouther as the Sixth Doctor with Julie Sharrock as Peri.

Doctor Who: The Ultimate Adventure by Terrance Dicks
- Original run: Various venues from 23 March 1989 (first night at Wimbledon Theatre, London) to 19 August 1989 (final performance at Congress Theatre, Eastbourne)
- A national tour starring first Jon Pertwee, then Colin Baker and, for one night only, David Banks as the Doctor.

Doctor Who Meets Albert Einstein by Justin Richards
- Original run: February 2005, The Young Scientist Exhibition, Dublin
- Produced by the Institute of Physics in association with BBC Worldwide, this short play starred Declan Brennan as the Doctor. Staged multiple times during the exhibition, the play explained the concepts of relativity to children in a fun way.

Doctor Who: A Celebration
- Original performance: 19 November 2006, Wales Millennium Centre
- A Children in Need charity concert of *Doctor Who* music and monsters, hosted by David Tennant.

Doctor Who Prom
- Original performance: 27 July 2008, Royal Albert Hall, London
- Presented by Freema Agyeman, this celebration of *Doctor Who* music included the *Music of the Spheres* minisode.

Doctor Who Prom 2010
- Original run: 24–25 July 2010, Royal Albert Hall, London
- The second *Doctor Who* prom, this time hosted by Matt Smith, Karen Gillan and Arthur Darvill.

Doctor Who Live: The Monsters are Coming! by Will Brenton and Gareth Roberts, produced by BBC Worldwide and developed in association with Steven Moffat
- Original run: Various arena venues from 8 October 2010 (first performance Wembley Arena, London) to 6 November 2010 (final performance Belfast Odyssey Arena)
- Matt Smith appeared on screen for this arena spectacular that also starred Nigel Planer as Vorgenson, son of Vorg, in a monster-packed spectacular that served as a sequel to *Carnival of Monsters*.

The Crash of the Elysium by Felix Barrett and Tom MacRae
- Original run: 30 June–17 July 2011, Media City UK, Salford
- The Eleventh Doctor again popped up on screen (and in person for a special one-off surprise appearance) during this 60-minute children's production.

Doctor Who Symphonic Spectacular

- Performance: 4 February 2012, Melbourne Convention and Exhibition Centre, Australia
- The first official live *Doctor Who* event staged outside the UK saw the Melbourne Symphony Orchestra performing music from *Doctor Who*, conducted by Ben Foster. The event was staged again at the Sydney Opera House from 15 to 21 December 2012, hosted by Alex Kingston and Mark Williams. A UK tour also ran from 23 to 29 May 2015.

TV SPIN-OFFS

Expanding the *Doctor Who* universe

▮ *K-9 and Company: A Girl's Best Friend* (1981)
Elisabeth Sladen and John Leeson returned as Sarah Jane and K-9 for a one-off BBC Christmas special.

▮ *Doctor Who Confidential* (2005–2011)
A behind-the-scenes documentary series aired on BBC Three.

▮ *Totally Doctor Who* (2006–2007)
Children's magazine programme broadcast on CBBC.

▮ *Torchwood* (2006–2011)
John Barrowman starred as Captain Jack Harkness in this darker, more adult spin on the *Doctor Who* universe. First produced by the BBC and then in co-production with Starz in the USA.

▮ *Torchwood Declassified* (2006–2008)
A 'making-of' series for *Torchwood*, broadcast on BBC Three and BBC Two.

▮ *The Sarah Jane Adventures* (2007–2011)
Elisabeth Sladen and her teenage gang of adventurers regularly saved the world in this hit CBBC series.

▮ *K9* (2009–2010)

Not an official spin-off, as the BBC had no involvement, this children's series was produced by Park Entertainment in Australia and starred a newly redesigned CGI incarnation of K-9.

▮ *Class* (2016)

Doctor Who returned to its very beginnings with this BBC Three series set at Coal Hill School. It was created by acclaimed novelist Patrick Ness, and featured appearances from Peter Capaldi's Doctor and the Weeping Angels.

WIRELESS WHO

Don't touch that dial! It's *Doctor Who* on the radio.

Title	Writer	Starring	Channel	Date
Exploration Earth: The Time Machine	Bernard Venables	Tom Baker, Elisabeth Sladen	BBC Radio 4	4 October 1976
Slipback	Eric Saward	Colin Baker, Nicola Bryant	BBC Radio 4	25 July–8 August 1985
The Paradise of Death	Barry Letts	Jon Pertwee, Elisabeth Sladen, Nicholas Courtney	BBC Radio 5	27 August–24 September 1993
Whatever Happened to Susan Foreman	Adrian Mourby	Jane Asher	BBC Radio 4	9 July 1994
The Ghosts of N-Space	Barry Letts	Jon Pertwee, Elisabeth Sladen, Nicholas Courtney	BBC Radio 2	20 January–24 February 1996
Music of the Spheres	Russell T Davies	David Tennant	BBC Radio 3	27 July 2008

DOCTOR WHO
ON THE BIG SCREEN

At the height of 1960s Dalekmania, Regal Films International released two big-screen Dalek movies produced by Max J Rosenberg and Milton Subotsky. The first was based on Terry Nation's first Dalek story. *Dr. Who and the Daleks* (1965) starred Hammer Horror star Peter Cushing as the human inventor Dr. Who with Roy Castle, Jennie Linden and Roberta Tovey as Ian, Barbara and Susan respectively. The sequel, *Daleks— Invasion Earth 2150 A.D.*, appeared one year later, with Bernard Cribbins and Jill Curzon as companions Tom Campbell and Louise, the Doctor's niece. Roberta Tovey reprised her role as Susan. The physical length of the celluloid for the two films laid end to end is 2,266.49 metres and 2,309.78 metres respectively.

STORIES THAT
NAME-CHECK THEMSELVES

Five minutes and nine seconds into the second episode of *Doctor Who*, the Doctor says 'Doctor Who'. You'd be surprised how often the stories name-check themselves in the scripts…

EPISODE TITLES

Until *The Savages*, *Doctor Who* episodes had their own individual titles and soon got into the name-checking game.

The Cave of Skulls
0:17:33—Za: 'I will take them to the Cave of Skulls.'

The Firemaker
0:09:50—Ian: '… in our tribe, the firemaker is the least important man.'

The Roof of the World
0:01:58—Barbara: 'It could be the Andes… Himalayas—the roof of the world.'

The Singing Sands
0:12:15—Marco Polo: 'Travellers of the Gobi Desert have good reason to fear the singing sands, Barbara.'

Five Hundred Eyes
0:07:48—Marco Polo: 'Have you heard of the cave of the five hundred eyes?'

Mighty Kublai Khan
0:16:41—Vizier: 'The Great Warlord and Master of the World, mighty Kublai Khan is pleased to grant you an audience.'

The Day of Darkness
0:09:54—Tlotoxl: 'The day of darkness is the perfect time.'

The Daleks
0:02:35—Dalek: 'Survivors of London—the Daleks are the masters of Earth.'

Conspiracy
02:02—The Doctor: 'There's some sort of conspiracy going on, my child…'

The Zarbi
0:10:19—Vrestin: 'The Zarbi will treat them as enemies.'

Crater of Needles
0:17:02—Menoptra Voice: 'We jettison craft at altitude five above Crater of Needles.'

The Centre
0:01:45—Animus: 'You will be brought to the centre.'

The Lion
0:18:16—El Akir: 'The Lion is in our cage.'

The Knight of Jaffa
0:13:34—King Richard: 'In the name of God, St Michael, and St George, we dub you Sir Ian, Knight of Jaffa.'

Four Hundred Dawns
0:13:55—Maaga: 'Some four hundred dawns ago, we were investigating this particular section of the galaxy.'

Airlock
0:19:12—Maaga: 'You are in the airlock.'

The Traitors
0:10:16—Mavic Chen: 'If the traitors are not caught at the landing zone, then Central City must be cordoned off until they are found.'

The Sea Beggar
0:23:34—Admiral de Coligny: 'The Sea Beggar! It's a title I'd be proud of!'

The Bomb
0:07:34—Monoid Three: 'What about the bomb?'

The Dancing Floor
0:00:30—Toymaker: 'Hunt the key to fit the door that leads out on the dancing floor.'

Johnny Ringo
0:05:57—Pa Clanton: 'Get me Johnny Ringo. Get him quick.'

The OK Corral
0:04:40—Wyatt Earp: 'Tell 'em, the OK Corral.'

■ STORY TITLES

After *The Savages*, episode titles disappeared, but the name-checks kept coming.

The Savages
Episode 1, 0:17:38—Dodo: 'What, to keep out the savages?'

The War Machines
Episode 3, 0:02:55—Green: 'He is a threat to the security of the War Machines!'

The Smugglers
Episode 2, 0:17:20—Blake: 'I'm after the smugglers.'

The Moonbase
Episode 1, 0:12:46—Earth Control: 'In the meantime, the Moonbase is to be put in quarantine.'

The Abominable Snowmen
Episode 1, 0:17:47—Travers: 'The Yeti. You know, the Abominable Snowmen.'

The Dominators
Episode 3, 0:08:14—Jamie: 'Aye, well the Dominators don't know anything about your gentleness.'

The Invasion
Episode 2, 0:20:32—Cyber-Director: 'The invasion must succeed.'

The Krotons
Episode 1, 0:01:20—Selris: 'You are now the companions of the Krotons!'

The War Games
Episode 7, 0:07:10—Security Chief: 'This Doctor arrived here on this planet we have chosen for the war games.'

Inferno
Episode 1, 0:09:20—Sir Keith Gold: 'Yes! As a matter of fact, some of the technicians have nicknamed this place the Inferno.'

The Mind of Evil
Episode 6, 0:10:03—The Doctor: 'It's the mind of evil, Jo!'

The Claws of Axos
Episode 4, 0:05:24—The Doctor: 'The claws of Axos are already deeply embedded in the Earth's carcass!'

The Daemons
Episode 3, 0:09:42—The Doctor: 'They were all inspired by the Daemons.'

The Curse of Peladon
Episode 1, 0:17:48—Hepesh: 'The legend of the curse of Peladon has been handed down through countless centuries.'

The Sea Devils
Episode 4, 0:09:00—The Doctor: 'All right, well let's forget about the Sea Devils.'

The Mutants
Episode 1, 0:14:06—Marshall: 'Hmm… the Mutants!'

Carnival of Monsters
Episode 1, 0:04:11—Vorg: 'Roll up and see the monster show! A carnival of monsters, all living in their natural habitat, wild in this little box of mine.'

Frontier in Space
Episode 1, 0:09:21—Draconian Prince: 'The treaty between our two empires established a frontier in space.'

Robot
Episode 2, 0:01:06—Sarah: 'There's a great robot in there!'

The Brain of Morbius
Episode 4, 0:10:47—The Doctor: 'The brain of Morbius in that body makes a terrifying combination.'

The Talons of Weng-Chiang
Episode 6, 0:15:39—Greel: 'Let the talons of Weng-Chiang shred your flesh!'

Underworld
Episode 2, 0:09:18—The Doctor: 'Welcome to the Underworld.'

The Pirate Planet
Episode 2, 0:23:14—The Doctor: 'Buried inside Zanak, the Pirate Planet …'

The Leisure Hive
Episode 1, 0:04:40—Romana: 'The survivors build a recreation centre called the Leisure Hive.'

Meglos
Episode 1, 0:12:26—Meglos: 'I am Meglos—only survivor of this planet.'

Full Circle
Episode 1, 0:17:13—Draith: 'Tell Dexeter we've come full circle…'

State of Decay
Episode 2, 0:08:27—The Doctor: 'I've never seen such a state of decay.'

The Keeper of Traken
Episode 1, 0:03:01—The Doctor: 'The Keeper of Traken'

Logopolis
Episode 1, 0:06:13—The Doctor: 'Logopolis'

Castrovalva
Episode 2, 0:36:23—Nyssa: 'Dwellings of Simplicity. Castrovalva. Where's that?'

Kinda
Episode 1, 0:03:27—Todd: 'The Kinda pose no threat whatsoever to the security of this expedition.'

Black Orchid
Episode 1, 0:11:24—Lady Cranleigh: 'The Black Orchid.'

Arc of Infinity
Episode 1, 0:15:42– Nyssa: 'Not much. Just the name the ancients gave to this region. The Arc of Infinity.'

Terminus
Episode 1, 0:21:52—Tannoy Voice: 'This is a special announcement from Terminus Incorporated.'

Enlightenment
Episode 2, 0:21:14—Striker: 'Enlightenment.'

Frontios
Episode 1, 0:02:26—Norma: 'Food is rationed on Frontios.'

The Mark of the Rani
Episode 1, 0:10:05—The Master: 'The Mark of the Rani.'

Timelash
Episode 1, 0:03:11—Gazak: 'If we stay here and are caught, they'll throw us into the Timelash.'

Paradise Towers
Episode 1, 0:01:18—Mel: 'Paradise Towers, here we come.'

Dragonfire
Episode 1, 0:09:58—Glitz: 'Depth of Eternal Darkness? Dragonfire? I should stop at home, if I were you.'

The Happiness Patrol
Episode 1, 0:06:42—Daisy: 'He is obviously a spy. She is obviously his accomplice. He will disappear and she can audition for the Happiness Patrol.'

The Greatest Show in the Galaxy
Episode 1, 0:01:15—Ringmaster: 'There are lots of surprises for the family at the Greatest Show in the Galaxy!'

Battlefield
Episode 1, 0:05:06—Warmsly: 'The dig, as a matter of fact, is a hobby. A battlefield.'

The Curse of Fenric
Episode 1, 0:22:40—Commander Millington: 'It's now, Judson. The Curse of Fenric.'

Survival
Episode 1, 0:05:35—Sergeant Patterson: 'Have you ever heard of survival of the fittest, son?'

Rose
0:03:10—Rose: 'Hello? Hello, Wilson, it's Rose.'

The End of the World
0:03:08—The Doctor: 'Welcome to the end of the world.'

World War Three
0:22:22—The Doctor: 'World War Three.'

Dalek
0:08:28—The Doctor: 'If you can't kill, then what are you good for, Dalek?'

The Doctor Dances
0:18:13—Rose: 'The world doesn't end because the Doctor dances.'

Bad Wolf
0:18:05—Rodrick: 'When it comes to the final, I want to be up against you, so that you get disintegrated and I get a stack load of credits courtesy of the Bad Wolf Corporation.'

New Earth
0:01:56—The Doctor: 'This is New Earth.'

The Age of Steel
0:29:24—Lumic: 'This is The Age of Steel and I am its Creator.'

Army of Ghosts
01:45—Rose: 'But then came the army of ghosts.'

42
0:01:42—Ship's computer: 'Forty-two minutes'

The Family of Blood
0:07:53—Baines: 'We are the Family of Blood.'

Blink
0:03:07—The Doctor: 'Don't blink!'

Utopia
0:03:10—Yana: 'One more lost soul dreaming of Utopia.'

Partners in Crime
0:29:24—Matron: 'Partners in crime...'

The Unicorn and the Wasp
0:21:24—The Doctor: 'The Unicorn and the Wasp.'

Silence in the Library
0:05:07—The Doctor: 'Million life forms, and silence in the library.'

Midnight
0:01:03—The Doctor: 'Taking a big space truck with a bunch of strangers across a diamond planet called Midnight?'

Turn Left
0:39:38—Rose: 'You need to turn left.'

The Next Doctor
0:05:29—The Doctor: 'The Next Doctor.'

The End of Time
Part One, 0:09:43—Elder Ood: 'The end of time itself.'

The Beast Below
0:01:59—Little girl: 'Though the man above might say hello, expect no love from the beast below.'

The Time of Angels
0:28:58—River: 'The Time of Angels.'

Amy's Choice
0:31:28—The Dream Lord: 'Amy's Choice.'

The Pandorica Opens
08:18—River: 'The Pandorica Opens.'

The Big Bang
0:29:32—Rory: 'The Big Bang.'

A Christmas Carol
0:12:35—The Doctor: 'A Christmas carol.'

Space
0:03:32—The Doctor: 'Worse than a time loop, a space loop.'

Time
0:0:25—Amy: 'Well the exterior shell of the TARDIS has drifted forwards in time…'

A Good Man Goes to War
0:14:33—Dorium: 'Demons run when a good man goes to war.'

Let's Kill Hitler
0:03:56—Mels: 'Let's Kill Hitler.'

Dinosaurs on a Spaceship
0:04:52—The Doctor: 'I know. Dinosaurs. On a spaceship!'

The Power of Three
0:40:02—Amy: 'The Power of Three'

The Angels Take Manhattan
0:29:29—The Doctor: 'The Angels take Manhattan because they can, because they've never had a food source like this one.'

The Great Detective
0:00:13—Narrator: 'In London in the time of Queen Victoria there were many tales of a remarkable personage called the Great Detective...'

The Snowmen
0:12:49—The Doctor: 'Clara, stop thinking about the Snowmen.'

The Bells of Saint John
00:02:43—Monk: 'The bells of Saint John are ringing.'

The Rings of Akhaten
00:05:44—The Doctor: 'Welcome to the Rings of Akhaten.'

Cold War
0:12:37—Stepashin: 'Well, the Cold War won't stay cold for ever, Captain.'

Hide
00:37:04—The Doctor: 'Because that's what you do. You hide.'

The Crimson Horror
00:01:11—Amos: 'The Crimson Horror, that's what they're calling it.'

The Name of the Doctor
0:43:28—The Doctor: 'But not in the name of the Doctor.'

Listen
00:00:16—The Doctor: 'Listen!'

The Caretaker
00:05:23—Danny Pink: 'The Caretaker. Smith. The Doctor.'

Kill the Moon
00:24:53—The Doctor: 'Kill the moon?'

Dark Water
00:29:17—Chang: 'It's so cool. Look at this. We call it dark water.'

Last Christmas
0:32:22—Danny Pink: 'Every Christmas is last Christmas.'

Sleep No More
00:23:45—The Doctor: 'Glamis hath murdered sleep, therefore Cawdor shall sleep no more. Macbeth shall sleep no more."

Face The Raven
00:22:24—Me: 'To break it in any way is to face the Raven.'

Smile
00:03:10—Kezzia: 'Is that smile supposed to look real?'

Thin Ice
00:07:53—A Victorian couple skate past a sign saying 'Danger Thin Ice'

Oxygen
00:00:49—Computer: 'Oxygen Levels Critical.'

Extremis
00:06:14—Pope: 'Extremis.'

Empress of Mars
00:21:54—Friday: 'She is Iraxxa, Express of Mars.'

HOW LONG WOULD IT TAKE TO WATCH DOCTOR WHO?

Got some time on your hands and want to watch some *Doctor Who*? Assuming every episode existed for you to pop into your DVD player, here's how long it would take to watch each Doctor's era from start to finish—with the grand total for the entire series at the bottom. Somebody get the popcorn…

- **FIRST DOCTOR**: 54h 24m 36s

- **SECOND DOCTOR**: 47h 19m 12s

- **THIRD DOCTOR**: 51h 53m 8s

- **FOURTH DOCTOR**: 69h 6m 4s

- **FIFTH DOCTOR**: 30h 3s

- **SIXTH DOCTOR**: 17h 18m 4s

- **SEVENTH DOCTOR**: 17h 5m 31s

- **EIGHTH DOCTOR**: 1h 31 m 24s

- **NINTH DOCTOR**: 9h 30m 38s

- **TENTH DOCTOR**: 38h 11m 18s

- **ELEVENTH DOCTOR**: 34h 51m 37s

- **TWELFTH DOCTOR**: (up to *The Doctor Falls*): 31h 36m 8s

- **GRAND TOTAL**: 429h 28m 29s

That's 25,768.5 minutes of *Doctor Who* or 1,546,109 seconds if you prefer.

APPENDIX

STORY LIST

Story name	Episode name
THE FIRST DOCTOR	
Season 1 (1963–1964)	
An Unearthly Child (aka 100,000 BC)	An Unearthly Child
	The Cave of Skulls
	The Forest of Fear
	The Firemaker
The Daleks (aka The Mutants)	The Dead Planet
	The Survivors
	The Escape
	The Ambush
	The Expedition
	The Ordeal
	The Rescue
The Edge of Destruction (aka Inside the Spaceship)	The Edge of Destruction
	The Brink of Disaster
Marco Polo	The Roof of the World
	The Singing Sands
	Five Hundred Eyes
	The Wall of Lies
	Riders from Shang-Tu
	Mighty Kublai Khan
	Assassin at Peking

Story name	Episode name
The Keys of Marinus	The Sea of Death
	The Velvet Web
	The Screaming Jungle
	The Snows of Terror
	Sentence of Death
	The Keys of Marinus
The Aztecs	The Temple of Evil
	The Warriors of Death
	The Bride of Sacrifice
	The Day of Darkness
The Sensorites	Strangers in Space
	The Unwilling Warriors
	Hidden Danger
	A Race Against Death
	Kidnap
	A Desperate Venture
The Reign of Terror	A Land of Fear
	Guest of Madame Guillotine
	A Change of Identity
	The Tyrant of France
	A Bargain of Necessity
	Prisoners of Conciergerie
Season 2 (1964–1965)	
Planet of Giants	Planet of Giants
	Dangerous Journey
	Crisis
The Dalek Invasion of Earth	World's End
	The Daleks
	Day of Reckoning
	The End of Tomorrow
	The Waking Ally
	Flashpoint

Story name	Episode name
The Rescue	The Powerful Enemy
	Desperate Measures
The Romans	The Slave Traders
	All Roads Lead to Rome
	Conspiracy
	Inferno
The Web Planet	The Web Planet
	The Zarbi
	Escape to Danger
	Crater of Needles
	Invasion
	The Centre
The Crusade	The Lion
	The Knight of Jaffa
	The Wheel of Fortune
	The Warlords
The Space Museum	The Space Museum
	The Dimensions of Time
	The Search
	The Final Phase
The Chase	The Executioners
	The Death of Time
	Flight Through Eternity
	Journey into Terror
	The Death of Doctor Who
	Planet of Decision
The Time Meddler	The Watcher
	The Meddling Monk
	A Battle of Wits
	Checkmate

Story name	Episode name
Season 3 (1965–1966)	
Galaxy 4	Four Hundred Dawns
	Trap of Steel
	Air Lock
	The Exploding Planet
Mission to the Unknown	Mission to the Unknown
The Myth Makers	Temple of Secrets
	Small Prophet, Quick Return
	Death of a Spy
	Horse of Destruction
The Daleks' Master Plan	The Nightmare Begins
	Day of Armageddon
	Devil's Planet
	The Traitors
	Counter Plot
	Coronas of the Sun
	The Feast of Steven
	Volcano
	Golden Death
	Escape Switch
	The Abandoned Planet
	The Destruction of Time
The Massacre	War of God
	The Sea Beggar
	Priest of Death
	Bell of Doom
The Ark	The Steel Sky
	The Plague
	The Return
	The Bomb

Story name	Episode name
The Celestial Toymaker	The Celestial Toyroom
	The Hall of Dolls
	The Dancing Floor
	The Final Test
The Gunfighters	A Holiday for the Doctor
	Don't Shoot the Pianist
	Johnny Ringo
	The OK Corral
The Savages	Episodes 1 to 4
The War Machines	Episodes 1 to 4
Season 4 (1966–1967)	
The Smugglers	Episodes 1 to 4
The Tenth Planet	Episodes 1 to 4
THE SECOND DOCTOR	
The Power of the Daleks	Episodes 1 to 6
The Highlanders	Episodes 1 to 4
The Underwater Menace	Episodes 1 to 4
The Moonbase	Episodes 1 to 4
The Macra Terror	Episodes 1 to 4
The Faceless Ones	Episodes 1 to 6
The Evil of the Daleks	Episodes 1 to 7
Season 5 (1967–1968)	
The Tomb of the Cybermen	Episodes 1 to 4
The Abominable Snowmen	Episodes 1 to 6
The Ice Warriors	Episodes 1 to 6
The Enemy of the World	Episodes 1 to 6
The Web of Fear	Episodes 1 to 6
Fury from the Deep	Episodes 1 to 6
The Wheel In Space	Episodes 1 to 6

Story name	Episode name
Season 6 (1968–1969)	
The Dominators	Episodes 1 to 5
The Mind Robber	Episodes 1 to 5
The Invasion	Episodes 1 to 8
The Krotons	Episodes 1 to 4
The Seeds of Death	Episodes 1 to 6
The Space Pirates	Episodes 1 to 6
The War Games	Episodes 1 to 10
THE THIRD DOCTOR	
Season 7 (1970)	
Spearhead from Space	Episodes 1 to 4
Doctor Who and the Silurians	Episodes 1 to 7
The Ambassadors of Death	Episodes 1 to 7
Inferno	Episodes 1 to 7
Season 8 (1971)	
Terror of the Autons	Episodes 1 to 4
The Mind of Evil	Episodes 1 to 6
The Claws of Axos	Episodes 1 to 4
Colony In Space	Episodes 1 to 6
The Daemons	Episodes 1 to 5
Season 9 (1972)	
Day of the Daleks	Episodes 1 to 4
The Curse of Peladon	Episodes 1 to 4
The Sea Devils	Episodes 1 to 6
The Mutants	Episodes 1 to 6
The Time Monster	Episodes 1 to 6
Season 10 (1972–1973)	
The Three Doctors	Episodes 1 to 4
Carnival of Monsters	Episodes 1 to 4
Frontier In Space	Episodes 1 to 6
Planet of the Daleks	Episodes 1 to 6
The Green Death	Episodes 1 to 6

Story name	Episode name
Season 11 (1973–1974)	
The Time Warrior	Parts 1 to 4
Invasion of the Dinosaurs	Parts 1 to 6
Death to the Daleks	Parts 1 to 4
The Monster of Peladon	Parts 1 to 6
Planet of the Spiders	Parts 1 to 6
THE FOURTH DOCTOR	
Season 12 (1974–1975)	
Robot	Parts 1 to 4
The Ark in Space	Parts 1 to 4
The Sontaran Experiment	Parts 1 to 2
Genesis of the Daleks	Parts 1 to 6
Revenge of the Cybermen	Parts 1 to 4
Season 13 (1975–1976)	
Terror of the Zygons	Parts 1 to 4
Planet of Evil	Parts 1 to 4
Pyramids of Mars	Parts 1 to 4
The Android Invasion	Parts 1 to 4
The Brain of Morbius	Parts 1 to 4
The Seeds of Doom	Parts 1 to 6
Season 14 (1976–1977)	
The Masque of Mandragora	Parts 1 to 4
The Hand of Fear	Parts 1 to 4
The Deadly Assassin	Parts 1 to 4
The Face of Evil	Parts 1 to 4
The Robots of Death	Parts 1 to 4
The Talons of Weng-Chiang	Parts 1 to 6
Season 15 (1977–1978)	
Horror of Fang Rock	Parts 1 to 4
The Invisible Enemy	Parts 1 to 4
Image of the Fendahl	Parts 1 to 4
The Sun Makers	Parts 1 to 4
Underworld	Parts 1 to 4
The Invasion of Time	Parts 1 to 6

Story name	Episode name
Season 16 (1978–1979)	
The Ribos Operation	Parts 1 to 4
The Pirate Planet	Parts 1 to 4
The Stones of Blood	Parts 1 to 4
The Androids of Tara	Parts 1 to 4
The Power of Kroll	Parts 1 to 4
The Armageddon Factor	Parts 1 to 6
Season 17 (1979–1980)	
Destiny of the Daleks	Episodes 1 to 4
City of Death	Parts 1 to 4
The Creature from the Pit	Parts 1 to 4
Nightmare of Eden	Parts 1 to 4
The Horns of Nimon	Parts 1 to 4
Shada	(Uncompleted and unbroadcast)
Season 18 (1980–1981)	
The Leisure Hive	Parts 1 to 4
Meglos	Parts 1 to 4
Full Circle	Parts 1 to 4
State of Decay	Parts 1 to 4
Warriors' Gate	Parts 1 to 4
The Keeper of Traken	Parts 1 to 4
Logopolis	Parts 1 to 4
THE FIFTH DOCTOR	
Season 19 (1982)	
Castrovalva	Parts 1 to 4
Four to Doomsday	Parts 1 to 4
Kinda	Parts 1 to 4
The Visitation	Parts 1 to 4
Black Orchid	Parts 1 to 2
Earthshock	Parts 1 to 4
Time-Flight	Parts 1 to 4

Story name	Episode name
Season 20 (1983)	
Arc of Infinity	Parts 1 to 4
Snakedance	Parts 1 to 4
Mawdryn Undead	Parts 1 to 4
Terminus	Parts 1 to 4
Enlightenment	Parts 1 to 4
The King's Demons	Parts 1 to 2
20th-Anniversary Special (1983)	
The Five Doctors	The Five Doctors
Season 21 (1984)	
Warriors of the Deep	Parts 1 to 4
The Awakening	Parts 1 to 2
Frontios	Parts 1 to 4
Resurrection of the Daleks	Parts 1 to 2
Planet of Fire	Parts 1 to 4
The Caves of Androzani	Parts 1 to 4
THE SIXTH DOCTOR	
The Twin Dilemma	Parts 1 to 4
Season 22 (1985)	
Attack of the Cybermen	Parts 1 to 2
Vengeance on Varos	Parts 1 to 2
The Mark of the Rani	Parts 1 to 2
The Two Doctors	Parts 1 to 3
Timelash	Parts 1 to 2
Revelation of the Daleks	Parts 1 to 2
Season 23 (1986)	
The Trial of a Time Lord	Parts 1 to 4 (The Mysterious Planet)
	Parts 5 to 8 (Mindwarp)
	Parts 6 to 12 (Terror of the Vervoids)
	Parts 13 to 14 (The Ultimate Foe)

Story name	Episode name
THE SEVENTH DOCTOR	
Season 24 (1987)	
Time and the Rani	Parts 1 to 4
Paradise Towers	Parts 1 to 4
Delta And the Bannermen	Parts 1 to 3
Dragonfire	Parts 1 to 3
Season 25 (1988–1989)	
Remembrance of the Daleks	Parts 1 to 4
The Happiness Patrol	Parts 1 to 3
Silver Nemesis	Parts 1 to 3
The Greatest Show in the Galaxy	Parts 1 to 4
Season 26 (1989)	
Battlefield	Parts 1 to 4
Ghost Light	Parts 1 to 3
The Curse of Fenric	Parts 1 to 4
Survival	Parts 1 to 3
Children in Need (1993)	
Dimensions in Time (minisode)	Parts 1 to 2
THE EIGHTH DOCTOR	
Television movie (1996)	
Doctor Who	Doctor Who
THE NINTH DOCTOR	
Series One (2005)	
Rose	Rose
The End of the World	The End of the World
The Unquiet Dead	The Unquiet Dead
Aliens of London / World War Three	Aliens of London
	World War Three
Dalek	Dalek
The Long Game	The Long Game
Father's Day	Father's Day

Story name	Episode name
The Empty Child / The Doctor Dances	The Empty Child
	The Doctor Dances
Boom Town	Boom Town
Bad Wolf / The Parting of the Ways	Bad Wolf
	The Parting of the Ways
THE TENTH DOCTOR	
Children in Need (2005)	
Born Again (minisode)	Born Again
Christmas Specials (2005)	
The Christmas Invasion	The Christmas Invasion
Attack of the Graske (Interactive red-button episode)	Attack of the Graske
Series Two (2006)	
New Earth	New Earth
Tooth and Claw	Tooth and Claw
School Reunion	School Reunion
The Girl in the Fireplace	The Girl in the Fireplace
Rise of the Cybermen / The Age of Steel	Rise of the Cybermen
	The Age of Steel
The Idiot's Lantern	The Idiot's Lantern
The Impossible Planet / The Satan Pit	The Impossible Planet
	The Satan Pit
Love & Monsters	Love & Monsters
Fear Her	Fear Her
Army of Ghosts / Doomsday	Army of Ghosts
	Doomsday
Christmas Special (2006)	
The Runaway Bride	The Runaway Bride
Series Three (2007)	
Smith and Jones	Smith and Jones
The Shakespeare Code	The Shakespeare Code
Gridlock	Gridlock

Story name	Episode name
Daleks in Manhattan / Evolution of the Daleks	Daleks in Manhattan
	Evolution of the Daleks
The Lazarus Experiment	The Lazarus Experiment
42	42
Human Nature / The Family of Blood	Human Nature
	The Family of Blood
Blink	Blink
Utopia	Utopia
The Sound of Drums / Last of the Time Lords	The Sound of Drums
	Last of the Time Lords
Animated series (Totally Doctor Who, 2007)	
The Infinite Quest	The Infinite Quest
Children in Need (2007)	
Time Crash (minisode)	Time Crash
Christmas Special (2007)	
Voyage of the Damned	Voyage of the Damned
Series Four (2008)	
Partners in Crime	Partners in Crime
The Fires of Pompeii	The Fires of Pompeii
Planet of the Ood	Planet of the Ood
The Sontaran Stratagem / The Poison Sky	The Sontaran Stratagem
	The Poison Sky
The Doctor's Daughter	The Doctor's Daughter
The Unicorn and the Wasp	The Unicorn and the Wasp
Silence in the Library / Forest of the Dead	Silence in the Library
	Forest of the Dead
Midnight	Midnight
Turn Left	Turn Left
The Stolen Earth / Journey's End	The Stolen Earth
	Journey's End
The Doctor Who Prom (2008)	
Music of the Spheres (minisode)	Music of the Spheres

Story name	Episode name
Christmas Special (2008)	
The Next Doctor	The Next Doctor
Easter Special (2009)	
Planet of the Dead	Planet of the Dead
Autumn Special (2009)	
The Waters of Mars	The Waters of Mars
Animation (2009)	
Dreamland	Dreamland
Christmas and New Year Specials (2009–2010)	
The End of Time	The End of Time, Part One
	The End of Time, Part Two
THE ELEVENTH DOCTOR	
Series Five (2010)	
The Eleventh Hour	The Eleventh Hour
The Beast Below	The Beast Below
Victory of the Daleks	Victory of the Daleks
The Time of Angels / Flesh and Stone	The Time of Angels
	Flesh and Stone
The Vampires of Venice	The Vampires of Venice
Amy's Choice	Amy's Choice
The Hungry Earth / Cold Blood	The Hungry Earth
	Cold Blood
Vincent and the Doctor	Vincent and the Doctor
The Lodger	The Lodger
The Pandorica Opens / The Big Bang	The Pandorica Opens
	The Big Bang
Minisode (2010)	
Death Is the Only Answer	Death Is the Only Answer
Christmas Special (2010)	
A Christmas Carol	A Christmas Carol
Comic Relief 2-part minisode (2011)	
Space / Time	Space
	Time

Story name	Episode name
Series Six (2011)	
The Impossible Astronaut	The Impossible Astronaut
Day of the Moon	Day of the Moon
The Curse of the Black Spot	The Curse of the Black Spot
The Doctor's Wife	The Doctor's Wife
The Rebel Flesh / The Almost People	The Rebel Flesh
	The Almost People
A Good Man Goes to War	A Good Man Goes to War
Let's Kill Hitler	Let's Kill Hitler
Night Terrors	Night Terrors
The Girl Who Waited	The Girl Who Waited
The God Complex	The God Complex
Closing Time	Closing Time
The Wedding of River Song	The Wedding of River Song
Christmas Special (2011)	
The Doctor, the Widow and the Wardrobe	The Doctor, the Widow and the Wardrobe
Minisodes (2012)	
Good as Gold	Good as Gold
Pond Life (5-part red button minisode)	Pond Life
Series Seven, Part One (2012)	
Asylum of the Daleks	Asylum of the Daleks
Dinosaurs on a Spaceship	Dinosaurs on a Spaceship
A Town Called Mercy	A Town Called Mercy
The Power of Three	The Power of Three
The Angels Take Manhattan	The Angels Take Manhattan
Christmas Specials (2012)	
The Great Detective (minisode)	The Great Detective
The Snowmen (Christmas Special)	The Snowmen
Series Seven, Part Two (2013)	
The Bells of Saint John	The Bells of Saint John
The Rings of Akhaten	The Rings of Akhaten
Cold War	Cold War

Story name	Episode name
Hide	Hide
Journey to the Centre of the TARDIS	Journey to the Centre of the TARDIS
The Crimson Horror	The Crimson Horror
Nightmare in Silver	Nightmare in Silver
The Name of the Doctor	The Name of the Doctor
Minisodes (2013)	
The Bells of Saint John: A Prequel	The Bells of Saint John: A Prequel
The Last Day	The Last Day
The Night of the Doctor	The Night of the Doctor
50th Anniversary Special	
The Day of the Doctor	The Day of the Doctor
Christmas Special (2013)	
The Time of the Doctor	The Time of the Doctor
Series Eight (2014)	
Deep Breath	Deep Breath
Into the Dalek	Into the Dalek
Robot of Sherwood	Robot of Sherwood
Listen	Listen
Time Heist	Time Heist
The Caretaker	The Caretaker
Kill the Moon	Kill the Moon
Mummy on the Orient Express	Mummy on the Orient Express
Flatline	Flatline
In the Forest of the Night	In the Forest of the Night
Dark Water / Death in Heaven	Dark Water
	Death in Heaven
Christmas Special (2014)	
Last Christmas	
Series Nine (2015)	
The Magician's Apprentice / The Witch's Familiar	The Magician's Apprentice
	The Witch's Familiar
Under the Lake / Before the Flood	Under the Lake
	Before the Flood

Story name	Episode name
The Girl Who Died	The Girl Who Died
The Woman Who Lived	The Woman Who Lived
The Zygon Invasion / The Zygon Inversion	The Zygon Invasion
	The Zygon Inversion
Sleep No More	Sleep No More
Face the Raven	Face the Raven
Heaven Sent / Hell Bent	Heaven Sent
	Hell Bent
Minisodes (2015)	
Prologue	Prologue
The Doctor's Meditation	The Doctor's Meditation
Christmas Special (2015)	
The Husbands of River Song	The Husbands of River Song
Christmas Special (2016)	
The Return of Doctor Mysterio	The Return of Doctor Mysterio
Series 10 (2017)	
The Pilot	The Pilot
Smile	Smile
Thin Ice	Thin Ice
Knock Knock	Knock Knock
Oxygen	Oxygen
Extremis / The Pyramid at the End of the World / The Lie of the Land	Extremis
	The Pyramid at the End of the World
	The Lie of the Land
Empress of Mars	Empress of Mars
The Eaters of Light	The Eaters of Light
World Enough and Time / The Doctor Falls	World Enough and Time
	The Doctor Falls
Christmas Special (2017)	
Twice Upon A Time	Twice Upon A Time

THANKS

Thanks, first and foremost, to everyone who bought and supported the first edition of *Who-ology*, making it the first *Doctor Who* book ever to hit the *Sunday Times* Bestseller list. You are all brilliant.

It goes without saying that a book like this can only exist with the assistance, knowledge and support of many friends and colleagues, so special thanks to:

Marcus Hearn, Peter Ware and Scott Gray at *Doctor Who Magazine*; The *Doctor Who—The Complete History* Team, John Ainsworth, Emily Cook and Paul Vyse; Andrew James, Jessica Burton, Amoona Saohin, Chris Thompson, Will O'Mullane, Lucy Ripper, Ricky Claydon, and everyone in the Titan Comics *Doctor Who* office; plus Richard Atkinson, Tom Attah, Alan Barnes, Daniel Brennan, Nicholas Briggs, Georgie Britton, Neil Corry, Richard Cookson, Tommy Donbavand, Alan Foale, Simon Guerrier, Toby Hadoke, Lee Hart, George Mann, Stephanie Milner, Jonathan Morris, Justin Richards, David Richardson, Derek Ritchie, Jim Sangster (you *still* know why), Paul Simpson, Tom Spilsbury, Steve Tribe, Matthew Sweet for his Dallas Cavell story, and Nick Webster.

An important shout-out for the amazing Andrew Pixley, whose series of detailed archive features in the pages of *Doctor Who Magazine* have been an invaluable resource in the compiling of *Who-ology*. It's gratifying to see this project continuing for the modern series in the current range of *DWM: Special Editions* and now *Doctor Who—The Complete History*. Andrew, we salute you.

Ben Morris for his wonderful illustrations and Lee Binding for the transcendental cover.

Special thanks to Albert DePetrillo at BBC Books for asking us to write the original edition back in 2012, Nick Payne and Joe Cottington for keeping us on the straight and narrow back then, and to Bethany Wright for taking up the mantle five years later.

And, as ever, our families for support and cups of tea—Clare, Chloe and Connie and Paula and Oliver.